THINKING ABOUT ART

Midnight, Tottenham Court Road 1982, C-type photograph, 28 × 80

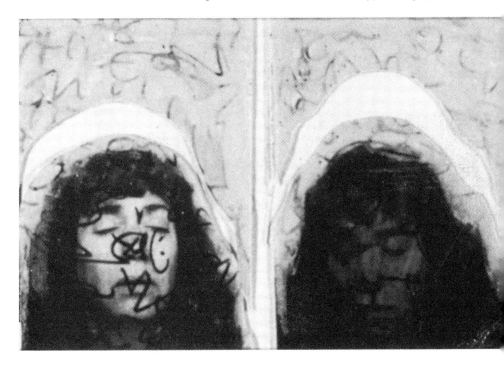

THINKING ABOUT ART

Conversations with

SUSAN HILLER

edited & introduced by Barbara Einzig
with a Preface by Lucy Lippard

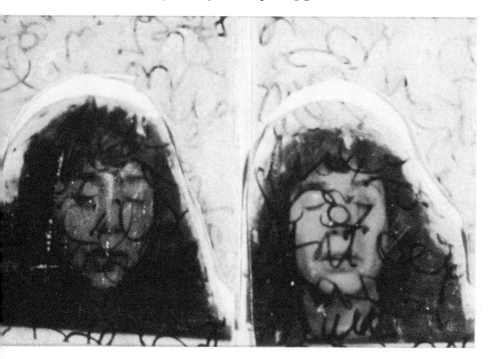

MANCHESTER UNIVERSITY PRESS *Manchester & New York*
distributed exclusively in the USA by St. Martin's Press

Preface copyright © 1996 Lucy Lippard
Introductions copyright ©1996 Barbara Einzig
All other textual material copyright © 1996
Susan Hiller

Published by Manchester University Press
Oxford Road, Manchester M13 9NR, UK
and Room 400, 175 Fifth Avenue, New York,
NY 10010, USA

Distributed exclusively in the USA and Canada
by St. Martin's Press, Inc., 175 Fifth Avenue,
New York, NY 10010, USA

ISBN 0 7190 4564 9 hardback
ISBN 0 7190 4565 7 paperback

First published 1996
00 99 98 97 96 10 9 8 7 6 5 4 3 2 1

British Library Cataloguing-in-Publication Data
A catalogue record is available from the British
Library

*Library of Congress Cataloging-in-Publication
Data*
Hiller, Susan.
 Thinking about art : conversations with Susan
Hiller / edited by
Barbara Einzig ; preface by Lucy Lippard.
 p. cm.
 ISBN 0–7190–4564–9.—ISBN 0–7190–4565–7
(pbk.)
 1. Hiller, Susan–Interviews.
 2. Artists–United States–Interviews.
 3. Feminism and art–United States. 4. Art and
anthropology. I. Einzig, Barbara. II. Title.
 N6537.H536A35 1995
 700'.92–dc20 95–11073

Designed in Bell by Max Nettleton FCSD
Typeset by Servis Filmsetting Ltd, Manchester
Printed in Great Britain
by Bell & Bain Limited, Glasgow

CONTENTS

List of illustrations *page* vii

Acknowledgements ix

Preface *by Lucy Lippard* xi

Introduction *by Barbara Einzig* 1

1 INSIDE ALL ACTIVITIES
 THE ARTIST AS ANTHROPOLOGIST

 Editor's introduction 14

 Art and anthropology/Anthropology and art (1977) 16
 Dedicated to the unknown artists (1978) 26
 An artist looks at ethnographic exhibitions (1986) 31

2 WITHIN AND AGAINST
 WOMEN BEING ARTISTS

 Editor's introduction 40

 Women, language and truth (1977) 43
 I don't care what it's called (1982) 45
 Looking at new work (1983) 51
 Portrait of the artist as a photomat (1983) 60
 Reflections (1989) 69
 O'Keeffe as I see her (1993) 77

3 FRAGMENTS OF A FORGOTTEN LANGUAGE
 AUTOMATISM, DREAM, COLLECTIVE REVERIES

 Editor's introduction 86

 Belshazzar's feast/The writing on your wall 89
 Abstract fire (1988) 99
 Theory and art (1988) 103
 The dream and the word (1993) 111
 The word and the dream (1993) 121

4 WORKING THROUGH CULTURE
CONVENTIONS OF SEEING

Editor's introduction *page* 134

Thirteen male absences (1978) 136
Notes for a conference on postmodernism (1982) 141
An audience for art (1991) 144
The idea of multiplicity in art (1992) 159

5 OBJECTS AS EVENTS EXTENDED OVER TIME
THE NATURE OF REPRESENTATION

Editor's introduction 168

Duration and boundaries (1975) 170
Collaborative meaning: art as experience (1982) 182
Slow motion (1991) 193

6 ART AND KNOWLEDGE
A CRITIQUE OF EMPIRICISM

Editor's introduction 204

It is not all really available for us any more (1992) 207
Working through objects (1994) 226
Beyond control (1995) 242

Appendix: *Sacred Circles* 252

Chronology of works cited 258
Selected bibliography 260

ILLUSTRATIONS

Midnight, Tottenham Court Road 1982 *page* ii, iii

Alphabet 1, Alphabet 2, Seance/Seminar, Self-portrait 1983 5

Notes for seminar at Goldsmith's College 6

Eaux de vie/spirits 1993. Photograph: David Cripps/Book Works 9

Susan Hiller sorting pottery fragments, London, 1977.
Photograph: David Coxhead 13

Fragments (details) 1977–78 22, 23, 30

Élan 1981–82 39

!0 Months 1977–79. Photograph: Arts Council Collection 48, 49

Sisters of Menon 1972–79. 52, 53

Self-portrait 1983 55

Sometimes I Think I'm a Verb instead of a Pronoun 1981–82 64

Midnight, Euston 1982 68

Georgia O'Keeffe 1961. Photograph: Anthony Vacarro 77

Belshazzar's Feast 1983/84 ('living-room' version) 84, 85

Belshazzar's Feast 1983/84 ('campfire' version) 96, 97

The Secrets of Sunset Beach 1988 108, 109

Crime and Punishment, J. Grandville, from *Le Magasin pittoresque*, France, 1847 114

Drawing, William Blake, England, early nineteenth century. Tate Gallery, London 114

Drawing, William Blake, England *c.* 1819. Tate Gallery, London 115

Notebook page, Albrecht Dürer, Germany, 1525. Kunsthistorisches
Museum, Vienna 115

Frontispiece, Marquis d'Hervey de Saint-Denis, *Les rêves et les moyens
de les diriger*, France, 1867 116

The Astral Light, Ophiel, cover illustration from *The Art & Practice of Astral
Projection*, USA, 1961. Courtesy of Edward C. Peach 116

Ceci est la couleur de mes rêves, Joan Mirò, France, 1925 © ADAGP, Paris
and DACS, London 117

The Dream, the Sphinx and the Death of T., Alberto Giacometti,
Labyrinthe, ed. Albert Skira, No. 2, Switzerland, 1946 117

Photomontage illustrating *The Dream Machine*, Brion Gysin and Ian
Sommerville, from *Olympia*, No. 2, Paris, France, 1962 117

Belshazzar's Feast 1983/84 ('bonfire' version) 119

Churinga, Nglia tribe, central Australia. British Museum, London 124

Painting, Clifford Possum Tjapaljarri, Australia, 1982. Collection
David Coxhead, London *page* 125

Chumash cave, near Santa Barbara, California. Photograph: Campbell
Grant, *Rock Paintings of the Chumash*, Berkeley, 1965 125

Petroglyphs, Lewis Canyon, Texas. Copy by F. Kirkland, from W. W. Newcomb
Jr., *The Rock Art of Texas Indians*, Austin, 1938 125

Ittal, Saora, Orissa, India, *c.* 1950. Copy by H. V. Elwin, *Tribal Art of Middle
India*, Oxford, 1951 126

Iroquois mask, New York State, *c.* 1915. New York State Museum, Albany 126

Talisman, Navajo Nightway Chant, New Mexico, *c.* 1900.
Photograph: Washington Matthews, *The Night Chant: A Navaho Ceremony*,
Washington D.C., 1902 127

Lapp shaman's drum, 1710. The National Museum of Denmark, Department
of Ethnography 127

Drawing, Chuckchi, Siberia, nineteenth century. The National Museum of
Denmark, Department of Ethnography 128

Dream Mapping (detail) 1974 129

An Entertainment (detail) 1990/91. Photograph: Edward Woodman/
Matt's Gallery, London 132, 133

Dedicated to the Unknown Artists (details) 1972–76 138, 139

An Entertainment (details) 1990/91. Photograph: Edward Woodman/
Matt's Gallery, London 149

Nine Songs from Europe 1991–95. Photograph: Gareth Winters 161

'Tuesday' from *Work in Progress* 1988. Photograph: Chris Swayne 167

Dream Mapping (details) 1974, 1986 178, 179

Monument (details) 1980–81 186, 187, 188, 189

Midnight, Baker Street 1983 197

Heimlich/homely 1994 203

At the Freud Museum 1992-ongoing. Photograph: Steve White/
Book Works 224, 225

שמחה /joy 1994; *Cowgirl/kou'gurl* 1992. Photographs: David Cripps/
Book Works 230

Seance/seminar 1994. Photograph: David Cripps/Book Works 241

Hand Grenades 1969–72 242

Measure by Measure (detail) 1973-ongoing 243

Painting Blocks, 1974–1981 250, 251

ACKNOWLEDGEMENTS

Susan Hiller wishes to indicate that the origin of this book is collaborative, and that very special thanks are due to everyone who invited her to speak about her work and ideas. *Thinking about art* is an anthology of selections from a large body of oral material instigated by the interest and commitment of many people. Specific acknowledgements to individual hosts, interviewers and institutions are provided with each chapter.

Susan Hiller also wishes to thank Guy Brett for initially suggesting the concept of the book to the publisher; Katharine Reeve of Manchester University Press for formulating the project in detail; Barbara Einzig for inspired and committed editorial shaping of the contents; and Lucy Lippard for contributing her generous Preface.

Thanks are due, also, to those who helped in assembling the book, specifically Jackie Haliday for facilitating long-distance communications between author and editor, and researching the chronology of works; Janni Perton for locating elusive tapes and transcriptions; and the librarians of the University of Ulster, Belfast for tracking down missing reference details.

The publishers wish to acknowledge the Arts Council of England's financial support for the publication of this book, and the Faculty of Art and Design, University of Ulster, Belfast for assistance with the expenses incurred in transcribing audio tapes and typing.

PREFACE *by Lucy Lippard*

Language, gender, desire and death are the immodest content of Susan Hiller's art. She is one of the few artists working today with the courage and subtlety to do such subjects justice, and in the process to move art out of its bounds. Because despite the frustrations and failures of contemporary 'high culture', the arts are the only field porous enough to reveal a view of the vast territory Hiller patrols:

> Artists . . . *modify* their culture while learning from it . . . Artists *perpetuate* their culture by using certain aspects of it . . . Artists *change* their culture by emphasizing certain aspects of it, aspects perhaps previously ignored. The artist's version may show hidden or suppressed cultural potentials . . . by revealing the extent to which shared conceptual models are inadequate because they exclude or deny some part of reality. Artists everywhere operate skilfully within the very socio-cultural contexts that formed them . . . They are experts in their own cultures.[1]

Hiller's brilliance is both critical and aesthetic, a fact that has been recognized by the British art world, though in her native US she is still little known – in part due to our appetite for importing aesthetic fast foods, and in part to her own resistance to categorization. Somewhat influenced by permutational minimalism and working in a 'conceptualist' third stream since the early 1970s, Hiller remains obdurately marginal to the movement treadmills. Uninterested in bringing issue-oriented politics directly into her art, she nevertheless proves that 'art with no overt political content can sensitize us politically'.[2] The complex body of work she has accomplished is informed by her empathy with the 'Other' and by her insight into the structure of language as a basis of social structures.

Susan Hiller studied at Smith College (coincidentally my own alma mater), and did graduate work in anthropology at Tulane University in New Orleans, followed by fieldwork in Mexico, Guatemala and Belize, on grants from the National Science Foundation and the Middle American Research Institute. Having completed her Ph.D. exams, in 1965 she underwent a 'crisis of conscience', a disillusionment with academic anthropology that focused on the impossibility of the 'participant/observer' posture. During a lecture on African art, Hiller found herself taking notes in pictures rather than in words, and experienced 'what I can only call an "exquisite" sensation'. Determined to 'find a way to be *inside* all my activities',[3] to be a full participant in the culture in which she lived, she became an artist. The decision coincided with the death of her mother, which suggests that it was also a rite of passage.

Hiller saw her crossover into art as a shift away from alienated approaches, yet she still had to fight for a 'home' in an art system itself characterized by isolation from social reality. At the same time she maintained her distance as a cultural 'outsider', travelling extensively in the 1960s with novelist David Coxhead in North Africa, India and the Far East before settling in Britain in 1970. This inside/outside dialectic is reflected in her stated insistence on 'analysis and ecstasy' as the sources of her formal vocabulary. She combines the 'irrational' (the autonomous mark, or unit) with the 'rational' (the desire to give form to these units of experience without sacrificing them to a false new 'whole'.

Hiller's fluid form and dialectical syntax was established by 1973 in a show she had at Gallery House in London. It consisted of *Transformer* – a large tissue-paper and nylon filament structure covered in marks suggesting symbols and glyphs representing non-existent alphabets – and *Enquiries* – a collection of culturally revealing 'facts' from a British popular encyclopedia (not yet joined by *Inquiries*, its American counterpart). *Transformer* was shown under Hiller's 'real name' and *Enquiries* under the pseudonym 'Ace Posible'. I read this as a hispanicizing pun: doing the possible (high card),(*h*)*ace posible*, or a statement of potential, *es posible*. In any case, the show was a collaboration between a socially recognizable self and 'another' self.

Hiller does not idealize 'otherness', and has never exploited the surface imagery or displaced symbols of other cultures, as so many artists did in the 1970s and 1980s. She brought with her from anthropology a methodology rather than any specific theory. When she uses cultural artefacts, from potsherds to postcards, she does not project meanings on to them but retains their 'idiosyncratic nature' which affects the way they are perceived and illuminates their significance in relation to our own culture – something most anthropologists ignore and of which most artists are ignorant. 'Without being sentimental', she has remarked, 'I think it's a kind of cherishing of things as they are, rather than trying to make them into other things. I deal with fragments of everyday life and I'm suggesting a fragmentary view is all we've got.'[4]

Hiller's art lives where we all do – between the everyday and the spiritual, microcosm and macrocosm, ordinary and extraordinary. Her quest is for a new language to oppose or expand that of the dominant culture, a language that will be generous enough to include the desires of the 'outsiders' – all culturally disenfranchised groups, and especially women. Such a language would also include material from the 'outer limits', the unspoken or the out-of-control, which was the point of departure for Hiller's *Group Investigation* pieces in the early 1970s. *Street Ceremonies* (1973) was a large-scale community

'performance' which drew a half-mile circle on an urban grid, mapping the geographical and cultural boundaries of a London neighbourhood within the larger framework of a celestial event – the autumn equinox. *Draw Together* (1972) explored the transmission of images telepathically to friends in other countries. *The Dream Seminar* (1973) was 'an investigation into the origins of images and ideas' with a small volunteer group.

 Dream Mapping (1974) was also an extended process incorporating discussion. It culminated in three nights when the seven participants slept out together at a Hampshire farm rich in 'fairy rings', formed by mushrooms. In the ancient tradition of conscious 'incubation' or inducement of dreams, Hiller had prepared the ground in selecting this site. Rather than being carried away to fairyland, as legend has it, the dreamers within the fairy rings were carried away into each others' dreams. The dream maps they produced after each night were finally superimposed into a composite that pictured the shared consciousness of an 'organic community'. Like virtually all of Hiller's works, *Dream Mapping* incorporated both intimacy and cosmic scope. By 'dreaming creatively and in an aware sense', the participants functioned 'as artists in a way we can hardly come to terms with'.[5]

 Hiller found in art practice ways to visualize 'certain chinks or holes through which it is possible to sense an enormous potential reality . . . I believe that art can function as a critique of existing culture and as a locus where futures not otherwise possible can begin to shape themselves.'[6] Hiller's view of self is therefore not tied to autobiographical experience. 'My "self" is a site for thoughts, feelings, sensations, not an impermeable, corporeal boundary. I AM NOT A CONTAINER . . . Identity is a collaboration. The self is multiple.'[7] After her directly collaborative *Group Investigation* pieces, and the book *Dreams: Visions of the Night* with David Coxhead, Hiller collaborated 'indirectly' with the writers of popular encyclopedias (*Enquiries/Inquiries*, 1973 and 1975) with the anonymous photographers, painters and retouchers of the ubiquitous British postcards entitled 'Rough Sea' (*Dedicated to the Unknown Artists*, 1976), with her unborn son (*Ten Months*, 1977–79), with unknown Pueblo Indian women potters (the fragments of whose art were the basis of a complex, key work about the abyss between cultures and the colonization of archaeological material in *Fragments*, 1977–78),[8] with forgotten urban heroes and heroines (*Monument*, 1980–81), with the nameless dead (*Magic Lantern*, 1987), with the puppeteers of traditional British Punch and Judy shows (*An Entertainment*, 1990) and with Sigmund Freud (*From the Freud Museum*, 1992–94). Somewhere between direct and indirect collaboration lies the work utilizing automatic writing.

 Hiller's first experience with automatism in 1972 was a landmark in her extension of identity from individual to collective. The dream work gave her

figurative access to the 'dictation' she received from *The Sisters of Menon*, and dovetailed with her desire to 'make without looking'.[9] Menon is an anagram not only for 'no men' (inscribed when David Coxhead tried to be the transmitter) but also for 'nomen' or 'name', the signified crying out for the signifiers to which they are entitled. *The Sisters of Menon* spoke in several voices: singular (I), plural (we) and collective (everyone); they were insistently repetitive, almost permutational:

> I am the sister of everyone/I am your sister/we 3 sisters are 1 sister/you are the sister/last night we were 3 sisters/now we are 4 sisters/you are the Sister of Menon/we are 3 sisters/we live on the air in the water/ . . . the riddle is the sister of the zero/who is this one/Menon is this one/three sisters are your sister/this is the nothing that we are/I live my sister . . .

The Sisters of Menon texts were first shown in 1973; the work was extended in 1979 to include commentaries and to become an artist's book as well as a cruciform wall-piece. In all of its incarnations, the work confirms Mikhail Bakhtin's observation: 'Discourse lives, as it were, on the boundary of its own context and another, alien, context.'[10] Automatic writing, in which unfamiliar signs rise to the surface of consciousness, is a metaphor for the unarticulated or unintelligible speech of women. Hiller has made it a reversible ground, both negative and positive, white on black and black on white, something that can be done by everyone and an intensely subjective experience.

In tracking the origins of language across the blurred boundaries between utterance and speech, gesture and image, drawing and writing, Hiller was seeking a way in which to confront the contradictions of female experience within a male reality. 'A woman is mute within our culture in that when she speaks, she speaks as a man.'[11] With *The Sisters of Menon* and later automatic works, Hiller was bringing the muse – the female irrational that men use – back 'into her own', into the muse's own central role. She took the title for her 1983 exhibition from Akhmatova's line: 'The Muse my sister looked into my eyes/Her gaze was bright and clear.'[12]

Automatism in modernist art is always traced back to the Surrealists, who (glossing over their art sources) fished the waters of the subconscious for images and innuendoes, where Hiller would map the entire ocean. It has been suggested that once visual art was opened to the 'irrational' more women artists were able to participate. But the artists who made Surrealism revolutionary were men who needed to co-opt the femaleness they adored, patronized, and feared, to tap the muse they understood as female. If the 'child women' the Surrealists loved had been fully permitted to grow up as artists, the men would have been displaced. As Whitney Chadwick has pointed out, the men manipulated their adopted

pathological states, but the *femme enfant* 'was allowed no such distance from her unconscious'. Men might simulate madness; women were simply perceived as mad. Yet these women also laid the groundwork for a new female consciousness. When 'alienated from Surrealist theorizing about women and from the search for a magical Other, women artists turned to their own reality' in self-portraits that exposed the roots of a very different experience.[13]

Hiller, then, is their heiress, reappropriating female 'truth' as seen through tears in the social fabric. Her long series of photomat portraits (most recently, self-portraits), begun in 1972, manipulate and repersonalize the genre's front-face, confrontational mode. Alone in the booth, the subject/object combats self-image, convention and technology. Hiller extended this idea when she began to superimpose the 'vital' automatic scripts on the 'dead' faces of the photographs, like the life spirals inscribed by Maori tattoos which were supposed to disappear at death. The script's squirming forms imply nature and culture, pain and pleasure, scars and adornment. Hiller sees tattoos and body painting as ways of 'marking out the body as a site of culture, redeeming it from nature, which is chaos'.[14] The writing/body overlay can also be inverted to become the meeting-place or arena of the biological force (creative, active *élan*, the automatic script which arises from 'underground') and a camouflage imposed from above which makes certain cultural acts invisible, merging them back into nature. The script forms either a barrier or a connection between the person (artist) beneath and those trying to know her from outside (audience). There might be an additional, unintentional, reference to those black blocks that obscure news photos of alleged criminals or mental patients – masking the 'outsiders' – the dominant culture's way of warning those conscious enough to use their alienation that they will be forcibly obscured from view . . .

Shirley Ardener, studying women's models of the world in many different cultures, might have been describing Hiller's photomat/automat portraits when she described the emerging patterns of behaviour:

Although not one was exactly like another, each seemed to display parts of a model, which they possessed in common. To understand this one may imagine a set of screens in which gaps appear in different places. Through one screen an eye and an ear can be discerned, through another a different ear and a nose, and through another an eye, a nose and a mouth, and so forth. Each glimpse is different in detail, but given enough evidence we can construct the structure of a face lying behind each screen. No two screens are alike, no two mouths are alike, and yet a hidden model of a face is common to all . . . In the end we have to risk an imaginative leap, to make a guess at the underlying structure, making adjustments as more 'screens' become available . . . [15]

The dream is the classic screen for self-projection, and dream fragments also epitomize lost images and unfulfilled desires. Like orgasm, they constitute a rehearsal for death. In *Monument*, the 1980–81 installation which attracted international attention, Hiller examined language and representation as prisons, memory and identity as escape routes:

> If the world is always being constructed through language, then what is 'out there' is the same as what is 'inside'. This is how the dead speak to us and through us. We speak their language. They are speaking when we speak. Only when we break this language do we break the temporal order. Only when I break this language can I speak.[16]

Monument consists of forty-one colour photographs (one for each year of the artist's life in 1982) arranged in a stepped cross on the wall; a park bench with its back to the wall; and an audiotape – a disjunctive, fictionally-personal text that muses on 'the ideology of memory, the history of time, the "fixing" of representation'. The photographs reproduce a group of Edwardian ceramic plaques from a London park, which commemorate the late nineteenth/early twentieth-century deaths of local 'heroes' who gave their lives to rescue others. The only added image is a nearly transparent graffito found in the park and copied by the artist in a style appropriately more ethereal than the original: 'Strive to Be Your Own Hero.'

The subject-matter of *Monument* is the pathetic 'immortality' guaranteed by such plaques – a public, but apparently ignored, image of the Other, the 'common people', and those uncommonly heroic who have lived out a social dream to their death. Hiller's tape lists the number of years the heroes/martyrs lived 'two modes of existence' – e.g., '16 years in the body, 101 years as a representation'. The discrepancies are poignant. These people 'perished in the flames . . . died of terrible injuries . . . fatally scalded . . . trying to save a child . . . supporting a drowning playfellow . . . rushing into a burning house . . . giving up her lifebelt and going down in the sinking ship': a catalogue of dramas that never come together, an incomplete mythology, with an ambiguous message. 'Strive to Be Your Own Hero' can be read as a confirmation of the Victorian moral code, or a rebellion against such codes.

> It was a discourse full of holes, to match a world composed of fragments . . . *Monument* represents . . . those who have gone, 'passed away'. Absence is a metaphor of desire . . . representation is a 'regeneration' of images and ideas . . . Time can't exist without memory . . . Memory can't exist without representation . . . Western industrial society demands from each individual perpetual self-sacrifice prolonged over a lifetime of effort. This form of self-sacrifice isn't seen as particularly admirable or remarkable and is not represented as exemplary.[17]

While denying neither history nor continuity, Hiller has pushed her way past them so she can turn back and view the past from a different angle – the angle of the lost but still dreamed of consciousness which is being reborn. She has observed that when automatism is used by men, it is often ideologically validated as science, but when used by women 'it is denigrated as the non-productive, threatening activity of mediums.'[18]

She confronted this contrast in *Élan* (1983), with its primarily unintelligible scripts and a soundtrack described by Lynne Cooke as 'wordless chanting . . . at moments an untrammelled lament reminiscent of keening, at others of lullabies and cradle songs . . . although it hovers on the brink of speech, it belongs ultimately to some deeper and more primary level of communication'.[19] The sounds are the artist singing, and excerpts from the spiritualist experiments of Latvian psychologist Konstantin Raudive, which purport to be the dead speaking. By positing 'science' versus 'occultism', the piece takes a shot at the vulnerability of technology, gullibly accepted as the new magic; it extends the nature/culture tension of Hiller's earlier work. In all the automatic writing works, there is a question of whether the 'language' is an extension of the coherent or a surrender to the incoherent; an evolution towards a new language or a regression to pre-linguistic marks or formalism. This question is a hook into Hiller's fundamental concerns.

The line between coherence and inchoherence depends partly on individual interpretation and partly on social contracts; if people promise not to think beyond the rules imposed on them, then 'coherence' will have much narrower boundaries. Hiller's notion of culture reflects these concerns by incorporating 'paradoxes involving the unexpressed but intended' (which describes much contemporary art) and 'the expressed but unintended' (raw material of culture).[20] At a certain point she stopped referring to her automatism as 'crypto-linguistic' and in 1983 was 'practically at the point of claiming that my newer automatic works *are* a new language, or are making one'.

Hiller's interest in popular culture is redemptive rather than populist. Having provocatively stated that soup ladles are as important as Rembrandts,[22] she deals with the perceived abysses between high and low culture by interfacing them. The wallpapers she selects for the background (or underground) of her *Home Truths* series 'bleed through' their glyphic covers; or perhaps the 'art' is open enough to allow the 'culture' to enter it. Unlike Pollock's anima-oriented skeins, which dead-ended as the abstract components of a personal style, Hiller's scripts remain open to contextualization. Isolated and freshly visible, the idiot ideological images of love and death – vacuous Pierrots and cute bombers – surrender their hidden agendas.

Many of her wallpapers are designed for the spaces in which children

dream and are socialized. The bedroom is a shelter and an escape-hatch; like dreams and nightmares, the wallpapers are intimate and terrifying. (What if a little boy can't 'live up to' those images of death?) The heroism that was real but forgotten in *Monument* is fake but ubiquitous in *Masters of the Universe* or *Secret Wars*. When Hiller lays her automatic scripts over the anthropomorphized, patronizing, gender-coded alphabet wallpapers sold in department stores, you can almost hear the screech of contact, like fingernails on a blackboard. Culture is our backdrop; art is too often our wallpaper, bereft of meaning. The squiggles of *Home Truths* are carved into the culture as though to document what is missing, to inspire desire for the absent. They are metaphorical openings into the 'closures' of fetishism, stereotyped social expectations that bring the would-be seer 'up against the wall'. On the other hand, the wallpaper defines a cosy, domestic enclosure, evoking in turn the fearsome embrace of the nuclear family. The pierced black cover suggests clarity in literacy or the desperate scribbles on the walls of jail cells.

Where regular patterning can offer a veneer of order or style, the ragged irregularities of Hiller's automatic script interrupt the relentless commercial repetitions of the wallpaper. Hiller has mentioned that she sometimes sees her recent work as 'letters home' to the USA, source of a lot of the ideological junk food that feeds British culture. Social change starts at home. It must be 'envisioned' culturally before it takes to the hills, the streets or the seats of the status quo. It is the common task both of a truly 'popular' and a truly 'high' culture to bring it out. With *Belshazzar's Feast*, the 1983 video installation acquired by the Tate and screened on Channel 4, Hiller becomes what William Blake called the 'awakened dreamer' – a functioning visionary collaborating with the culture, confronting social control with the 'mystery of everyday things and thoughts',[23] despite the threat this poses to the dominant preference for controllable mystification.

'Lucidity is the first step of the awakened dreamer', wrote Hiller and Coxhead in their book on dreams. In her works titled *Bad Dreams* and *Lucid Dreams* (1981 and 1983), Hiller sets out to 'erode the supposed boundaries between dream life and waking life.'[24] Such a process is socially dangerous because it implies the fulfilment of popular desires for change that are currently channelled off into science fiction, horror movies or TV sitcoms, where fantasies are imposed from outside and above.

The rehabilitation of the communal imagination, its reawakening from the restless, potentially lethal sleep imposed by corporate culture, is a major aspect of Hiller's enterprise. In *Belshazzar's Feast* she uses the TV set as a metaphor for the communal hearth,[25] but on the screen flames leap and flow with subliminal energy, like uncontrollable nature threatening to burst its cultural

bonds, but also at times like the mesmerizing monotony of the airwaves. Domesticity is evoked by wallpaper in the installation; it too has its dark side, its own agenda, in the ideological message its pattern carries. On the sound-track of the tape, a 'preconscious' singing alternates with recollections of the Rembrandt painting and the Bible story of Belshazzar's feast enunciated by Hiller's son Gabriel, and with news stories about the appearance of alien faces on local TV screens announcing some doomful fate for the planet.

The subtitle 'What the fire said' appears early in the video, warning us that this is a parable and that we are to 'read' or 'listen to' the flame forms (which resemble the glyphs of automatic writing), the fluid, primal forms of fire and flood as they crackle, merge and disintegrate again. As in *Élan*, the language is doubly concrete – both seen and heard – and the video introduces movement as well. Other levels operate between the child as annunciator, symbol of beginnings, young enough to be learning language and memory, contrasted with the 'alien' heralding doom and conclusion, or death. The 'alien' faces were reported to appear in photographic negative, at midnight, when British television used to sign off for the night. Midnight is a moment between wakefulness and sleep, one day and the next, one world and another. Hiller's auto-photomat self-portraits are titled *Midnight, Baker Street*; *Midnight, Boca Raton*; they, too, give the impression of moving between two conditions, as in a Celtic twilight.

Like the flames (and domesticity, and woman herself) the singing sounds are both beautiful and scary, nourishing (lullabies) and fearful (spells or dirges, lulling to death). They evoke the chants of societies that are not necessarily preliterate but perhaps superliterate in their development of an oral tradition. (Similarly, Gabriel's 'short' memory is contrasted with cultural 'long' ones.)

'Civilized' language is perceived as written, nor oral, not pictured. Western scholars don't even recognize the ancient ideographic languages of Africa as 'writing'. Robert Farris Thompson has written of the *nsbidi* – the 'cruel letters' of the Ejagham people – that their signs represent ideas and 'many powers, including the essence of all that is valiant, just, and ordered . . . The moral and civilizing impact of *nsbidi* betrays the ethnocentrism of an ideology that would exclude ideographic forms from consideration in the history of literacy.' Foreign to Western thought are concepts rendered through 'visual music' – such as a drum that is meant not to be played but to be displayed, 'an instrument of significant silence, not reverberation'.[26]

As the video's sounds evoke emotions and the dancing ideograms of the flames evoke images, viewers are still forced to make their own pictures, create their own fantasies or content, since the subject-matter remains 'out of sight'. Neither the Rembrandt painting nor the news headlines, and certainly not the

faces of the aliens and the dreadful message they convey, are ever seen. They are absent, like the ghostly negative face, white on black, a hole in a surface. The news stories are a middle ground between fantasy and fiction. They are read in a whisper. Thus Hiller silences, or subdues, the dominant voice, and may imply that the mass media are a conspiracy against 'us'. The message brought by the alien is also too awesomely negative to be spoken aloud and can only be presented in an unknown language, as the words *Mene Mene Tekel Upharsin* appeared on the wall at Belshazzar's feast and were interpreted by Daniel in the role of the artist; he couldn't read the language either, but he communicated a sense, or a vision of its meaning ('numbered, numbered, weighed, divided'). The layers of *Belshazzar's Feast* peel away from form (handsomely seductive, titillatingly disjunctive) to subject-matter (home, holocaust, the media) and finally to content – which emerges and recedes from the 'faults' in the other two. On this shifting ground between what we 'get' and can hold on to, and what we sense, but escapes us and is 'lost', we are exposed to Hiller's 'fruitful incoherence'. 'I'm reviving the audience's recognition', she says, 'that they are not separated from those kinds of feelings and experiences, but simply that they've been repressed.'[27]

By addressing the cultural tragedies inherent in the invisible, Hiller is reconstructing the bridge art is supposed to be. Her desire to know the unknowable roots of language is a kind of radicalism. Her insistence on the fragment's autonomy parallels the feminist resistance to assimilation into a patriarchal culture. Her gift (to us) is related to the 'mystery of things that increase as they perish',[28] the power of fragments like the broken potsherds in prehistoric graves or the sacrifice of lives in *Monument*. By convincing us that her scripts are meaningful language as well as drawing, Hiller pressures us into the difficulties of discovering new structures in the familiar. With her we return to the crossroads where the symbol – the great communal composite of meaning – broke down under the weight of its function into signs which could be rearranged and expanded more or less infinitely, and can be faked by our 'masters'. Here lie not only the roots of art, but the roots of all 'free expression'.

NOTES
1 See 'Art and anthropology/Anthropology and art' in this volume.
2 Sarah Kent and Jackie Morreau, 'A Conversation with Susan Hiller', in *Women's Images of Men*, London: Writers & Readers Press, 1985.
3 'Art and anthropology/Anthropology and art'.
4 See the unabridged version of 'Dedicated to the unknown artist' in *Spare Rib Anthology*, Harmondsworth: Penguin Books, 1982.
5 All quotations about *Dream Mapping* are from 'Duration and boundaries' in this volume.
6 Interview with Lisa Liebmann and Tony Whitfield, *Fuse*, November/December. 1981; 'Art and anthropology/Anthropology and art'.
7 *Sisters of Menon*; quoted by Guy Brett in *The Sunday Times Magazine*, 11 March, 1984.
8 Texts by the artist accompany most of these works. In the one on *Fragments*, Hiller notes

that our word 'symbol' derives from the Greek word for a broken potsherd, and that in Hebrew and Latin potsherd means 'link' (*Susan Hiller: Recent Work*, exhibition catalogue, 1978, Kettles Yard, Cambridge/ Museum of Modern Art, Oxford).

9 Letter to Annette van den Bosch, quoted in *Art & Text*, nos 12/13, 1984, p. 106.

10 Mikhail Bakhtin, quoted in Terry Eagleton, *Against the Grain*, London: Verso, 1986, p. 115.

11 'Dedicated to the unknown artist.'

12 *Susan Hiller 1973–83: The Muse My Sister*, exhibition catalogue, 1984, The Orchard Gallery, Londonderry.

13 Whitney Chadwick, *Women Artists and the Surrealist Movement*, Boston, Mass.: Little Brown and Company, 1985, p. 74.

14 Note to the author, 1986.

15 Shirley Ardener, *Perceiving Women*, London: John Dent & Sons, 1975, p. xix.

16 From the soundtrack of *Monument*. While Hiller uses whatever medium is most compatible with her work's demands, installation is a preferred form, since it is sufficiently fluid to accommodate different contexts and even different cultures, as was the case with *Monument*.

17 *Ibid.*

18 Quoted by Guy Brett in *City Limits*, 12–18 March, 1982.

19 Lynne Cooke, 'Susan Hiller', catalogue essay in *The British Show*, British Council/Visual Arts Board of Australia, 1985, p. 71.

20 Hiller in audiotape discussion with Mary Kelly, 'Ideology and Consciousness', *Audio Arts*, vol. 3, no. 3, 1977.

21 See 'Looking at new work' in this volume. In this interview Hiller also says that her 'alphabets' should not just be seen in purely pictorial terms or as decorated surfaces, but taken seriously as a form of patterned utterance. She says, . . . 'I'd like to see a full phonemic study some day.'

22 'Dedicated to the unknown artist.'

23 In conversation with the author, June 1986.

24 'Looking at new work' in this volume.

25 A twenty-four hour electronic fireplace programme is currently available on cable television in the USA, and in 1969, Dutch artist Jan Dibbets did a public television piece in which he transformed the TV set into an electronic fireplace for twenty-four minutes during the Christmas holiday. Hiller is aware of these precedents but unlike them, her flame images are not 'realistic'; they are slowed-down, recoloured and often accompanied by wraithlike, monochrome doubles.

26 Robert Farris Thompson, *Flash of the Spirit*, New York: Vintage Books, 1984, pp. 228, 237.

27 See 'Belshazzar's feast/the writing on your wall' in this volume.

28 Lewis Hyde, *The Gift: The Erotic Life of Property*, New York: Vintage Books, 1979, p. 181. Hiller has applied this principle to her own work, creating new works from fragments of older works; see her discussion of *Work in Progress* in 'Slow motion', pp. 193–204 and of *Hand Grenades, Painting Blocks* and other recycled works in conversation with Stuart Morgan, pp. 242–52, both in this volume.

INTRODUCTION *by Barbara Einzig*

From the mid-seventies to the present day, Susan Hiller has been asked questions about her work by members of the public, including writers, critics, curators, art students and others. She has answered some of them in interviews and conversations and by giving lectures and seminars in galleries and colleges. Tape-recorded, transcribed, and edited, a selection of these talks comprise the present volume, *Thinking about art: conversations with Susan Hiller.* The word 'conversations' has been used, despite the fact that some of the talks included here adhered to the protocol of the formal paper, in order to emphasize Hiller's commitment to *dialogue* as the condition of her speech, a commitment to talk as collaborative investigation rather than authoritative act.

These public occasions have provided both Hiller and her audience with opportunities for greater insights into her art, an art that integrates an analytical orientation and takes as its subject the foregrounding of culture. Last year, speaking in a conference on art education, Hiller characterized her way of speaking as allowing 'the different kinds of ways an artist thinks – the personal, perceptual, formal, social and theoretical – to emerge and problematize one another'.[1] As an articulation of these different ways, *Thinking about art* highlights precisely those issues in the history of art and culture that are now the focus of heated debate in both the art world and academic circles. These issues are being generated by the profound shifts in cultural paradigms that are happening today. As many critics and theorists have noted, categories of art and culture – categories of knowledge –

reflect the Cartesian divisions our world is heir to: mind/body, self/other, subject/object, and, most notably, us/them. With the gradual demise of Eurocentrism and with new developments in social history, ecology, cybernetics, economics and other fields, these divisions no longer hold, and something new must take their place. Under attack is the traditional view of art as an absolute category with universal standards of quality, produced only by specialists.[2] The idea of the art work as aesthetic object to be objectively viewed is also being contested. It now appears that art may instead be a relative, culture-bound phenomenon; everyone may be thought of as an artist; and the usefulness of an object may not exclude it from the artistic rubric. Rather than being an object (even if it is constituted as such), a work of art may essentially be, in Hiller's words, 'a place where one thinks, feels and acts. Here we can collectively begin to visualize and construct new knowledges'.[3]

In Hiller's view, art is epistemology, the study or theory of the nature or grounds of knowledge, and she finds those grounds in culture, viewing it as a kind of lens. Because we see everything through this lens, we lose consciousness of it; we forget we are wearing glasses, and take our grasp of things as natural, the only way of seeing things, objective truth. This 'problem of culture'[4] is the central problem foregrounded by Hiller's art. Regardless of the forms her art takes – installations, photographs, collaborative works, videos or paintings – the theme is always our embeddedness in culture and how the outline of culture inscribes what we know. By making this

embeddedness visible, her works become sites in which conventional ways of seeing are 'seen through' . . . they become the grounds of possible transformation.

In the late seventies I corresponded with Hiller about an issue on dream that I was editing for an American interarts magazine.[5] As I wrote in the essay published there, I was concerned with the place of dream in our culture, its status as an imaginary experience, excluded from the effective, social, 'real' world. I found Hiller's collaborative performance work *Dream Mapping* positioned in the realm that concerned me, '*between* the communicable and the incommunicable', the conscious and unconscious. I followed her work throughout the eighties, corresponded, saw her exhibitions in New York. Her œuvre continued to inhabit and expand this place *between*, defying traditional divisions between rational and irrational forms of enquiry.

The talks that are gathered together here are conducted in very much the same spirit. They are both instructive and evocative, rigorously analytic and passionate, planned and spontaneous. And just as Hiller's artworks are structured by what she has called a 'set of interlocking metaphors', the talks return again and again to particular tropes, referencing her own art works as well as general cultural and theoretical issues and debates.

This introduction addresses Hiller's *way* of speaking to these issues, her relation to language. While her role as a cultural analyst has often been attributed to her background as an anthropologist, which was of course important to her development, I see it instead as being more crucially based in (1) her commitment to a view of artists as participants in the creation of the effective, social, 'real' world, and (2) the

nature of her art, which I characterize here as an art of *calibrations*, a principle derived from linguistic models. It might be summed up as a mobile, fluid, open structure employing various languages or 'registers' of both rational and irrational nuance; meaning occurs *between* these languages. (I address the paintings in which this principle is most succinct in part as exemplar and in part because they are barely touched upon in the talks, although they are a very visible component of Hiller's work.)

In editing this book, I have tried to allow the different modalities of Hiller's thinking to have their own way, not to be forced into the linearity of the prepared paper. Yet it seems useful to characterize those different ways of thinking and to identify the main issues that she addresses – to provide, in short, a conceptual overview. I have therefore divided the book into six parts, each featuring a particular vantage point on Hiller's practices. The divisions are both personal and practical – they are intended as a means of bringing these vantage points into greater relief and definition than would a standard chronological order. A number of the talks range widely in topic and could have been included in another part as well; I suggest that the reader conceive of the conceptual overview as being 'in the round'. Hiller's work, composed as it is of interlocking metaphors and practices, can be imagined as a globe that can be viewed or entered from multiple, equally valid points. (I have also sometimes subjected the texts to processes of elision and condensation, largely due to spatial limitations.) Each chapter has its own introduction, which outlines in detail the issues and debates that Hiller addresses in the texts that follow and provides descriptive information on artworks

referred to in that part. A summary of the content of these chapters is included at the close of this general introduction; a chronology of works cited (pp. 258–60) will assist the reader in locating specific illustrations of Hiller's artworks.

ARTISTS AS CREATORS OF THE REAL

> Bacon and Descartes & the rest of their family . . . cut the world into reason & unreason, claimed the domain of truth & reason for their own & left this truthless domain – the imagination – to the artists. It was a dreadful gift, made to us most formally by Kant, I suppose, & this domain . . . excluded us from any capacity to construct the true & the real.
>
> David Antin

As stated above, Hiller's qualification as cultural theorist is specifically as an artist, and she posits that such a 'construction of new knowledges' by artists may contribute to the creation of the real. In the first talk included in this book, she states that 'because of the collaborative formation of its meanings, art enables certain futures not otherwise possible to appear', and she is experienced enough as a social scientist to realize that this view makes her not an idealist but simply an artist who works at comprehending the mechanisms of historical change in social systems of knowledge. As such she is a forerunner of the growing number of artists whose work explores cultural signs and codes, a development occurring within a social context exploding with competing cultural codes and conflicting languages.

Hiller believes that 'artists may offer "paraconceptual" notions of culture by revealing the extent to which shared conceptual models are inadequate because they exclude or deny some part of reality'.[6] For as Maya Daren observed

(as cited by Hiller below), artists have been the only professional members of Western culture who never bought the Cartesian viewpoint and its valorization of detached 'objectivity,' if for no other reason than their consequent disenfranchisement. In one of the earliest conversations included here, 'Duration and Boundaries', Hiller sets herself the task of 'always telling the truth', an intention that is not so much a moral imperative as it is a concern with making and interpreting 'the real'. Hiller often includes found materials in her work. They tend to be things so ordinary that they are taken for granted, but Hiller reads them with an anthropological sensibility as meaningful expressions of 'our own complexity, perplexity, and conflicts. . . '.[7] Whatever her choice of materials – postcards, shards of pottery, commercial wallpapers, paint, canvas, or paper – they are never treated as neutral or blank, but as artefacts packed with cultural assumptions. Because of the fact that Hiller's art practices contain a theoretical component, an investigation of the basic nature of her art may be helpful before approaching the talks.

SUSAN HILLER'S ART OF CALIBRATIONS

Hiller layers and plays off the artificial (the made-up) against the natural, the intentional against chance, the personal against the social, the known against the unknown. Within one work she includes multiple languages, codes, materials. Meaning occurs somewhere *between* them. As she has said of 'installation' art, 'What I mean by an installation is something that occupies a site in such a way that objects, spaces, light, distances, sounds – everything that inhabits the site – everything is defined by its relationship

to all the other things.'[8] The unifying principle underlying Hiller's diversity of means, sometimes almost hidden within particular works and sometimes made quite explicit, is that of *calibrations*, correspondences between languages; Hiller's is an art of relations. The term is that of the linguist Benjamin Whorf, who found the place of meaning not in words and morphemes but in the patterned relations between them, in their rapport, the 'processes and linkages of a NONMOTOR type, silent, invisible, and individually unobservable'.[9] While I am borrowing Whorf's term for the utility of its precision, similar ideas that locate the site of meaning as being *between* languages, as being in motion, can be found in the thinking of Michael Bakhtin and his notion of registers; of Walter Benjamin and his theory of translation; and of Kurt Schwitters in his practice of 'working through . . . the playing off of material against material'.[10]

In her Freud Museum talk, Hiller responds to a questioner by saying, 'I want to allow spaces between the either–or you seem to believe in.' The site of meaning is found not only *between* languages but also between Hiller's different kinds of art practices, which, as one becomes more familiar with her work, each begin to refer to one another. Her variety of means itself becomes alphabetic, elemental, combinatory, open, and the Cartesian divisions she may be said to be examining (mind/body, self/other, subject/object) are not so much destroyed as released from stillness and set into motion as plays of permutations rather than opposites. When one holds her different works simultaneously in mind, one may experience the sensation of a reverberating harmonics.

THE PAINTINGS

Within this discussion I will be focusing on Hiller's paintings of the late 1980's and early 1990's.

These works quite literally display the process of mobile, syntatic layering that I refer to above as *calibrations*. All of them are in mixed media on wallpaper mounted on canvas. The paint is thin or transparent – dispersion, ink, washes of grey, black, greenish blue, mustard. The works incorporate Hiller's form of 'automatic script' that is discussed in detail on p. 00 and in the third section of this book, 'Fragments of a Forgotten Language'. In the paintings, Hiller has photographed the script, blown it up, and then projected it on to the surface, painting black ripolin around the 'letters', turning the background wallpaper into the foreground.

One may say that in these paintings Hiller 'works through' culture; the layers are not there to create a 'layered look', but to form a kind of web of interference, a playing of relations through which conventions of seeing may be examined. *Not for Joshua* has been painted on an olive green, ochre and golden wallpaper. The paint forms a record or story of its numerous applications, repetitive and careful, sheer to the point of solidity. (Hiller speaks of her paintings as 'diaries' that she continually works on; the blackness she thinks of as 'having everything present within it . . . achieved through writing, rewriting, brushing out and beginning again'.) A kind of osmosis occurs between the layers of paint, illuminating what makes up the wallpaper itself: printed inks floating in designs over a mass of pulp fixed as a sheet of paper.

In *Alphabets* or *For Dirty*, the wallpapers are more visible. Hiller always

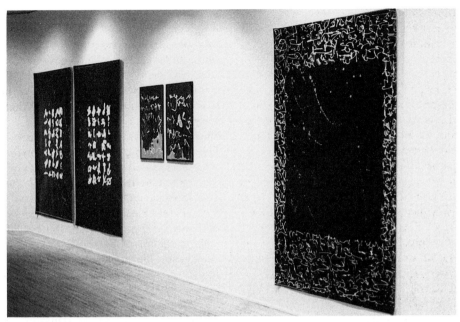

l. to r.] *Alphabet 1, Alphabet 2, Seance/Seminar* (2 panels), *Self-portrait* 1983; hand-coloured photographs

uses 'popular' wallpapers, often paints on fake tile and wood-grain wallpapers, and makes frequent use of children's wall coverings. The latter are gendered surfaces: sappy maidens for the girls and bomber pilots for the boys. The imagery presents cultural stereotypes, ideas of nature, of femininity and masculinity, of domination and submission. There is a tension between the comfort of wallpaper, its reference to an individual's domestic life, and its anonymity as a mass-produced product, repeating the same images over and over by means of a machine, not a hand.

Although Hiller's paintings could be characterized as beautiful, they have about them an unsettling quality. The contradictions and tensions of the languages that are present in her work are not resolved but are left in motion, like powder in a liquid that refuses fully to dissolve and settle. She has said that

'my own sense about what a painting would be is that it would pose questions to you about what it is, what you are in relationship to it, and how you begin to formulate the relationship'.[11]

HILLER'S RELATION TO LANGUAGE

I want to show how one can claim a position of speaking from the side of darkness, the side of the unknown, while not reducing oneself to darkness and the unknowable.

Susan Hiller, 'Looking at new work'

Introducing and providing an editorial context for the texts in *Thinking about art* seems to me to require a twofold treatment, for we are reading both 'what' Hiller is saying and 'how' she is saying it. The 'what' I refer to as issues and debates; my division into parts focuses on this aspect, outlined below.

Here I would like to touch on the

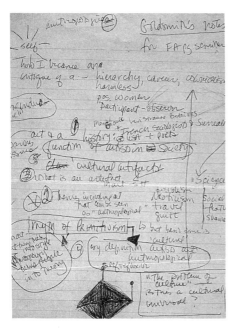

Hiller's notes for seminar at Goldsmith's College ('It is not all freely available for us anymore', in this volume)

'how', an aspect more evident in some texts than in others, for the talks, conversations, and interviews included in *Thinking about art* sometimes seem closer to the page or notes one imagines Hiller reading from and at other times closer to the sway of performance, the live presence of others listening, interrupting. This is the oral aspect of the talks, the voice that was present but is now in print. Hiller points out that the way her thought can spontaneously inform her language, unexpectedly associative, makes these talks 'as close to the vocal improvisations in some of my pieces as they are to the written articles or essays I've produced occasionally'.[12]

The artist reports that she generally tries to stay away from the formal lecture situation, instead using these occasions as opportunities to think on her feet, 'to formulate a theme or link between

different works I've made, to place them or illuminate them. I try to use these occasions to deepen my own understanding, rather than to produce a thumbnail sketch of my practice or a snapshot of the highlights of my career.'[13] She characterizes her talks as informal, improvised; they begin with rough notes, such as are illustrated here. This extemporaneous approach enables her to monitor and respond to the shifting nuances of audience mood, temperament and character. As she says, 'A good part of my visibility as an artist has come about not through academic support or investors' interest or establishment backing, but through a kind of ongoing rapport with an audience.'[14] By speaking subjectively, personally, autobiographically; by integrating within her talks a specific awareness of her audience; and by continually referring to and insisting upon the role of artists as makers of meaning, carriers of the values of our society, Hiller takes the position that 'discourse', as defined in linguistics,[15] is an essential component in the creation of art history. Thus she insists on the right of artists themselves to talk about the meaning of art and its 'truth in the real',[16] claiming again and again that art is a 'first-order practice' as important in contributing to our fund of cultural knowledge as any of the other humanistic or scientific disciplines. In doing so she takes the artist out of the restricted area, the romanticized garret, that location of what Maya Daren refers to as 'the artist as native'.

Hiller's attitude towards language in both her art works and in her talking about them bears the mark of her anthropological background in linguistics and her knowledge of oral traditions. In the first interview she ever gave to an art

magazine she said that she lived far away from words. She has a cautionary, wary attitude towards them, for she realizes how they can 'fix things, pin them down in a way that has nothing to do with the fluid movement of awareness'.[17] This limitation finds a parallel in the acquisition of language: the human infant is able to produce the sounds of any language soon after birth, but just when the child masters a native tongue and acquires capacity for communication within the native cultural group, that child loses the ability to produce the sounds active within other languages.

The reader may find the photographic documentation provided here somewhat cryptic in relation to the installation works. This is because they incorporate sounds or serial images which cannot be shown easily on the page, and in discussions regarding the selection of this volume's illustrations Hiller indicated that providing multiple sensory modes 'is an important aspect of my practice, since I am always working with the fact that we are fragmented beings, receiving contradictory input via different senses, via rhythm, pace, etc.'.[18] In a number of Hiller's installations, she uses an audio component. Often this expands or transcends the notion of 'voice' or first-person speech through incorporating other voices as well as her own. Hiller allows those voices to inhabit her: she does not quote in the expository fashion familiar to the written tradition but *pronounces* the words of others, invoking the presences of others as the shaman calls her helping animal spirits, whose voices and cries are heard as part of shamanic narrative.[19]

She also includes her own vocal improvisations using sounds unrecognizable as any language, meaningless vocables delivered in mysterious whispers and distorted tones, much as Schwitters did in his great *Ursonate*.[20] Audiences have reported hearing the sounds of her audiotape for *Élan* as snatches of Arabic or Hebrew and as the music of Australian aborigines or Native Americans. She likens them to the earliest sounds of infants, thinking of these languages as

> new possibilities . . . maybe languages of feeling, languages of the body. Could it be even a language of subjectivity, instead of a language of social discourse . . . It's intensely pleasurable to break with coherence in this way. The rhythms and energies of making these sounds and marks might be close to what people think of as trance states and yet are totally different, because they take place in full consciousness and I can let them happen at will – in this way, they are exactly like drawing or painting, and maybe jazz singing also.[21]

This usage of voice in Hiller's work also brings her close to the poetic tradition, in which words have their own resident powers and do not so much explain as evoke.

Hiller's talks may assume a filmic, episodic quality, with certain themes, stories, quotations returning again and again, as if visited upon the artist. In editing them, I have tried to retain somewhat the element of repetition, for in returning to the same points of reference over and over, Hiller is closest to the oral tradition, with its grammar of significant, rhythmic intervals.

ISSUES AND DEBATES

As mentioned above, *Thinking about art* is divided into six chapters, each focusing on an aspect of Hiller's work and involving discussion of particular issues and debates.

Part 1. Inside all activities: the artist as anthropologist
Susan Hiller became an artist to 'find a way to be inside all my activities'. Her art then became a way for the viewers/participants to get inside their own activities, to recognize themselves as part of the modern composition.[22] This part examines the Cartesian split between observation and participation and how this effects our view of the 'other'. What does it mean to put 'ourselves' at risk when experiencing the life and art of 'others'? How might this change our understanding of that art? Why have indigenous cultures been considered as having no aesthetic, analytical systems when evidence exists to the contrary? What do existing modes of exhibiting ethnographic objects convey? Hiller discusses the shift of these objects from the natural history museum to the art museum as a continuation of colonialist attitudes and suggests a format that documents the interactions of Western history with these objects. She situates her own practice by means of these clarifications.

Part 2. Within and against: women being artists
The title here refers to a quote from 'Looking at New Work': 'I'm determined to insert my work with automatism within and against the tradition of the gestural in modern art . . . against the reactionary, self-aggrandizing gesturalism that has re-emerged recently, and within the socially motivated investigation of mark-making initiated with the Surrealist group.' This part includes consideration of various feminist issues – as Hiller values and reconsiders aspects of life traditionally associated with women – interiority, domesticity, phenomena of the margin,

the edge, the uncanny, and the ecstatic. How does the assignation of these aspects to the realm of women reflect larger cultural divisions and categories, and what other models are available to us? She extends these issues into art history, investigating, for example, the relation of landscape painting to the female body and how automatic writing and other visionary phenomena have been interpreted according to the gender of the artist.

While addressing the exclusion of women artists from art history, Hiller also explores how the *manner* of including such artists as Georgia O'Keefe has not resolved but extended the problematic of women's position in relation to cultural production. She views Stieglitz's portraits of O'Keefe as a 'revelation that the artwork produced by her is available for the same kind of erotic delectation and scrutiny as her body'. In contrast to this continuing objectification of women and women's art as male projection, Hiller asserts the importance of the female artist as 'a speaking subject whose work represents her time as much as her place, her world-view as well as herself, her mind as well as her body'.

Part 3. Fragments of a forgotten language
This part examines the place of dream and revery within culture. 'Like the language of the flames ("tongues of fire"), and the automatic scripts ("writing on the wall"), these incoherent insights at the margins of society and at the edge of consciousness stand as signs of what cannot be repressed or alienated, signs of that which is always and already destroying the kingdom of the law.' The texts take up issues generated by the consciousness/unconsciousness split within discussions of Hiller's automatic

script. They include passages that reveal Hiller's complex relation to theory and her commitment to art as a means of enquiry, 'questioning, problematizing, the hierarchies that seem self-evident within our culture'. She raises questions about the origins of images in art; the relationship between the artist and art history, between dream and inspiration;

and about whether ideas are individual, unique, and private or collective in origin.

Part 4. Working through culture: conventions of seeing
The four talks included here all address the use of cultural artefacts in works of art. Dialogues concern the inherent

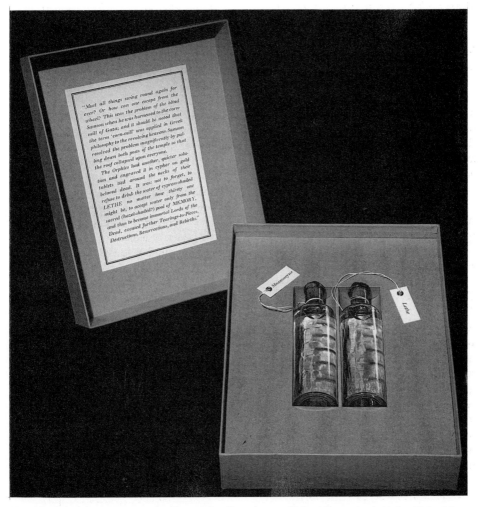

Eaux de vie/spirits 1993; customised box with collected water, Robert Graves text; 33.5 × 25.5 × 6.8

meaningfulness of common cultural objects, objects of daily life – a quality erased by culture (even as it is culture-specific) and disclosed by art. Techniques of this disclosure specific to Hiller's art works (such as *Dedicated to the Unknown Artists, Enquiries/Inquiries* and *An Entertainment*) are suggested, including changes in scale, multiplicity and repetition; the resultant rhythms, phases and intervals are related to linguistic models of meaning. The texts include considerations of ideas of the natural in art, as well as popular formats as art. A conversation with Colin Gardner is included here because it deals specifically with the differences and shared ground between American and British culture, particularly in relation to issues of theory.

Part 5. Objects as events extended over time: the nature of representation
This part includes talks of a wide chronological span, and in doing so reveals how Hiller's move from participatory events to gallery works and installations relates to issues of visibility, conceptualism, audience and the collaborative creation of meaning. Included are considerations of issues involved in employing photographic

processes in artworks. Underlying this discussion is a concern with the nature of representation, documentation, truth. Hiller reveals the dichotomy between events and objects to be a cultural construct: 'Objects are simply shapes resulting from actions and events that hold together long enough in one general condition to be considered as units.'

Part 6. Art and knowledge: a critique of empiricism
Here the attitudes of colonialism as they relate to culture and art are examined, along with alternative modes of engagement with 'the other'. This final chapter contains a condensation of three talks that Hiller gave at the Freud Museum in London, in which she addresses a number of issues, including the prerogative of artists in contributing to a critique of culture, and the interrelationship between aspects of Hiller's work and between that work and the world outside it. In the very recent interview that closes the book, Hiller provides her own retrospective view of artistic format as a kind of cultural artefact. Throughout this part, memory and forgetfulness, erasure and disclosure, absence and presence are continually touched upon as themes of art.

NOTES
1 Susan Hiller, 'An Artist Looks at Art Education', in *The Artist and the Academy*, ed. Nick de Ville and Stephen Foster, Southampton: University of Southampton Press, 1994, pp. 105–15.
2 See Thomas McEvilley's lucid essay, 'Revaluing the Value Judgment', in *Art & Otherness: Crisis in Cultural Identity* (New York: McPherson & Company, 1992).
3 Personal communication with the author.
4 Compare James Clifford, *The Predicament of Culture* (Berkeley and Los Angeles: University of California Press, 1990).
5 See *New Wilderness Letter 10: Special Dream Issue*, ed. Barbara Einzig, Winter 1981, which includes a presentation of Hiller's *Dream Mapping*.

6 See 'Art and anthropology/Anthropology and art' in this volume.
7 See 'Dedicated to the unknown artist' in this volume.
8 Personal communication with the author.
9 Benjamin Whorf, 'Thinking in Primitive Communities', in John B. Carroll (ed.), *Language, Thought, and Reality: Selected Writings of Benjamin Lee Whorf* (Cambridge, Mass., The MIT Press, 1976 [1956]), p. 67. While some of Whorf's conclusions may now be outdated in the field of linguistics, for the general reader his insistence upon linguistics as a quest for meaning (a quest fully informed by anthropology) enabled him to transcend Eurocentrism at a relatively early date (this

essay was written around 1936). His conclusion to this essay contains the following passage: 'Does the Hopi language show here a higher plane of thinking, a more rational analysis of situations, than our vaunted English? Of course it does. In this field and in various others, English compared to Hopi is like a bludgeon compared to a rapier' (p. 85).

10 Kurt Schwitters, *Merz 1. Holland Dada* (Hanover: Herausgeber Kurt Schwitters, 1923).

11 Susan Hiller interviewed by Michael Archer, *Audio Arts* magazine, vol. 14, no. 1, summer, 1994.

12 Personal communication with the author.

13 *Ibid.*

14 See 'Working through objects: Susan Hiller at the Freud Museum' in this volume.

15 'According to Beveniste, the locutor of a historical enunciation is excluded from the story he tells: all subjectivity and all autobiographical references are banished from historical enunciations, which are thus constituted as the mode of enunciating the truth. The term "discourse," on the other hand, designates any enunciation that integrates in its structure the locutor and the listener, with the desire of the former to influence the latter. . . . "Its means," Jacques Lacan has said, "are those of speech in so far as speech confers a meaning on the functions of the individual; its domain is that of concrete discourse, in so far as this is the field of the transindividual reality of the subject; its operations are those of history, in so far as history constitutes the emergence

of truth in the real"' (Julia Kristeva, *Language, The Unknown: An Initiation Into Linguistics*, trans. Anne M. Menke (New York: Columbia University Press, 1989), p. 11).

16 See note 15.

17 See 'The word & the dream' in this volume. See also the reflections of Lévi-Strauss on the perils of written language; the only element that he finds in common among the earliest civilizations that had written languages is slavery, and he specifically links writing to this ability to control other human beings (Claude Lévi-Strauss, *Tristes Tropiques*, trans. John and Doreen Weightman, New York: Viking Penguin, 1973).

18 Personal communication with the author.

19 I want to state clearly that this analysis of Hiller's attitude towards language should not be interpreted as equivalent to comparing her to a shaman, which I am in no way doing. Having published numerous translations from Siberian shamanic traditions, I am aware that shamanism is a social, professional role: to be a shaman, the culture must be shamanistic.

20 *Scherzo der Ursonate*, recited by Kurt Schwitters; recorded by South German Radio, Frankfurt, 5 May, 1932.

21 See 'Portrait of the artist as a photomat', in this volume.

22 See Gertrude Stein, 'Composition as Explanation', in Patricia Meyerowitz, ed., *Gertrude Stein: Writings and Lectures 1909–1945* (Baltimore, Maryland: Penguin Books, 1967), pp. 21–30.

1

INSIDE ALL ACTIVITIES

THE ARTIST AS ANTHROPOLOGIST

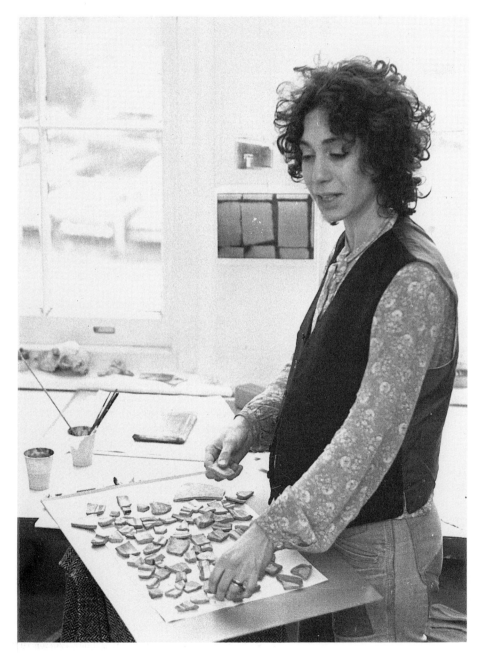

EDITOR'S INTRODUCTION

I'm determined to insert my work with
automatism within and against the
tradition of the gestural in modern art . . .
against the reactionary, self-aggrandizing
gesturalism that has re-emerged recently,
and within the socially motivated
investigation of mark-making initiated
with the Surrealist group.

Susan Hiller, 'Looking at New Work'

The following six talks and interviews
address feminist issues as an integral part
of the social fabric. It is through what
the critic Guy Brett refers to as Hiller's
'intervention as an artist in the social and
given'[1] that she provokes new ways of
looking at the social and the given, the
real world we are in. As is observed
below, Hiller has validated and
reconsidered aspects of life traditionally
associated with women, acknowledging
'the interest of the things in my own
world, ordinary things, things that are
not considered very important . . .'.[2] Her
work has often been engaged with areas
traditionally ascribed to the feminine –
phenomena of the margin, the edge, the
uncanny, the ecstatic. Yet she
consistently connects these realms with
the 'analytic', breaking the stranglehold
of the rational/irrational dichotomy.

Hiller is well aware of the particular
predicament of women whose artistic
careers are committed to exploration of
the irrational; women painters hardly
fared well within the Surrealist ranks.
Leonora Carrington's 1976 commentary
on the occasion of her retrospective at
the Center for Inter-American Relations
in New York City is telling 'The furies,
who have a sanctuary buried many
fathoms under education and brain-
washing, have told females that they will
return, return from under the fear,

shame, and finally through the crack in
the prison door, Fury.'[3]

By drawing on philosophical and
anthropological perspectives and insights,
Hiller calls forth the furies, complicating
the dichotomy by questioning the very
idea of the self and of interiority.[4] She
states that the 'diversity in my work
comes from a real attention to the
particularities of materials as well as from
the relinquishing of any notion of
selfhood that is fixed or commodified'.[5] If
in earlier years it might have been said
that Hiller's relation to feminism was a
complex one, it might now be said that
anyone's relation to feminism is a complex
one, or that feminism's relation to the
culture of both men and women is
radically complex. The awareness of
'lacking an authentic first-person voice'
and modes of repetition, circularity, and
call-and-response sorts of interactions are
no longer relegated to the realms of the
'irrational' and the 'natural' as they
increasingly become recognized as
features of new, digitalized technologies
and media; studies of the self as a series
of relations are popular in academia. By
considering the talks below – which span
more than a decade – as a group, the
reader may observe how Hiller's
connection of the ecstatic and analytic has
gained increasing context through the
concurrent expansion of the linguistic
method into semiotics and feminist
theory.[6] As Hiller observes below, her
1977–78 work *10 Months*, which dealt
with her own pregnancy, 'relocate[d] the
emotional source of those images
[landscape images] right back to their
origin in the female body'. Thus she
ironically analyses the tradition of
landscape painting, suggesting that its

analysing their colours and shapes; lists of Pueblo design names and categories; quotations from contemporary Pueblo potters ('Art [Tradition] and Dream [Inspiration]', see p. 30) as well as images, diagrams and charts suggesting parallels between the activities of archaeologists and artists. Museological and archaeological systems of classification were visually displayed alongside indigenous Pueblo typologies and the artist's own representations. Hiller says that she works 'in relation to the artefact rather than a blank canvas as an acknowledgment of the culture that has formed me'. Thus she works alongside the Pueblo potters, not appropriating the formal aspects of their art but drawing parallels with her own activities as both artist and anthropologist, finding an equivalent between their sources and her own. Through dreams and through references to cultural paradigms, both art and science are created, and there is no hierarchical distinction between them.

Here can be seen the elements that recur over and over throughout Hiller's *œuvre*: archaeology, sifting through fragments, retrieving what has been discarded, reviving memories and dreams and merging disparate languages. She mingles classification with revelation in an art of finding, placing, painting and retouching, of inventing and copying not

as machines but as people do, in a dance of learned, sensual response. Nearly a decade separates 'Art & anthropology/ Anthropology & art' and 'Dedicated to the unknown artists' from 'An artist looks at ethnographic exhibitions'. Yet as Hiller recognizes in the last lecture, it is precisely this span of time that allows her to 'locate connections and relationships' and to present postmodernism 'as a construct, one that interrogates categories and that brings "the primitive" back into view as a site of need and fantasy essential to the construction of Western identity, thus freeing it from its projection on to real other people who have been burdened by us with essentialist, timeless qualities'.

Hiller's insistence that one's experience of the art and life of 'others' must hold the potential for changing one's own mind, life, and culture; her determination to experience 'ethnographic' art with attention to the aesthetic systems and categories of its makers and with awareness of the interactions between 'the objects displayed and our own history'; her awareness of 'detached looking' as a limiting cultural myth and her appreciation of culture as an invented lens through which we see (and are blind) – these issues are if anything more dangerous and promising now than they were when she took them up in the 1970s.

NOTE
1 See Roy Wagner, *The Invention of Culture* (Chicago, Ill.: University of Chicago Press, [1975] 1981).

ART AND ANTHROPOLOGY/ANTHROPOLOGY AND ART

1 INTRODUCTION

Thinking about what it might be I could do here today, I came up with the idea of mediation; that is, I might present some information to you about my subcultural group – artists – and in return, you would later let me know something about how your subculture views my views and my subculture. I can do this by telling something of how I think artists work, and by giving the view of an artist on the ways that anthropologists see art, and the way artists see anthropology. This is all complicated by the fact that I once studied anthropology myself, although I no longer have the point of view of an anthropologist, and very little confidence in my ability to speak as one – so please consider this talk that of a non-specialist in your field . . . On reflection, I decided to air my particular viewpoint throughout, rather than aiming at formulations more appropriate to your special competence than to mine, so I shall certainly not attempt any kind of programmatic statement or broad survey. Perhaps, in fact, you may find what I say fragmented and inconclusive and somewhat controversial; that would be fine. For the necessities of truth-telling in art practice have trained me to accept that a personal viewpoint must always be central, as illustrated in those diagrams that show the world of relationships from the ego's position. Everything I will say today (and probably everything I ever say) is of subjective[1] importance only, with no claim to 'objective' significance.

So I'll begin by describing something of my own background, and the internalized conflicts which help to explain my current attitudes and work, before going on to explore a bit of the relationship between art and anthropology as I see it, discussing specific art issues illustrated with instances from my own work.

2 CONFESSION OF CONFUSION

When I was twelve I read a pamphlet by Margaret Mead called 'Anthropology as a career for women', and I decided to become an anthropologist. I had intended previously to be an artist, but the way to go about that had never been entirely clear to me; great artists were geniuses, and it seemed that geniuses were born,

Paper read at the Institute for Social Anthropology, Oxford University, 6 May, 1977, at the invitation of Signe Howell.

not made. Whereas to become an anthropologist you went to one of a very few universities, and studied hard. Perversely, I selected an East Coast women's college where the practice of either art or anthropology was given little support, although the study of art history as an academic discipline was considered respectable. In my sophomore year I discovered an unused seminar room in the library basement, where brown and green bound volumes of early issues of the *American Anthropologist*, the *Memoirs of the Proceedings of the Institute of Ethnology (Smithsonian Institution)*, and the *Papers of the Middle American Research Institute* stood in glass-fronted cabinets next to shelves filled with dusty cardboard boxes of neatly labelled shards and projectile points, feather head-dresses, and faded sepia photographs of dead Smith girls in long dresses holding shovels, frozen in poses representing being caught in the act of digging.

I loved that room for what it provided me: role models of adventurous women and a sense of the pioneering, bluestocking days of my college, now degenerated into academic respectability and a merely suburban concept of ideal womanhood; and the look and sense of 'the primitive', artefacts to be touched and smelled, works of ancient or exotic origin, objects of mystery; plus, an idea of intellectual community, of scholars united in the decipherment of a puzzle and the quest for enlightenment on the fundamental question, 'What is the nature of man?'

Art history, which seemed to be mainly about the Renaissance, and the token 'practical art' courses couldn't compete, and although I didn't realize it at the time, the picture of the world of art we were presented with showed it as an exclusively male domain, which was very discouraging. In contrast, within the tradition of American anthropology, there was always Margaret Mead to fall back on, or Ruth Benedict, or Ruth Bunzel, Gladys Reichart, Elsie Clews Parsons and others.

When I began my postgraduate work at a different university, I was equipped with a broad social science, humanities and art background, and a disdain for detail that was in conflict with the crash course in archaeology, physical anthropology, world ethnography and linguistics that I was exposed to. In the second year I had time to catch my breath and relax into a geographic area specialization where all the disparate kinds of 'facts' could at least be sorted into degrees of relevance with reference to their proximity to or distance from this roughly bounded locale. Thus, I could begin to 'place' data. But the process was subtly undermined by a historically organized analysis of the development of theory (Lévi-Strauss had just begun to be required reading, and we considered his work very briefly) which cast doubt on the nature of the facts themselves and seemed to require a kind of uncommitted debate about abstractions – what the American philosopher Charles Peirce called 'the

comparative morphology of conceptions' – that I found depressingly
alienating. Even more disturbing to me was the key issue in the practice of
anthropology: the role of the participant/observer. A passionate commitment
to the values and goals of the people one observed – exemplified in the writings
and life of John Collier, for instance – was no longer considered acceptable.
Maud Oakes, Calixta Guiteras-Holmes, other anthropologists whose work I
admired were judged unprofessional or eccentric. Theory was all-important,
abstractions easily juggled. 'Participation' was clearly meant as a kind of
formal pose to be adopted for a limited period. Then the anthropologist would
take 'his' or 'her' data away from the culture studied to make something else of
it. This something else could perhaps, if sufficiently refined, be of use somehow
within the anthropologists' own culture. (What kind of use was never very
clear – it was only later when we found out what the CIA and other agencies
had done with anthropologists' work in South-East Asia that some of the
possibilities emerged.) And this 'work' was to be a source of income,
promotion, acceptance and status for us. So much I understood.

Sensitively aware that something wasn't working, my advisers invited me to
teach an anthropology course for undergraduates, probably thinking that in
explaining the basic assumptions of the field to others, I would eliminate my
own doubts; yet all that happened was a clarification of my confusion. Basically,
I simply could not understand how the principle of cultural relativity could
operate in the psyche of an individual. If an anthropologist had actually
experienced a different sense of causality, for instance, or even its total absence
as a category of explanation, rather than just coming across the idea of such a
possibility, perhaps in Kant or in someone else's ethnographic material – then
surely, this, like any other real-life experience, would alter the perceptions of
the anthropologist, and change the entire course of his or her development?

But, on the whole, they returned from jungle or desert and wrote theses or
books that were themselves contained within traditional academic categories of
recognition. Not only was there very little mediation between the peoples
studied and our society, but the basic hypothesis behind these comparative
investigations – the reason for the whole effort of analysing and presenting
alternative models of reality – was never made explicit. World-view cancelled
out world view, and we were left with the same alienated, materialistic and
rationalist position we began with.

Our cultural categories were not 'superior' to those we studied, but nothing
actually impinged on them. They did not change. Fieldwork did not provide
revelations into the nature of any 'ultimate' reality behind the varying sets of
perceptions one learned of. It was just an exercise in observation and limited social
interaction, and the source of yet more 'comparative' data and model-building.

Casteneda had not yet been published, and I didn't know Maya Deren's work, or Leiris's, and in any case, their experiences and books would have been unacceptable within any American anthropology department . . . I could not make a synthesis of my experience and 'reality', or rather, I did not understand that they are not divided.

Retrospectively, I see this confusion as an instance of the confusion of an entire generation. Later on, my fellow postgraduate students mostly became involved in distancing activities: theorizing, teaching, publishing and computerizing. Some few became politically active, dropping out of anthropology entirely. One of the most brilliant, who wrote well, committed suicide while attempting to cast his intense fieldwork experience into 'acceptable' academic form. One had the perspicacity to unite the romantic subjectivism which had drawn him towards the study of American Indian mythology with the newly arrived 'objective' theories of Lévi-Strauss, and after a successful teaching career metamorphosed into a succesful academic translator and storyteller . . . In my own case, during a lecture on African art, I began to draw in the margin of my notes and experienced what I can only describe as an 'exquisite' sensation. I had not drawn for two years, having been totally committed to an intellectual quest, and the joy of hand/eye activity was almost overwhelming. I determined to find a way to be *inside* all my activities: temperamentally, I could not do this then within anthropology as I experienced it, nor did I have the ability to modify the field. I hope never to forget that moment of brief clarity.

Later that summer, on a generous grant, I went down to Central America to do preliminary fieldwork. Because of my grant, I had enough money to travel in comfort, so that my experiences were more carefully controlled than on previously risky, serendipitous adventures in that part of the world. Having a topic to investigate made me narrow and focus my observations. Knowing I was going to 'write up' the material shaped the decisions I made about 'spending' time to advantage and making good 'use' of informants. The whole activity was a goal-oriented job, a task to complete . . . I felt like a caricature.

Returning, I mechanically studied for and passed all the Ph.D. examinations, including the rigorous oral exam, and then resigned from the department. A year later in Paris, obliged to fulfil the grant requirements, I wrote an MA thesis that did not disclose the secret revelation of the afternoon in the African art lecture. It did not expose my enthusiasm for the Mayan peoples or the reasons why. It did not attempt a critical analysis of my role and function. It bored me to write, and it must have bored everyone who had to read it. I said I would never again do anything so self-destructive, and I believe I haven't.

3 ART AND ANTHROPOLOGY AND VICE VERSA

What is art? is a question as persistent among contemporary artists as What is anthropology? is among contemporary anthropologists. On the other hand, it cannot be said that What is anthropology? is much of an issue among artists, although there are some interesting ways that anthropology is used by artists or can be said to have involved them, and in the same way it can't be said that the question What is art? is of primary importance to anthropologists, although many of them seem to have no hesitation in naming and assigning some cultural manifestations to this category. I'm not convinced that anthropologists have much interest in the art of their own culture, and I think some of them would probably be at a loss to describe developments subsequent to, say, Cubism . . . In the same way, artists have been highly selective in their use of anthropology and biased in their definitions of what it is.

Anthropological studies of ethnographic art sometimes contain certain assumptions about the definition of art which are curiously out of step with arguments about such a definition among artists. For contemporary artists have extended its definition to include a range of activities rather than a series of objects such as paintings or sculptures. Performances of various kinds, and analytical or theoretical work, extend the notion of art beyond the sense of visual representation into the exploration of ways of seeing, feeling, perceiving, knowing, and ultimately, being, in the world. The investigatory aspects of art practice are today seen as more fundamental than their formal manifestation, so that an understanding of art derived from an iconographic or stylistic analysis still leaves aside the major issue of whether, in fact, the notion of 'art' is necessarily associated with the notion of object or product.

Curiously, the practices of artists within our own culture are rarely investigated by anthropologists, whose opinions may perpetuate certain assumptions derived from art-historical descriptions of the art of previous eras, which are then projected on to the situations of other societies. A rigorous self-critique and debate about the function of art, the role of the artist, the role of economic and political institutions in promoting certain definitions of art and in using art for ideological purposes (while alienating artist and public), the relationship between artists and the rest of society – all this is very much a part of art practice today, and what art is and ought to be is examined against a comparative background of historical and ethnographical data. A fortnight ago at an artists' conference I heard various speakers put forward the view that art as it exists in our society does not exist universally or historically. Creativity is not necessarily confined to a few individuals, nor is art itself necessarily an elitist or specialist product.[2]

Similarly, I think that most of the ways artists have used anthropology are equally curious. For many years the data of ethnography have been source material for Western artists. At the very beginnings of modernism, African art profoundly modified the formal ideas of artists like Picasso, Derain and Matisse, who adopted sculptural or pictorial conventions from exotic cultures without any knowledge of the original meanings of the material. An analysis of African woodcarving as *art* didn't occur until Europe had extended its domination over vast regions of Africa and thus intensified the relations between those two parts of the world. It was an artist, Maurice de Vlaminck, who in 1905 launched the vogue for collecting African material on the basis of its aesthetic appeal to Europeans, rather than as mere 'barbarous curiosities'. . . And it was Picasso and Derain who discovered that African art could prove a source of inspiration to European artists in search of new techniques, in something of the same way that Africa itself could prove a source of wealth to Europeans in search of new markets and materials.[3]

The use of the data of ethnography by Western artists is not limited to material culture, nor to the early twentieth century, but can be seen in the contemporary 'mythic' or 'ritual' variety of performance art, which attempts to fuse a numinous sense of the world, often derived from impressions of 'primitive' cultures, with the very contemporary idea of self-referential activities dealing with formal innovations for their own sake. Although anthropologists define rituals as highly coded events that express meanings available to all members of the community, this is not the nature of most performance art, which remains somewhat esoteric and elusive. Nevertheless, its practitioners intend to depict revelations that break through to community experience, and I believe that if they could develop more expertise in the nuances of their own culture, rather than tending to borrow symbols from the ethnography of 'primitive' societies, this might occur.

There are other aspects of contemporary art that go further and look to anthropological theory to provide models. The work of these artists tends to be illustrative, often in a literal sense. For example, with a truly contemporary lack of confidence in her own function, a gifted younger artist (Judy Clarke) based a series of works on Mary Douglas's book *Purity and Danger*.[4] Highly controversial, her exhibition received a good deal of publicity, centred on the theories illustrated by the artist rather than the artist's work. Later, the artist's name was given incorrectly as 'Mary Douglas' in an article by an art critic citing the most significant art works of the past few years. The prevalence of this tendency to look to anthropological theory as a norm has come about through the work of some highly articulate artists who have urged that art practice be 'objectified', that is, they contend that the conceptual art movement

Fragments 1977–78 (details); potsherds, gouache drawings, charts, texts, etc.; installed size variable

left⟧ Red/black potsherds in polythene bag

below⟧ partial installation view, Hayward Gallery, London

facing⟧ section subtitled 'Floor Array'

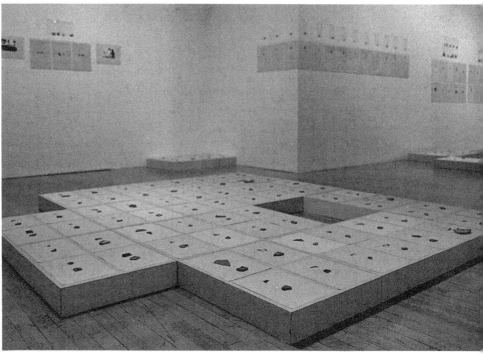

externalized and analysed some features of art activity that previously had been internalised. Semiotics is seen as key, along with the work of Lévi-Strauss, and this trend can be clearly seen in the work of the British school of structuralist film-making and in recent work by the New York branch of the Art Language group.

After that set of fairly critical notes on both artists and anthropologists, you may find it strange when I say that I still don't know what art is, as a category of actions and things distinct from all other categories, although I think I can recognise art-like or artistic behaviour when I see it, and I have some idea of what it is artists do. Looked at like this, art-like behaviour seems to be universal, and there is no reason to establish an object-defined hierarchy of instances which are more or less 'art', with sculpted or painted works at the top and string games or wooden ladles at the bottom. Art-like behaviour is usually public but can certainly exist among a limited number of observers, say a family or neighbourhood, if that is appropriate in the cultural setting. Full-time practitioners of these activities, or paid professional artists, may or may not be distinguished from part-time amateur practitioners. The kind of definition I'm looking for places the emphasis entirely elsewhere. Artists, in the

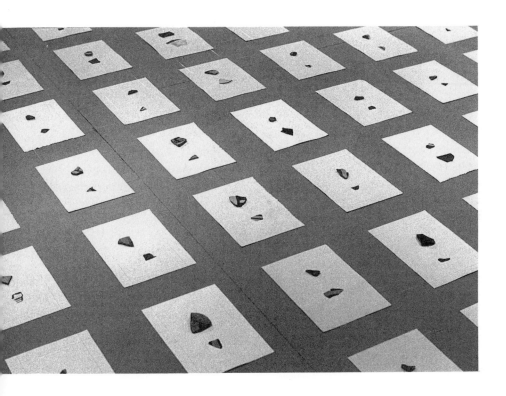

sense I mean, *modify* their own culture while learning from it. The artist, like everyone else, is an insider. Artists' work depicts biographically-determined social conditioning. Artists' work does not allow discontinuities between experience and reality, and it eliminates any gap between the investigator and the object or situation investigated.

Artists *perpetuate* their culture by using certain aspects of it. Art activity is largely a manifestation, depiction or symbolization of internalisations that are the result of socio-cultural conditioning; my personal production may seem enigmatic or paradoxical and it may well feel solipsistic or paratactic,[5] but to be recognizable to any degree it must, to a great extent, be 'merely' conditioned by factors that condition everyone else – language, social structures, economic conditions, etc.

Artists *change* their culture by emphasizing certain aspects of it, aspects perhaps previously ignored. The artist's version may show hidden or suppressed cultural potentials. Artists may offer 'paraconceptual' notions of culture, by revealing the extent to which shared conceptual models are inadequate because they exclude or deny some part of reality.[6] Artists everywhere operate skilfully within the very socio-cultural contexts that formed them. Their work is received and recognized to varying degrees within these contexts. They are experts in their own cultures.

As a woman and as an artist I have the special problem of expressing perceptions which to a great extent are unrecognised or distorted by our culture in general. I'm much indebted for the insights into this difficulty offered by recent work in anthropology.[7] Without these clarifications I might still be struggling to affirm a link between negative internalisations and the necessities of positive expression. Certainly my ambiguous placement within this culture has been painful to recognise and difficult to express, but I have found that this vantage point paradoxically gives me privileged access to certain chinks or holes through which it is possible to sense an enormous potential reality, of which our culture, (and within it, what I have called my 'ambiguous' placement) is a mere curtailment.

4 SOME MORE ABOUT ART

Now that I've spoken about myself and artists in general, and maybe a bit about anthropology, I'd like to say something to you about my work. I've always been interested in working with and presenting work to different kinds of people, but today is the first time I've done this with an academic audience . . . If you could visit my studio, or participate in one of my group investigation pieces, or see an installation or work of mine, I'd be fairly confident that something of what I'm

about would emerge. But here, in the arbitrary circumstance of me standing before you, talking, I'm mainly aware of the vast gap between that and the work . . . Here are slides, to be seen in a minute, and a few portable items – books, photographs – which I'm conscious of as the souvenirs of experiences whose extensions in time and space and whose sensuous characteristics seem to be negated by such condensation. Talking . . . talking *about* ideas and issues . . . me talking, the rest of you silent . . . responding with minimal gestures, shifts in position, eye movement . . . None of this has anything at all to do with how I work!

I find a great joy and pleasure in working. But I find it painful to describe work from the outside – it's that participant/observer split I criticized before . . . I can say what the work feels like to make, and what I intended, but that's very different from describing what it's about on completion. Since art exists primarily in its relationship to the viewer who must participate in it, intimately experience it, establish an I–Thou dialogue with it – or else get nothing from the experience except a vague feeling of alienation – it's a yielding to contemporary pressure to encapsulate experience that's responsible for my feeling that I ought to be able, somehow, to explain what it is I do.

NOTES

1 For a recent discussion from the viewpoint of a philosopher, see Roger Poole, *Toward Deep Subjectivity* (London: Allen Lane, 1972).

2 Art and Politics Conference, AIR Gallery, London, 15–16 April, 1977.

3 This point is examined in detail in Hiller's review of the *Sacred Circles* exhibition of North American Indian art and in her book *The Myth of Primitivism*; see the Appendix to this volume [ed.].

4 This exhibition took place in 1974 at Garage Art, London; the work in question was acquired by the Tate Gallery.

5 In a personal communication, Hiller noted that she sometimes borrows words from texts she admires; she was introduced to the word 'paratactic' through reading David Coxhead's 'A Hundred American things: a list' in *Speed King* (London: The Human Constitution, 1970), p. 23 [ed.].

6 See Poole, *Toward Deep Subjectivity*.

7 See especially *Perceiving Women*, ed. Shirley Ardener (London: Dent, 1975).

DEDICATED TO THE UNKNOWN ARTISTS
an interview with Rozsika Parker

> *During April three exhibitions of your work opened in relatively conventional galleries[1], yet you are highly critical of the 'art world' structure.*

I would say that my using the gallery context at the moment is strategic. I am trying to insert a different kind of world-view into the middle of current notions of what art is . . . If you want to communicate you are impelled to insert your work into the art of your time . . . The decision to place your work within the gallery art context can cause incredible stress. At this point, I don't know any women artists who are not stressed.

> *I can understand that putting your work up for public judgement would be stressful, but why is it particularly acute for women?*

Well, the work often won't be seen properly, it won't be seen clearly. And no matter how much validation I receive from the mainstream, I can only see my presence within it as intrusive. And the difficulties that I get into are, I believe, the difficulties of communication and language based on a different perception of the world . . . A woman is mute within our culture in that when she speaks she speaks as a man. This is a point I think Cora Kaplan made brilliantly about the first person in poetry.[2] Women poets come up against important difficulties when they get outside the area of expressing personal feelings. When they try to speak as I-the-poet-speaking-for-humanity, a false note often enters their work and one feels a kind of inauthenticity. This is a problem we all face. You can seem articulate and feel alienated. You have to suppress your alienation in order to remain articulate.

> *And that becomes personally destructive . . .*

Exactly . . . It's when we try to deal with the contradictions arising from our experience within conventional frameworks that we have no language.

> *How does your work challenge conventional ways of seeing reality?*

In the three shows on at the moment, the components of the works are cultural artefacts, postcards, fragments of pottery, photographs from automatic machines and clippings from popular encyclopedias. Now conventional art materials (canvas, paint) are mute, it's only when work is put into them in terms of presentation and analysis that they say anything. So by extension what I'm trying to do in my recent work is to make articulate that which is inarticulate. I'm interested in these cultural materials for the unspoken assumptions they convey.

Abridged from an interview originally published in the journal *Spare Rib*, 72, July 1978, pp. 28–30. Rozsika Parker is a writer and psychotherapist in practice in London.

Could you describe a work?

Take *Enquiries/Inquiries.* I present a series of slides which are photographs of texts taken from popular encyclopedias, one British and one American. They purport to give information about questions of fact, and what first intrigued me was that they gave this data in the form of a catechism, in other words, the questions are rigidly followed by the correct answers. That indicated to me that there was some effort towards imprinting these notions indelibly on the mind. And I discovered by looking at the sets that they carried inbuilt assumptions which are extremely curious. After a while just observing the repetition of certain ways of asking questions indicates that there is a very rigid mental set involved. As an American I feel personally embarrassed by the details of the American set, but I understand that the British set can be just as excruciating. It has a great deal of hierarchical thinking built into it. But both cultures share the same symptom – the lived experience of a person is cut off by a kind of verbal formulation of that experience.

Did you make the piece from an awareness that as a woman you are negatively positioned in culture by language?

When I wrote about the piece I said that to examine the givens of a culture implies to some extent that you are separated from it. I didn't say that I am separated from the language of my culture *because* I am a woman. I don't want to make those kind of statements, I want the art to speak. I don't want to label it 'here is the work of a feminist artist'. That notion has been very much degraded; to call people feminist artists is to box them off into an area which cannot insert itself, cannot contradict mainstream notions of art. Feminists are shunted off to a little side-track called 'feminist art'.

And it's characterized as being utterly unconcerned with notions of what art is and only concerned with making strong, direct statements about the position of women in our culture. In fact I'm not sure that work such as yours which examines language, social structures and art forms would be stamped as 'feminist art'.

I think there are radical implications in a more subtle form of intervention. By, for example, looking at notions of sexuality in a popular image to expose our underlying cultural assumptions.

Let's talk about your piece called Dedicated to the Unknown Artists *in which you collaged and presented hundreds of seaside postcards, all titled* Rough Sea.

What they are saying is paradoxical and contradictory, as I believe our notions are. In most cases the images show a turbulent sea encroaching or threatening human structures, and we get the impression of nature as threatening, wild and terribly thrilling. Some of the postcards show people standing like voyeurs

watching some sexual act – watching the waves crashing towards them. I include a quote from Marie Corelli (a best-selling Victorian novelist) in which she speaks of 'earth the beautiful and her lover the sea' because her images of the sea are tempestuous and sexy and active, therefore masculine. Yet normally the sea is referred to as female.

> But natural disasters like hurricanes are called female, maybe a rough sea viewed from the shore is characterized as male because it's seen as powerful rather than uncontrollable and destructive.

We attribute characteristics to the sea or the land depending on whether we value them positively or negatively. And so you have a number of terms colliding in supposedly ordinary seaside postcards. If you were an anthropologist dealing with another culture you would pick up on the pattern of gestures, artefacts, eating, you would try to make a coherence out of it, but we are so constrained within our own culture that we simply discard these manifestations of our own complexity, perplexity and conflicts. And we dismiss them as only postcards.

My conviction is that popular formats may well be art. A postcard is after all a miniature picture. In some of the postcards where the original image is photographic, hand tinting has been added. We tend to think of this sort of thing as a mechanical process, but by comparing several examples based on one initial image, it is easy to see that each painter painted the image completely differently. Aspects of imagination, fantasy or whatever enters the process inevitably. Human beings are not machines; they express their creativity in their gestures, in their ordinary, mundane working gestures. And it's those sorts of things I am trying to bring out in that piece.

> A lot of male artists work with discarded fragments of everyday life. Do you think your work differs from theirs?

Yes, they usually make new wholes out of fragments. They don't see their work at all as I see mine. They see it as sculpture. I present the idiosyncratic nature of each individual unit as a sign. Without being sentimental, I think it's a kind of cherishing of things as they are, rather than trying to make them into other things. I deal with fragments of everyday life, and I'm suggesting that a fragmented view of the world is all we've got. Take that chair over there; we only see it now and for a short time, we're not seeing its entire history.

> As women we have a particularly fragmented view of the history of our art. Do you think that has affected your ideas about the role of the artist?

I've always been interested in investigating the origins of ideas and images, and my assumption is that they are collective and not individual. I worked from 1968 to 1974 with other people in various kinds of group structures to allow people to see for themselves that this was so. Perhaps as a woman I had to make

explicit the notion that the ideas I had were not idiosyncratic – in a sense I
needed to work collaboratively in order to enable me to feel strong enough to
state them.

> *You no longer work collectively but always make it clear how your work
> depends on other people's, whether it is the postcard artists or the Pueblo Indian
> women potters whose shards you work with in* Fragments. *You point out that
> the Pueblo women say they draw inspiration from their art history, from a
> tradition of pottery-making handed down for over two thousand years from
> mother to daughter, as well as basing their painted pots on designs that they
> have dreamed at night. Are you saying our culture makes too rigid a distinction
> between rational and irrational thought?*

Yes, our culture more than most makes a distinction between the rational and
irrational, between empiricism and intuitive ways of apprehending the world.
In my experience those kinds of distinctions don't have any validity. In my work
I'm trying to approach a kind of reconciliation of rational and irrational factors
which seems to me a lived truth for many people, particularly for women. For
myself, I can only say that this is part of the way I see things.

> *It's true that a comparatively large number of women became involved in
> Surrealism, which as an art movement aimed to unite the rational and
> irrational, conscious and unconscious, and which supported the notion of the
> artist as medium rather than a domineering, ordering force.*

It's been argued that the subjugation of women has strengthened certain
faculties, because in order to survive women had to develop resources to judge
the nature of people and situations. Our culture, however, has laid great stress
on the development of rational, thinking faculties in people and dismissed or
minimised the irrational, calling these qualities feminine, negating them,
calling them extra-sensory perception.

> *Except when male artists draw on irrational modes of thought or dreams, and
> then it's termed inspiration provided by The Muse – the female, silent,
> representative of the unconscious and the dream.*

Yet there are numerous instances in the history of science of great insights
coming to people in a way that our culture dismisses. In other words, when you
study the history of science, you study it as a history of empiricism,
experimentation and the formulation of hypotheses, but in fact so many
important insights of science have come through what are called irrational
means that we have to conclude that the way science described itself is not
value-free.

Our culture does use the kinds of insights that, say, dreams bring at the
same time as dismissing these insights as unreal, feminine and mystical.
Whereas other cultures acknowledge that information or solutions to problems

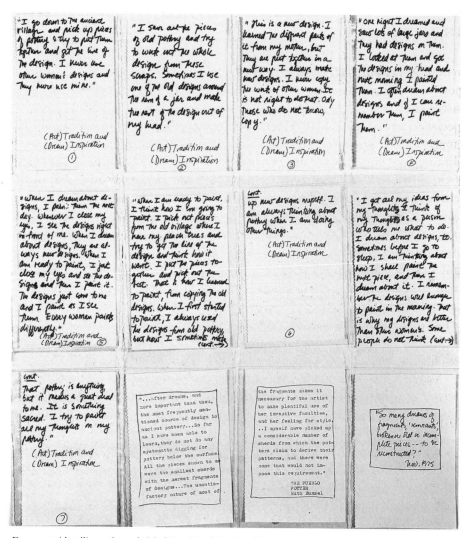

Fragments (detail); section subtitled 'Art (Tradition) and Dream (Inspiration)'

come to people through dreams . . . I think that because of the situation of women in our society, they may have a kind of privileged access to those ways of knowledge, and I don't see them as antithetical to, or less significant than the more dominant, rational modes.

NOTES
1 Parker refers to *Enquiries/Inquiries* and *Dedicated to the Unknown Artists* at Kettle's Yard, Cambridge; *Fragments* at the Museum of Modern Art, Oxford; and *The Photomat Portraits* at Hester van Royen, London all showing concurrently in April 1978.
2 Cora Kaplan (ed.), 'Language and Gender', in *Papers on Patriarchy* (London: Publishers Distribution Cooperative, 1976).

AN ARTIST LOOKS AT ETHNOGRAPHIC EXHIBITIONS

In my work I have the tendency to return again and again to certain themes and motifs. By the time I had begun to show what I made to other people and to participate in exhibitions, I had already decided not to force myself to specialize too narrowly or to censor out anything that might interest me to do, simply because aspects of a diversified art practice (for instance, making both paintings and video events) might appear contradictory according to the tenets of those days. The pleasure I took in thinking I was making a new definition of artistic integrity was private, because, of course, this approach was first ignored, then misunderstood, later criticized as 'lack of consistency', subsequently accepted as postmodernist, and now it seems as though everyone is – and always has been – working in this way, and that it is only 'natural' for contemporary artists to do so. I offer this to you not only as irony, but also as a small instance of the way individuals enact shifts in cultural perspectives. Looked at like this, the private experience of a subject struggling to discover, formulate and articulate her own possibilities is not accounted for, but it does not follow that it is of no account.[1] This talk, like all my work, takes this paradox into account, and is delivered from an artist's perspective.

Maya Deren, dancer, film-maker, artist, and ethnographer, described the perspective of the artist and its implications for looking at other cultures:

> I believe it is not altogether inappropriate to consider that the peculiar and isolated position of the artist in Occidental culture might arise from the fact that he alone among professionals, does not – by definition – accept certain beliefs which have so long been the premises of Occidental thought. Is it not worth considering that reverence for 'detachment' – whether scientific or scholarly – might be a projection of the notion of a dualism between spirit and matter, or the brain and the body, the belief that physical, sensory – hence sensual – experience is at least a lower form, if not a profane one, of human activity and moral judgement? . . . Is it valid to use this means to truth in examining Oriental or African cultures which are not based on such a dualism?'[2]

My talk today has emerged as part of this experience and this way of thinking. Retrospectively, the tendency I have to 'return again and again to certain themes and motifs' has spread itself across enough time and enough behaviour to make it seem easy enough to locate connections and relationships that may have occurred years apart or have shown themselves in very different

Paper read at a conference entitled 'Making Exhibitions of Ourselves: The Limits of Objectivity in Representation', organized by the Museum of Mankind, London, 13–14 February, 1986.

materials and forms, for this is not the first time I have tried to think about matters connected with the topic of today's conference. My talk today ought to be considered in the context of earlier artworks of mine such as *Fragments*, and it ought to be heard in conjunction with an earlier text called 'Sacred Circles'. I've included the text as a hand-out which it would be useful to read before proceeding any further.[3]

After reading 'Sacred Circles', you will undoubtedly realize that one way an artist can look at ethnographic exhibitions is in sorrow and anger, for the essay makes a series of moral, ethical and political points. Perhaps this could be kept in mind as a corrective to the widespread notion that a formal idea, or even 'beauty' is what artists are seeing when they look, or even what they are looking for in what they see. It may even correct the impression some people have that 'beauty' blinds us to other kinds of truth.

Over the eight years since 'Sacred Circles' was published, there has been a remarkable resurgence of what might be termed 'neo-primitivism' in the work of many European and American artists. The return of masks, skulls, sexual symbolism, mythic beasts, murky penumbras, wood-carving, 'expressive' gesture, rough painting and other identifiable traits, which has temporarily obscured other versions of the 'primitivist' tendency in art and which exists alongside them, along with the growth or return of an associated critical vocabulary that uses words like 'vigorous', 'mystical', 'primeval', 'authentic', 'symbolic'; combined with an exceptionally eager market of private and institutional consumers, is a phenomenon that has become a dominant theme in the art of the 1980s. What I wish to emphasize here is that the problems I raised in 'Sacred Circles' are problems not just for the general public, but also for any artist who works in a culture permeated with references to 'the primitive', and in a visual tradition crammed with borrowings or influences from tribal or ethnographic cultures.

It's important to mention that my continuing interest in the problems raised in 'Sacred Circles' has been refreshed periodically over the past eight years by certain conversations with students and artists of my own generation. These conversations have tended to describe a situation where we now find ourselves. Critical practices that urge the politicization of art (that art be made and received *only* as 'information') or their counterparts (that art be made and received *only* for its 'aesthetic dimension') have failed to map the terrain; furthermore, both the formalist and historicist constraints of (some) late modernism(s) and the amnesia of (some) current postmodernism(s) are actually impediments both to making sustantial, meaningful works of art and to understanding art within our own society. It has been argued that the typical notion of postmodernism admits of no recent past, only an endlessly

reformulated present and an imaginary prehistory construed as a primeval swamp of significations. However, since the notion of an 'imaginary prehistory' and the tendency towards borrowing from so-called anonymous tribal sources seem to have characterized Western art throughout the modernist period as well, it is perfectly possible to suggest that these themes are typical of all 'modern' Western art in the broadest sense.[4] In the situation I am describing, 'modernism' looks as much like an ideological invention as 'the primitive', which some modernism(s) and some postmodernism(s) situate oppositionally. On the other hand, *my* kind of postmodernism explicitly presents itself as a construct, one that interrogates catagories and brings 'the primitive' back into view as a site of need and fantasy essential to the construction of Western identity, thus freeing it from its projection onto real other people who have been burdened by us with essentialist, timeless qualities.[5] *This* postmodernism might justifiably be considered a break with modernism, since there would be evidence of a rupture in the construction and signification of difference and otherness.

This brings me back to the resurgence of attention in recent art to all those tendencies that formerly were sorted under the label 'primitive', and to motifs and forms borrowed from or influenced by tribal or ethnographic art. It also brings me to the point of looking again at exhibitions of ethnographic art, which I notice with a certain astonishment are once more taking place 'everywhere', with maximum exposure in art magazines. Clearly, 'primitive art' is a constructed category, related to notions of 'the primitive' against which Western culture has created its self-definition.

> Outside our showcases there is no primitive art, particularly in the nonliterate societies where the museum and gallery objects have been created . . . The concept of primitive art is a Western one, referring to creations that we wish to call 'art' made by people who, in the nineteenth century, were called 'primitive' but in fact, were simply autonomous peoples who were overrun by the Colonial powers . . .[6]

Binary, oppositional sorting is sometimes held to be a universal precondition for cultural definition, for language and for thought. Certainly, as a concomitant of binarism, European thinking has tended to project on to exotic, relatively powerless peoples a kind of eternal stability, as though they were natural phenomena out of which myths could be created in order to define and demarcate Western culture. Until very recently anthropological and art-historical commentators tended to be non-judgemental about the implications of this kind of thinking, as they were themselves its agents.[7] Any exhibition of ethnographic art and artefacts is a display (of individual objects and of itself as an object) that remains caught in this mode of thought and its consequences.

The ethnographic art exhibition as a whole, including the process of creating it and its reception by the public, is the site where this basic tendency in our culture formally displays itself. It is so visible that it is hard for us to see what it means.

Perhaps ethnographic exhibitions present themselves so visibly because they are symptoms seeking cures. Two kinds of cure, in the form of alternative modes of presentation and description of the objects contained within an exhibition are available, but both reveal themselves under scrutiny to be part of the problem, not part of the solution. First, there is an increasing reliance on the aesthetic 'cure' for ethnographic exhibitions, which treats the objects as art, 'on their own merits'. That is, we judge them meritorious and project value onto them as though it were somehow intrinsic or *objective*.

> The museums of ethnology . . . have increasingly presented their objects . . . as worthy of purely formal study. They have been willing to take the 'ethnocentric' risk of making judgements which separated the finer objects from the more everyday ones . . . Thus the artistic creations of the primitive cultures have entered fully into the world history of art to be, like those of any other culture, understood and appreciated on their own merits.[8]

Or, to quote Henry Moore: 'All that is really needed is response to the carvings themselves, which have a constant life of their own, independent of whenever and however they came to be made and as full of sculptural meaning today to those open and sensitive to perceive it as on the day they were finished.'[9]

I find a certain raw honesty in these acknowledgements that the display, consumption and meaning of ethnographic objects should be determined solely by the subjective feelings and cultural values of Western society, since the objects under discussion now 'belong' in Western museums and collections, far from their original contexts. They are now, truly, 'ours'. Furthermore, this approach at least accommodates, albeit unconsciously, an acknowledgement of the fundamental terms upon which Western display of 'primitive' objects is based in the first place: these objects signify the 'other' as a projection against which this society defines itself. This is their primary meaning for us.

In exhibitions of the 'scientific' or 'informative' sort, the problems of projection are virtually doubled, making decipherment more difficult. The assumption in these exhibitions is that meaning can be *appended* by means of explanatory labels, captions or videos which refer viewers to factors exterior to the object but nevertheless determining it, like social customs, ritual, production techniques, myths, etc. Yet as we certainly now know, the knowledge we have of other peoples is not the same as their knowledge of themselves. The emergence of our definition of ethnographic 'facts' was only

possible on the basis of a history of colonialism which constituted all the peoples who were colonized as objects, just blurry aspects of 'the other'.[10]

In every possible way, ethnographic exhibitions are addressed to *us* and construct *us*. A self-enclosed discourse about the timeless and universal takes place, in which meanings are constituted and exchanged among ourselves and an entire symbolic picture is created. No matter whether the exhibition presents itself as 'art' or as 'information', its meaning can be said to occur at the place where our own thought collapses upon itself. The cures remain binary and oppositional, either 'temptations to mistaken speculations about primitive peoples' or 'invitations to forget, for the time being, those people and look at the thing as art'.[11]

An ethnographic exhibition is a display, and a display is something to look at. Maya Deren, as quoted earlier, suggested that 'detachment' or what she calls 'objectivity' creates an inability to understand other cultures and their productions. Detachment privileges representation over sensuous reality; detachment always only looks from a distance. Detachment is one side of the Western equation of truth with 'seeing'. (Seeing is believing.) Hegel, for instance, claimed that vision was superior to the other senses because of its detachment from its objects. Yet vision is hardly disinterested in its maintaining of distance. Perhaps detached looking always objectifies, in order to maintain its distance? In any case, what interests me is the fact of the proliferation of display, of exhibitions, the *emphasis* on detached looking, across an entire cultural field where the source of the symptoms (of which the ethnographic exhibition is one) perhaps can be found.

The modern Western person is constituted through representation. Representation ('the suppression of "the multitudinous affinities between existents" in favour of "the single relation between the subject who bestows meaning and the meaningless object"') is the primary means of underpinning the modern Western desire for mastery and control over the world.[12] Detached looking at ethnographic exhibitions is at the very heart of the construction of ourselves as members of a culture, for the items on display are inevitably voided of meaning (for all the reasons I have indicated and by means of the specific procedures for doing so elucidated in 'Sacred Circles') so that the subject – the Western spectator or curator – can constitute himself/herself with reference to these items, upon which s/he bestows meaning. Both 'aesthetic' meaning, as art (the objects exhibited as vehicle for subjective feelings) and 'scientific' meaning, as information (the objects exhibited as vehicle for fantasies of knowledge about 'the other') are really discoveries of our own assumptions.

At this moment, when Western culture seems to be threatened by external

forces and riddled with internal contradictions, it is not surprising to find a proliferation of ethnographic exhibitions alongside an abundant return of related references and motifs in the work of many Western artists. These forms of display are crucial to the construction of our personal selves as subjects in a fictional discourse in which 'the other' remains a fantasy, as well as to the production and maintenance of a cohesive cultural self-identity for Western society, one integrally connected to its historic need for imperialist domination. The part that curators of ethnographic exhibitions take in this process relies on producing complicit 'knowledge'.[13] What part do artists play? Certainly, much of the 'primitivizing' in contemporary art acts just like a mirror dumbly reflecting back images of 'the other' as a focus of dreams, fantasies, myths and stereotypes. But – and this is much more interesting to me – tendencies are emerging in art that do not privilege seeing over, say, hearing or touch, as well as tendencies that represent, interrogate or relativize the basic terms involved in the process by means of which the Western self is constructed. My own interest, and that of certain other artists, lies not in images that reflect and thereby perpetually recreate primitivistic fantasies, but in images that reflect *upon* such notions, not in an arid or alienated analysis but in modes that honour what Foucault called 'the inexhaustible treasure-hoard of experiences and concepts, and above all, a perpetual principle of dissatisfaction, of calling into question, of criticism and contestation of what may seem in other respects to be established', filed under ethnography.[14]

Although the perspectives of modernism and postmodernism offer artists no guidelines on the ethics of appropriation, debate on this point has emerged among artists. It is also among artists that the notion of art as a collection of material objects is most fiercely contested. It is artists who insist that their work is *both* aesthetic (a vehicle for subjective feelings) *and* useful (an expression of cultural tendencies and values). I have already given hints of how it comes about that practices claiming objectivity and detachment are less able to give clear indications of what they are doing than practices like art, that stress interiority and subjectivity. Probably for these reasons, curators and exhibition organizers have failed to understand the implications of their own work. There is only one way that ethnographic exhibitions themselves can become part of the process of bringing to light the way our culture constructs itself in opposition to a fantasized and oppressed other: the basic facts are that 'we' have in 'our' possession a multitude of important objects, whose display by us commemorates our subjugation of the makers and our destruction of their history, and perpetuates our attempt to obliterate their indigenous realities. It would be educational, to say the least, if ethnographic exhibitions would begin to make us aware of the interaction between the objects displayed and our *own* history. Without allowing

ourselves the luxury of false empathy, we could then begin to follow our thought to the place where it collapses upon itself, the site of representation, and source of ourselves as subjects in a culture dedicated to mastery of a mirage, symbolized by the projection of 'the other' on to real other peoples.

NOTES

1 I might add that something else unaccounted for in presenting this talk as a written text is the problem of gendered language, an issue I commented on informally while making this presentation. Clearly the universal 'he' of all the sources I quoted, from Maya Deren to Foucault to Heidegger, makes it difficult for me to integrate the quotations with my own words.

2 Maya Deren, *Voodoo Gods of Haiti*, (St Albans: Paladin, 1975), p.172.

3 See the Appendix to this volume.

4 For instance: 'These images are drawn from a stock of preclassical, pre-Columbian and primitive sculptural objects . . . whose forms are recurrent through time and across cultures, and whose effective and symbolic potency seems in no way culture-specific. They are images that conserve spiritual constants, carrying them across from one cultural circumstance to another. Access to this stock . . . is one of the defining aspects of modernist sculpture.' Mel Gooding, 'William Turnbull', *Art Monthly*, February, 1986, p. 16.

5 These ideas were extended and clarified in *The Myth of Primitivism*, compiled and introduced by Susan Hiller (London and New York: Routledge, 1991) [ed.].

6 Nelson H. Graburn, ed., *Ethnic and Tourist Arts: Cultural Expressions from the Fourth World* (Berkeley, Calif.: University of California Press, 1976), p. 4.

7 For example: 'It is the nature of civilization, as contrasted with primitive life, that its carriers and beneficiaries come to know, to think, and to judge in terms of forms and ideas that come from people other than their own': Robert Redfield, 'Art and ikon', in Charlotte Otten, (ed.), *Anthropology and Art: Readings in Cross-Cultural Aesthetics* (New York: American Museum Sourcebooks in Anthropology, 1971), p. 60.

8 Robert Goldwater, *Primitivism in Modern Art* (New York: Vintage Books, 1967), p. 13.

9 Henry Moore, 'On primitive art', *The Listener*, 24 April, 1941, pp. 598–9.

10 Colonialism empowered Western culture to link itself to other cultures 'in a mode of pure theory . . . From that starting point, it avoids the representations that men in any culture may give of themselves, of their lives, of their needs, of their significations laid down in their language . . . Instead, it sees emerging behind their representations the norms . . . the rules . . . the systems . . . which it alone is privileged to enunciate and by means of which the West finds it possible to know that which is not given to or which eludes the consciousness of other peoples about themselves': Michel Foucault, *The Order of Things* (New York: Vintage Books, 1970), pp. 376–7.

11 Redfield, 'Art and ikon', p. 42.

12 'According to Heidegger, the transition to modernity was not accomplished by the replacement of a medieval by a modern world picture, but rather, "the fact that the world becomes a picture at all . . .". For modern man, everything that exists does so only in and through representation. To claim this, is to claim that the world exists only in and through a *subject* who believes he is producing the world in producing its representation. "There begins that way of being human which mans the realm of human capability given over to measuring and executing for the purpose of gaining mastery of that which is as a whole . . .". Heidegger's definition of the modern age – as the age of representation for the purpose of mastery – coincides with Theodor Adorno and Max Horkheimer's treatment of modernity in their *Dialectic of Enlightenment* . . . "What men want to learn from nature is how to use it in order wholly to dominate it and other men." And the primary way of realizing this desire is . . . representation – the suppression of "the multitudinous affinities between existents" in favour of the single relation between the subject who bestows meaning and the meaningless object': Craig Owens, 'The Discourse of Others', in *Postmodern Culture*, ed. Hal Foster (London: Pluto Press, 1985), p. 80, note 32.

13 That is, knowledge that accedes to the formation of 'that way of being human which mans the realm of human capability given over to measuring and executing for the purpose of gaining mastery' (Heidegger, in Owens, *ibid.*).

14 Foucault, *The Order of Things*, p. 373.

facing] *Élan* 1981/82; thirteen photographs and audio soundtrack; overall size 304.8 × 233.75

WITHIN AND AGAINST

WOMEN BEING ARTISTS

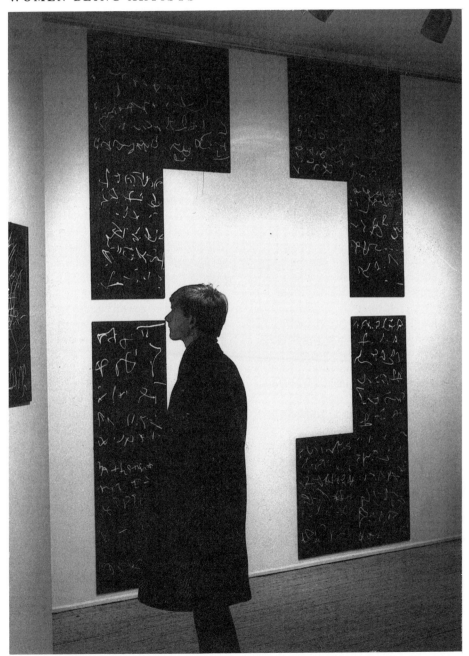

EDITOR'S INTRODUCTION

A rigorous self-critique and debate about the function of art, the role of the artist, the role of economic and political institutions in promoting certain definitions of art, in using art for ideological purposes . . . the relationship between artists and the rest of society – all this is very much a part of art practice today, and what art is and ought to be is examined against a comparative background of historical and ethnographic data.

Susan Hiller, 'Art and anthropology/
Anthropology and art'

In recent years the number of 'art and anthropology' courses has increased as artists, critics and historians of both art and culture cross traditional disciplinary boundaries. The dedication of an entire department to this hybrid field may be read as one more signal of deeper shifts in the organization of Western knowledge-systems. With overnight changes in geographic boundaries turning maps and money into useless paper and displacing whole populations, it is no accident that studying 'the invention of culture'[1] becomes pragmatic; hitherto 'objective' categories are being re-examined, along with attitudes toward the 'other', now among 'us'.

Susan Hiller has long raised questions particular to this frontier: where does subjectivity stop, objectivity begin? Why has one become the domain of art, the other of science? How do anthropologists see art, artists see anthropology? Since modernism and postmodernism offer no guidelines to the ethics of appropriation, how can the artist be ethical? How has the 'primitive' come to be located in the past, and how does the picture change if it is reconsidered to be part of the 'modern'?

What happens when ethnographic objects leave the museum of natural history and enter the art museum? Why the surge in neo-primitivism? How do 'individuals enact shifts in cultural perspectives'? She identifies as 'the key issue in the practice of anthropology: the role of the participant-observer'.

It was in fact while doing anthropological fieldwork in Mexico, Guatemala and Belize, following postgraduate studies in anthropology, that she experienced great discomfort in the role of observer and left the field to become an artist, to 'find a way to be *inside all my activities*'. This has continued to be important to her as an artist committed to the collaborative creation of meaning, and in the following talks she examines the role of the artist as carrier of societal values. Asserting that art and artists do know things ('art is a first-order practice'), she rejects the persona, as did Duchamp, of 'the dumb painter', while equally rejecting that of the artist as authority who has the last word. When speaking to anthropologists at Oxford, she warns that 'you may find what I say fragmented and inconclusive and somewhat controversial; that would be fine'.

Her installation exhibited at the Museum of Modern Art, Oxford, and the Hayward Gallery, London in 1978, was in fact entitled *Fragments*. It directly referred to her anthropological experience in its use of painted shards of Pueblo pottery created by now-anonymous women. The installation included hundreds of these shards, which at that time were easily found, half-buried and broken; an equal number of gouache drawings of fragments; charts

contours have been shaped not by 'going outside' the self, here the intensely experienced self of the pregnant woman, but by the sensuous understanding of landscape through the knowledge of the body.

Even earlier, in 1972, she began investigating how automatism has been interpreted according to gender, with women who see things portrayed as 'spooked', disturbed, while men were regarded as visionaries, whether of the artistic or scientific variety.[7] She initiated her signature automatic script with random marks in blue pencil on a blank sheet of drawing paper. The writing that emerged spoke in a number of voices, saying: I AM YOUR SISTER/THE RIDDLE IS THE SISTER OF THE ZERO/WHO IS THIS ONE/MENON IS THIS ONE/THREE SISTERS ARE YOUR SISTER/THIS IS THE NOTHING THAT WE ARE . . . Such messages were displayed by Hiller the following year, and six years later commentaries were added, an artist's book created, and the work was mounted in the form of a negative cross. This is the *Sisters of Menon*, Hiller's first use of the automatic script that continues to appear in her works. Just as *10 Months* calls traditions of landscape painting into question, *Sisters of Menon* questions traditions of signature, self-representation, portraiture.

In 1981–82 the scale was enlarged in *Élan*, an installation of colour photographs based on negative projections of her scripts. Konstantin Raudive's 'Voices of the Dead'[8] and Hiller's vocal response and commentary were released into the air by means of an audio tape. The artist also pursued a series of self-portraits that were over-written and doubly engaged with automatism; the photographs were made in an automatic photobooth. She also

began 'producing without any sense of amazement and a great deal of pleasure, a rather refined calligraphic series – a set of marks that simply flows. The marks are the record of my hand pressing. . .'. Her description of this 'production' as a 'recording' gives even the ecstatic mark a scientific, documentary status, a mark of her engagement in the 'socially motivated investigation of mark-making initiated with the Surrealist group'.

She has made systematic use of the grid; developed a tactile, time-based seriality (compare *10 Months*, pp. 48, 49 with *Sometimes I Think I'm a Verb instead of a Pronoun*, p. 64); and utilized such elegant media as hand-tinting, coloured washes and liquid gold leaf (see *Self-Portrait*, p. 55). Her art is both sensual and analytical, hot and cool. She is inside the materials she works with – feeling them and literally 'being in' them through the use of photographs of her belly, hand, face, recordings of her own voice – but she is outside them at the same time, manipulating, reworking, categorizing them.

Within the territory of feminism as a slow-release mechanism for overall cultural changes in modes of perception, Hiller is both a pioneer and a cautionary presence. As fragmentation and multiplicity enjoy increased currency in art, Hiller warns of how they can become emptied out of meaning:

> The consolations of formalism, displayed again and again to prop up aspects of tradition, are an insistent refusal to see art as a vehicle of change and as a reflection of contemporary meanings. No matter how up-to-date her subject matter or medium, it is always possible for an artist to comfortably reject the realities of split subjectivity, divided audience, gender differences, fragmented society, historical contingency.[9]

NOTES

1 Guy Brett, 'Susan Hiller's Shadowland', *Art in America* 79: 4 (April 1991), p. 187.

2 See Susan Hiller, 'I don't care what it's called', in this volume.

3 *Leonora Carrington: A Retrospective Exhibition* (New York: Center for Inter-American Relations, 1976), as quoted in Whitney Chadwick, *Women Artists and the Surrealist Movement* (New York: Thames and Hudson, 1985), p. 218.

4 Compare Maurice Merleau-Ponty, *The Visible and the Invisible* (Evanston, Illinois: Northwestern University Press, 1968), p. 3: 'We see the things themselves, the world is what we see . . . but what is strange about this faith is that if we . . . ask ourselves what is this *we*, what *seeing* is, and what *thing* or *world* is, we enter into a labyrinth of difficulties and contradictions.'

5 Personal communication.

6 See Julia Kristeva, *Language, The Unknown: An Initiation into Linguistics*, trans. Anne M. Menke (New York: Columbia University Press, 1989), p. 328.

7 See Jean Fisher, *Susan Hiller: The Revenants of Time* (London: Matts Gallery 1990), unpaginated.

8 Between 1965 and 1974, Dr Raudive, a Latvian scientist, made thousands of recordings of such voices by amplifying the silence in apparently empty rooms.

9 See 'Reflections', in this volume.

WOMEN, LANGUAGE AND TRUTH

Each of us is simultaneously the beneficiary of our cultural heritage and the victim of it. I wish to speak of a 'paraconceptual' notion of culture derived from my experience of my ambiguous placement within this culture. This placement has been painful to recognize and difficult to express.

From my awareness of my situation has come an acceptance that for me there is no possibility of adopting a theoretical stance (on any issue such as 'women's practice in art') based on the language of an(y) other. It is always a question of following a thought, first incoherent, later more expressible, through its process of emergence out of and during the inconsistencies of experience, into language.

And this means I cannot claim to represent a 'position' which has already been defined in available terms, political, sociological or art-historical. I am being far from modest in taking up this position, for it seems to me to be the essential issue facing us. And the area in which this 'language' I am speaking about, verbal or visual, makes itself possible, is limited. But within these limits there is great freedom.

Although I can certainly be located within any grid system that the viewpoints of politics, sociology or art history lay upon the world of experience in innumerable permutations and in varying degrees of subtlety; and although I am exposed every day to the common generality of attitudes whose limited range indicates the basic ideological 'set' involved – describing me as a woman, artist, foreigner, etc.; and although in addition I myself have inevitably absorbed and incorporated all of these attitudes and many of these viewpoints; and although 'I' must be in some sense co-determinate with this culture, and my expression, *to be comprehensible to any degree*, merely an aspect of it, yet I can find myself ONLY in refusing to speak in ready-made terms as an example, representative or instance.

Those of you who are first and foremost involved in the women's movement or in pursuing a political programme as artists will perhaps feel an uneasiness, or hear this as a negation of more obviously 'committed' perspectives. That would be unfair. So let me add a particularly paradoxical note: my terms of expression and my painful and tenuous grasp of my – really our – situation, means that I am fully capable of actions that imply that my being is incorporated within any one of these categories. Thus from time to

Hiller's contribution to a panel discussion on 'Women's practice in art', organized by the Women's Free Art Alliance at the AIR Gallery, London, 20 February, 1977.

time I have participated in effective political actions based on a tentative analysis or an incomplete theoretical stance; I can describe my own experiences within the modes of the modern feminist confessional tradition; and I can discuss art in terms of issues, and 'who and when' . . .

In proportion to the strength I gain and the illusion of consistency I give as a conscious user of these conventional languages of the culture, I lose my sense of reality. But in proportion to my non-use of these conventional languages comes a loss of certainty and public effectiveness and the appearance of inconsistency. This is a true dilemma, and now I will exhibit the inconsistency I have mentioned, for I must speak of it from the point of view of the categories 'woman' and 'artist' which we know to be in collision. The results of this collision can't yet be seen, but I envisage an eventual explosion, ending in mutation of all personal, political and cultural themes . . .

To sum up would be premature, obviously. But I can end with the following: (1) all my ideas begin as part of the necessity for truth-telling in art practice; (2) not being entirely at home in the ordinary, dominant languages makes this less than simple. At the same time, it gives me a wide range of options; and (3) the greatest self-betrayal for an artist is not indulging in anarchic or careless opposition to rational politics, but in fashioning acceptable SEMBLANCES of truth.

I DON'T CARE WHAT IT'S CALLED

... I was working then in the United States. We were being told that as social scientists our work existed outside of the real world in a particular way, that is, it was value-free, it was objective, and it was meant to exemplify pure academic research values. Well, the Vietnam War in a very practical sense showed everybody in the social sciences, at least in the United States, that this wasn't so, because the data of anthropology were being used by government agencies to subvert village life in South-East Asia. So of course all these anthropologists who thought they were doing this pure form of work quite quickly were brought to realize that there was nothing that couldn't be used in a particular way. That was one reason why I left anthropology.

Another reason was that (although I didn't have a clearly articulated notion at the time) it was apparent to me that there was something odd about the position of women not just within the practice of anthropology, the special status of women anthropologists, but there was also something odd about the kind of information about women in other societies that was being fed back into our society. In anthropology men and women are trained to go out into the field and gather information, but they have traditionally gathered information only from the male speakers of the tribe for all the reasons that we now understand. The men have always spoken about the women of their tribal groups, so the information about women that is being filtered back into the social sciences tends to reinforce all the usual patriarchal views of women. Now the odd thing about that is that many of the first and second generation, at least of American anthropologists, were women – Margaret Mead, Ruth Benedict. But they had not in any way been able to alter the kind of patriarchal thrust of the discipline. That was deeply disturbing to me as a postgraduate student, but I couldn't quite put my finger on where the problem was.

The third reason was that social or cultural anthropology pivots around the notion of the participant observer. This is a kind of schizoid notion. It means that people from a dominant society go out to observe the culture of another society and adopt for a short time the formal role of being a participant within that society, but all the time are chalking up this information which they then take out of the original society back into their own society and use it to build their own professional career. In the early seventies there was a lot of radical

Presented as an informal talk for the Women's Art Movement's *Quantum Leaps* event in Adelaide, when Hiller was visiting Australia as a guest of the Visual Arts Board in the summer of 1982. A longer version of the text was published in the journal *Artlink*, September/October 1982 (unpaginated), transcribed and edited by Stephanie Britten.

anthropology that tried to correct these positions, but particularly as far as the position of women is concerned it's not something simple to deal with.

So I left anthropology and I decided to become a painter, and one of the reasons I was able to make that transition was that I had studied at an American university, and American universities don't produce specialists. I had taken painting and drawing courses. So I started off painting, and learning to paint, and had some exhibitions of paintings, but at the same time I was doing other things which I didn't think of as art, and it took a number of years for me to say *I don't care what it's called, that's what I'm going to do*, and what it turned out to be was an approach to art practice that takes some of the methods and/or attitudes towards art from anthropology, and uses them to deal with cultural artefacts from our own society.

I made the decision when I left anthropology that I never wanted to be again an observer, that I didn't believe there was anything called 'objective truth', and I didn't want to be anything but a participant in my own experience – I didn't want to stand outside it; and I didn't want to denigrate the interest of the things in my own world, ordinary things, things that are not considered very important, things like postcards, broken things, cultural discards. And over the years I've evolved an approach to these materials which looks at what you might call the unconscious side of our own cultural production.

An early piece of mine was called *Dedicated to the Unknown Artists* and I used postcards that I found in Britain, postcards of the sea, that had the caption 'Rough Sea'. It was very curious. I found the first one of these when I went to a British seaside town called Weston-super-Mare (I went there because of the name) and the postcard had this tempestuous ocean crashing against these little houses and it said 'Rough Sea' on it. And then a few weeks later I was in Brighton, and I found this card that said 'Rough Sea, Brighton', and I realized that if there were two that implied the existence of a set, and after that for about three years these cards found me everywhere, I literally couldn't get away from them, and I used to have a lot of fun sorting through them, playing with them, classifying them, comparing the images, looking very closely at these miniature art things, and then I decided to make a piece of work based on that experience.

In order to do this work I decided I would take the stance of being the curator for this body of little pictures, and as the curator one of my jobs of course would be to produce a catalogue, so I produced a small book which is the catalogue for this 'museum exhibition' of tiny seascapes. The book is a kind of summary of some of the themes of the images: lots of times the buildings in the background have been painted in by hand, the same wave with different buildings; or in places where the sea is never rough, seaside towns in Britain

that are famous for their calm seas, someone will have airbrushed in a big wave; and then a lot of them have frames, and the notion of frame is included in the postcard idea; and then there are quite a few that come from paintings. These were very curious to me. They contradict a lot of the ideas we have about paintings, about let's say, sensibility, original response to scenery, etc., because the painting images in the postcards all conform to a set of strict conventions so that one locale looks exactly like another locale. But in the *photographs*, because they go through these odd stages of photography, re-photography, etc., images from the same negative can be radically different in their different stages of production. So I did an installation in which I played visually with the cards to bring out some of these things, and then because the initial fascination for me had been in this mysterious redundancy or doubling of two languages, a visual and a verbal, descriptive language, I also used words to make complex tabulations in chart form of all these kinds of things, which query notions of photography versus painting and so on, and produced a second publication in which I analysed all this material.

The piece has a great deal to do with Britain as an island. Someone once said to me that only a foreigner could have done this piece, and I realized that my position gave me a privileged access to some kinds of insights that perhaps the British themselves didn't have into their own tradition of landscape art.

What's interesting to me about this piece is that still in those days I wasn't able to be explicit about what the real content of the work was. I hoped people would see it for themselves, as I had seen it. It was the sexuality, the symbolic significance of the imagery that created a most obsessive perpetuation over the years in the making of these postcards. In the tabulations that I made I included comments by the people who had sent the postcards, only in so far as the comments referred to the picture on the other side, which was what really gave me the clue to this. On one level they showed the power of art to structure people's experience, because they would often say 'Dear Mum, the sea today is *just* like you see in this picture.' The other thing is the incredible excitement that the British seem to feel about the waves, and there were a lot of comments like 'Dear Mum, What an exciting day! The sea has tossed us about, we've been wet . . .'. They just went on and on, a most bizarre thing. Then I began thinking about nature/culture, male/female gender attribution, etc., but I was not being explicit about that . . .

Years later I made a work called *10 Months*, a piece in ten units. I was pregnant in 1976–77, and I took photographs of myself and kept a journal, but I didn't have any intention of making it into a piece of work at that point. I was just trying to keep a record of the internal and external changes of that period. As someone who was already a mature artist and aware of the metaphors of

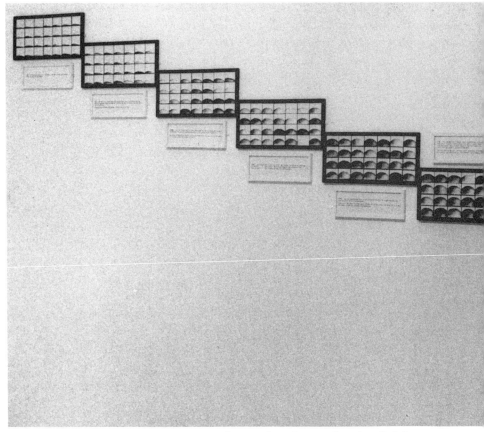

10 Months 1977-79; ten photographs and ten captions; installed size 203 × 518; detail *facing*] monochrome composite photograph 21.5 × 54.6; caption 10.2 × 38.1

creativity that come out of pregnancy, I was interested. Afterwards it became clear to me that I had to make a piece of work. It wasn't until some time after my child was born that I found out several things. The average pregnancy is 280 days, which is not nine and a bit months, but ten lunar months, and in fact in France old women still call the months of pregnancy the *lunes*, so this is still quite current in folk knowledge.

Like many other things concerned with the female body it has a natural rhythm which is not clearly stated by the solar calendar. That gave me a principle of organization. That was when it became possible for me to make a piece of work out of it. I had been taking these full-figure photographs, and thinking of the moon thing, the moonscape, landscape analogy; I made a decision to just use the section of the body you couldn't talk about, the

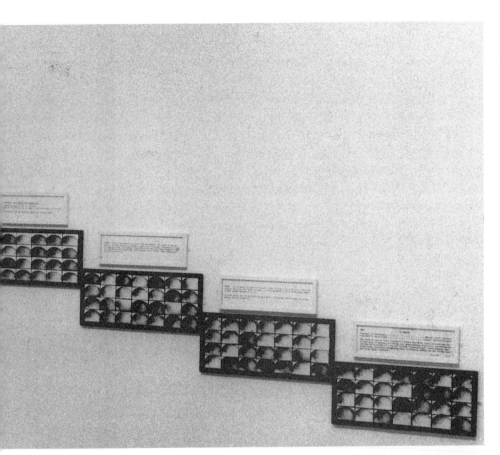

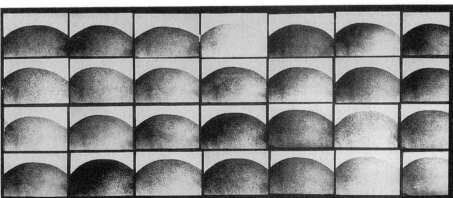

SIX/ She speaks (as a woman) about everything, although they wish her to speak
only about women's things. They like her to speak about everything only if she
does not speak "as a woman", only if she will agree in advance to play the art-
ist's role as neutral (neuter) observor.

She does not speak (as a woman) about anything, although they want her to. There
is nothing she can speak of "as a woman". As a woman, she can not speak.

pregnant part, using a tiny little section of the 35 mm negative, thus all the graininess. Having made that decision, to excerpt, as it were, a part of the body, I then knew what to do with the journal I'd been keeping, a huge plastic carrier bag full of scraps of paper, so I selected out bits from each month that seemed particularly relevant. Then when it came to organizing it on a wall there were certain things that had to be done which dictated my choices. Because I wanted the first image in a month to link up with the last image of the previous month and I wanted to make it absolutely clear that they followed on, so the sections had to abut which made the piece take a rather dynamic shape on the wall. I was shooting black and white film, and I decided to leave it in this rather stark mode to break with the traditional sentimental image of pregnancy. It's an incredibly fertile *mental* time, quite extraordinarily rich, not just the body and its changes, but the mind as well.

And then presenting words posed a particular difficulty, which eventually was solved by the texts themselves. In the first half, the texts that I chose to use were subsidiary to the physical. I was dwelling on the physical changes, so I could put those texts underneath the images of the body. But in the second half of my pregnancy I was quite tormented and perplexed by a number of things, for example, by observing myself, being a participant and an observer (I began thinking about mirroring, self-image, this sort of thing), and I began theorizing, reading a lot, trying to understand what I was going through. Thinking then became primary, so I put the texts above the images, and they balance out symmetrically.

This piece has been quite contentious in England for a number of reasons. There hadn't been, in England, any work done by women artists on pregnancy. Since pregnancy in art is quite an important theme, this piece disturbs traditionalists. Also, of course, it makes explicit reference to landscape imagery. It seems to relocate the emotional source of those images right back to their origin in the female body. Some art historians found this subversive. Was I deliberately commenting on the British landscape tradition?

The piece was deeply disturbing, also, to other people who find it hard to accept the right of a woman to be both the artist and the sexed subject of the work. When I got very depressed about it I used to think of that nice little drawing by Suzanne Valadon, *The Model Paints*. She did this little sketch of herself naked, doing a painting, which is marvellously unselfconscious, a brilliant little drawing, and I realized that there were precedents, there is a tradition, and it's just as disruptive as it's ever been.

LOOKING AT NEW WORK *an interview with Rozsika Parker*

*Looking at your new work, the first thing that strikes me is that your automatic
writing works – the scripts – have changed considerably since you produced*
Sisters of Menon *in 1972.*
Yes, now I'm producing without any sense of amazement and a great deal of
pleasure a rather refined calligraphic series – a set of marks that simply flows.
The marks are the record of my hand passing, and though they're certainly
patterned, regular, formalized, and in their own terms, articulate – they don't
represent anything, in a literal sense.
 Are you saying the new work doesn't mean anything? Sisters of Menon
 *seemed to me to have been insisting that we decipher the script and understand
 the meaning of the text.*
Among the other things it's doing, the *Sisters of Menon* script reformulates the
encounter between the Sphinx and Oedipus. The *Sisters* text revolves around a
new perspective on the question, Who am I? The Sisters ask, 'Who is this one?'
and they answer themselves, 'I am this one. You are this one. Menon is this one.
We are this one.' It's a new starting-point. Identity is a collaboration, the self is
multiple. 'I' am a location, a focus. It seems to me my newer scripts are clearly
rooted in this understanding. This 'writing' is a way for me to speak my desire
for utterance. I used to describe the signs themselves as crypto-linguistic, that
is, representing language referring to language, or pretending to be language –
now I'm practically at the point of claiming that my newer automatic works *are*
a new language, or are making one. (*Laughter.*) One that is, at the same time, old
in terms of our individual personal histories.
 *Are you now deliberately changing the 'feminine' associations of automatic
 writing?*
That's complicated. First of all, the timing seems right to give this work a more
central place in my own practice, since there's now a context in recent linguistic
theory and feminist thinking. When I began to work in this way, ten years ago or
so, theory hadn't yet begun to link up – well, let's say it couldn't link up the
'analytic' and the 'ecstatic'. So I very gradually begin to exhibit small automatic
works alongside other projects, and this seems to have worked. What I hope for
now is that these works should not just be seen in purely pictorial terms, or as
decorated surfaces, but taken seriously as a form of patterned utterance. (*Points.*)
You see that series of small studies for large photoworks called *Alphabet*,

Interview of December 20, 1983 originally published in *Susan Hiller 1973–83: The Muse My Sister*,
(Londonderry: Orchard Gallery, 1984) the catalogue for three simultaneous 1983 exhibitions of
Hiller's work. Rozsika Parker is a writer and psychotherapist in practice in London.

Lexicon, Self-Portrait, Autobiography, etc.? That could provide a beginning. I'd like to see a full phonemic study some day. Perhaps I'll have to do it myself.

> *I can see how automatism relates to your concern to widen the notion of what we define as art and to question conventional ideas of the artist, but how does it connect to your ideas on women's relationship to language?*

Well – although for years I recognized the gap between our 'fruitful incoherence' and the use of so-called rational discourse, which by definition means white, middle-class, male language in our society, to articulate ideas – yet it still took time for me to fully understand my own dual programming. I'm

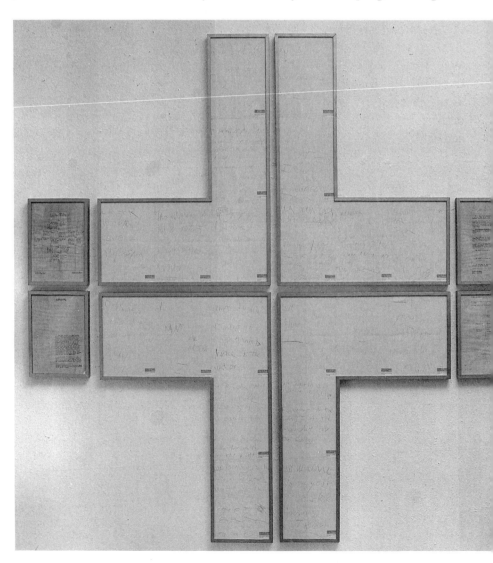

now more at ease with the fact that when something really new is coming into being in my work, I lose my grasp of it in intellectual terms. This leads me to a commitment – this makes me realize that to put the new into old language is to destroy its ability to intervene and change the system of ideas we live under.

I remember in our interview in 1978[1] you said to me that it's when we try to deal with the contradictions arising from our experience within accepted frameworks and categories that we have no language. You went on to say that the lived experience of a person is cut off by a kind of verbal formulation of that experience. So I see your present work with automatic writing as a validation of what you call 'fruitful incoherence'. How does this relate to another important strand in your work – your concern with art in its popular dimension? How accessible are the automatic works?

Well, as you know, on one level I'm a populist, so of course I worry about being too esoteric. But strangely, it's a non-problem, since a good part of my visibility as an artist has come about not through academic support or investors' interest or establishment backing, but through a kind of on-going rapport with an audience. This particular area of my work has found terrific support from all

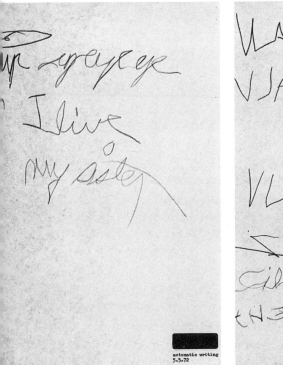
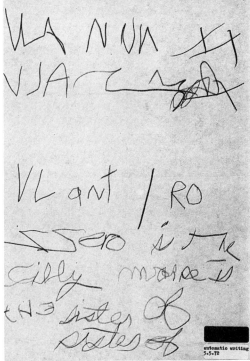

facing]
details *above]* *Sisters of Menon* 1972–79; blue pencil, typewriting, gouache, labels; overall size 193.1 × 182.9

kinds of people, including many who've had little or nothing to do with the art world or recent debates on language. Among others, young women who are struggling with their own incoherence tell me they identify with this aspect of my work. They feel they recognize these signs – what can I call them – ? These ineffable signs – because don't forget that on one level the world is constantly presenting us with signs that we as women have to deny or translate. My scripts are signs with a slightly exotic, hieratic feel to them. They don't accuse us the way signs in the world do.

You mean they are not placing us – forming us –
Right, because they go on and on in a rhythm like breathing or walking. They relate to internal rhythms which are not aestheticized or distanced from us physically. Listening to other people describe their reactions to them, and to my voice improvisations on *Élan*, I've been pleased to discover there is a direct, perhaps unconscious response to communication from the unconscious – or something like that.

In our last interview, we talked a bit about Surrealism. How do you now relate to Surrealism?
I don't like what's called Surrealist painting and I feel the Surrealists have been badly misunderstood. I'm determined to insert my work with automatism within and against the tradition of the gestural in modern art – *against* the reactionary, self-aggrandising gesturalism that has re-emerged recently, and *within* the socially-motivated investigation of mark-making initiated by the Surrealist group.

Looking back on their experiments with automatism, and then tracing the fate of automatism within painting has given me insight into how what was intended to be subversive turned into an acceptable look or style. Breton's writings on automatism were part of his endeavour to reconcile Marxism and psychoanalysis. He felt that a grasp of the implications of automatism would eventually erode all notions of personal property rights and individual authorship of works. (I've been working on that point for years, but you know being a woman artist and giving up one's property claim to one's discoveries is not quite the same thing as it is for a man, since one is never acknowledged to have had a right in the first place.)

The early automatic pieces produced by the Surrealists were collective and anonymous. An involvement with spontaneous gesture and utterance erodes notions of personal authorship because everyone can do it – no minimal standards. So why put your name to it? Particularly since it's unpredictable and seems to be outside any kind of individual control.

I've looked into what happened to this approach historically. Jackson Pollock began working very much in the tradition of Surrealist automatic

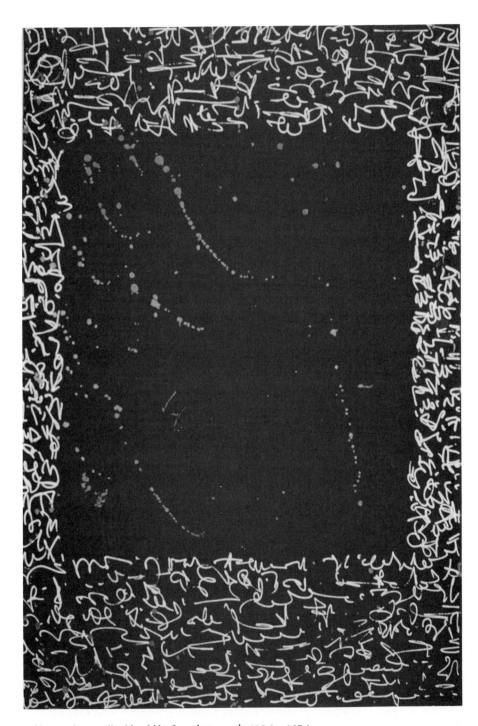

Self-portrait 1983; liquid gold leaf on photograph; 208.3 × 137.1

drawing, and his drawings turned away from recognizable figurative shapes into records of physical gestures. Numerous other artists liked the look of this and began to replicate it endlessly. No one ever went back to investigate the root of it – what it meant, and its implications for definitions of the self, creativity, inspiration, the nature and function of art, etc. . . .

You've worked with unconscious communications in the form of dreams for years now. How has the work developed and changed?

The early pieces I did with dreams were collective, collaborative projects. *Dream Mapping* for example, attempted to discover whether or not there are shared structures that underlie individual dreams. In these recent wall pieces we're looking at, I'm trying to erode the supposed boundary between dream life and waking life. The work is clearly positioned in the waking world, since the pieces start off with photomat portraiture, but it uses the disconnected and fragmented images produced automatically by these machines as analogies for the kind of dream images we all know, for instance suddenly catching a glimpse of oneself from the back. It doesn't seem accidental that the machines produce this kind of image, because, as I've been saying for years about popular, disposable imagery, there's something there beyond the obvious, which is why it's worth using in art. Maybe it's the way this kind of photobooth image emphasizes the frame, the way the image is quite constrained by the frame or the way the frame cuts it out of its context (see p. 64).

I think it was James Hillman who said something about the fact that we worry all day about what our dream self gets up to – people talk about this in analysis and so forth – but what if our dream self is deeply, deeply disturbed about what we get up to during the day? (*Laughter.*) So much of the truth about the situation of women that has been discovered through the hard intellectual work of the women's movement is about retrieving repressed, suppressed, unknown, rendered invisible, erased, negative meanings – so it makes sense to locate this work from the other side looking back.

Your work has always confronted the opposition our culture maintains between the rational and irrational, between empiricism and intuitive ways of apprehending the world, between dream life and waking life. And within the dichotomies you have validated and reconsidered the 'sides of life' associated with women. I mean, dreams and night are so often dismissed as mystical, unreal, unreliable, quintessentially feminine. It seems to me, though, that you face a problem here. How can you work with supposedly feminine areas without being identified with the material by your audience to the point of being seen one-sidedly as purely irrational, etc?

I suppose you're referring to the works that have a romantic look and no texts, such as *Towards an Autobiography of Night*? In this series I'm simply saying,

'this is my territory'; if anyone has the right to claim it, it's me, asserting that I'm the one who is speaking, rather than being spoken about. Working with liquid gold leaf, I've pointed out the illuminated aspects within these night-time images – lights in houses, pools of moonlight on the rocks, birds that in traditional symbolism stand for the illumination of the spirit, and of course, the full moon in all the pictures. So there's a kind of pun: gold paint equals 'illumination' as in old manuscripts, and I'm also using the gold for light in darkness. This is meant to be about my own illumination – you know, the way they convey sudden insight in cartoons with a light bulb and the word 'thinks'. I want to show how one can claim a position of speaking from the side of night, the side of the unknown, while not reducing oneself to darkness and the unknowable.

Obviously, I'm not unaware of the danger of associating myself with nature – colluding in my being assigned, as a female, to 'the natural'. That's why in each scene I include a human handprint, mine. That's the first sign on cave walls of the human self. It's a symbol as well as a representation, and simultaneously evokes the cultural and the natural – and it's androgynous. I certainly hope that my work isn't a demonstration of the problems of being a woman and an artist, but of some possible solutions. Probably everything worth doing in art is risky and dangerous, personally and professionally, and the danger of possible misinterpretation you mention is only one of many dangers.

In what way does your use of postcards today, as in Towards an Autobiography of Night, *differ from* Dedicated to the Unknown Artists *and the other postcard works of yours from the early and mid-1970s?*

In the early postcard works I was totally guided by material qualities of the cultural artefacts I took as starting-points. By extending the old 'truth to materials' idea to cultural materials, I found contradictions and unexpected meanings. I treated the materials as keys to the unconscious side of our collective cultural production. The shape of the large panels in the first postcard works was the same as an individual postcard, and texts were included because the postcards themselves had texts in the form of captions. I was quite strict with myself about keeping to guidelines present in the materials themselves.

Dedicated to the Unknown Artists was about the contradictions between words and images, and dealt with the fact that words don't explain images – they exist in parallel universes. But what happened with that piece was that because it ventured to use words at all, the words were taken as primary and explanatory. This taught me something about the power of words in our society.

Now I would say that I'm more impatient, quicker, less discursive, maybe rougher – certainly a whole lot more physical and surer what needs doing.

So now the meaning in your postcard works is elicited by the juxtaposition of image with image – in Inside a Cave Home . . . *you have painted images of rough seas hanging over the sideboards of twelve identical domestic interiors, and in* Towards an Autobiography of Night *you use the powerful image of the hand. Looking around, I can see a similar shift in all your work toward a greater physicality.*

My work is always dialectical. I'm trying to define and then resolve contradictions, formal, art-historical, personal, etc. One of the contradictions I came to perceive very clearly was that my work, while distrusting the whole notion of the rational and objective, had the look of the rational. This seemed odd to me, since I knew how the work had been made. As soon as I had grasped the problem, the work freed itself in particular aspects, but of course I'm still not interested in arranging things in arty little shapes. My origins as an artist are in Minimalism, and I take the minimalist grid to represent a non-hierarchical orderly way of arranging things, so I use it as a basic principle quite often, usually, in fact. I'm not interested in aesthetics, and saying that so often seems to have shocked people, since the work is aesthetic in its own way, almost as a by-product . . .

You as the artist seem far more present in the works from, say 10 Months *(1977) onwards. Previously yours was a hidden, ordering presence, now in the new work it's disruptive.*

Doing something gestural and physical can have a richness of implication; so can shifts in scale. By enlarging the images I'm using nowadays I'm trying hard to engage the viewer in levels of meaning that come through seeing, and the emotional and intellectual reactions we have towards what we see. In the photomat works, for example, I try to enable people to have an actual physical identification with the fragmented body images I'm using.

I've put myself through ten years of research and investigation so that I could clarify my ideas, and now I trust myself absolutely.

Let's talk a little about some of the newer photomat works in this context. I see this series as a particularly good example of how you have pursued the same themes in your work for over ten years, while the presentation of the material and the implications you draw out are constantly evolving. You in fact began the series in 1969 – the end results were miniature portraits and part of a process of collaboration. Today you work with your own body. How and why did the change come about?

As well as collaborative portraits, I retrieved discarded images from machines, images in which people had obliterated or hidden their faces with their hat or

scarf, their hand, the machine's curtains, or sometimes they would attempt a picture of another part of their body. Initially I saw this as an expression of how these people had been victimized by society by colluding in their own erasure. But if you consider that there is no intervening photographer, it might be a way of them saying, 'when I'm alone, when no one is taking my picture, who am I, where am I?' There is no gaze of the other. So – I developed these semi-obliterated and abandoned images of unknown people into a series called *Incognito*.

I had always avoided self-portraiture in my work, refusing to make a statement in the traditional way that artists do, as if the first person were speaking. I would instead set up situations where I was collaborating with other people, or using some device that enabled me to speak on behalf of or along with a number of anonymous others, while attempting to raise that kind of anonymity to social, artistic visibility. So all that changed, through my own developing understanding of gender and representation.

Later, I began working with the machines myself, in the same way, in sympathy with all those people who use these machines all the time. I imitated their gestures and hid my own face in various ways. Then I began to use the frame edges to make strange images of my isolated arm or hand, which for me as an artist are as important as my face in terms of identity. Then I began to turn my back to the camera, using my right or left shoulder, playing with the curtains and the frame edges. Gradually I included some faces, shutting my eyes and refusing to look out at the viewer scrutinizing my image (see p. 68).

As I understand this, the absence of an 'I' voice in your early work was a deliberate project to deconstruct the traditional notion of the artist's ego and identity. Later you developed a new position determined by the problem facing women speaking as individuals in a language and culture that denies difference among women but lumps us together into a stereotype. How did you resolve the difficulties arising from putting yourself, as a woman, on show?

I realized I couldn't present my face in the literal sense, because that's not how one experiences it from inside. The solution seems, at the moment, to combine the notion of face with the notion of signs, or texts, using my automatic writing. These newer works contain levels of meaning, almost puns – writing your own script, self as text which is itself self-authored. Visually, it looks as though the scripts are on the skin like tattoos, which is, of course, a fiction. I'd like to make a distinction between lacking a unified first-person voice, which isn't necessarily a problem, and the undermining of authoritative self-presentation through simply existing in a world where one's authenticity is determined by representations of the other.

NOTE
1 See 'Dedicated to the unknown artist' in this volume.

PORTRAIT OF THE ARTIST AS A PHOTOMAT

First of all, a few words about the photomat self-portraits, the large cross-shaped works somewhere between images and objects. I've been working on a photomat series for more than ten years, and there are a few things – perhaps obvious but maybe not – about why this particular format and why this artefact (the automatic photomachine) are of such fascination to me.

This is the tail end of the great tradition of portraiture that we are discussing. What it's come down to is this miniature head and shoulders view, complete with draperies in the backround, referring to the great tradition, now available for anyone to use as a form of identification. But in this particular form of portraiture, there's no intervening photographer. You're asked to engage in a private capacity with the automatic camera and to project your own self-image towards that camera as towards a mirror, in order to produce a document that verifies your identity in a public sense. In addition to the draperies which optionally form the background, there is another set of curtains that is foregrounded – I mean the ones one pushes aside in order to enter the privacy of the little booth. It's almost like a confessional booth, with the camera as silent witness . . .

Until quite recently I was pursuing this series in works that retained the miniature scale of the originals. I was committed to that scale in terms of encouraging a form of intimate scrutiny on the viewer's part. The departure I've made in these new works is, first of all, to shift the scale, beginning as always with the miniature format and enlarging it up to the point where the heads become almost life size. In order now to engage the viewers collectively by using a more public form of address – but also now to create a new situation in which an actual physical identification takes place between the body of the viewer and the body of the subject of the portraits. In order to really understand the positions of the bodies in the images, to understand what's happening with shoulders, etc., you now have to go through a process of physical participation rather than just looking (see p. 68).

One other thing I've done in this particular series is to play with the idea of rejecting the constraints of the format. The format itself is curious and says a number of things about the way we identify and document 'self' in this culture. First of all, it's episodic and filmic. That is, one progresses through the various frames or alternative versions in a linear fashion starting at the top left, top

Transcript of an improvised talk introducing Hiller's recent work to the Patrons of New Art from the Tate Gallery, who visited her exhibition at Gimpel Fils, London (March–April 1983). The talk was taped to provide information for reviewers from the BBC radio programme *The Critics*.

right, lower left, lower right, almost as though no single image of self can sum up its existence. It's a fragmented existence, fragmented in time, in other words. Because of the constraints of the frame which corresponds to the inner space of the photobooth, it's almost impossible to do much except show your head and shoulders. The best alternative I've been able to find is to use hands, which I've substituted for face in many cases. I've also rejected the notion of the frontal view by showing my back, shoulders, etc. And I've often allowed the frame to cut off bits, thus presenting body parts rather than wholes.

I've also played with the notion curtains/lack of curtains, and black/white/colour. So there are pictures of me wearing black jackets against a dark curtained backround and white jackets against a dark curtained background, or wearing black jackets against a plain light background and white jackets against the light backround. I've reduced the idea of monochrome to a kind of abstraction. Then I've highlighted the flesh – what would be the skin tones – with hand touches either in ink or pastel, and I've then re-photographed the lot in colour and enlarged them. So . . . you've got black-and-white photographs with colour added ending up as colour photographs.

I'm quite interested in the sort of seductive come-on created by the texture of the paints, which is emphasized by enlargement while denied by the perfectly flat surface of the photograph. This is my kind of playful reference to photography as a meta-medium, as against the claims made for the return of painting these days – in other words, my photographs can certainly supply the supposedly exclusive pleasures of painting . . .

The cross shape of each work comes from the artefact itself, because the four images are divided by a cross-shaped white margin which is not intended to be seen as meaningful. This neutral white cross has been painted and so I've made it positive and also I think, meaningful, in the sense that the meaning which is denied in the original here has attention drawn to it . . . Then as usual in my work I use this shape which exists in the negative in the original artefact, in order to build up an architecture for the work. One needs, in fact, five sets of photographs to indicate a cross.

Somebody asked if this was a form of directorial photography, and I find the question rather interesting. All presentation of the self is directorial in that sense. But this is much more abandoned and looser than most artists' approaches to what we nowadays call directorial photography. I enter the booth with a set of ideas and I loosely rearrange myself in order to carry these out as well as possible. But one has to leave a great deal open as I'm working blind and have no control over the unexpected brought about by different focal lengths, lighting, etc. in various photomat booths. So it's a relatively improvised presentation of self.

I think it was Roland Barthes who pointed out a long time ago that all societies put a tremendous amount of energy into encoding meanings in their artefacts, and they put an almost equal amount of energy into denying meaning, claiming that the objects are naturally the way they are or neutral; they don't mean anything. Now of course my interest in artefacts is precisely this, to make visible, as it were, the unconscious language of our society through revealing something. But I don't think this work has ever been deconstructive, because it is simultaneously a kind of exorcism of internalized constraints and at the same time a sort of celebration of knowledge, self-awareness of my relationship to these facts. The work offers itself as a model, a demonstration of some ways out. In other words, I'm discovering through material practices some points of view that indicate that this culture, this society, is not seamless or without holes, it's not entirely coercive. I have a degree of freedom; we all have freedom to make models to revise the social reality that we are embedded in, which is sometimes experienced as total. And I want to emphasize that for me, this freedom – which has in turn its own contradictions and constraints – this freedom is much more important than the supposedly more political use by artists of any programme or philosophy formulated in non-art terms. People in England are sometimes confused by this, as they tend to see work only as either conservative or 'political', meaning left. I think there's another way to be innovative, which is to make art that itself functions as a kind of model for the artist in the first place.

My discovery of these options hasn't derived from any kind of a priori theoretical position based on the work of somebody else in a field outside art. These ideas are within art, are part of art. I would say my work looks for experientially valid solutions based on an engagement with visual materials and histories, and it's through manipulating them in a way that is curiously like an extension of the old notion of truth to materials extended to cultural materials, that I make work. I find things out through an engagement with materials, including ideas, but never through any process of abstract thinking . . .

I enjoy doing this work. Some people think it's intense and disturbing; it's been described as 'moody', obsessive, etc. *Fragments*, which was in the Hayward Annual a few years back, *10 Months* and *Monument*, both of which have been shown on many occasions, have all been described in these terms. What may be perceived as 'intensity' probably comes out of my personal struggle to achieve what I call the truth, ironically, truth-telling in art practice. This is made so elusive, so difficult, so mysterious in some way by what I've previously spoken of as the 'curtailments' of language and gender, let alone the position of art within our culture. So I derive a great deal of pleasure when I'm able to break with what I've been calling the languages or language of the dead, and to call to

account an entire art tradition, at least in my own mind. I think I feel this is what art has been about for some time.

I'm struck by the fact that I was talking before almost entirely about the process of making the photomat self-portraits which led up to thoughts about what might be called my intentions, or what I think is the point of view from which I tend to make my work, the point of view that informs my practice as an artist. It might be useful to say something about the gap – what I think of as the gap – between intention, my intention, and interpretation, your interpretation. Going back to the seventies, when I was coming together as an artist, I can recall that one of the significant contributions of the conceptual movement was that artists became articulate critics and speakers on behalf of their own works. It got to the point where art critics and the public seem to have felt totally unable to say anything other than repeating back again statements made by the artists on behalf of their own work. Well, it seemed to me, always, that there was an enormous difference between the stated intention of anyone and the way that I, as a viewer, might respond to their work. Of course I very much respect and give credit to this notion of the artist as an intelligent and articulate participant in cultural debate, but I think I would almost certainly deny the relevance of intentionality as far as interpretation goes. I've tried to avoid writing too much, except when the writing is actually part of a piece of work – in other words, I don't like writing *about* my work because I don't want to preface it too much, don't want to double-guess the viewer, make the viewer passive. This means that by describing how I make work and telling you a little bit about my personal feelings about why and how I work, I in no sense intend to limit your interpretation which may well, in the long run, turn out to be more 'true' than my own.

In the gallery at the moment, positioned between the photomat portraits just mentioned and the large installation with sound called *Élan*, is a work of mine in eight parts on eight panels. It is called perhaps oddly, *Sometimes I Think I'm a Verb instead of a Pronoun*. This is a quotation from the American General and President Ulysses S. Grant, which in fact I used previously in an early automatic writing and drawing piece exhibited a couple of years ago. Clearly what's happening here has got to do with the question of, say, presence or absence of the female subject, the female person who is the subject of these works, namely me. I am using the curtains in the photomat booth and views of myself as seen from behind. In other words, I turn my back to the camera to create some of the images and I pull the background curtains of the photobooth over my face in others. I'm attempting to obliterate or deny the normal sorts of presentations that we expect to see when we look at a portrait.

Sometimes I Think I'm a Verb instead of a Pronoun (details, two panels of twelve-part series) 1981–82, C-type photographs; 72.4 × 111.1

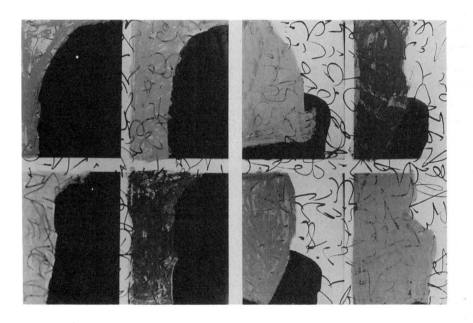

By the use of colour in these works, I think I've suggested a relationship between positive and negative space so that the curtains, which are coloured throughout, create shapes which don't seem to be markedly different whether they are made into background by an object like a shoulder projecting in front of them, or by being pushed forward to cover up a face. That's a complicated way of saying what I think is pretty obvious from looking at the images. So here we have a sense of a person represented as a series of actions which deny the normal sort of stable presence we expect in an art work, but call upon a negative presence which is carried out formally by shapes formed by the actions.

Over the surface of these shapes or embodiments are a set of crypto-linguistic calligraphic signs or marks. Slips of the pen, they've been called – automatic writing, etc. – which make up a kind of personal handwriting for me that's been evolving over the past ten or twelve years. You could take a look at the *Sisters of Menon* book to see the origins of this particular series of works. But it's not a work that's engaged just me, it's got a very long history within modern art, going back to Surrealism and the experiments with automatism, through that influence to the works of Jackson Pollock, Mark Tobey, etc. in the United States and Henri Michaux and Dubuffet, etc. in Europe. Even artists as far removed from the tradition of gesturalism as, say, Ad Reinhardt, had deeply significant encounters with it. I don't want now to go into any sort of argument about what the phenomenon consists of, except to say that, in my case, I've begun to see it as a kind of calling to account of the ideas of the artist's handwriting and personal mark, the personal touch, which are always contrasted with conventional and coded notational systems . . . For me, it's a kind of substitute for the spurious or uncomfortable 'me' of social discourse, specifically of patriarchal social discourse, which locates me as an iconic figure as soon as I begin to represent myself in an art work. To substitute for this spurious 'me' I use these signs which don't represent my so-called subjectivity, but perhaps ironically refer to notions of an authentic 'I' demonstrated by voice or signature . . .

Élan is the third piece of work in the current exhibition (see p. 39). It's a wall installation of thirteen panels and a sound tape. Like most of my work it's built up on analogies coming out of a particular choice of starting point, in this case sound tapes made by a Romanian scientist, Konstantin Raudive, who left sound tapes recording in empty, silent rooms. By amplifying the minute traces of sound in those silent rooms, he obtained supposedly historic voices, such as the ones you hear on *Élan*. I'm not a spiritualist and I certainly don't advocate the theory put forward by Raudive and his colleagues that these were the voices of the named dead, some kind of mechanical seance. I also don't believe other

explanations put forward that this was a form of telekinesis, that Raudive so desired to obtain these kinds of results that he managed to imprint the tapes from a distance with these voices. Nor do I think he faked them. What interests me here is something about how we interpret, how we make sense of . . . In almost all the examples I've used, we're always told ahead of time what the utterance will be, and it's often a curious mix of middle-European phonemes which are attributed to named speakers and translated. There's no Swahili or Arabic or anything of that sort. What you hear is what you are told to expect to hear.

So this is really about interpretation, as well as about language and history. I began by responding to the material via sound. So on the *Élan* soundtrack, what you hear as a chanting voice alternating with snatches of Raudive's material, is my vocal improvisation. When I first made the tape I thought of my improvisations as a way of discovering the limits of freedom available to the individual voice against this dense background of history as noise. Later I thought of it rather differently, as a set of vocal traces or marks, evoking the body.

The wall panels in *Élan* use the same kind of hand-made notation as the *Verb* pieces I discussed earlier. They match the sounds to a large extent. The title of the piece came from the first intelligible word I could decipher from the scripts, *élan*. When I looked up this word I discovered it meant 'ardour, eagerness for action, literally vital force, hence in philosophy, the inner creative force in all organisms'. This is a way of dealing with or answering the question, what is this mark, what is this sound? It represents an ongoing, energetic principle.

The sounds feel archaic. People have said it seems to sound like Arabic, Hebrew, even like a Celtic lullaby, and I've also been asked if it's Australian aboriginal singing or American Indian music. My intention was very simple, to allow my voice to improvise in any kind of made-up sound or tune I was able to achieve. So the archaic or distant quality that seems to suggest some place or time long ago or far away suggests, as a hypothesis, that I'm using a kind of pre-Oedipal speech. That is, these sorts of sound relate in some way to the babble of phonemes by the infant at an early stage. As a feminist I'm interested in this because it points to a kind of communication prior to entering into language as a sexed speaker. My own term, 'fruitful incoherence', suggests that out of this formlessness can come form and the beginning of new possibilities in language. Maybe languages of feeling, languages of the body. Could it be even a language of subjectivity, instead of a language of social discourse – who knows? It's intensely pleasurable to break with coherence in this way. The rhythms and energies of making these sounds and marks might

be close to what people think of as trance states and yet totally different, because they take place in full consciousness and I can let them happen at will – in this way they are exactly like drawing or painting, and maybe jazz singing also . . .

In formal terms the visual part of the *Élan* installation is a series of panels organised around a central empty space. It's an open configuration, an open-ended configuration, meant to imply that many more panels, many more marks, could be added, and leaving the central issue of interpretation and personal projections open to the viewer. To the viewer's left of the main installation is an isolated panel which was, in fact, the first set of marks I produced in this particular series. It interests me that in some ways you could almost consider it a dictionary or alphabet for the rest of the piece in that there is, I think, no kind of mark in the rest of the panels that doesn't first appear here. And you can see that what seems to have first taken place, in terms of hand movement, was that various marks were drawn over or superimposed one over the other, and you get a dense configuration of the sort we would normally call a drawing. Then the marks or bits of shapes of lines or signs seem to separate themselves out and to come to look more like individual letters following on with a degree of regularity.

What I feel about the relationship between writing and drawing is that we have got to go quite a long way back in our own cultural history to understand what is at issue here. Without going into very much detail, I would like to point out that in ancient Greece, I am told, which is the source of our intellectual and cultural history, there was only one word for both writing and drawing. In other words, whatever distinction there is between linguistic notation and any other sort of representational or expressive mark, this distinction would have come about much later.

Élan is a piece about expressing rather than representing, and should, I think, be understood as having a very close relationship with my earlier installation, *Monument* (p. 188–89), which is about representing, not expressing. Both of them deal with themes of death, history, memory and authenticity from different points of view in a kind of dialectical alternation.

The *Élan* panels are actually photographic negatives produced as positives. My initial marks were black on white. The panels are enlarged from the originals and the negatives were processed like slides to make these prints. It's a kind of analogy to the way the Raudive voices were produced – tapes of silence which were amplified until what seemed to be not present, what was not heard, became audible. In the same way, I've used what was not seen – in other words, the background – as the positive part of these prints. Since they've been enlarged from much smaller originals, you get this exaggerated, suggestive

quality as though the marks had been made with a light pencil against a background of darkness. This was a conscious decision on my part to produce visual substance with a dramatic and emotionally resonant appearance, to emphasize the 'illumination' the work provided for me.

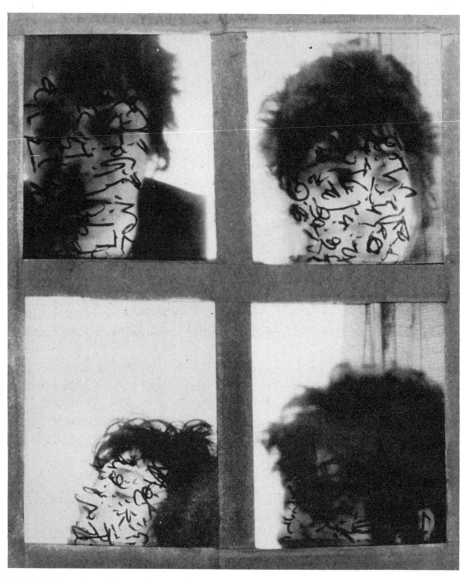

Midnight, Euston 1982; C-type photograph; 61 × 50.8

REFLECTIONS

A couple of weeks ago when the title of my talk – 'Reflections' – became known
to a number of people with whom I teach at the Slade, I was subjected to a kind
of jocular inquisition as to what the title could mean. Someone said to me, I
hope it's not going to be a talk about mirror images in art; and someone else
said, I do hope you'll show some slides, I can't bear to listen to an artist talking
for an hour without any slides. So I think I should begin by saying that the talk
is really about reflections, and there will be no slides, but at the end of it I will
be showing a videotape.

This talk is playing but playing quite seriously with ideas about reflection
and art, not in the sense of images of reflections or mirror motifs in painting,
but reflection as an underlying function of artists' work. This talk is prose. It's
around some ideas that might give an idea of the context within which art
work operates. It's poised somewhat oppositionally to my videotape which it
introduces, where a subversive lyricism can come into play.

It's interesting, as an artist, looking at words and trying to see them – and
almost impossible, since as Walter Benjamin observed the longer you look at a
word, the further away it gets. It gets lost in other words. The basic idea of
reflection is an optical one, and it's appropriate that we have this term in
English for meditative, contemplative, deeper-than-normal thinking ... which
possibly has some suggestion of retrospection and/or analysis embedded
within it. But the problem with the word reflection, despite the accuracy of the
way it gives primacy to the role of the visual in our particular culture's
approach to thinking about thinking – the problem with this word is that one
somehow imagines a mirror or some other hard, shiny, reflective surface, dark
until illuminated from outside, shining only with borrowed light, exhibiting or
reproducing the images of things themselves, which are thus second-hand,
clearly, and of course, reversed. From Newton to Lacan, the reflecting surfaces
we call mirrors have always been present in our language and thought as
metaphors for seeing, and as analogies of the mind's function as the connection
between subject and object.

Personally, I always think of reflections as watery, fragmented or broken
images interfering with one another, as in a pool of water that is never entirely
still. If the surface of the water in the pool is likened to a mirror, it would have
to be a two-way mirror, an interface between the objects which are reflected in

Invitational lecture delivered 22 November, 1989 at University College London. The Townsend
Lecture, on a topic of art or art history, is given annually in commemoration of William Townsend.

it from outside and the objects in the pool, which are seen through it. These two sets of images mingle, disturb each other, making new images as the ripples break and recombine and one's point of view shifts and adjusts. And the surface of the water is not only a reflecting skin but a permeable boundary between two elements or populations. So this is an emphasis I'd like to place, on the overlapping, the fracturing, the merging, of the process of reflection. For this is the slipping and sliding, the breaking, of the whole notion of the referential . . . perhaps, even, as has been suggested by philosophers, an end to the notion of any clear relationship between a fixed outside referent and its transparently mirrored image. This is not intended as a negation of the notion of 'reality', but simply a suggestion of my own position. The implication for visual artists is that any naive idea of representation and any crude notion of a stable, real world which is purely transcribed by us, is simply not possible.

In fact, my own idea of 'reflecting' is as tactile as it is visual: in *Monument* (a work of mine from 1980), I referred to the process of thinking as 'groping among underwater plants, unable to see either my hands or the vegetation'. This is a physical, precise sensation. The eyes are free to look while the hands work, and the skin and nerves register sensations, textures, temperatures . . . and the brain is able to imagine and picture on the basis of the experience of the hands, as well as to notice whatever it is the eyes see. Perhaps they see nothing at all except the hands disappearing down into the pool, feeling around for the plants and dredging and stirring up the mud so that there is no surface reflection at all.

I'm suggesting we acknowledge some perspectives of the dreamer, perspectives that are undermined as one speaks, in that, as a dreamer, you can be simultaneously the protagonist of the dream and the viewer watching the action on the screen of the dream. It's the sensation of being both inside and outside thought, of thought being both inside and outside one, this double vision. We have inherited it unnoticed through the way our language structures whatever it is we call thinking, propping up either the outside referent or the subjectivity of the protagonist in rapid alternation. This fluctuation, this fragmenting, this slipping is precisely what I aim to engage with during this talk . . .

I always feel that my past as an anthropologist is overemphasized in the art world, probably because people think it sounds authoritative and respectable. But what *I* learned as an anthropologist was that the world can never be seen 'objectively', and that I could never be part of any discourse that claimed it could be. When human beings 'collectively orchestrate'[1] their visual experience together, each submits her retinal experience to the socially agreed-upon description of an intelligible world. Vision is socialized. We can understand

how strong this socialization of vision actually is by remembering that any individual deviation from the social construction of visual reality can be named hallucination, misrecognition, disturbance. Any notion of a world seen and any notion of a 'seer' is culturally defined, and so is any notion of what kind of relationship – if any – might exist between them . . .

There's a story about mirrors that illustrates how I understand reflection to work in terms of socialized seeing. In this story, the mirror seems to have some of the characteristics of my reflective pool; that is, the relationship between the person looking into the mirror and the image perceived has been interfered with and transformed. The story, supposedly a Scandinavian folk-tale, also illustrates how I understand the way that what we call visual art in our society works in relation to 'the visual'. Before I tell this story, I need to say that I believe an art object is a reflective device which shows us what we don't know that we know. I'll come back to this point a bit later on.

> Once upon a time, an old fisherman found on the beach a circular object that he had never seen before. It was a mirror. Examining it carefully, he exclaimed: 'Good Lord! It's my father.'
>
> The man treated the object with great reverence, and hid it away in a box. From time to time, he took the father-fetish out to look at in great secrecy.
>
> His equally elderly wife, intrigued by this ritual, took out the object one day in his absence. When she looked at the mirror she cried: 'I knew it! It's another woman! But thank God, she's old!'[2]

What has intervened in this story between the mirror image and the viewer is something of what I tried to account for by suggesting that a pool of water in, say, a forest, with mud, leaves, roots and fish would be a better picture of reflection than the notion of images reproducing themselves neutrally off a clear empty surface. For between us and the world is the transforming medium of language, and 'the sum of discourses' that make up culture.[3] The story is about an experience of *déjà vu*, since each person is able to interpret what is seen only in terms of what is already known. The misunderstanding of each character points to some very profound insights on the part of each, insights which are not consciously understood by either.

What both viewers *share* in their experiences of reflection is that they both see their mirror images as older than themselves. This seems to me to illustrate more than personal vanity, but to show, in a way that neither the protagonists nor the story itself recognizes, the occult truth that the reflected image is, indeed, older than the person. For between the retina and the world exists a network of signs, consisting of all 'the multiple discourses on vision built into the social arena'.[4] When we look, we are caught up in the web of signs and signification that existed long before we were born. Just as when I learn to

speak I am inserting myself into systems of discourse that were there long before I was, when I learn to *understand what I am seeing*, what and how I see is formed by paths laid down before I arrived. My reflected image is certainly older than I am, since 'what it looks like' or 'the way it looks' is already defined by the existence of signs and meanings that predate my personal existence.

The mirror story reinforces this reflection by its emphasis on the self-*mis-recognition* experienced by each character. Anthropology could offer, at this point, a range of human solutions to the problem of the divided self: for instance, knowledge of societies where individuals assume different names for different functions; or where there are distinct and particular terms for aspects of the self, including a specific word for my image when seen as a reflection by me; or human languages where the subject expresses herself verbally rather than pronominally; or where the significant word for 'self' would vary according to whether an emphasis on its universal aspects (self as 'breath' or 'soul') or on gender and relationship (self as 'mother of so-and-so') was most important; or would announce its temporary emptiness of any defining characteristics other than being a social unit (self as 'name'). And modern psychoanalytic thought has introduced to Western culture the idea of the heterogeneity of the self, breaking the tradition of a unified subject, revealing the multivalent, discontinuous, inconsistent, precarious identity of individuals in our society. The mirror story might be a fable about what happens when we begin to think about how reflection works, or it might be a fable about how art functions to reveal what we don't know that we know. In both guises, it uncovers what we simultaneously know and don't know about the illusory coherence of the self.

What do we know that the characters in this story don't know about the *differences* in their misperceptions, when the man sees himself as his own father and the woman sees herself as 'the other woman'? For instance, is there a sense in which each man is, indeed, his own father? And is there, indeed, a sense in which each woman is the other woman? The story shows that as we experience ourselves through a shared culture and language which structures how we see the world, our self-reflections are seen by us differently according to gender. There are differences in the social, cultural, linguistic and historical placement of each sex, so that the man's devotion to his self-image (misperceived as father-image) is contrasted with the woman's rejection of her self-image (misperceived as the image of another.)

The points of reference built into my work are the embeddedness of 'the visual' in culture, the provisional nature of selfhood, the split subject, and gender differences. These assumptions will not seem odd to those of you for whom they are, already, self-evidently true; for many of you, also, these ideas

are incorporated into your own specialist practices. But speaking as an artist and under the auspices of a great British art school, it is clear to me that these notions are bitterly contested, even today, and especially *here*, along with other ideas that would be simply accepted as truisms or conventions in other places. The term 'critical practices' is often used here pejoratively as a means of dismissing or marginalizing certain kinds of visual art – which sets up the false dichotomy 'critical art' v. 'real art'. This rather silly and outmoded debate is as much a waste of time as the debate over painting v. photography, and the fact that both recur over and over again masks deeper debates over 'tradition' v. 'innovation' which have never been resolved. They have never been resolved because they have never been honestly defined and because they are ideological – that is, their function is to veil certain cultural assumptions about who has the power to 'see', who sees 'correctly' and who does not. But *whether they like it or not*, all artists are engaged in critical practices, since the job of artists is to find an expressive format for shared aspects of subjectivity, in a particular time and place.

All artists are deeply implicated in the social construction of the visible world, a construction built collectively, over time, and therefore one which, as we know from the study of art history, changes over time. As T. S. Eliot asserted, making a distinction between creation and criticism is too blunt, and it is made only by those who do not pay sufficient attention to the intense criticism that goes into all art-making, what he called 'the frightful toil of sifting, combining, constructing, expunging, correcting, which is as much critical as creative'.[5] When Eliot quoted Ruskin's dismissive remarks about certain English watercolourists, who were described as 'going into the countryside to paint just as sheep go into the fields and chew at grass',[6] Eliot was saying that they were not really artists, since in a very lazy way they lacked critical standards, a need to search for reasons for what they were doing, or any serious desire to raise questions about the relationship of their own values to contemporary experience. They failed completely to take any attitude through to a logical conclusion or even to see that it might have a conclusion; where they saw contradictions, their laziness showed in their taking whichever side was better for their career, while their reticence prevented any articulation of ideas. An air of secrecy or privacy surrounded certain practices, and there was a refusal to disclose motives or intentions, as though something would be given away, or as though the work's beauty were so fragile it could be destroyed by intelligence or needed constant enhancement by many acts of passive veneration. The fact that paintings (or sculpture, or films, or photographs) can be produced *uncritically* does not mean that *art* is being produced, since art is in the making, not the product. The making either is or is not part of the

discourse of art, and simply because an object consists of paint on canvas does not make it art. Ruskin saw this and Eliot saw this; in other words, it is not a new idea.

As an aside, or perhaps a detour, I might add that photography is not a new idea, either. Photographs are not necessarily either art or not art, but it seems extraordinary that now, when we are well into the age of digital reproduction, a debate about mechanical reproduction as a possible means of artistic expression could still be continuing. The fact that photography and related media, such as video, are deeply implicated in vernacular and commercial practices may have a lot to do with this.

As a foreigner and a woman, it is entirely clear to me that for some time now there has been a shift away from certain modes of reflecting and seeing, although deeply-held, archaic notions still inform much of what passes for art criticism and art teaching in this country. In the nineteenth century, the truth lay in the retina, the physiology of the eye and the neurology of the optical mechanism. In the twentieth century, assumptions about pure form and cultural universals entered art schools in teaching that based itself on the psychology of perception. These assumptions dominated formalist art criticism which defined art as the domain of the retinal, and they displayed themselves in museum exhibitions constructed to deliberately decontextualize art objects in order that the viewer might experience unmediated pure form.

The dominance of this approach has extended far beyond its original boundaries. Formalism limits the structure of meaning to the formal integrity of a work, internally coherent and seen in isolation. Yet by now, at the end of the eighties, when we say 'formalism' perhaps something additional is intended. Certainly it is intriguing that some kinds of painting – constructivism, for example – that foreground retinal and perceptual issues have managed to avoid formalism's rejection of socio-historical impingements, while developing articulate formulations of the function and role of art. In contrast, consider certain kinds of painting that carry on traditions of representation predating the classic period of abstract painting when the terms of formalist criticism were most clearly articulated, or others that first arrived on the scene in an anti-formalist incarnation. Nowadays both sorts freely utilize formalist criteria to describe themselves, thus avoiding any discussion of content or motivation. It seems to me that limiting discussions about art to the terms laid down by formalist criticism continues in the present under various guises, no matter how inappropriate to the work being examined. This is a powerful way of enforcing the traditional view that there is a universal community of shared values, perceptions and aesthetic reactions – a reclamation of a prelapsarian wholeness that predates the interruptions and disruptions of recent history.

Speaking as a working artist, I can see that this tendency is reinforced by conventional art history, which refuses to recognize that all codes of connotation operate within social formations. Western art history privileges values such as abstract design, order, harmony, etc. as universal verities that transcend culture; it fails to see these values more accurately as manifestations of our society's deep desire for the consolation such ideas of order might offer.

The best contemporary art reveals the terms and conditions of our common cultural dilemmas, our embeddedness in the structures of meaning which, no matter how complex, have made us what we are. Good art provides a sense of a collective secret being shared, a secret brought out to look at together in recognition of our shared plight. The consolations of formalism, displayed again and again to prop up aspects of tradition, are an insistent refusal to see art as a vehicle of change and as a reflection of contemporary meanings. No matter how up-to-date her subject matter or medium, it is always possible for an artist to comfortably reject the realities of split subjectivity, divided audience, gender differences, fragmented society, historical contingency.

In the 1980s the terms 'pluralism' and 'postmodernism' have been deeply inflected by formalism so that pluralism has come to mean an abundance of different styles existing alongside each other, and postmodernism an eclectic homogenization of various historical references. Individual works are still read formalistically, as autonomous and self-sufficient. But such readings flatten our critical and historical reflections on who we are and what art is and can be. Artists, too, confuse the paradigms under which they work. The myriad responses an audience can have in realizing the potentialities of a work are conflated with unresolved internal contradictions and confusions within the work. Sharing a secret is not the same as making something that is primarily a claim to undecipherable autonomy. Complication of means and simultaneity of competing images and events do not necessarily evoke an audience's collaboration in the act of making meaning.

Meaning is social. Art activity is fundamental to the production of meaning. Like ritual in traditional societies, art-making is a primary tool employed by our culture to change the direction of history itself. It is as disruptive as it is reflective. Art is transformative in nature; it doesn't seek to return to some primal or originary moment, to restore a fictional lost wholeness, but to move forward the society that has generated the sense of loss and division. Because the best contemporary art implicitly defines or announces the terms of difference that have caused the splitting, it consciously implicates itself in the historical process. And because of the collaborative formation of its meanings, art enables certain futures not otherwise possible to appear.

Earlier on, I mentioned that 'art' is in the making of something, not in the end product. Edmund Carpenter describes an Inuit village in the spring. Warm weather has arrived, the ice houses have melted, and everyone has left. The wet floors of the abandoned igloos are littered with exquisite, tiny figurines – miniature figures of animals and people, beautifully carved bone and ivory fragments. They have been left behind with the other rubbish because they are of no value: the art of carving is the art of making something, not the something made.[7] However, we are not Inuit, and *we* privilege seeing over making and objects over processes. Artists need to collect all our little ivory fragments together and show them to someone in order for a conversation to take place. This conversation is another form of making something, which we call meaning. Objects such as paintings, performances or films are important in the conversation as reflections of meaning, as visible signs of the interrelationships and complexities of reflection, and as tokens of the value we give it. In other words, it seems to me that our entire idea of art involves the notion of audience. The audience is a concept defined and clarified by the art work. There is a kind of primary audience, real or imagined by the artist, a kind of in-group privy to the codes and structures of the work. This audience has no need to decipher the work since it understands itself as part of it. And then there is the potential audience, drawn from the wider community. This audience may discover that at first it does not recognize its own reflection. I think that a community can be created of our collective misrecognitions and reflections. My work is based on the assumption that you have the choice of joining the primary audience rather than remaining with the alienated one.

NOTES

1 This phrase is from Norman Bryson, 'The Gaze in the Expanded Field', in *Vision and Visuality*, ed. Hal Foster (Seattle, Wash.: Bay Press, 1988), p. 91. The rest of the paragraph integrates some basic anthropology with Bryson's elegant analysis.

2 Michel Frizot, 'Idem ou le visage de l'autre', in *Identités: de Diskeri au Photomaton* (Paris: Editions du Chêne/Centre National de la Photographie, 1986) [this publication was produced as an the catalogue to an exhibition in which several self-portrait works by Susan Hiller were included. Ed].

Cette légende nordique illustre le passage oblige . . . 'Un pêcheur trouve sur une plage un objet circulair, dont il ignore l'usage (c'est un miroir). Le contemplant, "Dieu du ciel," dit il, "mais c'est mon père!" Il cache l'objet-père dans une malle et lui rend souvent visite. Sa vielle épouse, intriguée par le manège, interroge en son absence l'objet de ce culte et s'écrie: "Je le savais; c'est une femme. Dieu merci, elle est vielle!"'

3 Bryson, 'The Gaze', p. 92.
4 *Ibid.*, p. 93
5 T. S. Eliot as quoted by Stephen Spender in *Love-Hate Relations: English and American Sensibilities* (New York: Random House, 1974), p. 162.
6 *Ibid.*, p. 144.
7 Edmund Carpenter, *Oh, What a Blow that Phantom Gave Me*, (New York: Holt, Rinehart & Winston, 1974), p. 17.

O'KEEFFE AS I SEE HER

In a way, this is a collection of detours around the subject, circling in on it. It's like a drawing, where the negative space is as important as the marks, and where individual marks don't mean much on their own. In the process, I've found my lines of thought converging or overlapping to define a tentative shape that may represent a sighting or wish for something that will emerge more clearly in the future . . .

To begin with, she was always old. I though I had discovered her for myself when I scissored this photograph from a magazine and pinned it up in my college bedroom in 1960 or thereabouts.

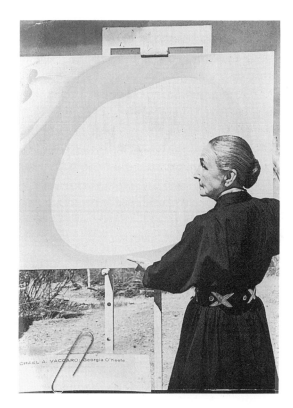

Georgia O'Keeffe, USA, 1961; photo-
graphic portrait by Anthony Vaccarro

Talk given on 9 May, 1993 at a symposium organized by Birkbeck College, University of London, in association with the South Bank Centre, at the Hayward Gallery, where the first major English exhibition of O'Keeffe's work was taking place. A shorter version of this talk was published in *frieze* (summer 1993, pp. 26–9).

She was old, she was famous, I was seventeen, maybe eighteen, and bored with Eleanor Roosevelt, Margaret Mead, Helen Keller and other worthy role models.

Four years later, after graduation, when I had to dismantle my college room with its wall of hundreds of massed images, what impulse, what motive, made me save only this one? I really can't remember now, but was it because the artist still intrigued me? Or was it because I liked this particular photograph so much? Or was it because I, too, wanted to live in New Mexico and wear Navaho jewellery? Or was it because I admired the luminous abstract painting from the *Pelvis* series shown here?

And how can I remember what, exactly, made me put this cut-out photograph away so carefully, like a flower commemorating a special day, pressed between two of the 600 large pages of the book I still think is the very best history of American art, Oliver Larkin's *Art and Life in America*? Preserved like a secret in the midst of its vast expanse, the photograph came with me to England inside the book, completely unremembered. I didn't look at either of them again for years.

By 1985, when I was asked to discuss my personal 'heroines' for a book of the same title,[1] I had been looking for a long time into the life and work of Georgia O'Keeffe. Curiously perhaps, like so many others, I had always been looking at her in isolation, not as part of any history of art. I proposed her as one of my heroines . . .

Our existence in the world as ethical beings requires us to render justice where it is due. My existence as an artist requires absolute honesty about my sources of inspiration. No degree of potential historical or social embarrassment could prevent my saying that undoubtedly, I would not have been able to be an artist of the kind I am without having leaned on her . . . or, rather, on my image of her.

And I don't even like her work that much, aside from the early vivid water-colours which I find very exciting, along with certain of the more abstract pieces from other periods of her life. I am in general agreement with Marya Mannes, who wrote in 1928 that, despite the work's 'frequent and unprecedented beauty' it is somehow bodiless.[2] There's something important here I need to return to later.

But I was an ignorant child, and she was the only artist who was female, like me, whom I'd ever heard positively praised. Without her, I might have gone for longer imagining that art was an exclusively male game, like American football. Artemisia Gentilleschi, Rosa Bonheur, Judith Leyster, had been forgotten. Artists I heard about, like Mary Cassatt, Marie Laurencin, Berthe Morisot, Meret Oppenheim, Hannah Höch, Lee Krasner, Louise Nevelson, Helen

Frankenthaler, Sonia Delaunay, Alice Neel were belittled or denigrated. People said they were all second-rate . . .

I didn't have the good luck to mistakenly believe when I was young that Cézanne was a woman, as one well-known artist friend of mine did.[3] She grew up thinking that, like Marianne or Joanne, Cézanne was clearly female, as well as the greatest modern artist in the world. By the time my friend discovered her mistake, she had internalized the notion that she, too, might some day be the greatest modern artist in the world, since it would be only natural for one woman to follow another in that position.

But speaking personally, it took effort and it took time to figure out why I was having certain doubts, certain depressions, certain complications. In the 1970s I struggled to define in words the implications of my ambiguous placement in language and culture as a woman and an artist. Thinking about these things was discouraging – thinking about these things was encouraging – there were debates, polemics, theories. I made work, I thought about work, I thought about making work.

Still, I hadn't looked at *Art and Life in America* for years and years. The book remained unopened until recently, when I loaned it to an English art critic who had been, I felt, expressing rather too freely his views on American art without knowing anything at all about its history. As I handed the book to him, the photograph fell out. I realized I had been looking at O'Keeffe as though peering into a mirror to get a glimpse of myself, trying to see some of the contradictory aspects of her importance for me and for so many other artists.

If I can't see myself except through looking at the other, what does looking at O'Keeffe show me? For one thing, it shows me that the frame of this mirror is too constricting, the reflection of O'Keeffe takes up the whole surface, it's too binary, just me and her, with no space for background or context. I'll come back to this point again, later on.

When I pinned this photograph on my wall, I already must have seen many reproductions of Stieglitz's photos representing the hands, the face, the naked torso of Georgia O'Keeffe. (In fact, some of these images were so familiar that my college friends and I sometimes referred sarcastically to our own inky or paint-stained hands as 'the hands of Georgia O'Keeffe', which struck us as hilariously funny.)

This photograph is not by Stieglitz. It is, as you can see, an image of an old woman looking at a medium-sized abstract painting. It is her painting, she painted it. And she is showing it to the photographer and to us, on a large studio easel transported out to the desert probably just to display this painting, which, being abstract, does not seem to me to benefit from being literally placed back in the landscape. In fact, this now makes me very uneasy. I know

how posed this image must be, I have posed for some equivalent ones myself. Still, it is a fairly conventional portrayal of the artist with one of her works. I must have been very glad, so many years ago, among all the hundreds of remarkable images of her that exist, to come across this one relatively straightforward picture of O'Keeffe with her work, standing by her work in an ordinary way.

Did no one ever photograph O'Keeffe actually working, painting? Did she refuse this? Was it too private? Or did she simply co-operate with various photographers, none of whom, for whatever reason, wanted to picture her at work? If so, her function in other people's work – that is, in their photographs – is that of an artist's model, providing a vehicle for the vision, fantasies, or projections of others. In which case, hardly any photograph of her can tell us much about her. They are all constructions, quite clearly. These images of O'Keeffe do not display her subjectivity, but rather the constitutive forces of desire in the men who photographed her. And though they may well be art, and useful too, in showing a range of fantasies and projections our culture allows as legitimate in respect to the female body, I care for them much less than I care for O'Keeffe's paintings.

Stieglitz showed her hands sewing, but never painting, as far as I am aware. Her hands caress a skull or a bit of gnarled wood, her hands are oddly folded or peculiarly posed in relation to her breasts, her neck, etc. In his photograph of her hands with a large pelvis-like watercolour, Stieglitz poses the hands at the perimeter of the pelvis shape as though fondling it rather languidly. By implication, these hands and this suggestive void are parts of one body. There is no separation between the artist and the work. Her painting replaces a specific area of her body, and her hands end at the wrist. We are witnesses to seeing the artist's work represented as an intimate part of her own anatomy.

In several related photographs O'Keeffe is shown gesturing provocatively, oddly echoing the arrangement of certain forms in her abstract paintings, which are displayed only as backgrounds, not as autonomous works. In another image, which features the juxtaposition of two artworks without any human presence, Stieglitz placed a small phallus-shaped sculpture in front of the large void at the centre of *Music Pink and Blue* (1919), documenting his own fantasy of an eroticized relationship between the abstract forms of the two works.

In looking at these photographs we are truly participating in a private view, not just witnessing the traditional relationship of a photographer to a beloved model, but being invited to share in the revelation that the artwork produced by her is available for the same kind of erotic delectation and scrutiny as her body. This is complicated.

In so far as this is a woman's body, the female onlooker, willingly or not, is

entirely or partially identified with the body under observation. It happens to be that of Georgia O'Keeffe, artist. Her art is shown as part of her body. In his portraits of her with her work, Stieglitz illustrates his belief that what he had found in her work, to quote his famous words, was 'Finally, a woman on paper.' Is there some way of looking, or some kind of interpretation by means of which we could exempt ourselves from seeing as if in collusion with the great artist, her husband, photographing her, her work? Here the dimension of desire appears, since we are not 'really' in the image we see: I desire to see O'Keeffe's work as separate from her body, as an act of conscious creation, as art. I do not wish to consume these photographs as the photographer intended me to; I do desire to see his intention as an artefact of his own desire, as his representation, not as a reading of her work, her desire. Or of mine.

How might I desire to function so as not be be fixed in my pose as the embodiment of the desire of another? This is urgent, for the future. Reading the body as the sole sign of identity is how patriarchy regulates the bodies of women. Herself as her body. Her body as a site of natural reproduction, not cultural production. Her femaleness reduced to her sexuality. To have to endure, as O'Keeffe did, having this said of one's life's work – that it 'registered the manner of perception anchored in the constitution of the woman. The organs that differentiate the sex speak. Women . . . always feel, when they feel strongly, through the womb.'[4] No wonder she hated being called a 'woman artist'; she couldn't speak as a woman, since her sexual organs did.

The artist's terrible struggle to locate, define, and represent her own subjectivity is conveyed by O'Keeffe in her work. But subjectivity, a sense of identity, doesn't reside in the body you can see – your own or another's. Re-presenting the body as a sign, identifying self with a sexuality defined by and for the other, re-inscribing woman as flower, is like rattling the chains of your prison. Without showing a way out, it signals the desire to escape. In O'Keeffe's work, the signal is loud and clear, sustained and courageous. There is no reason, having heard it, not to understand it as a message or statement lucidly analysing a situation, a predicament.

One of O'Keeffe's strategies in painting was to undermine or destabilize the notion of the female 'body' by eliminating its traces in her work. Her paintings are always images, never objects. In this they seem to be talking back to photography. This is implied in her adroit references to photographic artefacts, in *The Shelton with Sunspots* (1923), for example, or in the extreme close-ups of flowers for which she is famous. Her refusal to *evoke* 'body' has especially interesting implications in those works, like the flowers, which are said to *represent* body, female body. In my experience, while it is possible in art to evoke 'body', this is not what is communicated through representation.

Intimacy is a blur, a smear, a stain, not a clinical sharpness. There is nothing in her work's content to justify its reception by viewers as 'living and shameless private documents'.[5]

I read content in the rhythms, contrasts, flows and gaps of the material practice of painting, not in its subject-matter. (To confuse subject-matter with content is literary.) Aside from early watercolours, her technique is coolly detached. No texture. Everything is surface, as in a mirror or through a lens. One might well say that it 'implied a kind of visual efficiency that could be taken as a symbol of intellectual honesty'.[6] In an interesting way, much of her work is as ungendered as the work of most American artists of her generation. This was how she dealt with the issue of subjectivity for most of her life.

And now I've come back to another point I left dangling earlier, the art-historical context: to do justice to O'Keeffe we need to look very hard at the other artists who emerged in the United States during the same period. She was in touch with many of them, and this set of connections ought to be visible to us. O'Keeffe's New York paintings need to be seen alongside, say, Charles Sheeler's *Church Street El.* Her early and late abstractions are related to those of her close friend Arthur Dove, for instance, his *Snow Thaw.* Her approach to landscape ought to be viewed in relationship to the work of her contemporaries with whom she had personal connections, like John Marin (*Mountain Top*), or the now-forgotten Louis Eilshemius (*Storm*). Otherwise, she will continue to be seen as an isolated figure, an aberration, a sport, a freak of nature.

Linda Nochlin's analysis of the position of women artists concludes that 'in every instance, women artists would seem to be closer to other artists and writers of their own period than they are to each other'.[7] This is an anti-essentialist refusal to see all women as woman, man's other. The artist who is a woman is a speaking subject whose work represents her time as much as her place, her world-view as well as herself, her mind as well as her body. O'Keeffe's work, more than most, exemplifies this dialectical sequence of terms. And in addition, it implies something more, something for the future. In 1925, in a letter to Mabel Dodge, she wrote:

> What the men can't – what I want written – I do not know – I have no definite idea of what it should be – but a woman who has lived many things and who sees lines and colours as an expression of living – might say something that a man can't – I feel there is something unexplored about women that only a woman can explore – the men have done all they can do about it.[8]

There is one very early Stieglitz photograph of O'Keeffe in a long dress holding a saw in her hand, beside a man on a ladder trimming trees – but I have never seen an image of her holding in her hand a paintbrush or a pencil. There

are pictures of her looking at rocks, bones, sticks; standing at social gatherings; naked in bed; and sitting in the desert. There are no photographs of her at work in the studio. In fact, it now occurs to me, my image of O'Keeffe is based on a photograph cut from a magazine long ago, that may well be the only one showing the artist as an unfetishized, full-bodied individual, alongside her work. Was it his idea? Or did she, for once, suggest the idea for her pose to the photographer?

NOTES

1 *Heroines: Women Inspired by Women*, ed. Lisa Tuttle (London: Harrap, 1988).

2 Marya Mannes, 'Gallery notes: intimate gallery', *Creative Art* vol. 2, February 1928.

3 Carolee Schneeman, *Cézanne She was a Great Painter* (New Paltz: Tresspuss Press, 1975).

4 Paul Rosenfeld, 'American painting', *The Dial*, 1921, pp. 649–70.

5 *Ibid.*

6 Oliver Larkin, *Art and Life in America*, (New York: Holt, Rinehart & Winston, 1960), p. 390.

7 Linda Nochlin, 'Why have there been no great women artists?', in *Art and Sexual Politics*, Thomas B. Hess and Elizabeth C. Baker, eds, (New York, Collier Books, 1973).

8 Letter from Georgia O'Keeffe to Mabel Dodge Luhan, 1925, quoted in Katherine Hoffman, *An Enduring Spirit* (New York: Methuen, 1984), p. 21.

overleaf] *Belshazzar's Feast* 1983/84; 20 minute video programme/installation; shows 'living-room' version of the installation (Los Angeles 1988)

FRAGMENTS OF A FORGOTTEN LANGUAGE

AUTOMATISM, DREAM, COLLECTIVE REVERIES

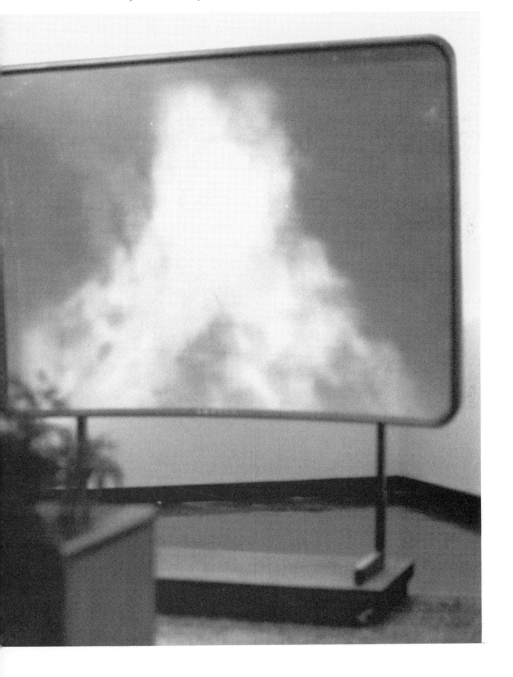

EDITOR'S INTRODUCTION

> My use of these primitive or incoherent
> utterances – signs and sounds – is like
> remembering the fragments of a language
> for which we've forgotten the rules.
>> Susan Hiller, 'Looking at new work'

The five talks and interviews included
here consider the place of dream and
reverie within culture, while at the same
time they contain passages in which
Hiller's appreciation of culture as dream
is evident. Her connection of such
seemingly disparate phenomena as a
television set and an ancient hearth (in
Belshazzar's Feast) arises from her
continual preoccupation with issues
relating to what Julia Kristeva has called
'*certain signifying systems* that are
themselves types of languages', or what
Freud identified as 'unconscious ideation
found in folklore, in popular myths,
legends, linguistic idioms, proverbial
wisdom and current jokes, to a more
complete extent than in dreams'.[1] When
ethnographers began attempting the
translation of native American chants,
they came up against various passages
which were deemed untranslatable,
'meaningless vocables'. Yet these
'meaningless' sections were often
precisely those that indigenous singers
regarded as the most powerful. Hiller,
like any story-teller, repeats her stories,
and one of her favourites is to talk about
Barthes describing how culture works
hard to present its most meaningful,
constructed objects as meaningless,
'natural', just the way things are. Hiller
states that she is concerned with 'that
denial of meaning or significance, the
relegation of things to the category of
the meaningless, the banal, the unknown,
even the weird and ridiculous'.[2]

Using the 'fragments of a language
for which we've forgotten the rules' is
inherently paradoxical, as language is a
whole system whose parts only acquire
meaning through their reference to each
other. As Saussure has noted, the unity of
language exists but cannot be discovered,
found out, yet the unity surrounds the
fragments, charging them with the
power of the whole; they become
lodestones of an unlocatable but real
polarity. The fragments are meaningful,
but as elements of a language this
meaning can never be fully identified or
known. The left-over quotient of
meaning would be what Malinowski
termed the 'coefficient of weirdness', the
power of the word resident in sound and
thought. This paradox is key to Hiller's
attitude and relation to theory, which she
cogently presents in her talk at Cal Arts
Valencia,[3] an institution famed for its
devotion to theory. Hiller situates herself
not in opposition to theory, but in
opposition to artwork that is 'highly
theorized ahead of time', work that in
Gertrude Stein's terminology would be
described as 'prepared' work (versus, in
Stein, 'work made as it is made'), work
that has no charge, no resident power.

The Steinian category of art work
that is 'made as it is made' is also
germane to Susan Hiller's *œuvre*, for by
linking the ecstatic with the analytical
she incorporates theory within her art
practice. One of her earlier collective
performance works, *Dream Mapping*,
further discussed by its participants in
'Duration and boundaries' below, took
place in 1974. Seven participants
recorded their dreams a month ahead of
their meeting, trying to evolve a system
of schematic notations – maps – to
represent these dreams. At the end of the

month, when participants slept outdoors in the 'fairy circles' of Hampshire, composite maps were compiled (see p. 00). *Dream Mapping* reflects Hiller's commitment to 'the tradition of the artist as mapmaker, one who is a cosmologist as well as a cartographer . . . That is, aspects of the world were explained in the same gestures by which they were drawn.'[4]

The title of this work contained within it the marriage between the irrational and the rational, inside and outside, subjective and objective, which was to become a consistent theme of Hiller's work. Such a union partakes critically and ironically of the heritage of Surrealism, whose motive force Breton in 1924 described as the 'finding and fixing' of the point where the real and imagined cease to be perceived as opposites.[5] We are not in a dream unless we are so within it that we perceive it as whole and fully extensive, like the real world. But we cannot tell the dream without being outside of it.

If the birth of modernism was synchronous with the discovery of the unconscious of the individual, in the period of the postmodern we are perhaps discovering the unconscious of society as a whole, displayed as the dream of culture. As in the search by theoreticians for the unity of language, this discovery is always incomplete. And Breton's 'point' of union is not 'fixed', but made visible by Hiller as an inherent, fluid play of opposites.

Whereas in works previously discussed Hiller mapped this dream of culture by projecting her automatic writing on to the two-dimensional surfaces of photographs and wallpapers, in *Belshazzar's Feast* (1983–84) and *The Secrets of Sunset Beach* (1988) she extends this procedure by projecting

within and on to three-dimensional environments, specifically, living-rooms.

Belshazzar's Feast is a video installation that has also been shown on commercial television. The imagery is of a fire, and the sound recordings of fire (taken from the BBC sound archives) combined with Hiller's voice and the voice of her son. Both the imagery and the recordings are freely manipulated by the artist (through re-filming, slow motion, tape loops, etc.) to produce intentional effects on viewers, even as the actions of making the art work bring about other effects which are allowed formally to enter the work. Thus Hiller's method is a bit like that of a Hollywood sound mixer, working with one ear to the conscious and the other to the unconscious channel, working between them. *Belshazzar's Feast* effectively displays television as the site of mythology that it is in our culture, while also making viewers conscious of how we imaginatively create what we see.

The *Secrets of Sunset Beach* is a photographic series that on occasion accompanies the *Belshazzar's Feast* installation. It reveals a Southern Californian interior – the house that Hiller rented during a teaching visit in 1988. She has projected negatives of her automatic script on to this interior, thus creating light 'whited-out' ghosts of language, which play in the room along with the natural effects of light and shadow that can be so subtle and rich in that part of the world.[6] The most mundane surfaces – such as that of an open-weave curtain of the type endemic to 1970s California, are made strange. This union of opposites is like an illustration of an observation made by Freud and cited by Hiller during her talk at the Freud Museum (see below) – that the 'heimlich', the domestic, and the

'unheimlich', the uncanny, are very close.

In 'The dream and the word', Hiller uses slides of various visual representations of dreams and a simultaneous commentary to illustrate her interest in 'questioning, problematizing, the hierarchies that seem self-evident within our culture', since from her point of view, 'using theory to understand art is as odd as it would be to use dreams to understand theory, or art to understand dreams'. Since one could claim that in some sense Hiller does indeed use art to understand dreams, what is at stake here may be the incompleteness of the understanding of that which cannot be fathomed, a commitment to what Hiller calls 'fruitful incoherence'. In 'The word and the dream' she again uses slides, this time to focus on the 'potential legibility' of the images for the people who made them. She raises questions about the origins of images in art; the relationship between the artist and art history, between dream and inspiration; and about whether ideas are individual, unique and private, or collective in origin.

NOTES

1 Sigmund Freud, *The Interpretation of Dreams*, in *The Standard Edition of the Complete Psychological Works*, James Strachey, ed. (London: Hogarth Press, 1953–74), 4: 341, as quoted by Julia Kristeva *Language, The Unknown: An Initiation into Linguistics*, trans. Anne M. Menke (New York: Columbia University Press), p. 273.
2 Susan Hiller, 'Theory and art' in this volume.
3 *Ibid.*
4 This quotation is from Susan Hiller, 'Dream Mapping', in Barbara Einzig (ed.), *New Wilderness Letter* 1: 10 (September 1981), p. 15.
5 André Breton, *First Surrealist Manifesto*.
6 This play of light and shadow was recognized by such Southern California architects as Schindler, Neutra and Harris, who, influenced by Japanese architecture, often camped out on the site for days before beginning their designs, positioning their buildings so that the plays of light could be enjoyed as fully as possible.

BELSHAZZAR'S FEAST/ THE WRITING ON YOUR WALL
an interview with Catherine Kinley

Perhaps we could begin by discussing the significance of the title of this work. It has a Biblical reference, obviously, and sounds slightly threatening — the subtitle is The Writing on Your Wall. *Would you like to go into that?*

The story of Belshazzar's feast is about how people were gathered together at a feast and in the middle of their party a hand appeared and wrote mysterious words on a wall – '*Mene, mene, tekel, upharsin*'.

In the English Bible those words are still given as they were in the original, as a set of nonsense syllables or signs.[1] And Belshazzar, who was the king, had a competition among his soothsayers for somebody who could tell him what the writing meant, and the prophet Daniel (who was by that time a very, very old man) was brought out of retirement. As I understand the story, he in fact could not *read* the words in a literal sense but was able to *interpret* them. He said that they meant that Belshazzar and his friends had been weighed in the scales of justice and found wanting, that they worshipped the gods of gold and silver, and that their kingdom would be destroyed and given to the Medes and Persians, which is, in fact, what happened historically.

I am very intrigued by the distinction between literally reading and understanding signs or marks, and interpreting them. There is also a Rembrandt painting, of course, on the subject of Belshazzar's feast,[2] which is what the child on the videotape (my son), is trying to describe from memory, having seen reproductions of it.

But isn't he also describing more than the painting? I seem to remember you saying that his description also combines his memory of the Bible story and that you were interested in this blurring of distinctions – analytical description versus memory, the piecing together of fragments.

Yes. The image is filled out in his mind with fragmented memories of the story the painting represents.

Also on the soundtrack is your own voice, a crooning voice-over, sounding like Celtic or Hebraic chanting or singing, but in fact improvised 'nonsense', and suggesting Biblical references to 'speaking in tongues', to divine inspiration. I believe you have used this improvised singing in an earlier work?

Yes, in an installation with sound I did a few years ago called *Élan*. In *Élan*, the

Interview conducted in January 1985 and published in the series 'Tate New Art/The Artist's View' as *Susan Hiller: Belshazzar's Feast* (1985). It is reprinted here with the permission of the Trustees of the Tate Gallery. Catherine Kinley is a curator in the Modern Collection.

basic materials I used were sound tapes of a series of experiments done by
Konstantin Raudive, what he called 'voices of the dead' experiments. Raudive
left tape recorders going in empty rooms and found that, for him at least, they
recorded a certain level of trace sounds which, when amplified, produced actual
coherent voices which he interpreted as being the voices of dead human
beings.[3] In *Belshazzar's Feast/The Writing on Your Wall* my basic materials are
some newspaper articles I came across about people seeing ghost images late at
night on their television screens after transmission was over. I've located that
within a very ancient tradition already recorded in Biblical times.

*So you didn't actually look for those articles after having decided the shape of
the work you wanted to do?*

No, they were found objects. I tend to find things and keep them around for a
while, if they're resonant then I sort of play about with them quite seriously
and eventually, if they seem significant to me in some way, push them as far as I
can in terms of analysis and hopefully come up with a piece of work which
brings out the latent or conscious meanings encoded in the artefacts.

*One critic writing about your work mentioned that these chanting voices (and I
suppose one could say the same thing about the automatic scripts you have used)
could be seen as a metaphor for the marginal position of women.[4]*

Well, you know the French call feminine all those utterances and insights
which tend to subvert or contradict the kind of mainstream ideological
package that we're presented with and to that extent, yes, there is a definite
relationship.

*Are you looking for an area to work in that remains relatively free from the
tendency in our culture to organize and analyse? (You acknowledge the
influence of Surrealism, and we will discuss this later.)*

It's an area of experience which is universal but which is pushed to the margins,
which is called mad or lunatic or yes, in some sense is completely remaindered
... which has an ancient, universal provenance and meaning for most people
because this break with coherence takes us back to the infantile period of our
individual past, when things aren't very clearly sorted out. My use of these
primitive or incoherent utterances – signs and sounds – is like remembering the
fragments of a language for which we've forgotten the rules. I'm reviving the
audience's recognition that they aren't separated from these kinds of feelings
and experiences, but simply that they've been repressed. Because the
phenomena occur socially as messages, usually messages of doom, it's as
though there's a very long history of individuals sharing insights into the kind
of lack of health of themselves and their culture ...

*Yes. There's an emphasis on retribution though, in the Daniel story. But you're
not implying that in your piece?*

No, what I'm saying is that there are genuine insights coming through individuals, but the forms these take are warped or twisted, and as a result, the insights are rejected, discarded. Repression is the source of what some people have described as the uncanny or bizarre mood of this piece. What Freud called 'the uncanny' is just this sort of potentially frightening projection, which leads us back to something old and familiar in our personal and social past. The weirdness or fright or bizarre effect is due to something repressed, I would say collectively repressed, modern ghost stories . . .

The image of the fire is the next thing I want to discuss. I know you are the co-author of a book on dreams[5] and I want to ask you about the things you've written about: the idea of sitting by the hearth and dreaming, the reverie or waking dream before the fire, constructing faces, strange shapes and so on.

This is an important key to the piece as a whole. I have the feeling that nowadays the television set functions like the hearth or fireplace used to. What I wanted to do with the imagery of this work was to establish for the audience their own ability to dream, to create images out of these free-floating, ever-changing shapes. This, of course, has a very long tradition in art; just think of Leonardo's advice to young painters to look at moss on rocks or drifting clouds to suggest forms. This notion that we project images on to a kind of wall or screen is important, and when you realize that the TV set exists in everybody's living-room as a potential vehicle of reverie, a potential message-bearing device, it's interesting that the very people who do use their televisions in this way are kind of relegated. The lady in the newspaper excerpt I quote on the tape, who fell asleep in front of her television and woke up and saw faces and then rang the BBC and so forth, was actually using television in the way that people used to use their fires. They would sit around, tell stories, sing, get ideas, see shapes, because staring into the flames stimulated visualization, imagination, creativity, even prophecy . . . So I've made a tape that engages viewers in this way.

You've said something about the newspaper articles that suggested the piece, so would you like to comment further on your working methods?

I tend to begin with something that already exists as a made thing, a cultural artefact. I then try to figure out why this thing seems to matter to me, and when I've discovered that, I move the materials around and respond to them. It's almost an extension of collage really, although more complex, to bring out what seem to me to be the latent meanings these materials carry. I think Barthes said a long time ago that all societies put a tremendous amount of effort into making things and an equal amount of effort into saying that these things are natural and couldn't be any way other than the way they are, and that they don't mean anything or express anything. I'm unravelling that denial of

meaning, or that contradiction in our way of looking at things. The kind of newspaper articles that were the starting-point for this work of mine appear from time to time and are then contradicted or ignored – *Belshazzar's Feast* is a long, slow look at what that's about.

> *It seems to me that, as in some of your other pieces involving the collection of ready-made items, you're actually assembling the material without superimposing an aggressive structure of your own. This calls to mind earlier works, your piece with potsherds and archaeological fragments and your rough-sea postcard piece, which comprised 305 . . . collected postcards, which struck you almost by accident as being images which could not be ignored because they were ubiquitous.[6]*

The thing is, you see, that as I go on making work, I am actually quite aware that I give a particular context and therefore a particular shape of interpretation and meaning to the material. I prefer to think in terms of *finding* rather than *making* this meaning, but the two activities can't really be separated. In *Belshazzar's Feast* I wanted to create a work in which the viewer would be entranced by sounds and images and thus have a slightly different take on the phenomenon and on the experience.

> *I know that you're not a 'video artist', but what is your feeling about working with video as against other media?*

Well, I worked with video a very long time ago, but I didn't use it to make tapes, I used video as a kind of interface in group situations. The reason that I used video in *Belshazzar's Feast* is because the basic cultural materials that interested me related to television, so it made sense. I'm not very keen on there being video artists or book artists or performance artists or any other sort of sub-group of artists. I think artists have the freedom now as they've had in other periods to extend themselves across a range of media, using whatever is appropriate for the particular project they have in mind. This may well be the only video work I'll ever make.

> *Has your background in anthropology, your knowledge of scientific methods of recording information, meant that it feels fairly natural for you to gather and present information in your art in a variety of different ways?*

Yes, that's certainly true. I suppose I would extend that in terms of art practice to say that personally I find a very great pleasure in making use of all the sorts of media that are available to us in our own time, just as artists in the past were very happy to use oil paint when tempera was passing out of fashion or whatever: the point to stress being that I don't consider that any of the newer media have any more of an objective significance than the traditional media.

> *Since the early 1970s you have been interested in automatism, in the 'divinely*

inspired' mark or, latterly, sound. Would you like to comment on that in
relation to experiments made by the Surrealists or perhaps to earlier ideas
about inspiration?

Well, I think first of all I have to throw out the notion of 'divinely inspired' and
simply point out that's another way of taking these kinds of insights and
phenomena away from us and locating them in some kind of otherness. The
kind of vocal improvisations that I use on the sound track of this piece are
related to the kinds of improvised marks made by my hand which are on the
wall and which are something that I have been involved in for a very long time.
Now the history of this sort of improvisation within twentieth-century art is
very interesting. If you look at the history of gestural painting, of course the
Surrealists were very involved in automatic drawing and writing. After
Surrealism, we get a kind of movement in two directions, through Jackson
Pollock and Mark Tobey and subsequent Abstract Expressionists in the United
States, and through people like Henri Michaux and Dubuffet and so forth in
France, a kind of investigation of this whole area. Now it seems to me that
what happened was that the *look* of these works became acceptable in stylistic
and formal terms, and subsequent generations of artists simply pursued this
look without any attempt to resolve the meaning of the actual phenomenon
itself, like what is an automatic gesture, what is a mark? Is it a kind of mental
trace mediated by the body? Is it a purely gestural reference, is it a sign, a
signifier, a fragment? And, of course, in American painting, which is
something that I suppose I've been very influenced by, you get a very
interesting kind of shift away from that version of abstract art in, for example,
the work of Ad Reinhardt, who was a very significant artist because of his
pronouncements about the painting as painting and the limits of painting and
the anti-psychological kind of thrust of his work, which fed into minimalism
and later into conceptualism.

Now one thing that is interesting about Reinhardt is that at a certain point
he was experimenting with gestural abstraction and I gather that he produced a
lot of works which he considered to have a kind of exotic calligraphic look: he
said it looked like Kufic,[7] which is a form of Arabic script. He felt so negative
about it that he considered destroying the works and with this he began his
whole polemic about the painting as painting and so forth. Now, what interests
me here is that certain sorts of marks come up over and over again in the work
of many abstract painters, but they never look at the marks themselves as
scripts, signifiers without signifieds, if you see what I mean. I think that there is
a particular appeal that the calligraphic has that comes about because the kind
of ongoingness of the marks relates to body feelings, something like breathing
or walking, it just goes on and on, it's interminable in a sense, it has a sort of

flow to it which in a sense represents the flow of life if you like . . . the flow of subvocal speech, mental imagery, ideation and so forth. Now I suppose that I would be happy if people simply stopped to think for a moment why this flow has such a highly structured quality to it. Why there is such a refined, coded use of marks.

I also want to say something about the fact that these phenomena, these marks, these sounds have a kind of primeval or primitive or foreign quality to them, but the fact that they keep recurring indicates that they constitute perhaps a kind of language in themselves.

The whole notion of understanding, it seems to me, is a very important and significant one here. A lot of the efforts of the past ten or fifteen years in art theory and criticism have been to deal with work as a set of meanings that can be understood intellectually, and there has been an effort to dismiss appeals to the emotions and feelings as kitsch. This seems to me peculiar, to say the least. We communicate with each other on all sorts of levels, not least on the level of feelings and that relates both to personal psychology and to a kind of cultural situation which is, I hope, represented by both the verbal and visual improvisations in this piece.

I feel this particular work is one which invites group viewing, it gathers people around the hearth, unlike Monument *(pp. 188–89), which is the work in your repertoire that I can relate most directly to. I think you said yourself that* Monument *was for 'one pair of ears only'. Do you feel that* Belshazzar's Feast, *on the contrary, suggests the possibility of group interpretation?*

In that sense this particular piece takes me back a very long way in my own work to when I was working collectively with groups of people around dreams and all those sorts of things.

Like your works involving dream analysis? I was wondering about that.

Yes, that's right. *Dream Mapping* and *The Dream Seminar* and pieces like that from the seventies. *Monument*[9] – because it is a meditation on death and heroism and positions the listener and viewer as part of the piece to be observed by an audience, with his or her back to the work, the listener then being seen by other viewers as part of the work – was a very different sort of enterprise. I think that *Élan* (p. 39),[10] the large installation piece that came in between, bridges the gap in a way. Of course I would be happy if this newer piece created a notion of collectivity in that sense, because what I am always trying to do, I suppose, is to bring into view those areas which are repressed socially and culturally, those areas in which we do in fact share; and to retrieve for all of us, myself included (because when I make a piece of work it's got that sort of value for me), a sense of ourselves as part of a collective, to insert the notion of ourselves as the active makers rather than the passive recipients of a culture.

*The idea of retrieval and by implication, appropriation, which is very much
part of contemporary art practice, also relates to the discipline in which you
were originally educated.* Fragments *(pp. 22–23), a work that you made with
American Indian pottery, is a good example. But nowadays a great many artists
incorporate non-art images and objects unaltered into their work.*

Well, you see, I'm only interested in artefacts in so far as they are part of an
interrogation and questioning of who I am, who we are and what the making
and placement of these artefacts is about. *Fragments* uses materials from
another culture which have been inserted within our own and asks questions
about why those materials were located in that way and what this could tell us
about ourselves and our own forms of so-called objective relegation. I played
with the notion of typology, historical development . . .

Categorization?

Categorization, and so forth. I think that *Fragments* offers some very
paradoxical conclusions, namely, that what we call art is done by men; that work
which is artful, has a 2,000-year-old tradition, highly articulate and so on, if it
is done by women is called craft. Now, extending that notion into more recent
pieces I've quite specifically aligned myself with those kinds of traditions
which our society calls marginal, and attempted to bring out, as it were, the
unconscious meanings in society's relegation of those materials to the fringes.

*You've often talked about your background in minimal art. How do you feel
about the recent developments in painting?*

Thinking about my own practice over the years, what I've understood is that
the ability to permutate items within a structure or system, which for me comes
out of minimalism, is something that I've been able to extend to cultural
artefacts. My basic approach really is a very old one, collage. It comes out of
Schwitters really, but the notion that you could juxtapose units which varied
very slightly one from the other was useful to me, and what I've done with all of
that is to push it a whole lot further and to try to draw attention to the actual
content rather than to the formal aspect of the work.

*We have chiefly discussed the contents of the videotape, can we now look at the
installation as a whole; besides the television/hearth you are presenting an
accompanying set of twelve collages. These consist of enlarged cut-out sections
of photographs you took of yourself in an automatic photobooth. The fragments
have been hand-coloured and re-photographed and are sandwiched between
clear sheets of perspex. In the Tate's installation each perspex panel will be
overlaid on a separate sheet of acetate on which you have executed a free
calligraphic drawing – what you call your 'automatic scripts' or 'automatic
writing' – although in an earlier installation you drew directly on to the wall.
You have been making similar 'photo-booth portraits' since the early seventies.*

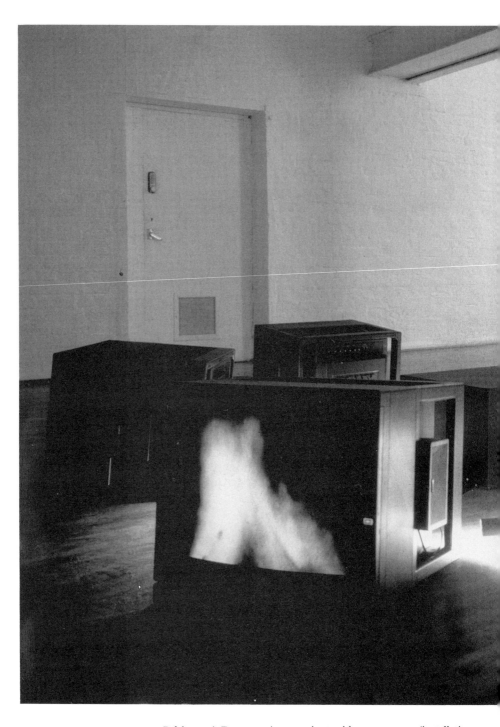

Belshazzar's Feast 1983/84; 20 minute video programme/installation;

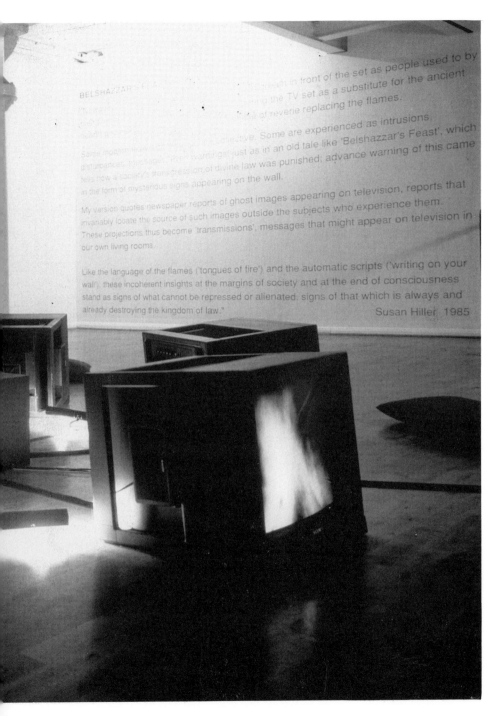

BELSHAZZAR'S ...

...ion in front of the set as people used to by ...ing the TV set as a substitute for the ancient ...of reverie replacing the flames.

Some modern ...

...ective. Some are experienced as intrusions, disturbances, messages, ... warnings just as in an old tale like 'Belshazzar's Feast', which tells how a society's transgression of divine law was punished; advance warning of this came in the form of mysterious signs appearing on the wall.

My version quotes newspaper reports of ghost images appearing on television, reports that invariably locate the source of such images outside the subjects who experience them. These projections thus become 'transmissions', messages that might appear on television in our own living rooms.

Like the language of the flames ('tongues of fire') and the automatic scripts ('writing on your wall'), these incoherent insights at the margins of society and at the end of consciousness stand as signs of what cannot be repressed or alienated, signs of that which is always and already destroying the kingdom of law."

Susan Hiller, 1985

shows 'campfire' version of the installation (Oxford 1992)

In fact they are unconventional as portraits in that each photograph shows only a part of your head or torso; your face appears only once, but your hands, the artist's hands, are much in evidence. Could you elaborate a little on the photobooth works, with especial reference to this piece? I know, for instance, that you are interested in the idea that in these automatic booths, the middleman, the photographer or mediator, is cut out, you can control your own image.

Yes, that's right, the photobooth camera acts like a mirror. Also, aside from my own frequent use of hands in earlier works, don't forget the hand that appeared at Belshazzar's feast and wrote the mysterious words on a wall . . . As you said, I've returned time and time again to photobooth imagery, so I'll just point out that these miniature portraits refer directly to the tail-end of a tradition – the draperies, the head-and-shoulders format and so on all derive from a history – just as the ghost images on TV screens refer to an old tradition, as I said. It's also worth remembering that the photobooth images are fragmented, partial and incomplete – like what we know about ourselves. If you look at them in formal terms they're sequential and episodic, like film. Certainly, there's a lot more we could go into about these interrelationships, about how the various items in the installation relate to each other as well as what they are in themselves, but I do dislike reducing the elements of any work to this equals that; the work's coherence is really around a series of interlocking metaphors. I'm retrieving and reassembling a collection of fragments, and that could be a way of looking at this work, which makes something potentially new out of remaindered items . . . what it means *as a whole* is up to the viewer to discover.

NOTES

1 Daniel 5. 24–8.
2 In the National Gallery, London.
3 Between 1965 and 1974 Dr Konstantin Raudive, a Latvian scientist, made thousands of tape recordings of such voices in apparently empty rooms.
4 Sarah Kent, 'Visual arts/Hearing voices', *Time Out* (8–14 April 1983).
5 David Coxhead and Susan Hiller, *Dreams: Visions of the Night* (London, Thames and Hudson, 1976, 1981, 1989).
6 Susan Hiller, *Dedicated to the Unknown Artists* (1972–76).
7 Kufic (Cufic), a form of Arabic alphabet found chiefly in inscriptions.
8 Reproduced in *Susan Hiller 1973–83: The Muse My Sister*, (Londonderry: Orchard Gallery, 1984), p. 7.
9 See Susan Hiller, *Monument*, (1980–81).
10 Reproduced in *The Muse My Sister*, p. 18.

ABSTRACT FIRE

I'm very interested in the way art works move or don't move from country to country, and the different kinds of interpretations and reactions people have. So I am happy to answer questions about *Belshazzar's Feast*.

Just to begin, I would like to say that I gather a few of you aren't familiar with the Old Testament tale of Belshazzar's feast. Rembrandt's painting of this is in the National Gallery in London. There is also a wonderful version with a cast of thousands by the English Romantic painter John Martin (1826) that I was very struck by when I first went to England. It's the story of the moving finger, the hand that appeared and wrote on a wall. What it wrote was nonsense, what seemed to be a message in an unknown language, crypto-words that couldn't be translated and even today are still nonsense syllables in my English Bible. The story tells how people assembled at a feast had a collective vision of what seemed to be an ominous portent of the future, and how Belshazzar, the king, had a competition among his soothsayers. In my piece, I was looking at modern analogies of that. I'm very grateful that you all speak English well enough to enjoy a video like mine that relies on the English language and also on a British set of cultural references. I haven't yet had any opportunity to try out this work outside an English-speaking audience, but I do know from other works of mine that the meaning may change almost totally.[1] I probably don't produce international art, or even believe the concept is valid. Art has to be very specific, very particular, very concrete.

I have read that you said this was a very low-budget work, from super-8. Was there any particular reason for using super-8 to begin with?

Well, I knew I wanted to end up with a video because the initial materials were about television, distorted newspaper reports about phenomena of reverie triggered off by TV. But I very much like the abstract qualities that super-8 to video can give, and I wanted an abstract fire. In fact, I filmed an enormous bonfire, outdoors on Guy Fawkes Night, that strange, archaic English holiday. I've always loved playing with scale, and so in a way this gave me a basic illusion to start with, that what was in reality a large fire, filmed from far off, produced the image of a little domestic fire, contained within the TV set, like the elemental fire contained by the hearth.

I continued to use illusionistic rather than 'real' sources throughout the tape, for instance the doubled image, the whitish overlay, came from re-filming

Edited transcript of a public discussion on 1 February, 1988, during the showing of *Belshazzar's Feast* organised by Ulysses S. Carrion at Timebased Arts, an Amsterdam exhibition space.

from a black-and-white monitor. The original super-8 film was simply looped and played over and over and reshot on to video from its projection. I was very aware of the TV screen as a surface that I wanted to emphasize. Interestingly enough, hardly anyone seems to take much notice of the fact that the images are so abstract and flat, like a painting. One example of how not much of this is noticed is that actually the speed of the fire, the light, is slowed down throughout my video. I'm sure you noticed that about the final third of the programme is in very slow motion, but possibly it wasn't so obvious that in fact all of it is in slow motion ... This is because fires on television or in films always look as though they are frantically darting around, say in the background, a fireplace or whatever, due to the quickness of the light registering on the film – but one's experience, especially of gazing into the flames, is more meditative, slower. So by slowing down the flames I found an equivalent which seems somehow natural and right, since no one notices it's mostly in slow motion – in other words, people only notice when it switches into extremely slow motion.

How did you do the sound, it is very strange.

The fire sound is from the BBC sound archives, an easily available source that many programme-makers use. I've used it before in other works, for different kinds of applause and laughter. Again, we made an enormous tape loop and played it continually while I read in a whisper. Due to money problems we had very little studio time and that part had to be done in one go. The child's voice came from a previously recorded tape I'd made with my son, and I had marked out the bits to be used, so they were dumped down on another track.

Interesting that these are ways of becoming more abstract, but really it all works to draw you in; I think that may be because of the chanting which you have not talked about.

That is me, in the sense of my voice – but I feel that to emphasize the fact of it being me and at the same time standing here speaking prosaically about it, may be a big contradiction.

I am very interested in kinds of improvisation, like the so-called automatic writing pieces I do. This is a similar practice with the voice. I am aware of some precedents in art, say Schwitters in *Sonata for Primeval Sound*, and Artaud, of course, as well as things I know about from ethnography, what are sometimes called 'meaningless vocables', and these are practices that relate so much to theories around language and the self; really they are in advance of theory.

Could you do your voice like a performance, live?

I have done the automatic writing live for camera, but no one has ever asked me to perform the voice live. I don't know if I would consider it appropriate to make it into a performance; it's not for looking at, it's for listening to. In fact, very little critical attention has been directed to this use of voice which has

been an important part of other pieces of mine also,[2] although I do notice there
is more raw use of voice emerging in other people's performances and videos,
and some students of mine have used keening and other kinds of traditional
musics, like chanting.

*When I saw this tape originally – and I want to say, I always wanted to see it
again, that's why I came to your discussion tonight; but I am not agreeing with
everything you have said at the beginning about messages of doom, etc. –
because for me it was about reading meanings into chance elements in general,
like the stars or anything. Without any sense of inference towards either
optimism or pessimism. Maybe your own interpretation is because artists can't
really accept anything that is disordered.*

When we were talking before I wanted to make it clear that the piece is about
our cultural tradition, and what happens when reveries occur spontaneously is
that they can become messages of doom, that's the tradition. Of course I
personally don't believe the world is going to end when four people have
identical hallucinations or whatever on the same evening, but they are terrified
and the media take this disruption or eruption of the uncanny as a message
being beamed in on us from elsewhere. In fact, one of my favourite reviews of
the piece from when it was shown originally in London, emphasizes the
weirdness, uncanniness of the sound-track combined with the flame image to
suggest premonitions of a new holocaust. What is important for me to
emphasize would be the multiple voices I am using, I am able to use.

Do you think it works as an installation better than on TV?

It works perfectly as a video programme on television. As an installation it is
very different because you don't have the idea of transmission from a remote
source, the TV station or channel, but you do have groups of people watching it
together. In the original version of the installation, the tape is the focus and
there are also automatic scripts on the walls overlaying photomat images, with
pointing fingers arranged around the video monitor which is set into a hearth
and surrounded by bits of wallpaper. The pictures and scripts are arranged a
little bit like those flying duck decorations, as a way of destabilizing while
using notions of the domestic. You know I have also been interested in how
messages can be read off wallpaper, as when you are a child lying in bed or
otherwise bored, looking at the patterns, imagining other pictures. I think of
the domestic as a source of fantasy, maybe because I have lived in England so
long, and the English are not only very domestic but also very imaginative; but
this poetic facility has been suppressed and comes out in decorative eccentricity.

Does this setting change the meanings?

Yes, but of course I am not the best person to say exactly how. From my point
of view, the installation starts with the flame, the hearth, and then radiates out

into a room within a space, say a setting inside a museum, and then maybe further out into the world again. It isn't a bounded installation, it's very open, not high- tech and not rigid. At the Tate Gallery in London, people were sitting on the floor in front of my pretend hearth, and I've also designed a round camp-fire version where people sit in a circle on the floor. It's inevitably about naturalizing a cultural space, using a cultural space like a home.

NOTES
 1 For example, when *Monument* (1980–81) was shown in Poland during the Solidarity period, it was understood to be a celebration of civilian heroism [ed.].
 2 *Monument, Élan, Magic Lantern* [ed.].

THEORY AND ART

I find the process of speaking about the work rather difficult – since anything I say 'about' my work tends to feel like an over-simplification, and at the same time, given the priority of words over images in our society, my words may begin to seem more authoritative than what they are 'about'. But since I don't get back to my own country very often, and I do really enjoy talking with people here, getting a different perspective and different feedback, I'm very happy to have accepted this invitation.

On the other hand, it's a bit scary being here because, as everyone knows, at Cal Arts theory is discussed non-stop – (*Laughter.*) Because I am becoming very sceptical about the role of theory, about artists talking theory, which is a sign of the increasing emphasis being placed on theory in teaching art and describing art. And since I am as the English say, a rather mischievous person who feels called upon to speak sincerely, even if this means saying unpopular things, I want to talk a little bit on this occasion about this practice of talking which artists indulge in more and more frequently. And for which we are also paid, I think it is essential to add. Probably the views I am going to try out on you arise from my background and training as an anthropologist, as much as from personal preferences and tendencies. On the one hand, I feel privileged to have experienced a marvellous education as an anthropologist, through which I assimilated ways of thinking about art – and about life – which have become part of me, and part of what I do as an artist. On the other hand, I was alerted to, almost traumatized by, the potentials for alienation that seem to be inherent in the anthropological practice of 'participant observation' and in the lack of fit between lived experience and theory. I have said very frequently that in the classical approach to fieldwork the data recorded by the anthropologist are 'collected', taken away, and used within our society to construct different meanings, meanings related to academic or museum careers more than to epistemology. If there is a return of the conclusions based on the data to the people who provided it in the first place, this would normally be in the form of bureaucratic, administrative uses of the material, which is thus further alienated from its creators. The anthropologist is also alienated from the material, since, although it is based on her lived understanding of the understandings of others, she is obliged to form it into theory which is

Edited transcript of an improvised lecture to students at California Institute of the Arts, Valencia on the occasion of Hiller's teaching visit in May, 1988 during her term as 'Distinguished Visiting Professor' at California State University, Long Beach. *Belshazzar's Feast* was exhibited concurrently at the University Art Museum.

detached from memory, experience and individual lives. This alienation is already encoded by the split term participant/observer, which implies that in some way I have never been able to understand, the object of enquiry is separate from the enquiring subject. From my perspective, this is a clearly false, clearly ideological split, that creates a hierarchy which locates embodied knowledge and the contradictions of lived experience 'below' the abstractions of overarching theory. My decision, more than twenty years ago, to become an artist was because I wished to avoid or relinquish the suffering as well as the benefits that result from accepting such distancing, alienating, hierarchical modes of translating experience. Because of this deeply felt insight of mine and personal traumas relating to it, I have for better or worse been subsequently hypersensitive to formulations that tend to abstract meanings and generalized applications, assertions of the superiority or precedence of theory over experience, as though theories were formulated and uttered somewhere outside the constraints of time, place, subjectivity and the body, and are therefore free of prejudices and mistakes.

Being an artist, according to Maya Deren, is in important ways the same as being a 'native', subject to the so-called objective scrutiny of others. Powerless, the artist/native's discourse is translated and abstracted, leaving its first context for a different place and function elsewhere. The utterance/artwork of the artist/native can be understood outside its original context, only when transformed by powerful, institutionalized strategies of appropriation. These strategies may originate from academic institutions, museums, governments or art collectors, but in any case the original utterance of the native/artist becomes part of a different conversation where it means something quite different than was intended by the speaker.

While I certainly don't intend to denigrate theory, which has its own role to play as simultaneously part of, but importantly critical of, these institutional strategies. I do want to keep it in its place, by pointing towards some issues that relate to art as I see it. First of all, art is a practice performed by artists. Art criticism is also a practice. Theorizing is a practice, or set of practices. I would like to suggest you take a look at the writings of some of the theorists you are nowadays thinking about, read these people, and see what kind of art they discuss when they are formulating their ideas. They certainly do not take up stupid art, but they also do not take up art that is more like theory than it is like any material practice in the world. These material practices are full of contradictions; I might say that they are *about* contradiction. They are not complete explanations of the world, and have not pretended to be complete explanations, at least since the Renaissance idea of perspective and all that was finally understood as a very particular cultural convention ... And it is these

contradictory practices, practices that embody contradictions, that interest the best contemporary thinkers.

In contrast, there are art practices that are based on the theories of these thinkers, art practices which these thinkers do not take into account. Quite a lot of the work that is being done now in art is highly theorized ahead of time. The artist tries to make the artwork conform to a given theory, to make it consistent, to tie it *illustrationally* to theory. This is its weakness. Such an approach locates art as a second-order practice, relying on ideas previously formulated somewhere else, and of course this art always lags behind the discourses it relies upon. Another problem is that this kind of art simply does not carry the intended meanings, which always need to be appended somehow, usually by the artist endlessly talking about or writing about her or his work. My intuition here is that one simply cannot second-guess oneself – making the super-ego the starting-point for art does not displace the other aspects of self, which may 'come out' in work even more strongly, in protest. Thus the talking about the work, which is always from the super-ego viewpoint, mistakes what the work is about, and in the long term substantially invalidates itself as accurate commentary.

Now you are not laughing, this is serious, it is upsetting. But why should this view be upsetting? Do you believe in theory? What does 'believe' mean in this context? Do you think theory can 'save' artwork, to paraphrase what Susan Sontag said about photography, that moralists always believe that the captions, the text, can redeem the image?

Of course it is equally true that other kinds of artwork, supposedly non-theorized – but I need to come back in a minute to this notion of non-theorized artwork – also do not carry their intended meanings, necessarily, and these are provided by the market-place, by critics, by audiences. So there is really no difference. It's all up for grabs. In a sense, I could even argue rather mischievously that the work based on theory, which is full of contradictions, is of interest in exactly the same way that all other art is of interest, to the extent that it is full of contradictions. And equally mischievously but very seriously, to come back to what this work that is nowadays dismissively labelled 'non-theorized' might be – let's remember what Goethe said a very long time ago, that 'every fact is already a theory'. This means that every decision, every unit, every object is the result of a set of opinions, a world-view, and ultimately of a theory. All art is grounded in theory, whether or not the artist can consciously articulate what it is. And even when the artist is articulate, the theory may be quite other than what s/he claims it is.

There is a habit of artists arguing for the position or placement of their own work within particular histories, and in recent times artists have also taken

to arguing that their work is more important than other artists' work because it takes on board specific theoretical or political perspectives. I like it very much when artists make these kinds of claims, because it shows me that artists are intelligent and alive to the world they live in. It interests me a lot more than claims for universal authenticity, for instance. But I do not believe their claims, necessarily. Why not? Because, like always, only time will tell which work, what kind of work, has staying power, what work has moved us towards a future . . . which of course can change over time, also, since there are many possible futures. I hope you are not misunderstanding this point. I believe that part of what artists do is inevitably conservative, conserving; and part of it is innovative, makes certain kinds of future possible, because it contests or negates certain cultural themes while validating others. But none of us can know the future of our society or of our work. We can hope, and we can work as best we can to enable certain kinds of future to emerge. But this has very little to do with making big claims for the rightness of what we do.

In fact, some artists believe so hard that what they do is right, that they find ways of discouraging their students from finding their own ways to do what is right. This is censorship. It happens in the most conservative settings, where conceptualism is mocked and the return to life drawing advocated. It also happens in places that define themselves as radical or innovative. Sometimes words become very important as weapons, so that until you have learned the words you are prevented from practising art. This is a denial of art as a valid material practice, in favour of a perhaps unconscious wish that art should become art criticism or art theory. The provisional nature of meaning in art, and our lack of any agreed-upon semantic system for analysing how and what something in art means, maybe causes distress or uneasiness in some people. I can see that it might be nice if it were really true that we could already read artworks like books, with a range of interpretations but a basic agreement about how to discuss these disagreements about meaning, but it isn't true. No matter how many big guns are brought out, or expert opinions, I don't see how we can agree the debate is closed.

What seems to have happened over the past fifteen years or so is that various ways of analysing popular culture, film and literature have become prescriptive, that is, these analyses have become models to be adhered to in the making of visual work. And yet, at the same time, as I said before, we still don't have any agreed ways of analysing what an art work means. About ten years ago I got into terrible trouble at a conference discussing feminist issues in contemporary art when I said that reading Barbara Hepworth's writings had made me very interested in the potentials in so-called 'abstract' art for expressing gendered, even proto-feminist meanings. This was a very unpopular

view among the most informed, most articulate people at the conference. I made things worse by saying that it seemed to me that because we still didn't have accurate tools for analysing how and what art means, we couldn't really distinguish any substantial difference in content in Hepworth's sculpture compared with Henry Moore's, yet the different experience of the artists and different placement of their work historically made it a feasible hypothesis that their work did mean quite different things. I was optimistic then about the eventual refinement of a semantic vocabulary, to describe formal issues as aspects of meaning in art, and I am optimistic now; I have no wish or need to exclude abstract art from the struggle of women to bring new meanings out of incoherence, and in the same way I am willing to imagine that not all so-called photo-text works are identical in meaning. A respect for differences seems to me to require that the all these things remain open issues at this stage, since it would be premature to close down the options before we have a clue what we are really talking about.

So the next time any artist tells you his or her work is excellent and correct because if Althusser were around he would agree with its theoretical starting-point, or Karl Marx, or Freud, Lacan, etc. – well, I'm suggesting you be a bit sceptical. Being sceptical is the sign of having an informed mind, a courageous mind – and artists truly do need to be like this. I'm assuming you already have the insight to resist views that argue for a universal human nature – which implies that the human is white, male and middle-class. So you are not sexist, racist, etc. in your views – but what about your work? What is the relationship between your views and your work? What does your work mean? And how does it?

This is a long way round to saying that I myself started off as a painter before I began to turn my attention to reconciling what I had experienced as a kind of split between an investigative practice and an aesthetic one. In the early 1970s I began to make works based on cultural artefacts found within our own society. I have never had a system that I am aware of for selecting these starting-points. I am attracted to items that I feel strongly about, for and against. A long time ago Barthes said that all societies put a tremendous amount of effort into making objects. And they make them just the way they want them to be, whether it is a ceremonial implement or a soup ladle. These are made just the way they are intended to be, and then everyone in all societies spends just as much effort saying these things don't mean anything. They could have been made any way. They were not specifically intended to have any meaning. They are just things. So in part, what interests me is precisely that denial of meaning or significance, the relegation of things to the category of the meaningless, the banal, the unknown, even the weird and ridiculous.

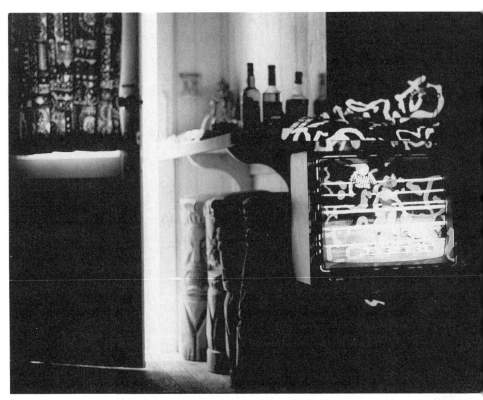

also facing] *The Secrets of Sunset Beach* 1988 (details, two images of ten-part series);
R-type photographs; 465 × 565 and 565 × 465

I have used a range of materials, each of which has determined the form of each work. Quite often I make large installations, but quite often I also make small things. Today, partly because I don't like to show documentation, and also partly because coincidentally I have a show on here, I've brought along a videotape. This tape is the central issue in my current installation which you can see at the University Museum at CalState, Long Beach. In the installation, which takes the form of a large, domestic living-room setting, things are not quite what they seem. Or rather, the installation problematizes the idea of things and their representations, so that the effect is destabilizing with reference to 'reality'. This contextualizes my video programme. For instance, there are plants in the installation, but they are excellent imitations, made of silk in Asia. The furniture is rented, but all the pieces are replicas of traditional English styles. There is a big red carpet, which is a cheap but effective copy of a Persian rug. Around the walls I've placed a new

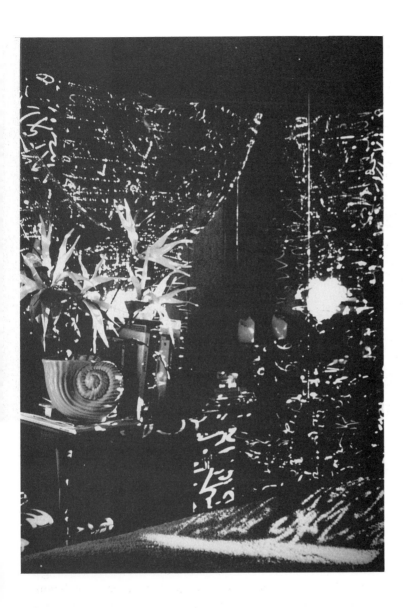

photographic series called *The Secrets of Sunset Beach*, which is about visual disturbances or intrusions of mysterious messages into local domestic settings. To screen the videotape itself, I've used one of those giant curved living-room video screens which are meant to make you forget you're watching television, so you think you are at the movies. What appears to be a sign – living-room – is really a metaphor . . .

[*Screening of* Belshazzar's Feast]

DISCUSSION

I understand we have time for a couple of questions, either on the issues around theory I brought out in my talk or about the video.

I have seen this before, on TV . . .

Yes, a small part of it was included in my section of *State of the Art*, a major documentary about contemporary art that was shown in sections on local television here in Los Angeles recently.

Yes, and every time I see this I have more and more. . . . I see dinosaurs, I have seen flying animals, it just gets more and more. . . . and I was wondering, see I sort of go into a dream state and I miss hearing some of the language and then I want to see it again. So, sort of, I have two questions, first I keep hearing something new also and I wonder if you would ever allow it to go into a video store where people could just rent it? So they could see it again. And my other question is, do you mind if people go off into their own sort of fantasies?

I really don't know if it would be OK to just let it go into a video store or not. Probably not, knowing what most of the videos there would be like. I would be upset if people got hold of totally the wrong idea, interpreted it against the grain, without any critical context. That may be inevitable eventually, but I hope it can be part of a total, social, gradual evolution of meaning.

From the artist's perspective, there are correct and incorrect interpretations of a work. Holding this work back at least temporarily from a mass distribution network is some kind of way of waiting until the context has grown up around it.

Once when I screened this work, a man who claimed to really like my work in general came up to me afterwards and said, 'I'm a fan, but this, this I can't stand.' He hated it. I said, 'Oh really, I mean some people find it very funny and so forth, but no one has said they hated it, at least not to me.' So I asked him what he didn't like about the tape. He said, 'I don't like those devils.' Those devils! He said, 'Why did you put all those devils on the tape?' I said, 'But Peter, I didn't. There is nothing there but the image of a fire slowed down and manipulated in various ways, making very intriguing shapes that invite possibilities of reverie, fantasy, imaginative image-making, etc.'

So I think his interpretation was wrong, because my intention was to make a work that would release the viewer into discovering or rediscovering, consciously, this human capacity to be able to say, 'Oh! Isn't this interesting, my mind is making pictures, and they are thus and so . . . 'That would be a good response, from my point of view. And this would add to the pleasure of viewing this work, not detract from it.

THE DREAM AND THE WORD

I've tried to figure out ways to talk about work, my own work, that don't give the impression that it's already used up and completed. I am trying to find a way to talk about work that gives me a chance to learn something through talking about it.

We seem to have come to a situation in the history of art where sometimes the custom of artists talking about their work has become almost more important than the work itself, and I feel this is a very dubious kind of practice. I want to stress that my talking about my work is tentative and that thinking is in progress. And that if there is any final point of reference, it is always the work. The emphasis is on the performative aspect of art, that is, the interrelationship between the work – whether it's an object or an event – and the viewer, who is a participant in the work. 'The work' includes the viewer, who is the medium through which 'meaning' is attributed or created. 'The work' is the best evidence of what the artist or the art practice is about.

I consider my approach to be evocative rather than instructive, and what I'm saying is really intended as an evocation of a set of ideas.

I would like to open by locating the places where certain tendencies within my practice might find their roots or beginnings. To lead up to these originating points, I need to set the scene by going back to some of the things I was thinking about in the seventies. I'm going to tell you a story that situates the questions I was engaged in then, although I only heard the story recently. I got it from an American poet who got it from an anthropologist who got it from the autobiography of another anthropologist.[1] This story has particular resonance for me because I used to be an anthropologist. I also think it has a lot of relevance to art, to the relationship between practice and theory in art, to making work and talking about it, to thinking about the dream and thinking about the word . . .

The story concerns someone called Maurice Leenhardt, who in the 1930s was visiting the New Caledonians, the host people he was going to study. But in this particular instance, instead of the anthropologist asking the natives questions, they asked him questions. And they came to him in a rather formal

1 Transcript of an invitational lecture at Glasgow School of Art, February 5, 1993. It was originally published in *Random Access: Staking the Claim for Art and Culture* (by Pavel Büchler and Nikos Papastergiadis, London: Rivers Oram Press, 1995) and is reprinted here with permission of the editors and publisher. Hiller's text was based on two earlier improvised slide presentations, November 30, 1992 at the Ruskin School of Art, Oxford University and December 1, 1992 at Chelsea School of Art in London.

delegation and said, 'Where does the wisdom of white people come from?' and he said, 'It comes from observation, free of superstition.' They thought that he hadn't understood their question. So they said to him, 'Where does the original idea of a thing come from?' And he said, 'I suppose you think it comes in a dream, the way your forefathers discovered a magic stone in a dream.' And they answered, 'Yes', and left it at that.

Now the New Caledonians are asking the ethnographer a very searching question, an epistemological question, which he is apparently unable to answer, except by assuming that because his own world-view is superior to theirs, they will not understand it, and so he must answer in their own terms, which they will understand, and which of course he also fully understands. His view comes from pure observation, free of superstition, and theirs comes from superstition. But they ask him in return, 'Where does the original idea of something come from, in other words, where does your whole concept of knowledge come from?' And he can't answer that, so he says, 'Well I suppose you people think it comes in a dream, the way your superstitious concept of knowledge comes in a dream.' And they go, 'Uh-huh . . .' which is the end of the conversation. This story addresses a polarity between what we might call 'the word' and 'the dream', between theory and practice.

This anecdote triggered off a series of uncomfortable associations in me, not all of which are simply negative reactions to its colonialist geopolitical aspects. It reminded me of Maya Deren's astute comment that artists in Western society are always in some sense 'the natives', since they are treated as subject-matter by critics and theorists, and as providers of goods for markets . . . And that led me to recall Sigmund Freud's early description of his own project as 'reclaiming territory from the primordial chaos of the unconscious mind' – with its echoes both of the whole colonialist mentality and of the culture-bound assumption shared with Leenhardt, of a hierarchically superior position assigned to a certain kind of knowing which is equated with something called rationality.

Freud saw both art and dream as manifestations of the unconscious, and/or presentations of neurotic symptoms. In what has always struck me as a rather peculiar scenario, the artist is somehow only a naive bystander in the process of producing an artwork. The artist has, according to Freud, a certain 'flexibility of repression' – that is, a fairly limited freedom to step aside and relax the control of his/her ego so that unconscious contents may emerge. The artwork illustrates or exemplifies the unconscious fantasies, desires, etc. of the artist by the same means used in dreams to disguise unconscious meanings from the dreamer/artist. The artist's production of work is, like the dream, an untheorized, unauthorized, almost unintelligent symptomatology whose

meaning is unknown to the artist. Someone else must provide the key to the work.

There is an exact parallel here with Leenhardt's dismissal of the indigenous epistemology of the New Caledonians as 'superstition'. I don't think it is unfair to describe this process as a form of colonialism. Someone discovers some place new, some place he's not been before. But for the people living there, it isn't a new place. Through this encounter, reciprocally, the power relationship which is established determines a hierarchy of value. The anthropologist 'discovers' the natives and 'discloses' their meanings. The natives' meanings are superstitious and irrational, or they are neurotic symptoms. In any case, they are not as rational or profound or overarching as the meanings of the explorer/psychoanalyst/anthropologist/art theorist, which can 'explain' and replace them.

Clearly, something is very wrong with accepting this relationship. Perhaps only we natives can see what it is. So let's start again to look at this relationship differently. In the most basic sense, we could say that a great many societies, like ours, find their point of origin in the word: 'In the beginning was the word', right? But just as many have their point of origin in the dream: 'In the beginning was the dream'. Now, what's the difference between the word and the dream? Well, we know that there is a difference between words and dreams in our own society. We relegate dreams to unreality, until they become texts which can be told in words, for diagnostic purposes. Words give meaning to dreams, in our society. It seems to me that if we could locate our own way of looking at dreams not as superior to the ways of others – unlike Leenhardt who assumed he had a rational metaposition that encompassed the superstitions of the New Caledonians – but simply as being one way, on a par with others, discarding our assumption of cultural supremacy for a minute, we might see that our ideas about dreams are entirely culture-bound. We simply *assume* that theory is more profound, more intelligent than experience, and that words are the proper vehicle for understanding dreams. But this may well not be the case. As an artist, I might argue that dreams and art and words are all just places where behaviour occurs, rather than representations or illustrations.

Using theory to understand art is as odd as it would be to use dreams to understand theory, or art to understand dreams. In other words, I'm interested in questioning, problematizing, the hierarchies that seem self-evident within our culture. To amplify this view, I will reflect on some images which show the way certain artists in Western society have represented dreams visually.

1⌉ First, an engraving by Grandville, a nineteenth-century French engraver, much appreciated later on by the Surrealists. Grandville in fact committed suicide, I believe shortly after making this particular illustration. Here Grandville seems to be accepting that the narrative structure of the dream is constructed like a story with a beginning, a middle and an end. Grandville is showing a number of stages or incidents of the dream, and you can see or read this very clearly. You can see his sense of guilt, in fact a kind of sexual guilt. The dreamer is portrayed as fleeing from a giant eye, a pun of course, the relentless super-ego. He falls into the sea, where he finds himself clutching the cross while pursued by a dreadful sea monster – the battle continues in the unconscious. It is all quite beautifully illustrative of nineteenth-century dream imagery, I think. The cross at the bottom is intended as a symbol of salvation, and apparently the artist's despair was due to his inability to accept the power of conventional Christianity to save him from his guilt. There are two main issues; first, the legibility of these images – we know what they mean, we can read them – and second, the artist's conventional acceptance of a narrative structure of the dream, which he depicts in an almost filmic, episodic way.

1⌉ *Crime and Punishment,* wood engraving after J. Grandville, France, 1847

2⌉ This next image is by William Blake, a little study, almost a sketch, of a dreamed room. This is more artefactual than Grandville. It has the sketchy look of immediate notes on a dream or vision, rather than a revised version. The fact that there are contradictory perspectives – a space within a space – may well be one of the important issues in the work, giving it a sense of documentary reporting. Another interesting thing is the unresolved quality of the central figures, which appear to be somebody writing or drawing at a table, with a larger somebody standing over, with a light source like a halo above. The sentence at the bottom wasn't written by Blake but by a friend who annotated his estate after his death. It says, 'I suppose this to be a vision, indeed, I remember a conversation with Mr Blake about it.'

2⌉ Drawing, William Blake, England, early nineteenth century

3] Drawing, William Blake, England
c. 1819

3] This better-known Blake drawing, like the Grandville, has the quality of a conscious art work, in the sense that it has been clearly reworked. It exists in several versions, very different from the Blake sketch of the little room. It seems possible that this portrait, entitled by Blake's executor *The Man Who Taught Mr Blake Painting in His Dreams* could be, in fact, a secondary elaboration of the figure standing over the seated figure in that sketchy little study. It is worth noting the point that we recognize what we are seeing. There is a mythical being, a person with a third eye, drawn in detail, depicted conventionally just like something in the waking world of consensus reality, no problem in recognizing it as a representation.

4] The combination of image and word in this page from Dürer's notebooks is an important aspect to consider, from my perspective. The presentation is artefactual or documentary. As Dürer told it, his dream was of a great fall of water from heaven on to earth. His text tells how frightened he was, so that the next morning, as soon as he got up, he made these notes and this drawing. Blake felt his dreams were intelligible, Dürer didn't. We are confronted with a picture and a set of words, and we still don't know what disturbed the artist because he didn't know himself. In medical terminology, this is what's known as a prodromic dream, a dream that predicts or diagnoses a specific physical condition or disease, for instance, a woman dreaming of a red flower just before her menstruation begins.

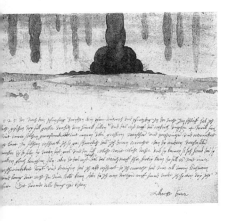

4] Notebook page, Albrecht Dürer, Germany, 1525

5] Next, a set of little coloured drawings from the notebooks of Hervey de Saint-Denis, who in the nineteenth century decided to study his dreams in detail in order to develop the capacity for lucid activity during sleep. The kind of consciousness that interested him involved being able to become fully aware that he was dreaming while dreaming, in order to move volitionally through the dream world. Hervey de Saint-Denis combined dream theories from exotic societies, perhaps derived from yogic practices, with nineteenth-century Western empiricism regarding inner states.

5] *Hypnogogic Studies,* Marquis d'Hervey de Saint-Denis, France, 1867

These are images of hypnogogic visions, visual notations or representations of what you might see just before falling asleep, those sparkly bits and bright colours you sometimes see while lying in bed with your eyes shut. Hervey de Saint-Denis made hundreds of these documentary drawings of what he called 'wheels of light, tiny revolving suns, coloured bubbles rising and falling . . . bright lines that cross and interlace, that roll up and make circles, lozenges and other geometric shapes'.

6] This is a late twentieth-century attempt to visually represent the same hypnagogic imagery by someone who was interested in mystic states, in the context of a set of doctrines and instructions derived from Buddhism and Hinduism. Here the subjective, abstract and uncodified light effects are seen as opportunities to experience a profound visionary illumination.

I will not elaborate on the meditation exercise which these diagrams illustrate, except to briefly list the stages of seeing that are relevant. First, not illustrated, looking into inner darkness; next, sighting the bright shapes so carefully diagrammed over many years by Hervey de Saint-Denis, and concentrating on the bright fragments appearing against a dark background, at which point the dark background is said to disappear entirely. The final stage in which the coloured fragments and shapes give way to a pure white light is also not illustrated. (You might like to try this exercise for yourself.)

6] *The Astral Light,* Ophiel, USA, 1961

7⟩ The most intriguing approach to dreams in modern art is not, to my way of thinking, Surrealist painting with its rebus-like homage to Freud's equation of dream imagery with wordplay. Instead, I am more inspired by this painting by Miró. It labels itself a photo in old-fashioned calligraphy, and says it depicts a dream colour. Taken as a whole, the painting may be ironic, it may be a joke, or it may be meant very seriously indeed as documentation, like Hervey de Saint-Denis's drawings. In any of these options, the artist would be commenting, very intelligently, on dream theory, by contrasting what the modern medium of photography and the traditional medium of painting can each achieve in documenting, illustrating, or evoking dreams.

7⟩ *Ceci est la couleur de mes rêves*, Joan Miró, France, 1925

8⟩ This is quite different, but equally analytic. It's by Giacometti, a set of precise diagrammatic drawings that record and investigate a troubling dream. It becomes a map or, as I sometimes think of it, a sketch for an installation. Giacometti says: 'I saw my design turn into an object . . . with immense pleasure I imagined myself walking on this disk and reading the story before me.' The everyday world of consensual, 'real' events would be glimpsed between panels representing specific dream scenes – an ever-changing sequence of relationships between dreamlife and life in the waking world.

8⟩ *The Dream, the Sphinx and the Death of T.*, Alberto Giacometti, France, 1946

9⟩ *The Dream Machine* is a simple revolving cardboard cylinder with a light bulb at the centre. Light emerges through configurations of slots and holes cut in the cardboard. The purpose of the machine is to stimulate imagination, image-formation and visionary experience.

Maximum effect is achieved with a light of at least 100 watts when flicker plays over closed lids brought as close as possible to the cylinder . . . The effects . . . continue to develop over a long period of time . . . In the bigger machines . . . whole moving pictures are produced and seem to be in flux in three dimensions on a brilliant screen directly in front of the eyes.

9⟩ Photomontage illustrating *The Dream Machine*, Brion Gysin and Ian Sommerville, France, 1962

With this cursory look at certain Western dream images, we have had a glimpse of some particular relationships between art and dream. With the exception of the Dürer, Giacometti and Miró we have been looking at pictures, not words. Nevertheless, I have emphasized the legibility of the images, which underlies their potential to be understood not just for personal or symbolic content but as insights about mental structures and the place of dreams in specific historical eras. It is possible to see them as accurate and insightful diagrams or maps.

These dream works fall roughly into three categories: the *illustrative* or descriptive, which picture or illustrate dream imagery of a more or less conventional kind; the *documentary* or artefactual, which attempt to achieve a kind of accurate reportage; and the *evocative*, which are meant to trigger off an experience similar to a dream. And sometimes there are intelligent combinations of these possibilities, as in the Miró painting. In my view, these works are as clear, as informed and as adequate in conveying a range of theoretical options and insights about dreams as contemporary texts were in different historical periods.

Several of my own works of the 1970s and 1980s were approaches to examining and relinquishing the dualism we set up between words and pictures, using dreams and dream imagery as basic materials. *Dream Mapping* (pp. 178–79) and *The Dream Seminar* were investigative works of mine made with groups of people, and which eventually led to some solo works, *Bad Dreams*, *Lucid Dreams* and all the works I have made using automatism, starting with *Sisters of Menon* (pp. 52–53).

Throughout all this work I have been convinced that illustrating dreams or describing dreams nowadays would be too limiting, with the increasing insistence on a codification of meaning and the correctness of certain theoretical approaches towards dreaming (*The Dream Police* is the name of a work I never made). Our society has given birth to an academic superego determined to repress individual dreams at the same moment as certain theories about dreams are dominating art criticism, literature, etc. As dreamers and artists, we need to retain a sense of humour while noticing how psychoanalysis is being increasingly 'used' to establish positions where academic specialists in theory can 'understand' on behalf of practitioners, who are supposed not to understand.

This old split between the ethnographer and the natives keeps coming back again and again. But the natives, ourselves, the artists who used to be experts in imagination and dream, do not seem to play this game as well as we might, not nearly as well as the New Caledonians, who occasionally knew how to ask a hard question.

I want to emphasize, again, that I have come across these insights in the process of making the works I've mentioned, as well as other works, like *Sometimes I Feel Like a Verb Instead of a Pronoun* (p. 64). I did not start off with a notion or theory I wished to illustrate. From the beginning of the 1970s onwards I was interested in visual ways of communicating dreams,[2] and research into this, combined with my personal predilections and experiences, are the roots of these thoughts. I am interested in creating a situation where, through my work, such things can distill out or clarify, making a new kind of sense both to me as the instigator and to the other people who establish the meaning of the situation, the meaning of the work, that is, the audience.

10⌉ My work takes the degree of lucidity I have found through dreams as the starting-point for a shared comprehension. My video programme, *Belshazzar's Feast*, is structured to provoke or seduce the viewer into an increased awareness.

10⌉ *Belshazzar's Feast* 1983/84; 20 minute video programme/installation; shows 'bonfire' version of the installation (Paris 1993)

It is not a dream or even based on a dream, but it is a mirror or a proposition, a proposal, like a dream can be. And the image in this mirror should be clear, whether you read it as personal and private or social and collective.

Nowadays we watch television, fall asleep, and dream in front of the set as people used to by their fireplaces. In this video piece, I'm considering the TV set as a substitute for the ancient hearth and the TV screen as a potential vehicle of reverie replacing the flames.

Some modern television reveries are collective. Some are experienced as intrusions, disturbances, messages, even warnings, just as in an old tale like Belshazzar's feast, which tells how a society's transgression of divine law was punished, advance warning of this came in the form of mysterious signs appearing on a wall.

My version quotes newspaper reports of 'ghost' images appearing on television, reports that invariably locate the source of such images outside the subjects who experience them. These projections thus become 'transmissions', messages that might appear on TV in our own living rooms.

Like the language of the flames ('tongues of fire'), these incoherent insights at the margins of society and at the edge of consciousness stand as signs of what cannot be repressed or alienated, signs of that which is always and already destroying the kingdom of law.

NOTES

1 See Barbara Einzig, 'Within and against: Susan Hiller's nonobjective reality', *Arts Magazine*, 66:2 (October 1991), p. 63. The citation is from James Clifford, *Person and Myth: Maurice Leenhardt in the Melanesian World* (Berkeley, California: University of California Press, 1982).

2 See David Coxhead and Susan Hiller, *Dreams: Visions of the Night*, (London: Thames & Hudson, 1976, 1981, 1989).

THE WORD AND THE DREAM

I'd like to speak with you today about interlinking ideas arising from my own work and my own process of work. Talking about these ideas leads to a set of philosophical Chinese boxes that appear during the act of being retrospective about what is an ongoing practice. Something complicated appears in the relationships between memory and the passage of time and history, recent art history . . . and my own sense of having lived through it, which becomes a curious issue as one gets older as an artist, simply because there is so much of a past . . . not just the collective past, or pasts in the plural, but one's own past of having made things and having thought thoughts about those things as one made them, and afterward. And then being aware of new perspectives brought to bear on the things one has made, some of which are enforced – that is, we all live through and are affected by shifts in cultural paradigms or fashions – but as well, one experiences changes in the way one personally thinks about past work, as seen through the emergence of more recent work, one's own and that of other artists. . .

Sometimes these newer ways of seeing and understanding are exhilarating, clarifying, liberating, but sometimes they are muddled, obscuring or distorting one's own understanding. . . The 'self' of an artist moves reflexively through a practice, modified by what has been learned from each work made.

This doesn't mean that I put these thoughts into words, in fact I'm suspicious of doing this, because from my point of view words fix things, pin them down in a way that has nothing to do with the fluid movement of awareness. So when I'm making work, I'm not thinking in words, and this seems to me to be true even when the piece of work itself includes words as part of a sound-track or as captions or texts. . .

When I use words I use them as materials in a material sense. I can do anything with words that I can do with materials like paper or paint – superimpose, blend, collage, tear, etc. I've used words quite a lot, beginning at a time when it wasn't fashionable in this country because the older modernist ideas hung on for ages – now it's considered OK again. But in the first interview I ever gave to an art magazine I said I lived far away from words. That increases my respect for them. I've learned to cope with temporary spells of mental incoherence that eventually formulate themselves quite precisely in a piece of

Edited transcript of a public lecture sponsored by the University of Exeter, 27 May, 1993. Hiller's text was based on a previous public lecture delivered on 23 November, 1992 at the University of Brighton, combined with an improvised slide talk given the following day to a group of postgraduate art and art history students at Goldsmith's College, London.

work. I can articulate clear thoughts about my work and ideas if I'm patient enough to let them focus themselves nonverbally first. This transaction between the nonverbal and the verbal makes it seem to me that representing or describing a thing or feeling means it's already in the past. So words seem to have more to do with memory and retrospection than with the present, the now. I value some invitations to speak because there is an unspoken within them, a further invitation to formulate a theme or link between different works I've made, to place them or illuminate them. I try to use these occasions to deepen my own understanding, rather than to produce a thumbnail sketch of my practice or a snapshot of the highlights of my career . . .

I've always made works that in my view take their form or shape from an initial starting-point in an artefact from our own culture. For example, in making a work called *Dedicated to the Unknown Artists* that originated in Brighton and was first exhibited in 1976 at the Gardner Centre Gallery of the University of Sussex, when I was artist in residence there . . . in this work, which started off with an interest in 'rough sea' postcards, I was struck by the juxtaposition of an image with a text. I was trying to pay attention equally to both aspects of the dual nature of these artefacts which always consisted of a both a picture and a designation. And I made a work that was a set of gigantic postcards, that is, panels in the proportion of a postcard, thirteen large panels each having words and images . . .

Today I want to look at an another early piece of mine called *Dream Mapping*, and to see how structural, formal, thematic aspects of it could relate to ongoing ideas that inform more recent works of mine you may be familiar with. And I want to try to go back to some of the ideas I've engaged with around language that might come together with the theme of dreams to become works you may have seen more recently . . . I'm thinking of the large wallpaper *Home Truths* paintings (actually I don't call them paintings, other people do, I call them scripts), the photographic self-portraits like *Midnight, Baker Street* or time-based installations like *Belshazzar's Feast* or *Magic Lantern*. My main interest is in looking at relationships of content. *Dream Mapping* was one of a series of collaborative works I made with other people in the mid-1970s, works that were not about producing objects, but about investigating – let's say investigating 'reality', in quotes. I called these pieces 'group investigations' . . .

Something I think interesting about Freud's notion of the uncanny is that this class of things is at once familiar and strange to us. Things which are ordinary and beneath notice can take on an aura of mystery and fear. Uncanny art would be art that frightens, because it somehow conveys something familiar that has been deeply repressed. Yet conveying uncanniness might be seen

somewhat differently, for example in the way that Robert Graves and other poets have theorized the true function of poetry to be the arousing of ancient human feelings of awe and strangeness . . . My works take as their starting-points quite ordinary artefacts like postcards, encyclopedias, dreams. *Belshazzar's Feast* originated in an article in *The Evening Standard*. I take all these things seriously as evidence of our shared human, cultural production and I don't find them alien or trivial. It's at the point of reception by certain types of viewers that the oddity or peculiarity of the works is defined; in other words it's the disturbance the works cause in some individuals that might mark them as odd or uncanny. And at the same time, the works make many other people feel familiar, comfortable, welcomed, relieved.

Although I didn't start off by wanting to be controversial, the way the work was received by some people demonstrated that I was. Experience showed me there is no such thing as 'common sense' that we all have in common, in fact the idea of common sense is just a way of enforcing an ideology in disguise. I did a work about this in 1973 and 1975, called *Enquiries/Inquiries*. In some ways *Enquiries/Inquiries* might be seen as the opposite of *Dream Mapping* since it uses a 'rational' format and presentation – it looks logical, and it is. But this logic is for the purpose of dislodging any idea that common sense is universal. It's interesting to me to look at this piece now, alongside *Dream Mapping*, a work that takes individual experiences that are usually private and finds things in common . . .

I'm going to make a confession; I don't believe in theory. I don't believe theory will save art. (That's a reference to Susan Sontag's idea that moralists always believe the caption can redeem the photograph.) In other words, I don't believe that words can correct images, that theory can radicalize art, that thinking can reform practice, that the ethnographer knows more than the natives.

I don't believe in theory, but I do believe in research and in experience and in knowledge that's embodied, not split off and relegated to the mind separately. Personally, I've never known a mind without a body. What this means to me, according to my own experience, is that one needs to re-feel everything as an artist and not take up ideas and issues that are second-hand or generalized as any kind of truth to pin your work to. At the same time I want to emphasize that I believe thoughts and feelings are collective, not private, that there are social and cultural formations that generate knowledge. This is a fascinating paradox of human being, and it's what artists deal with. Dreams are located somehow just here, in the paradoxical intersection of subjectivity and privacy with socio-cultural determinants.

In the 1970s I was thinking about things like: Where do images come from

in art? What's the relationship between an individual artist and art history, between inspiration and tradition? Between an artist as an individual and everyone else, society or whatever you would call it? Are ideas individual, unique and private, or do they have a collective origin? How come so many artists get the same idea at the same time, all around the world, not knowing of each other's work? How come only one of them gets the credit and the social rewards like fame and money for having the idea? How come this kind of situation is always told as a case of influences, certain people influencing others, instead of maybe a case of simultaneity? And so on, lots of intriguing questions.

I built up a couple of large works, such as *Fragments* [pp. 22–23], around the questions. At the same time I was doing some research on dreams in art.[1] A lot of societies other than our own see dreams as a metaphor of origination, originality, the place where something comes from. Songs, cures, solutions to problems, art images, even social movements and entire religious philosophies are said to have originated in dreams.

I'd like to show you a few of the images, artefacts and maps of dreams from other societies that have helped me in my own work. In dealing with these exotic visual materials it's essential to emphasize the potential legibility of the images, although to us they may remain cryptic and abstract. This doesn't mean they're unreadable to the people who made them. On the contrary . . .

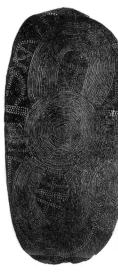

1] The Australian aboriginal concept of the Dreaming or Dreamtime is that of an era when the mythical ancestors of the aboriginals lived – but at the same time, it exists in the here and now as part of a contemporary situation that validates the events of today. It functions as a kind of charter of possibilities. The Dreamtime is eternal, a period when humans and nature came to be as they are now, but at the same time, this is happening now and always . . . The *churinga* is a material manifestation of this concept. It's a secret, numinous, occult map of Dreamtime events seen from the point of view of the spiritual essence of an individual, the part of the self that exists outside time. The map is both collectively known (to the particular group of related individuals who have inherited knowledge or information about a specific segment of the Dreamtime myth, which in turn describes a specific section of the Australian landscape) and individually owned and created.

1] Churinga, Nglia tribe, central Australia

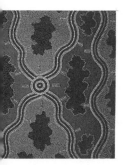

2⟩ Painting, Clifford
Possum Tjapaljarri,
Australia, 1982

2⟩ Traditionally *churinga* are kept hidden, but nowadays the acrylic painters of Papunya and other aboriginal communities are disclosing some aspects of their maps in paintings that are very public, available to anyone, and also very successful commercially. These paintings are more than aesthetic or symbolic representations of mythological features of the Australian landscape. There is a political agenda at work, in that each of the paintings is a map of the Dreamtime origins of a specific area of Australia. The paintings are therefore claims to land ownership, documents which establish primary land rights.

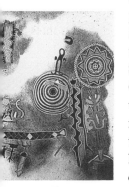

3⟩ Chumash cave
(detail), near Santa
Barbara, California

3⟩ The American landscape is marked with petroglyphs, pictographs, paintings, giant earthworks and other inscriptions that can no longer be deciphered, for example these wonderful paintings from a cave in the hills above Santa Barbara that I was able to visit on a recent trip to California. Unfortunately the significance of these artworks which were created by Chumash Indian people will now never be fully known. Only the purely formal aspects of their meticulous images can be appreciated today. All that is known about them is that the paintings are said to record or document the dream journeys of Chumash shamans. Most of the original inhabitants of California placed a special emphasis on dreams and the ability to dream lucidly and usefully.

4⟩ Petroglyphs,
Lewis Canyon,
Texas

4⟩ These incised notations on a rock wall are reported to have been created by Native Americans who ceremonially ate mescal buttons (*peyote*), slept for twenty-four hours by the rock wall, and on waking, recorded their dreams. This tradition of going to a special place to dream and doing something to enhance or amplify the dream is very widespread. For example, in ancient Greece and Rome, people travelled to sacred sites where special temples were dedicated to dreaming; at these sites, rituals were performed to intensify dreams. There are carved graffiti like these petroglyphs, but in languages that can still be read, at many Classical European sites, testifying to the dream experiences that took place there.

5] The Saora people of India create a sacred
art on the walls of their houses using
information obtained in dreams. These
pictographs are called *ittal* – 'writing'.
Anyone may paint one, following directions
given in a dream, but if the dream doesn't
specify exactly what form the picture should
take, a specialist artist is called in who will
prepare himself to receive this information in
a specially sought dream. Until this
particular dream occurs, the artist won't eat
and must sleep near the wall where the
picture is to be drawn. The theme of these
pictographs is almost always expressed as a
house, represented by a rectangle or square,
within which spiritual events and beings are
rendered schematically. These drawn homes
for spiritual beings are miniature temples
placed on ordinary house walls, a space
within a space that transforms the wall,
making it a more transparent border between
the spiritual and material worlds, or between
dream and waking reality.

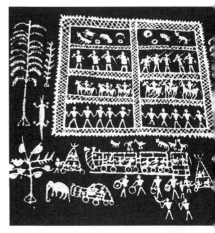

5] Ittal, Saora, Orissa, India, *c.* 1950

6] There are many intriguing ceremonies
and customs all over the world that aim to
improve the quality of dreams and the
intensity with which they are recalled. There
are also many fascinating approaches to
dream interpretation. For instance the
Iroquois of New York State traditionally had
specific procedures to follow to find out what
desires and wishes were expressed by a dream
– even if the dream had been completely
repressed and forgotten by the dreamer. They
held regular formal ceremonies to gratify
dream wishes, and for people who had
forgotten their dreams, dream-guessing
ceremonies in which cornhusk masks were
worn were held twice a year.

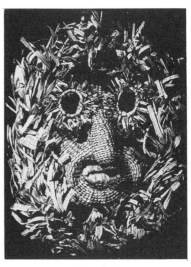

6] Iroquois mask, New York State,
c. 1915

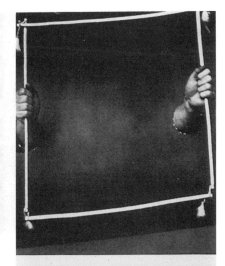

7⟧ Talisman, Navajo Nightway Chant, New Mexico, *c.* 1900

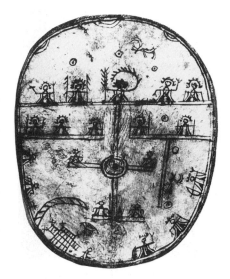

8⟧ Lapp shaman's drum, 1710

7⟧ Other dream ceremonies may be enactments of dreams that have achieved mythic status. For example, among the Navaho of the American SW, the Nightway chant and ritual which lasts for nine days and nights is said to record the dreams and visions of a mythical being known as *Bîtáhíni*, the Dreamer. All the aspects of this ritual – its dances, music, colours, incense, recipes, masks, sandpaintings and cures – are said to have been revealed to him in a dream. Participating in the ritual is a way of recreating the original dream, of becoming identified with the originator of the dream and the ritual, of recreating the mythic, transformative aspects of the dream for oneself. The art work produced during and for the ritual is 'original' in the sense of reproducing the art produced by the founding dream, and it is 'personal' in that it's produced anew by a specific individual who is a participant in the ritual.

This great black square or space which opens out from the folded, linear shape is a diagram illustrating the dimensional relationships between the material and spiritual worlds.

8⟧ This is a diagram or map, very precise. It depicts the shaman's dream journey through the centre of the three worlds – earth, heaven, the underworld. The drum itself is said to project the primal sound that organizes the cosmos. On a more mundane level, the sound of this annotated drum induces a state of ecstasy that serves as the vehicle for the shaman's journey.

9] This is explicitly drawn as a map of roads between the dreamed levels of heaven, middle earth and the underworld, roads that can be travelled by humans and supernaturals. The idea of the map is to show how not to get lost during dreams by going to the wrong place. Personal information obtained in a dream is made public, is shared. Paths to the worlds of dawn, evening, and night pass through the pole star which is mapped at the centre of the world, while sun, moon, planets and stars shine simultaneously.

9] Drawing, Chuckchi, Siberia, nineteenth century

In all of these examples there has been a visual language that can be read by everyone within the society. There has been a connection between the personal and private and the collective and public. In some ways it seems that 'drawing' might actually be better understood as 'writing', in the same sense that the ancient Greeks had only one word for what we divide into two ideas, pertaining separately to images and to words. It might be just as valid to think about these dream pictures, artefacts, diagrams and maps as texts as it is to think of them as depictions. In some, for instance the *ittal* from Orissa, this is completely justified from the perspective of the makers themselves, in other cases, like the Australian *churinga* or Lapp drum, textuality is implied (since both may serve as historical records), while the cave paintings from California or the petroglyphs from Texas seem as close to hieroglyphs as to aesthetics. The Navajo talisman is said to be a diagram of dimensionality, the Iroquois mask a kind of projection screen. . . . All this would take more time than I have at my disposal to develop properly. But I hope you will remember that I have emphasized the legibility of these pictures. Some of them are even called 'writings' quite explicitly. These dream materials fall roughly into three categories: the *evocative*, which are meant to trigger off an experience similar to a dream; the *illustrative* or descriptive, which picture or illustrate dream imagery of a more or less conventional kind; and the *documentary* or artefactual, which are a form of reportage.

10] This brings me to my piece called *Dream Mapping*, which took place in 1974 as a collective work for ten invited participants. I found a site in the country where there was an unusual occurrence of fairy rings, circles formed by the *marasmius oreades* mushroom. I wanted to look into some traditional British ideas about dreaming, for example the idea that if you fall asleep in a fairy circle you'll be carried away somewhere, perhaps lose your mind and gain fairy knowledge, etc.

I gave participants a dream notebook with a map of the dream site on the cover. I provided books with space for both words and pictures, and asked participants for a month before we met as a group to try to start evolving a way of notating dreams visually, to try to get away from the idea of telling dreams in words. So we had diagrams, notations, maps in order to break apart the received notion of dream as a narrative in linear time. I saw my role as creating a structure in which certain possibilities of memory and awareness would be enabled, and perhaps a collective language would emerge.

After a month, we met at the site. For three nights people slept out of doors in the mushroom circle of their choice. This was already taking the dream from

10] *Dream Mapping* (detail) 1974; site specific group event, Hampshire, England; participant's dream notebook

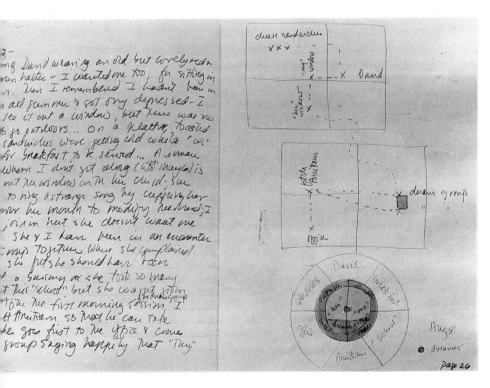

inside to outside. Since we came together as a group to do this, it was already a collective situation. Each morning I asked participants to make drawings or diagrams of their dreams, omitting all words. Perhaps it could be said that the art took place privately and individually, while only the documentation – the drawings – is visible. I like these dream maps very much. There is a light-hearted struggle to make something visible.

Dream Mapping was something open-ended, experiential, more like a roughly choreographed dance than a scientific experiment. The final stage of the piece was making three collective dream maps. We took all the individual diagrams from each day and superimposed them, ending up with a collective dream notation of the group's nightly dreams. We certainly didn't have the same dreams, although there were interesting coincidences. But perhaps because of culturally determined limits on kinds of notations, there were very intriguing overlaps where two or more individual dream events overlapped. We all became very elated whenever this happened. For instance, on one night 'dolphins' overlapped with 'clouds' and this became the concept 'cloud/dolphin', which seemed to have to do with the way new concepts or ideas come about.

The documentation of Dream Mapping is now the only evidence that something took place. Although this work was something of a touchstone for me later, it was otherwise limited to the participants, who were also the audience. I guess I believe, although some of you may not, that there is something communicative about art, that it needs to go beyond the artist and the primary audience for the work, and that if it doesn't it doesn't really qualify as art because it isn't available, it isn't part of a discourse.

So I began to think that Dream Mapping and other works were problematic. Nevertheless, I'm still very fond of this piece. Realism may have dictated my conclusion that an end product that can freely circulate over time and space is a better solution than a one-off event. But speaking retrospectively, I would like to emphasize that what a piece of work like Dream Mapping does very effectively is to focus participants on lived experience and embodied knowledge, eliminating any mind/body split. Embodied knowledge isn't the same as theory, it isn't exactly the same as visual experience either. Embodied knowledge may be in conflict with theory and with visual experience. We have knowledge of what we have physically known, and we have knowledge via what we have physically known. This knowledge can't be alienated from us but our access to it may be limited and confused.

I believe that art can allow us access to this knowledge, which will be different for each of us. In this way, art is a vehicle for shifts in understanding and behaviour. Dream Mapping effectively intensified the ordinary. By making public what is normally private, it showed what we didn't know that we knew.

In the years since *Dream Mapping*, I've tried to find other ways to express this understanding to wider audiences, while still emphasizing the reflexive, performative aspects of art practice. Many more people have seen *Belshazzar's Feast* or *Monument* than could ever have participated in or heard about works like *Dream Mapping*. But I hope my original intention of allowing participants access to their own capacities for revelation, in the context of collective histories, hasn't been forgotten or substantially diluted in my later works.

NOTE
1 David Coxhead and Susan Hiller, *Dreams: Visions of the Night*, (London: Thames & Hudson, TK, 1976, 1981, 1989).

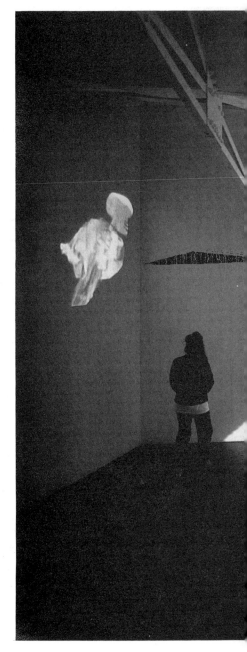

An Entertainment (detail) 1990/91; four interlocking
video programmes with sound; size variable

WORKING THROUGH CULTURE

CONVENTIONS OF SEEING

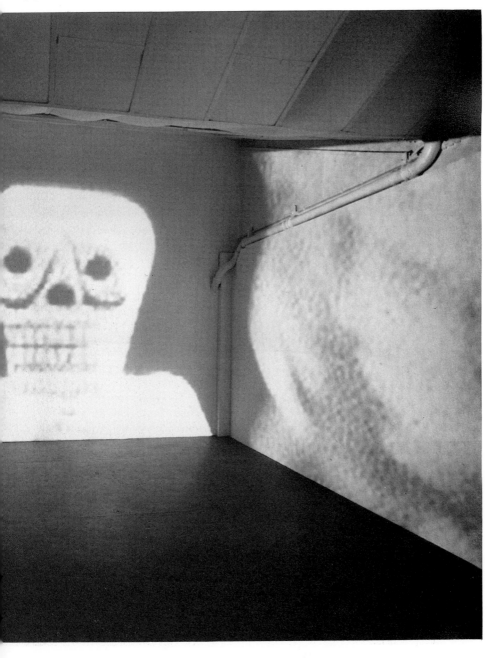

EDITOR'S INTRODUCTION

> In the relation of a known and unknown quality, the unknown varies and modifies the known.
>
> Kurt Schwitters, *Merz 1*

The art of Susan Hiller may be said to be a 'working through' of culture.[1] All materials in her hands are handled as artefacts of culture; there are no blanks. If she uses paper or paint she does so in such a way that how that paper or paint has been made somehow comes into play. It is as if the production processes that have been bound into the materials are unbound and set into play through the way she uses them.

The four talks, interviews and conversations below deal with this issue of employing cultural artefacts in works of art. As Hiller points out in 'The idea of multiplicity in art', this topic has come to the fore, 'because the eighties were certainly about recycling cultural imagery and the nineties so far appear to be about recycling objects'. Here Hiller extends the question of singularity versus multiplicity to the realm of prints/photography/video versus painting and sculpture, addressing the philosophical biases behind art-historical categories. The conversation with Colin Gardner is included here because it deals specifically with the differences and shared ground between American and British culture. The contemporary emphasis upon theory is considered within the framework of the educational systems of both countries. Discussions of the presentation of cultural artefacts are extended into the arenas of marketing and mass media.

Hiller's 'working through' of cultural artefacts – in this case, postcards – in *Dedicated to the Unknown Artists* (p. 138)

reveals their hidden aspects, the ways they have already been 'made up', labelled (often falsely), hand-painted, retouched, framed. This installation is comprised of hundreds of 'Rough Sea' postcards of the British coastline. Eleanor Heartney has commented on how the cataloguing of these cards made clear that the 'images conform to specific conventions, a reminder that the nineteenth-century picturesque still lives in our conviction that landscape looks most "natural" when it adheres to preexisting notions about what is scenic'. Heartney also notes that Hiller's documentation and analysis of these images are scientific techniques, yet her use of them reveals that they are not 'objective' procedures but creative of the phenomena they describe.[2] Additionally, the repetition of these images – the same wave over and over on the same rock – allows rhythmic and sculptural qualities to emerge, as in the arrangment of the *10 Months* photographs (p. 48).

Enquiries/Inquiries is also a work of repetition. Shown for the first time at Gallery House in London early in 1973, this is a slide show using two projectors. It is a 'working through' of 'facts' from two sources, one an English book called *Everything Within: A Library of Information for the Home*, dating 'sometime subsequent to the accession of Edward VIII but prior to the reign of Elizabeth II' and the other an American collection of a similar nature 'dated from some time during the Presidential term of Franklin D. Roosevelt but prior to the term of office of Harry S. Truman'.[3] These materials, appearing over and over on the wall as configurations of darkness

and light, reveal how 'facts' are also 'made up'.

Another method of 'unbinding' the materials is to move them and to change their scale. In the recent video installation *An Entertainment* (p. 132), the puppets of Punch and Judy shows are blown up and cast as patterns of light moving over the four walls that hold us in. 'By enlarging the images I'm using nowadays, I'm trying hard to engage the viewer in levels of meaning that come through seeing, and the emotional and intellectual reactions we have towards what we see.'

Rhythms, phases and repetition in all of these works suggest again the features of a language, the large scale or suggestion of duration in time engaging our contrasting 'real time' experiences with these same objects or images. The objects are thus carried out of their emphemeral, momentary status; like a very common word repeated over and over until it becomes strange, repetition allows banal cultural images to be unbound from our blind use of them, forcing us to see these postcards, puppets and texts and to become aware of how it is that we see.

NOTES

1 Kurt Schwitters originally used the term 'working through' to describe his painstaking revision of literary texts, and then in relation to his late collages of 1937 to 1947. In the latter he reworked reproductions of paintings by other artists, as well as some of his own earlier collages.

He described the process as a 'playing off of material against material'.

2 Eleanor Heartney, 'Susan Hiller', *Art News* (June 1988), p. 193.

3 Susan Hiller, *Susan Hiller: Recent Works* (Cambridge and Oxford: Kettle's Yard and the Museum of Modern Art, 1978), pp. 14–15.

THIRTEEN MALE ABSENCES *an interview with Paul Buck*

Your most recent finished work is Fragments *(p. 22). It's extremely complex, but perhaps you could describe it briefly.*

The basic materials are approximately 300 very small pieces of broken pottery that I collected years ago from the surface of a mound which had been a rubbish dump for Native Americans. I have painted 300-odd representations of these potsherds, in earth colours, so that my activity was analogous to the initial work of the artists. For they get their ideas for pottery designs from found broken pieces of old pottery. So I'm suggesting that art activity is always a picking up of fragmented bits and using them to create the new. I'm also suggesting that art and archaeology are similar activities in that the action of sorting, classifying and analysing experienced reality is the same for both artist and archaeologist.

The piece has a lot to say about the role of women in art.

I'm saying that very strongly. By including in the piece various statements by contemporary American Indian potters, I've placed them within the context of contemporary art. All artists validate their work in two ways, just like these women do: they either get their ideas from prior art, or inspiration . . . the aspects of dreams in the piece.

The male is shown by his absence, right?

Yes, in a section called 'thirteen male absences'. One of the reasons that women in this culture have trouble achieving credibility as artists is the patriarchy simply cannot accept women as being primary makers of meaning. That's where the problem comes. When sorting the fragments I found thirteen pieces of flint, the debris left over after projectile point-making, spearheads or arrowheads. The male was signified by absence of his artefacts. It seemed to me important to present that as a kind of alternative picture to the way we usually see things, the female absent from culture.

The display concept of the material is extremely challenging to an interested viewer.

I could describe the room installation as dealing with a reconciliation between painting and sculpture. I could also describe one side of the room as dealing with developmental conceptions of time in that I arranged the materials in three wall sections, first monochrome, second bichrome shards, and third polychrome shards. On that side of the room it's also significant that I've placed

Interview of April 1978 originally published in *Centrefold: The Artists' News Magazine*, Toronto, 1979, vol.4, no. 2. Paul Buck writes for bands and singers, and is a poet, novelist and translator.

the pictures above the shards, saying it's already dealing with our ideas about the material rather than the material itself. On the other side where I put the fragments above the pictures, I arranged things by shape and size, which are actual conditions of the material brought about through experienced time. Of course, the major part of the work is the floor section that deals with the whole reality and representation issue – it's a more lyrical version in a way.

Do you feel that perhaps it's so complex, so many possibilities open to reading?
The whole idea of analysis to me is a way of expressing one's freedom, mental freedom to understand the world. When you do a piece like this, you are entirely free to make the kind of connections you want to make. I don't think I did anything which was inaccurate in terms of that body of material, and it seems to me that the activity of anthropologists and archaeologists is 'art' in the sense that it's a playful formulation, reshuffling of categories, categories of knowledge and information.

You don't actually say the pottery work was originally made by women do you?
No. But in the 'Art (Tradition) and Dream (Inspiration)' section (p. 30) where some short texts appear, it should be obvious, since the pronouns are all 'she' and 'her' . . . It comes across quite clearly that men are only mentioned in absence, and that did seem to provoke some anger. Good, it ought to anger some people.

How was Dedicated to the Unknown Artists *(p. 138) sparked off?*
I found a picture postcard in Weston-super-Mare that said 'Rough Sea', and I was fascinated by the fact it had a caption. Then a few weeks later I found another one that said, 'Rough Sea, Brighton' and I realized if there were two, that implied the existence of a set, and after that for about three years I literally found them everywhere.

Why isn't the work called Rough Sea?
It's called *Dedicated to the Unknown Artists* because I took the stance of acting as curator for the work of the unknown artists who created this specific body of materials. One has on the one hand an image and on the other a verbal designation. A mysterious doubling or redundancy. By a kind of truth to materials I did a visual presentation of their work and an analysis, a set of tabulations.

You also noted relevant remarks of the senders.
Like 'We had a storm today, just like this one.' Sometimes they made lovely poetic descriptions. One brilliant one led me to discover a whole category of cards. This simply had written on the back: 'faked'. I looked hard and realized the waves were faked, and that led me to others. They were initially pictures of very calm seas and this idea of 'rough sea' was overriding. This shows the power of words to structure reality.

All your work seems related to art activity, doesn't it?

It's a consistency, but I would say I contradict the notion of art being about itself. Because all the pieces are about art activity they are also about art with reference to life. What I'm looking at in *Unknown Artists* is a set of cultural ideas that basically come down to certain obsessions about nature in relation to culture. I mean the sea threatening the buildings. Notions of sexuality come into that, notions of male and female, active and passive. I'm interested in cultural metaphors . . .

Another work where you use cultural materials is Enquiries/Inquiries.
That's right. *Enquiries/Inquiries* is a very basic exercise in applying certain notions about what culture is, about what a fact is, about what reality is. I'm dealing with the body of our own folklore which purports to be true fact, and I'm trying to bring into question what a fact actually is, and what it says about what we think is the nature of reality.

also facing⌉ *Dedicated to the Unknown Artists* (details) 1972–76; 305 postcards, charts, maps, books, etc.; mounted on fourteen panels each 66 × 104.8

Enquiries *is based on an English encyclopedia work, and* Inquiries *on an American. Both of the 1940s and 1950s.*

Yes. What struck me as odd was that each question was followed by a single correct answer, just like in the Catholic catechism. When the texts are presented as images and shared by an audience to contemplate together, as you can do with slides, an awareness develops in the audience, first of a kind of embarrassment or kind of humorous denial of the fact. I mean people at first feel that there's some nonsense involved in it, which is very hopeful to me. It seems very promising that people can look at their own cultural data in that way. And later, at least from my viewpoint, in watching comes almost a kind of terror at the extent to which we are conditioned through language to accept certain notions of truth and reality, which may in fact be contradicted by our lived experience.

Both Enquiries *and* Inquiries *have been shown separately, but at the*
Serpentine in 1976 you showed them as one piece. What struck you at the time?
I felt personally responsible and embarrassed by the attitudes in the American
set. They seemed to me to be overwhelmingly about two things, one a kind of
social cynicism . . . for example, slang vocabulary words for politics that relate
to corruption, exchange of favours, etc. The other a disorientation, with
questions like 'Can an object ever be wider than it is long?' Things like that
seem to express a complete misalignment in relationship to the environment
which has to be put right, once and for all, by getting the facts straight. The
British set was full of social snobbishness and a kind of imperialistic bias that
the whole world is available. English people watching have a reversal of my
reactions. Embarrassed at their own exposed culture, and finding the American
exotic and folksy.

When you commenced this work you were more interested in the materials to be
used?
That's right. That's why I always thought of the piece as an extension of
painting. Basically it's a collage transformed into another medium. I wanted to
represent the pieces of paper and the actual texts as they appeared to be, but to
illuminate them as much as possible by presenting these images as slides. They
lend themselves to a kind of cyclical repetitive rhythm, which is what you get in
the slide show. It's a cycle of forty minutes in which you can come in at any
point and leave at any point.

The Photomat Portraits *have been in progress since 1970, I believe.*
Yes. What interests me about them is that like the postcards, the tail-end of the
landscape tradition, the photomats are contemporary portrait format. The fact
that in our tradition of formal portraiture we have a weird situation where an
artist over a period of time paints a picture of a person who is a passive object
for the artist who composes a composite image of the person through time,
which ends up being one image which falsifies the time experience of the actual
making of the portrait.

You take the subjects to a number of booths and allow them to take their own
portraits in whatever manner they wish?
Right. The variations come in the way the subject reacts in the cameras,
colours, lighting . . .

And faultiness of machinery?
Yes, because I also collect discards, photos thrown away for one reason or
another near the machines.

And once the material is collected?
Then I look at the photos and come up with some kind of statement that brings
into focus what the person is saying about himself or herself.

POST?MODERN?ISM?: NOTES

Isms come and go but work goes on . . . My work has been going on through several ism's . . . Isms are about defining territories and excluding some people from the ranks of the privileged . . . Never having benefited from any ism, I've got into the habit of considering myself an outsider . . . So I find myself on this panel with some bewilderment.

Post?modern?ism? IS IT WORTH DISCUSSING, I wondered . . .

NO, if it means a return to certain *formats*

YES, if it means a return to *content*

NO, if it means a stylish reinforcement of the conservative, racist and sexist predilections of the art establishment

YES, if it means a genuinely subversive examination of the social and psychological origins of our images and ideas

NO, if it provides dealers and museums with old-fashioned easy-to-handle items that shock and titillate

YES, if it avoids the traps of both avant-gardism and nostalgia

NO, if it means falling back on a superficial and ideologically-constructed 'primitivism'

YES, if it represents a real desire to break the enforced superficiality of *some* late-modernist/conceptual practices

NO, if it means marginal subcultures are ripped-off and misrepresented

YES, if it means popular codes and formats are taken seriously

Hiller's typed notes for a panel discussion on postmodernism at the Institute of Contemporary Art, London, 29 May, 1982 were in this form. The event was organized by art critic John Roberts; other panellists were Stuart Brisley, Michael Newman, John Stezaker, Denis Masi, Alexis Hunter and Graham Crowley.

NO, if jokey historical references are used to disguise real contemporary struggles for the recognition of new practices, marginalized groups, radical attitudes

YES, if it means we are closing the gap between 'experience' (ours) and 'reality' (theirs)

NO, if the notion of history-as-farce merely reinforces conservative interests in order to retrieve a threatened territory

YES, if at last we have recognized that history (and art history) are *constructed*

NO, if it refers to a set of sly, tongue-in-cheek, opportunistic attitudes that *trivialize* the potential of art

YES, if it means freeing ourselves from internalized authoritarian voices urging us to *repress* our feelings and 'objectify' (censor) our means of expression

NO, if it means artists allowing themselves to be conned by words like 'play' and 'pleasure', so that we never ask, Whose pleasure? Whose game?

YES, if it means recognizing art as a kind of work leading to the expression of the deepest levels of our shared subjectivity

I was an anthropologist before becoming an artist. After a couple of painting exhibitions and a number of real-time pieces for group participation, I began making works that used cultural artefacts as basic materials. An attitude towards 'form' had become, almost inevitably, it seemed, an attitude towards 'content', as my two kinds of training merged. This is an oversimplification, of course, since I had left anthropology and developed a critique of its practice for reasons very similar to my shift from minimalist painting to this new *something*.

Too tedious to trace history of my work from 1972 to the present but:
 1 *list of artefacts* (cultural discards): photomat images, postcards, broken pottery and china, dreams (my own and other peoples'), ESP experiences, texts from popular encyclopedias, photographs of myself when pregnant, automatisms of various sorts, language, my own paintings, memorial plaques.

2 *approach to form*: lend self to the materials, discover what is required to bring out the 'mute speech' of the objects, reveal the contradictions and depths; this is a new kind of 'truth to materials', an extension of this old sculptural notion. Each piece takes its own form.

In 1972 I wrote that I was investigating the origins of images and ideas. I *assumed* that these were shared, that art was social, that analysis and pleasure were not in opposition, that artists could, and ought to be, simultaneously makers and thinkers.

There was also an *assumption* that by looking at aspects of life usually ignored in art practice, or at cultural items normally considered to be trivial debris, a new 'take' on social reality might emerge. Thus my work was never exclusively self-referential or self-contained, which made it unfashionable in the years it first emerged.

Ten years later, I can see that at the basis of these assumptions is the belief that we are all simultaneously the beneficiaries and the victims of our cultural heritage. My work proposes a paraconceptual notion of culture – that is, it aims to reveal the extent to which existing conceptual models are inadequate because they exclude or deny some part of reality. It is, as a friend once pointed out to me, an exorcism as well as a celebration.

AN AUDIENCE FOR ART *a conversation with Colin Gardner*

Although I first saw your video Belshazzar's Feast *(1983–84) at a London gallery, it was actually first aired on Channel 4 TV.*
Yes. When Channel 4 started in England, it had a very special brief. It was meant to include intellectual or serious kinds of programmes. And that also meant that you had things like American football. Minority thinkers. And it had a very specific brief to emphasize 'multiculturalism', to show political films and work by women. But it is a commercial channel. It has advertising. And what they found was that if you target audiences along those lines and you select compatible commercial products, you can do very well. So it had a very specific commercial brief. It didn't have this American idea of there being this big kind of mass audience out there. Screening *Belshazzar's Feast* was targeting particular specialist audiences through artists' videos. I'm not really sure, but perhaps they targeted a couple of thousand people or something.

But Channel 4 unfortunately has changed a little bit. It's having to give up some of those programmes. It's still very interesting, with an enormous audience. I mean, millions of people watch it. It's not a tiny little local channel, it's national.

I did notice that Cheers *is shown on it though.*
Yes, all those American shows; *Cheers, LA Law, Roseanne, Beverly Hills 90210* or whatever it is, they're all on Channel 4. This is minority viewing in England, so that's interesting.

The whole idea of seeing messages in your TV after close-down is very much part of the British television experience. It seems to me that this particular English context is important because English television actually closes down, which is essential to the idea of your piece. In Britain you are given a certain amount of relief from the relentless, twenty-four-hour non-stop bombardment that you get in this country. And English TV only has four channels. They've only actually had the fourth channel for about six, seven years, I think. And around about one in the morning, after The Epilogue, *the religious message, the test card comes on and then the screen goes blank. And it doesn't come on again until the following morning, around 7.00 a.m. I think[1]. And you get the test card for a few more hours and then programming starts around 11.00 in the*

Edited transcript of Hiller's presentation as Visiting Art Council Chair at the University of California, Los Angeles, 25 March, 1991. The conversation took place in a staged environment arranged by the artist to resemble a TV talk-show living-room, with two armchairs in front of large projected images of flames from *Belshazzar's Feast*. Colin Gardner is a writer who teaches at the University of California, Los Angeles and at the Art Center College of Design, Pasadena.

morning. Sometimes a Welsh programme, for example. So your video is very much built upon the cultural context.

Do you think so? Well, of course, I'm going to disagree with you. The reason I don't think it's totally particular to England is because this idea that people use their television sets to project fantasies on to is something that occurs wherever there is television.

Yeah. The idea of falling asleep with the TV on, whereby it influences perhaps what you dream about, and then you wake up and you're not sure how much time has elapsed. Except perhaps by the realization that maybe two hours worth of programming has gone by, so that TV acts as an index of time passing.

Well, that's the basic analogy. I think that's all very clear. This idea, which has been said before, first by Marshall McLuhan as far as I know, and then by numerous other artists and commentators, that television functions now as the hearth or fireplace used to. And ever since the beginning of the human race, there has been this relationship between people and fire as a moving screen in the place where they live. People always used their fireplaces to sit around and look at the flames and see shapes, tell stories and so forth. Now that most people don't have fireplaces, they have television sets that tend to function in the same way.

There are some programmes that you can relax to, even I think simulated fire. Isn't it in New York where they have the twenty-four-hour fire on New Years? So this was my way of trying to take that quite a bit further and talk about that particular kind of phenomenon of reverie in a very overt way.

Can you explain a little bit about the Belshazzar's feast element of the story?
Well, that's the story from the Old Testament. John Martin did a wonderful Belshazzar piece. It's about twelve feet high. William Walton wrote an opera based on it, and there's this wonderful Rembrandt painting. The child on this tape has seen that painting and is trying to talk about it. He's talking about the painting, not the actual story in the Bible. It's the story of Nebuchadnezzar and his corrupt court, who were in the middle of a very great feast when mysterious words appeared, written by a disembodied hand on the wall above their banquet table. And they called in all the king's soothsayers, who were unable to read this message because it was in an unknown language or indecipherable script, or something of the sort. Finally they called upon the prophet Daniel, who at that time was a very old man. The 'Daniel in the Lion's Den' story was from much earlier in his life. He was by now a very, very old man, so they called him out of retirement and asked him what this message said. Now he couldn't read it either, but he interpreted it. And that's one of the things that interests me a lot, the difference between reading and interpretation. And he said it says, *mene,*

mene, tekel, upharsin, which means 'You have been weighed on the scales of justice and found wanting, and your kingdom will be destroyed and given to the Persians.' So it's one of those stories about something quite inevitable and mysterious, an indecipherable occurrence which is a prophecy of doom in some way. And this is a theme that runs through a lot of what I like to think of, quite affectionately, as lunatic fringe perceptions. That whatever the message is, the message is always a prophecy of doom. In my video, the newspaper stories about the people who saw the ghostly faces on their TV screens, you probably noticed that it leads from the face to some kind of doom-laden message. When it occurs in our society, this kind of vision always causes anxiety.

So I began to think about the newspaper stories, and realized that what had happened was that the capacity of the human mind to visualize and to use a moving screen or patterned screen to project different stories on to, that ability is so marginalized in our particular society that it has to be empirically treated. In other words, the messages must come from outside. So the newspaper reporter who set about investigating this phenomenon assumed that there was an external source of this emanation, as the text says. And then they go into things like, 'Are there flying saucers? No, there aren't, of course, but could there be?' There was a denial of the capacity to dream or the capacity to rewrite the television story. In other words, society denies a very pleasurable, very ancient, universal ability that people have. In that sense I considered my piece to be a kind of critique of empiricism. What I wanted to do was to try to make something that would allow people, or even convince people, that this ability was there. So that in my piece they see shapes and so forth and not just flames.

> Right. I noticed when I was looking at it that the blaze as a catalyst to enter into a reverie is always there, but the structure of your video – the frame, the voices, and so on – tend to rein you back in again. There's always that cultural framework, as if to say, 'OK, that's enough reverie. Let's get back down to empirical brass tacks. Either reverie or empiricism, one or the other.' But you were telling me once before that this attitude tends to be built into the culture to a large degree, because the idea of the uncanny, which is triggered by these kinds of events, has been part of popular culture for a long time. Particularly in, say, the circus or fairground side-show. And that has also played back into your work.

The kind of artefacts our culture produces often take the guise of technical tools for furthering knowledge, whereas, in fact, their historical uses are equally that of side-show or fairground pleasure-making instruments. Such as the slide projector, which I've done a piece called *Magic Lantern* about. In that piece I tried to evoke the unknown history of the slide projector as originally

and obviously the precursor of the cinema. And the first magic lantern shows were often ghost tales and scary things. They used to be advertised as 'a thrill in the dark'. And that side of it does interest me a lot: the fact that popular culture has maintained this attachment. But at the same time, I feel that my work is an attempt to take that a little bit more seriously. That is, both the denial that goes on culturally, but also the reality of that side of our being. Yet I also hope that I'm not bringing people back to a simple empirical explanation. It's always ironic. It *has* to be ironic. My positioning is ironic on it too.

Yes. I think the audience is certainly distanced to create a framework to analyse rather than to be sucked into some kind of hippy-dippy, hocus-pocus.

Well, some people are.

Some people are. But your last major installation, An Entertainment *(1990) fed that back into the 'Punch and Judy Show' as a popular entertainment. And you were suggesting that it's very much a controlling device for the potential reverie/fantasy of children, where all these really ugly elements are put into a very coherent context and therefore made safe. Could you discuss that a little bit?*

I filmed over three years at various itinerant 'Punch and Judy Shows' in England. And then what I made was a boxed theatre. But it's very, very big. The walls are twelve feet high and twenty feet long. And these puppets are re-projected and altered considerably because I used tiny little bits which are looped, slowed down, frozen and so forth. So that the adult audience is reduced in scale in relationship to these enormous figures, as well as bombarded on all sides by colour and sound, which, like a child, one doesn't know exactly how to decode. Something may happen behind you or to the side. There are moments of silence and darkness; pictures may travel around the walls and then reverse and go around the other way in sequence. All four walls may suddenly come to life at once and move in unison. So then a kind of choreographed disorientation occurs. This is something that's very important in a lot of my work. The idea is to problematize ourselves, so that we know we have eyes and ears, but they're separate and they're perceiving differently. And not necessarily in sync or giving us the same unified message all the time. We have the rest of our body which feels and touches and is very responsive to shifts of scale and so forth. And then in the middle of all this is what we think of as 'the self'. Which I think of as 'selves', of course. And I think the basic thing I'm trying to reintroduce or emphasize is this kind of complexity.

What happens in the normal everyday world with the 'Punch and Judy Show' is that kids are taken to it by their parents. The children are usually terrified. After all, it is a story of a misshapen, phallic creature – who in fact goes back to Attic Comedy as a comic type – who murders his wife, beats up

and kills his child and basically kills everybody else that he has a chance to, with a lot of big stick fighting. All this is actually the origin of our word 'slapstick'. Punch's stick is the slapstick, right? I always hated that kind of comedy, the Three Stooges and all that. Anyway, so the child is perplexed and terrified, and the parents say, 'Oh, look at Mr Punch. Isn't he cute? Isn't he sweet? Isn't it funny?' And this is where it all starts. A denial of one's own relationship to some kind of reality. Because you're told your perceptions are quite wrong. So my piece undoes that. It's a really scary piece, I hope. It frightens me when I see it now.

So it's really an attempt to come to grips with the kind of atavistic elements that are suppressed by a rational discourse. Getting them to leap back out again. Yes, because in my version I got rid of a lot of the Victorian characters: the policeman, the judge and so forth. And the dead puppets don't come back to life again at the end of my version, either. And the story isn't told from beginning to end. I was very lucky because I found some puppet shows that used the really frightening bits like Death and the Hangman and so forth. And I really loved those elements, they're wonderful. So mine is a myth; it's telling the myth of these cultural dichotomies between good and evil, male and female, rationality and intuition. Because Punch *is* Britain. He is the jolly, Mr Average, rational man and kills everybody in sight. He's usually whistling; he has a funny little song which he sings. Those dichotomies are not only ancient culturally, they might even be biological . . . You have to understand that in the Punch and Judy play there's always a puppeteer. Punch is always on the puppeteer's right hand (of course the audience sees this on the left hand). And all the other characters are on the left hand, so they're all interchangeable. You have the baby, the woman, all the animals, the horse, the crocodile, etc., etc., Death, the Devil. They're all left hand-characters. Punch is the right-hand character. And so the whole structure of the thing goes back to issues of left/right brain.

So most of your work really accentuates binary structures, and you use that as a jumping off point to try and undo it. But, for example, in Belshazzar's Feast, in that kind of structure, even a pre-given narrative is still present. I notice for example that the video opens with the fire very low, as if it's just been lit. And it gradually wells up, comes into full prominence, and then dies back down again. So you have a whole sense of something, a cycle, a very coherent narrative structure. Even in creating a narrative that's attempting to get the audience to break out of that very structure. It's as if you're saying you can't break out of it really, except maybe temporarily in the reverie.
I guess I wanted it all at once and at the same time. I want to think that you can have it both ways. And also the narrative, such as it is, is always carried on in the visual, not in the text.

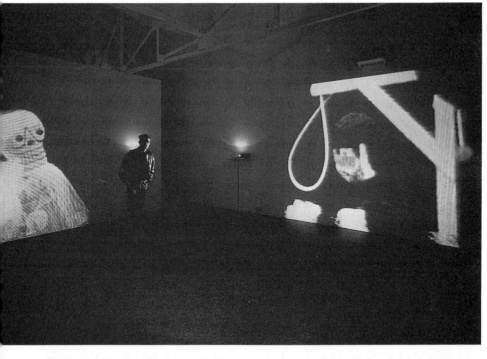

An Entertainment (details) 1990/1; four interlocking video programmes with sound; size variable

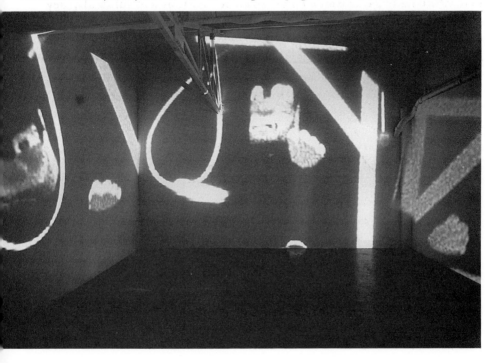

Right.
So again there's a reversal of several things. It's why I read the newspaper articles in a whispered voice, because I'm saying, this is a secret that we share, that our culture is very odd and turns psychological experience into a kind of false empiricism. It's a shameful secret that I think we're all victims of.

We were talking about this idea – I was basing it in Nietzsche and you were rooting it in anthropology – of the Dionysian versus the Apollonian. The Apollonian in Nietzsche's analysis of Greek tragedy is always associated with the image, light, the visual, and to a degree, order and harmony, while the audio, the sound, is associated with this atavistic, primeval, body-oriented, visceral passion. And for Nietzsche Greek tragedy, which brought the two together into a kind of marriage where the Apollonian tamed the Dionysian, but the Dionysian gave the Apollonian more passion, is the high point of culture. I was seeing further infiltrations of those two attributes where you actually start to invert them. The image starts to become more atavistic, the audio more ordered and rational. But you're saying there was a particular anthropological source for that.

Well yes, I remember that conversation. I was quoting back to Ruth Benedict who, in that early period of American anthropology, which is out of style now but is interesting I think in terms of the idea of cultural patterns and themes, wrote *Patterns of Culture*, in which she divided societies into Apollonian and Dionysian. And, for example, she felt the Kwakiutl culture of the north-west coast was Dionysian and so forth. I can't remember who was the Apollonian, possibly the Samoans or something. I didn't ever consciously think about that, but of course, as you say, I'm very sensitive, I suppose, to these cultural dichotomies. And so this light/dark binary is something that I am very interested in. I don't know if it's visceral, though. This is an interesting thing. I think the voice is body. That's why I started introducing voice into my work about ten years ago. *Monument* (1980–81) is an installation where there's a sound tape that you have to listen to on headphones, so that you're listening privately in a public situation. And then as a viewer you're seeing it against the backdrop of these inscriptions (pp. 188–89).

What are these inscriptions, exactly?
They are photographs of mine of memorial plaques of ceramic tiles that are in a park in the East End of London. And the park was set up in a very class-oriented way. That is, it was for ordinary Londoners who had died heroically, and I saw this heroic behaviour as masking the fact that these people were in fact giving up their lives all the time, but that was never positioned heroically. So heroism is culturally constructed and it exists for certain reasons. And the sound tape, which you listen to on the park bench, goes into that. It's actually

on representation, gender, heroism, capitalism and a whole lot of other things. Ideas you might have if you saw these things in a park and sat down on a bench, as I did. Anyway, you're looking out from the inscriptions, so you can't see and hear at the same time. Other people can see you listening, but they can't tell what you're listening to. Again we have this idea of trying to make it as clear as I know how that we have these many parts of us that perceive and utter in life.

So in *Belshazzar's Feast* and *Magic Lantern* and a couple of other pieces that I've done, there is this use of signifiers without signifieds, or you could say meaningless representations, or nonsense. Just like *mene, mene, tekel, upharsin* is crypto-linguistic. That is, it mimics language like autistic language does. So these things interest me very, very much.

Now, as you know better than I, I'm sure, it also interests people like Julia Kristeva and other French theorists who have talked about the pre-Oedipal phase of infant socialization, and this is a kind of anti-Lacanian thing, and I don't want to debate it. I think it is an interesting point; I think it would be called the babbling stage, where there's a strong message from the body and the voice is unable to attach itself to things. A child says a sound and it's only later that the parents say, 'Oh she's saying mama, or daddy, or dog', or something. Of course she isn't saying anything. She's making sounds. And Kristeva talked about the joyfulness of this, as a kind of release from language. And it has surfaced in the work of quite a few artists in the past. Kurt Schwitter's for example, in *A Sonata for Primeval Sound*. I mean, it makes me giggle every time I hear it because it's just nonsense. It's fabulous. And of course Artaud is, as you know, a famous example of this sort of thing. It occurs cross-culturally. Many societies have immensely elaborate songs and poetry which are, as they tell people, sheer nonsense. There's a kind of pleasure in the sounds.

It's also entered into rock 'n' roll. 'Wop bop a loo bop a lop bam boom' is not that far removed.

I think that's right. Also scat singing. It's entered into a lot of things.

Right. You were making a point, distinguishing between the idea of reading something and interpreting something. Is it possible to read something 'purely' for any length of time without lapsing into interpretation? One of the major problems of being an artist and translating ideas into art is that art, like everything else, occurs in a discourse which is fairly rigidly structured. And therefore, putting these ideas into the discourse encourages a strongly framed interpretative reading from the word go. Here we are, for example, pontificating about these ideas, interpreting away quite happily. And the work then needs to somehow reassert itself despite that discourse. How does one attain it?

Some artists have always loved talking about their work. This has been going

on for centuries. I don't particularly like it; I consider what I say about my work
to be quite separate from the work, and I don't consider that I have the final
interpretation, or indeed that there is one. I think there's no difference between
interpreting and reading and writing. To me there's immunity there. And I feel
absolutely free to take meanings quite at random from other people's work, and
rework them. And I think we all do this, and we all know that there's a lot of
theory around all of this. On the other hand, artists have to try as hard as they
can to be as clear as they can about their own intention. It's absolutely no good
saying, 'Oh I don't really mind, anyone can say anything they want to.'

Look, the point is, everyone will say whatever they want anyway, so it's very
helpful to be able to say what the intention has been in making the work. This
should not make a closure of interpretation. But of course some artists have
felt that it does. One of the main ideas about conceptualism was in fact that the
artist was and should be indeed the final critic of the work. That what an artist
wrote about her or his work is what he'll admit. That was replaced in the
eighties by a return to more of a romantic notion of interpretation. Now I
think those ideas from conceptualism are coming back and being re-examined.
But they can't ever be accepted in quite that literal way any more. Just because I
can write about my work doesn't mean that I am necessarily the final
interpreter of it.

*Yes. I was trying to set you up actually, so that I could then get across the idea
that writing about the work is another way of generating another kind of flow.*
So what part does an art work then have in the critic's practice? Are you saying
it just triggers off your ideas?

*Well, the art work exists for what it is and then the writing takes off from it in
whichever way it will. It generates a flow or a narrative, or whatever you would
like to call it, and therefore produces a new thing of sorts. Reading the art work
through a piece of writing remakes the art work through the new parameters.
But of course the art work is still there as a thing too.*
I have this argument all the time: that art should precede, not follow theory.
Because afterwards it seems, aha, we understand it. But beforehand, the job of
the artist is to try to put it together without words. That doesn't mean we
shouldn't use words. I've used text all along. But I'm saying that the kind of
thinking that happens, at least for me, has to bypass certain restrictions
imposed by language. And the use of language in the work is the use of just
another kind of material. It's like a material practice. So I can understand a
critic taking off on an art work, because you can take off on a word like that if
you are an artist, and indeed artists do.

*Do you see that as an overt political position? In terms of, say, patriarchy,
capitalism or whatever? For example, I'm sure you've had certain criticism*

about this area being not materialist enough, in a good Marxist sense. Do you think it's relevant to materialist practice?

Well, the short answer is yes. I also have to say that the context in England is different than it is here.

Maybe you should talk a little bit about that.

Well, we have had in Britain an extremely interesting range of art practices. Some of which were highly theorized, because, don't forget, England is very close to France . . .

Geographically.

Geographically. Then they popped up over here afterwards. So what I'm seeing a lot of in the United States is stuff we were doing ten years ago in England in terms of the way artists are getting into theory. And those debates were totally shattering for everybody. People began to tell other people that they weren't doing the right thing or it wasn't politically correct. I'm kind of stubborn I guess, because people always felt that the work I had done before was politically correct, but the work that I had just done was never politically correct. So I learned after a while that there was always going to be just a little bit of a time gap. Because after all, people who aren't into art have as much trouble with art as I have with theory or a foreign language. I'm not up to date. So there's always this kind of discrepancy in terms of who's positioned where.

In the early seventies when I first became involved in the women's movement in England, I had been an anthropologist. And I was invited to join this patriarchy think tank. Which was very interesting, but the thing that upset me deeply was that I was invited as an anthropologist, which I hadn't been for several years. And when I said, 'But I'm an artist, you know', they said to me, 'Well if you're an artist, you can join the Wages for Housework Group and make posters. But you can be much, much more valuable if you would help us to theorize patriarchy.' And I thought, this is another one of those cultural dichotomies, another one of those kinds of splits. I felt art as a discourse had as much to say and can contribute as much as any other discourse. And when it borrows from, or allows itself to be censored by other discourses, it loses its position as a first-order practice. I think art has as much to contribute as philosophy, or geography, or anthropology, or psychoanalysis does. It just does it differently. And when it borrows from anthropology, let's say, it's always behind where anthropologists are at.

Art theory today is about thirty years behind where literary theory is. Is that true?

To a degree.

You mean this is inevitable when you're crossing over from one kind of practice to another. But the final truth of that, for me, and this is the ironic thing, is that

it's not an argument on the same level. When you look at major French theorists and the artists that they're talking about, that they find interesting and major, the artists they are in awe of, they are never the artists who borrow or depend on theory. So art is clearly useful to other practices only in so far as it doesn't borrow from the message of one or another.

Do you see your work actually fitting into any kind of British 'movement'? Are there British movements?

Well, I don't know, I'm asking you. For example the Art in America *issue that had the article about you² also had an article about new British painting that you were excluded from, even though you paint. Would you have belonged in that article, and if so, what would be the kind of structural parameters that you would fit into?*

What they're talking about now in Britain is the necessity of talking about Britishness. This is a thing that is contested and celebrated at the same time. And I'm sure it's the same in the United States. What is American art, what is not? What does this mean? Such and such. It seems a little old-fashioned to me. But Britishness by definition excludes people who aren't British. I can't be British. I can never be British. I just live there.

What has emerged in the past five or six years in England has been a resurgence of conceptualist and minimalist practices. Differently from the first time around, except for work by women artists who've always been doing that. Because what this work is now doing is using certain formats to talk about issues of content; for example identity, sexuality, and so forth. And borrowing styles from a few years ago. So within that I suppose I fit in, since I've been doing content-oriented work quite visibly and for a long time.

Are these new practices theorized?

A lot of the work, yes. Theory as a kind of decoration. And that's happening here, too. Artists who really are brought up on theory and use it like icing on a cake in some way. But it doesn't seem to be in the work. It's sort of appendaged to the work in some odd way.

Do you think that's because we now have a whole generation of artists who are a product of art schools and have a theoretical background from their initial training in art? Isn't it somehow inevitable, if art comes out of a certain academic framework based on theory? If, for example, they're reading art magazines and they want to get written up, and you have to have some kind of theoretical carrot for writers to get interested, why not tailor your work to a theoretical framework?

Yes. I don't know whether that's cynical or whether you're again trying to provoke me.

Both.

Both, yes. Well, what I actually feel about that – I have to go backwards to say something about what I believe is art. People who are doing this thing we call art are doing it because it is the way that they can best say whatever it is they have to say. And they could not do it within any other framework, or they would, because it would be a lot easier in some ways to do it in some other discourse. So, given the very varied nature of the society and culture that we live in, all sorts of people find themselves within this area called art. And, as I keep saying, it seems to me that one of the major things that art is, is epistemological. It's asking questions about how we know and what we know, and this sort of thing. And when people are positioned in a society that gives them a very poor education until they get to art school and they start asking questions, then of course they turn to theory, and it is absolutely right that they should. I'm not cynical about the way people are using theory, I just wish they knew more than the tiny package presented by most art schools, and that they had more confidence in their function as artists to be first-order thinkers, as much as anyone is. I hate it when theory encourages conformity, not thinking.

> *But do you think the marketing element needs to be taken strongly into account? Do you think about marketing at all?* Belshazzar's Feast, *for example, was shown on British TV. Well, that's marketing. However you want to look at it, it's a way of getting it out to your public. It's framed, taken into their living-room. Of course it works well with the piece, for it's about TV.*

It worked. It was the best way to show the piece, actually.

> *So can you tell us something about the parameters of actually using TV in that context?*

Well, I've done a few things on television, but this is the only complete programme of mine that's been broadcast. And I literally walked in off the street with this tape under my arm. I was not commissioned to do it. I had had a very small Arts Council grant. And after I had finished the tape, but not before, I realized that it was taking apart television. But I didn't think of it that way, because what I thought I was doing was extending or expanding the frame within which one will see certain phenomena that were related to television. Then I realized that the perfect place for it would be television, because, people would be in their cave homes by their television fire. They would be all over the country and watching this thing at the same time. So this item about seven people seeing ghost images would be very funny to them. And it was, it was great.

Now that was a really nice experience. The announcer rang me up the day before and asked me how would I like this piece introduced. And in fact he told people not to switch off their sets, that something very strange was going to

happen. And then he came on at the end, after close down, and he whispered, 'Now this is close down.' So he was amusing and informal, and the whole thing was really very nice.

When Channel 4 then sent my piece over to the States to be seen, I discovered that American public broadcasting networks really market and really have this fantasy of a kind of unreconstructed audience out there that has to be condescended to. They cut all their artists' videos down to very, very short pieces, because they say that is the average viewer's attention span. And I sat there as they said this to me, and I said, 'What, what, what?' I mean, that's why we're doing something else. Everybody I know is trying to stretch the range of the viewer. If I wanted to make television, I'd get a job making television. This is something different. It was as though we were talking two separate languages. You were talking about marketing, but, Colin, you've lived here in this country for too long because everything is not marketing.

It is in this country.

No, it isn't. Because what art does, and this, it seems to me, is a really important thing, it doesn't pander to a pre-packaged and pre-defined audience. Art creates its audience by drawing people together in recognition of their shared misrecognitions, dilemmas, problems, whatever it is. Art *creates* different audiences. That's the key thing. So to try to show a videotape which is precisely about that in this kind of American condition of, 'Oh well, we have to let them get up and get pretzels or something', seemed really odd to me. And then they wonder why artists' videos aren't popular on television here. I mean, they're taking five minutes out of someone's half-hour programme and showing that. That's very unfair. They don't say they're doing it, either. They don't say that they're just showing excerpts.

It's the same rationale why soccer is not shown on TV here, because you can't interrupt it. Can we talk a little about the works with text on photographs (the Midnight *series of self-portraits, pp. 68, 196)? The idea of the text and the image both cancelling each other out, but also not doing that. It's actually the first body of work of yours that I ever saw.*

Did you find them disturbing?

No, I thought it was interesting, obviously because of all the text elements, which was something I was interested in. But of course they are images of you, too.

Yes. They're photobooth images. I've done hundreds of pictures of other people using photobooths, which I conceive of as a small theatre. It has curtains. And it's also the challenge of the traditional portraiture of the head-and-shoulders format. So at a certain point I began to wonder why I wasn't taking pictures of myself, and I had been thinking about all the things we've all

been thinking about: self-image, self-presentation, self-enactment, whatever you want to call it. How one's image is then read, contextualized. This was at the end of the seventies, when I first started doing the self-portrait series. And then I did a couple every year or so.

The idea was to take the inside and put it on the outside, in that this mysterious 'calligraphy' would be a veil between the viewer and the representation of face, of a woman's face. It happened to be my face. And I thought, someone's making puns. It's hard to say it quickly, but it was about the idea of the hand of the artist juxtaposed with the portrait. So here I was actually this hand, and that was on the surface of the photograph. You have to understand, the images start off as tiny miniatures, and then I do this writing, as I call it. It's actually not writing, but it amounts to the same thing. And then they're enlarged. The reason I call it writing and not drawing is because the Greeks had only one word for writing and drawing, and that interests me very much. The flow between mark-making, meaning and writing. This is an area which is very important to me.

The thing that struck me about it is the idea that it became also a kind of generic language. It's very much like the way graphic designers use Greek and Latin text – they call it Greeking – to map out pages before the real text goes in. They are actually real Latin and Greek words, but the context dictates that they don't mean anything. But of course they do. They've simply been reframed through another context.

Well, I think there's a little seduction involved in the crypto-linguistic, that which poses or masquerades as language. It invites you to unravel a mystery or an enigma, and we all love looking at pages of calligraphy or books in a museum case, in ancient . . . something-or-other that most of us can't read. It's something about the flow of it. It's like walking or breathing: one thing follows another thing. Instead of all the marks being one on top of each other as they are in drawing, they're just spread out in time and space. And there's a kind of physical attraction to that. I guess it's not so interesting if you know or speak Arabic, but for people who don't know it, it would have that same kind of element. Posters in Russian, for example, always look amazing.

Right. Even though they might be saying, 'Buy these shoes.' I was particularly struck by how much your calligraphy looked like Arabic, Hebrew or stenographer's shorthand. Were you interested in developing a flow between these different scripts and your verbalized, linguistic sounds?

No, but it's just as interesting because I've also been accused, when I showed this in Ireland, of chanting in ancient Gaelic or something. I have a number of theories about this – on various days I offer different interpretations. I feel that everything we've ever heard or seen we of course remember. And I always loved

calligraphy of languages I don't know. So obviously I'm emulating that to some extent. But the way it feels to me is that my hand is moving very quickly and I'm drawing. At one time I thought I discovered or invented a new language, and I seriously proposed to myself that I would do a linguistic study of it, because when I was an anthropologist I used to do studies of human languages. And I thought, oh, this is interesting, certain marks keep occurring, and so forth. And then I realized this is simply an extension of this thing about the artist's handwriting. Because if you look at Masson, for example, not his figurative paintings, but his more abstract works; they are built up on a series of black marks which, if you could take them out of the context of the painting, look like Arabic. He then puts colours around them and they look amazing. Now this has happened to everybody who has ever experimented with this kind of writing. It always ends up looking like Arabic. But it isn't Arabic. Maybe it looks like Hindi, I don't know, but we say Arabic because that's the one people tend to be most identified with. I've had Japanese people come up to me and say, 'Oh, you've written the Japanese word for something here in the middle.' Which could well be. I have no idea. People often like to find words in it. It's like finding faces in the flames. It's exactly the same thing. It's a lot of fun to do.

NOTES
1 As British readers already know, this is not true any more; TV in England goes on until quite late, and there is no 'close down' on most channels [ed.].
2 Guy Brett, 'Susan Hiller's Shadowland', *Art in America*, April 1991, pp. 136–43.

THE IDEA OF MULTIPLICITY IN ART

My work spans a range of materials and media – from paintings, photography, three-dimensional objects, large-scale installations, sound and video works, books, through to non-material events. . . I could describe it in terms of materials, or in formal terms, or in terms of genres, or in terms of personal obsessions and interests, the ideas and feelings I seem to be committed to. The main problems involved in talking about one's work as an artist seem to me to be not to make the work sound banal and used up; not to make it seem as though everything is known about it; and not to make what I *say* the focus of the discussion.

It's easier for me if I can imagine or assume you might have seen, or seen illustrated in various books or magazines, some works of mine, for instance a large installation called *Monument* (p. 188), based on the idea of memorial plaques to civilian heroes, which uses photography, sound, and a park bench; or *An Entertainment* (p. 132), a room-sized theatre of the unconscious, made of extremely large video images on four walls, with quadraphonic sound, based on Punch and Judy performances. Or my photographic self-portraits that seem to circulate quite a bit in group exhibitions, as do the wallpaper and so-called automatic writing so-called paintings of mine of the past few years . . .

Yes? you've seen some of them? Good, then some of you will know that I'm rather fond of impure mixtures of materials and techniques, so quite a lot of what I make doesn't fit well into any of the categories I suggested before. On a couple of occasions I've even made a print, one of which was included in the RCA's fund-raising portfolio a couple of years ago, and must be the reason I've been invited here today under the auspices of the printmaking studio.

Over the years I've been asked so often why I work in many formats, why I don't have an obvious visual style that runs through everything I do. My answer to that is that I don't think the notion of consistency is very interesting, useful, or even, real, although of course it has obvious commercial use, where the package that constitutes the artist's *œuvre* is what's for sale. As far back as I can remember, this idea of stylistic development and consistency is what has been put forward as the most important thing for artists. It wasn't as easy as it sounds now to resist self-censorship and the discomfort of critics or collectors when every show I made had its own individual, different look. Yet nowadays my decision to follow my own wishes and impulses in developing my long-term project seems not so peculiar. It seems hundreds of other artists have also

Edited transcript of an informal talk to students at the Royal College of Art, 19 February, 1992.

decided to do this. Or maybe artists have always been like this and it is just a different way of seeing what someone's work is, not ignoring or rejecting the bits that don't fit in. And artists perhaps realizing they don't need to censor their own production, that they don't need to obey someone else's ideas of integrity and consistency. That maybe even this goal of consistency (like a toothpaste, a brand of flour, or some other product) is ideological? That this idea of consistency is purely imaginary?

On the other hand, when I look back over my work, in fact it strikes me that there is a real similarity and consistency in all the works I have made, which superficially may appear diverse. I have only so much flexibility, I have only so much range. Even if I tried hard to make every work look different, it wouldn't. There are habits, there are predilections, there are strong rhythms and tendencies to work in certain ways. So over a long period of time I would say that any artist's work is bound to have a uniformity, whether or not that was an intention, and the more time passes, the more uniform one's production appears.

In this sense, one major consistency in all my work is that I always begin with something that already exists as an item of culture, a cultural artefact. This is something that probably to your generation seems quite normal for an artist, because the eighties were certainly about recycling cultural imagery and the nineties so far appear to be about recycling objects. But of course when I began to work like this it was considered transgressive, and blamed on the fact that I had studied anthropology.

Maybe, it has occurred to me, artists have always started like this. Surely the blank canvas is already a cultural artefact? Maybe the piece of paper is the cultural artefact, and its boundaries and edges. Maybe no one starts with anything blank at all? Think about how children learn to draw. If you have ever watched a tiny child, maybe with some crayons – they will make very large circular gestures, physical gestures. Then someone points out the piece of paper to the child, whose first 'drawings' are only those marks that accidentally end up on the paper. The rest of the gestures are all outside the frame, unregistered. So, there are these big gestures and this bounded area where the marks acquire a kind of status that they don't have when they fall outside that area. Then someone picks up this piece of paper and there it is, a drawing. What's the next stage? The next stage is afterwards, when we say to the child, 'What is it?' And they want to be able to answer, so they make up something. They tell you – whatever. It's only something physical, a gesture, initially. But all children are clever. They learn the idea of representing very quickly, they learn to tell you it's a house, a tree, a dog, a person, whatever.

I remember asking my son, 'Oh, what is it?' He might have been three or

four at the time. There were quite clear shapes on the piece of paper, two parallel lines with a set of short parallel lines running between them at right angles, sort of. And then there were some zig-zag shapes, like mountains or something. And I said to him, 'What is it?' He said, 'It's railway tracks and big Ws.' Then I realized that alphabets and pictures had become the same to him. Subsequently a lot of my work in the eighties centred on this idea, that there really isn't any necessary distinction between, say, writing and drawing. For the ancient Greeks, there was only one word for writing and drawing, for the activity of doing both. I like this idea. From a different perspective, in our society kids are growing up in a world where the visible signs consist of both words and objects. A billboard is quite literally a sign. So the idea of representation of the young child crosses over without hesitation between language and things.

I found that especially interesting because in my work I've always tended to be fascinated by cultural artefacts that double something linguistic and something pictorial, for instance postcards with texts, as in an early work called *Dedicated to the Unknown Artists* (p. 138), which pleasantly is having a second incarnation in recent exhibitions in the United States, or in a recently completed work, also based on postcards, called *Nine Songs from Europe*. In *Dedicated to the Unknown Artists*, I used postcards with beautiful, spectacular

Nine Songs from Europe (detail) 1991–95; 9 postcards, varnish, rubber, glass, etc.; installed size variable

'rough sea' images, cards that also had a caption that said 'rough sea', and this caption was always printed on the front of the card, over the picture sometimes, in the same pictorial plane as the picture; in fact both words and picture went through the printing process together, so there is a merging of signifier and signified. What interests me is this image that comes with a name, that comes with a label, a description, a designation . . . So that even when the photographs of the sea originated maybe in a resort in the West Country where they never have rough seas, they so longed to fit themselves into this category that the card would be entitled, even when the picture showed a pathetic little wave, it would still say 'rough sea'. Or sometimes the waves would be airbrushed or painted in, to look impressive even when they were not.

This formed the basis of a very extensive early piece, which in a way is still ongoing, because people keep sending me these cards, and I feel obliged to do occasional 'addenda' – updates on the original piece. *Dedicated to the Unknown Artists* was the beginning of a whole way of working in art, and I think I will describe it briefly.

Before I do that, I'll just mention that it also made an intervention into the world of collecting, postcard collecting. Before the piece was widely shown in the early seventies and widely written about, even mocked in the press – the 'is this art?' kind of article – the 'rough sea' cards were not seen as a collecting category, like trams, cathedrals, etc. You could find them in unsorted piles of bargain cards on stalls, or sometimes in the sections under 'resorts'. But afterwards, in market stalls and antique shops, they started to have 'rough sea' as a category of its own, and the cards became very expensive.

I wanted to make something that had both words and images. So I made large wall panels that were the same proportion as a postcard, roughly 3 x 5. I used these to display certain visual juxtapositions and categories, accompanied by a commentary in the form of charts and tabulations. My stated stance was that I was curating this body of artworks. I also produced a picture book called *Rough Sea* and a book of words, commentaries and analyses, a photocopied book called *Notes*. I felt that this way of working, taking the formal aspect of the final work from the initial thing one began with, went back to something that had been emphasized very strongly when I was a student. It isn't fashionable nowadays, but seems to me very relevant to the way a lot of you are working, the idea of 'truth to materials'. We were always taught this meant something about handling organic materials, like wood or stone. But if you think of materials as I have suggested, as being in and of themselves by definition culturally defined, artefactual, and then you consider this idea of truth to materials, you may find it can give you some interesting guidelines about how to develop the formal aspects of your practice.

So basically that is how I have continued to work. Alongside these big, discursive pieces, installations, etc., I have also always worked on individual objects and a set of so-called paintings that have been exhibited quite a lot recently. I try as much as possible to emphasize impurity and to show different kinds of things together, but this isn't always possible. As you know, in this country there is a really strong wish some people have to see paintings as totally different from other kinds of art practices. From my perspective, I call these works of mine 'scripts' and they are always on wallpaper.

Wallpaper, ordinary domestic wallpaper, has interested me for a long time, as it interested artists in the past, these patterns we choose to live with. My scripts are really a kind of diary for me that runs alongside more public works. It's writing or drawing, performed in solitude and for me, maybe maps showing me where I am with myself at any particular moment. I like the diary analogy, because I live alongside these 'paintings' in the same way you do with a diary. And at the same time, they're just like all my work, a look at 'culture', because they don't start with a blank canvas but with wallpaper, and with a self or selves that are culturally constructed.

So what am I doing here at the invitation of the printmaking studio? If none of the works I have talked about are specifically prints? Well, I have my own way of thinking about printmaking. If you look back quite a while you see that printmaking developed later than painting, drawing and sculpture as an art practice, and it added something to the traditional practices, the idea of multiplicity. Clearly prints challenged the idea of the unique object more precisely, directly and confrontationally than copies of paintings or casts of sculpture, although in recent times some prints intend to have the quality of semi-uniqueness about them. But in thinking about the effect of the early artists' use of prints, from Mantegna through Dürer, Rembrandt, Goya, you will have to accept the obvious, that multiplicity instead of a singularity is what is essential. Then, it seems to me, one must say that out of the idea that multiplicity is acceptable within art practice can be derived the legitimacy of a range of other things that interest me very directly. For example, videotapes, which are multiples, photographs, etc. And I don't see why we should stop at a certain point and fetishize a particular historical moment, and stop dead the idea of printmaking to limit it to particular traditional craft skills and not go on to cherish the new skills. Art schools always want to stop dead, but it seems to me that it's logical to understand that not only photography as an art practice, but all the things that have come out of that, videotapes, etc. need to be seen as extensions of the theory of printmaking. Because if we didn't have prints accepted within fine art practice, we wouldn't have the idea of mass-produced multiple images at all within that practise, and conversely we could

say these are not intrusive or new ways of thinking but practices with an immensely long history.

Having said this, and none of you disagreeing, I wonder if you all agree with me? I doubt it, but perhaps I have managed to get you to see video as part of printmaking. I now want to talk briefly about why I feel more at ease with my own videos being located within fine art than within television. Personally, I think there is a problem, particularly in this country, about where artists' videos and photographs and performances fit, where they fit in. I think this is because this is an old country. In an old country with old ideas, maybe there is a real emotional investment in fixing certain practices which dominated certain past historical moments. Maybe it's because Britain never was a major art country when painting and sculpture were the dominant practices, and now sees the chance to catch up, though it's late again. I never heard a painting called a 'picture' until I came to this country, certainly not by artists. And there is also the idea that, to define the Britishness of British art, it should look old . . .

When you come from a new country, you get drawn into what tends to be a celebration of the new, which is equally strange, so that in Australia and Canada there is major support for art in the most recent technologies, computer work, video, whatever. So according to my observations, where one's work fits is only to some extent under the artist's control, whether it is seen as oppositional, for instance. Since my own work as an artist developed in Britain, I have to admit I like the British tradition to the extent I believe there are some things worth saving. One of the things I think is worth saving in the more traditional view of art is the idea that art is quite different from advertising or fashion, in that advertising or fashion or television are creative fields of work that set out to create ephemera, things that aren't meant to last. Whereas art, in my view, is a category where we locate things that are meant to last.

So with video, for instance, if you can think of it as related more to printmaking than to television, when you make video work you will want to do something that will be worth seeing more than once, maybe even worth seeing ten, twenty years from now, alongside works by artists in different media. So you put a lot of time, a lot of effort, a lot of committed passion into making the work. In contrast, if you make videotapes with a televisual way of thinking about the practice, you make videos to be seen once, preferably on TV, and that's that. You don't really expect them to look good five years later, you expect them to look a bit funny like old pop videos are usually funny. You place major reliance on the latest technology,which is why they tend to date quickly, because technology is always moving on and becoming cliched, which is why it should always serve artistic ends and never be its own end. I hardly ever make videotapes but I am talking about them because I think these ideas are what we

need to think about when we make any kind of work. That is, what's the point of spending so much time, energy, money to make any art at all if it's just to be consumed and disposed of? What other purposes does art serve? What is art for?

If you make any kind of art, but particularly art called 'time-based', there may be a temptation to make work which is very disposable, which you would never want to see again after the initial showing because it had dated, and in fact you will never have an opportunity of showing more than once in any case because no one else will want to see it in later years, either. Strangely or not so strangely, a lot of contemporary funding in these areas seems to encourage what is ephemeral, what I think of as the 'circus' part of the bread and circuses equation. There is an unconscious conflation of 'new media' and 'ephemeral'. I am not being hierarchical when I say it is important to think clearly about differences between practices like TV, design, fashion, etc. and what we call 'art'. My view is that if you can do something creative, real and satisfying in any other field but art, do it. Do it. Don't give in to art unless that is the only way you can do whatever you must do. If you can make creative TV, for goodness sake don't waste time making art videos. Go do television. I really mean this. But – if you can't say what you have to within these other fields, and you have to say it within art, then you simply must think about what's different about art.

Art can be multiples, it can be time-based, it can even be ephemeral. But in some sense it's never made to fit anyone else's brief. It's not a project managed by a curator who brings in an 'artist' to design a show according to the curator's understanding. It's not a project designed to fit a fantasized audience that needs to be 'educated'. It's not a project designed to sell another product, or even necessarily to sell itself in a commercial sense. A major function of art is to create its audience, and each work will create its own audience. Television, design, etc. are ways of working that have pre-packaged or pre-selected audiences and commissioning clients. Their audience is targeted and constructed as consumers of products to whom are beamed an explicit message which is supposed to be heard passively. Whereas in art the audience is collaborative in generating the meanings of a work. The work means nothing without this, this active generation of meaning. The work circulates as a token of meaning. In this sense, the artist is also part of the audience for the work as well as the maker of it, and there is an open circulation of meaning among all participants. Speaking personally, I would say that as an artist one discovers meaning gradually, through the making of something and experiencing its circulation. I think that's exciting, that's for the future . . .

5

OBJECTS AS EVENTS EXTENDED OVER TIME

THE NATURE OF REPRESENTATION

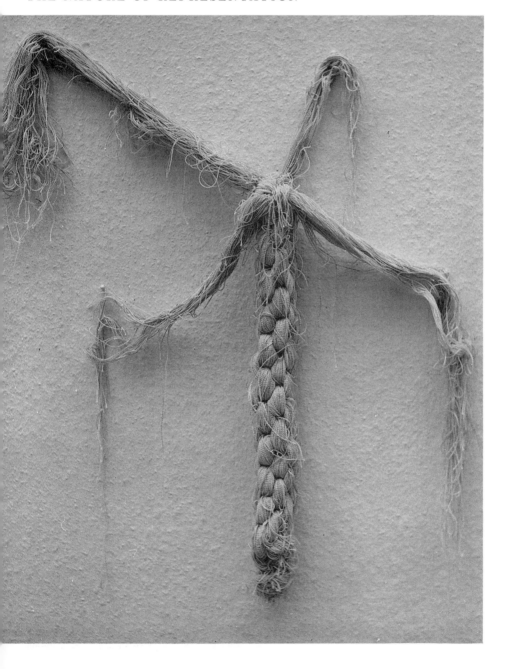

EDITOR'S INTRODUCTION

> In 'reality', which you know is a paradoxical notion in itself, no dichotomy exists between objects and events. Objects are simply shapes resulting from actions and events that hold together long enough in one general condition to be considered units.
>
> Susan Hiller, 'Duration and boundaries'

Perhaps photography and its terminology of 'exposures' most practically acquaints us with the fact that all images we can see in fact represent events that occur in time; all photography is time-lapse photography. The following three talks and conversations include considerations of issues involved in employing photographic processes in artworks. Underlying the discussion of photography is a concern with the nature of representation, a concern with documentation and truth. Photography's confrontation with such concerns has recently been intensified by the computer manipulation of photographs, such that they can no longer be read so strictly as 'documentation', an index of truth, and in a court of law can now be subject to expert analysis when introduced as evidence.

In the early conversation 'Duration and boundaries' the emphasis is on experience *per se* as art. The participants in Hiller's *Dream Seminar* and *Dream Mapping* consider how description itself is incomplete and partial as representation of the 'truth' of the events they collectively participated in. Hiller's concern with community and audience can be seen to influence her course as an artist, as she moves away from works in which there is no audience but only participants, in which the action

occurs in the street, to works more oriented towards artefacts and objects. What is clear from the discussions by the *Dream Mapping* participants in 'Duration and boundaries' is that memory itself is a fragmentary trace of any collective event. Indeed, perception itself is partial, an incomplete 'recording' influenced and constructed by unconscious processes.[1]

In 'Collaborative meaning: art as experience' she considers conceptualism and communicates how she desires an art that offers aesthetic/non-cognitive experience *'by means of* being open to contextualizing, thinking, feeling and meaning'. Her discussion of *Monument* (1981) reveals how her work consistently strives for 'collaboratively arriving at meanings', while enlarging the audience, combining participation in an event with the more conventional gallery-going experience of 'looking'. Colour photographs of nineteenth-century memorial plaques are mounted on a wall: SARAH SMITH PANTOMINE ARTISTE AT PRINCE'S THEATRE DIED OF TERRIBLE INJURIES RECEIVED WHEN ATTEMPTING IN HER INFLAMMABLE DRESS TO EXTINGUISH THE FLAMES WHICH HAD ENVELOPED HER COMPANION. Sitting on a park bench, one listens through headphones to the artist's voice reciting an analytic revery: 'This is my voice, unrolling in your present, my past. I'm speaking to you from my here-after, the hear-after . . . Now it will speak to you about . . . the 'fixing of representation: fixed, like a photograph, taped, registered, or inscribed . . .'

While 'Slow motion: an interview with Andrew Renton' might also have been included in other sections of this

book, ranging widely as it does over the history of Hiller's work, I have chosen to include it here because I feel that the underlying theme of this conversation is truth-telling in art. In this Hiller discusses her 1980 *Work in Progress*, which very directly demonstrates her conception of the relation between object and event. She brought into Matt's Gallery in London several paintings that she had exhibited at Garage Art Ltd in 1974. As Jean Fisher describes it:

> She then proceeded to unravel the weave of one canvas, thread by thread. At the end of each day, the pulled strands were hung in skeins on the wall. At the end of the first week, each skein was hand-worked, by knotting, looping or braiding, into individual three-dimensional 'thread drawings' or 'doodles', whilst the remaining canvases were cut into small rectangles, baled into little bundles and given a date stamp.[2]

The doodles and bundles were then exhibited. In a film[3] the artist explains that the forms of the doodles arose from her response to the materials and to the space of the gallery, a response that had been internal and invisible while she was taking the canvas apart. In this way, the doodles and bundles are like photographs of the internal and external spaces: photographs of the space between.

Hiller's photomat self-portraits connect the idea of duration to the span of a human life, and a dear one at that – the artist's own. As many writers have by now acknowledged, photography is a potent reminder of death, as if the solution the paper is washed in is not a chemical but the water of Lethe. The series also continues the artist's project of investigating the representation of the self, a woman artist. Unlike Georgia O'Keeffe, she takes her own photograph, framing it in the same way that children learn to draw. Only part of her is visible: 'The rest of the gestures are all outside the frame, unregistered', provoking the viewer to ask what is being registered here, and how. In comparing *Midnight Baker Street* (p. 198) with *Sometimes I Think I'm a Verb Instead of a Pronoun* (p. 64) one observes that this writing is almost like drawing, or the drawing almost like writing. Where is the main expression? The face is the site where expression is read, but here it is a canvas, and the Pontormo-like colours turn the person into a photographed series of tones. The colours repeat and relate as another rhythm, marking both the time in which these objects were made and in which representations of them are now seen.

NOTES
1 See Rudolf Arnheim, *Visual Thinking* (Berkeley, Los Angeles, London: University of California Press, 1969). Of particular interest in regard to the theory issues discussed in the third section of this book, 'Fragments of a forgotten language' is the observation that 'vision, in particular is, as Hans Jonas has pointed out, the prototype and perhaps the origin of *teoria*, meaning detached beholding, contemplation' (p. 17). Compare Hiller's discussion of senses other than vision in 'Reflections: the Townsend Lecture' in this volume.

2 Jean Fisher, *Susan Hiller: The Revenants of Time*, Matt's Gallery, London, 1990.

3 Produced by Christopher Swayne and the Arts Council of Great Britain, 1980.

DURATION AND BOUNDARIES

... This entire seminar situation is a work in progress, and not in any sense merely retrospective, although it's 'about' work done at some past point in linear time. This past point and that work can only be remembered or talked about, but it cannot be seen or participated in any longer. So memory and imagination, which are probably inextricable, are making it all up again right now ...

Those, those of you who participated in any of these past events – maybe you will feel able to talk about them in detail. One person's view of events can't be more than that. So please join in.

First, some definitions. The terms of discussion will be limited to works that can only be talked about or participated in – mainly *Street Ceremonies, The Dream Seminar* and *Dream Mapping*, because there are a number of participants and rememberers here tonight ...

So that excludes works on paper and canvas which can be seen today in some aspect resembling their original forms, although it might include those works on canvas and paper that can no longer be seen. In 'reality', which you know is a paradoxical notion in itself, no dichotomy exists between objects and events. Objects are simply shapes resulting from actions and events that hold together long enough in one general condition to be considered units. If your sense of time were accelerated, events of long duration such as the pieces to be talked of tonight might be seen as discrete units standing out visibly for a short time from other shapes which also represented events of long duration.

The first piece of the sort we are discussing took place in 1968–69, over a period of several months, in London. There was really no awareness of antecedent or simultaneous work that was an influence. The 'happenings' of an older generation of artists were performances in a very different sense. It seems interesting ... maybe ... to clarify the term 'performance art' here. The word 'performance' can refer to a situation in which there is a distinction between participants and spectators, thus the noun: 'a performance'. A performance is often more or less repeatable and theatrical. But it's interesting to consider the verb: 'performing', meaning 'enacting'. In this sense performance means simply an enactment, an event in which the process of carrying out something is

Edited transcript of Hiller's talk on 26 November, 1975, during 'The Artists' Sangams', a series of discussions among artists, writers and musicians at Tone Place, Covent Garden, London. To emphasize the performance aspects of talking, she imposed two 'rules' on herself, 1: to tell the truth, and 2: to speak without using any first-person pronouns. The series was organized by John Sharkey, who is a poet, author and editor.

emphasized. The works which are going to be discussed and which are sometimes called 'group investigation pieces' are performance art in this sense. This work is not theatrical. There is no audience, that is, no role is allocated to spectators or observers. Yet a performance does take place in the sense that explicit instructions organize the activities of participants. Subjective experiences and personal reactions function as aspects of a closely designed structure. These pieces are designed 'as if' the formal model were the choreography of a dance where footwork is not always of primary concern, or the setting up of an experiment whose outcome is believed to be incalculable.

STREET CEREMONIES

This is something to look at and pass around: a box containing material relating to *Street Ceremonies*, a big piece . . . in all senses. Movement took place over a very wide area. This piece occupied seven hours of time – a lot of people took part. In fact, it was completely open to members of the public to join in, and many did. The piece rested on a sense of organic community. But now in 1975 it seems as though there must have been a need for self-justification that made it necessary to promote work in terms of ideas that . . . could be accepted, simply, as the givens for all these pieces. Others may feel differently on that point.
 What do you mean by self-justification?
Self-justification . . . in terms of rather grandiose . . . metaphysical and/or political statements about the validity of work . . . which seem now inappropriate. This is part of the difficulty mentioned initially about how to arrive at a simple description of what happened. In a sense, it's an intriguing problem. Those of you who are artists perhaps agree that there are always two ways of talking about work, one from inside the work and one from outside, and while it seems quite clear that a valid art can lend itself to description on many levels, the effort here is to simply give a . . . what's the word, what's the word for something without value judgements?
 Objective? Impartial?
Impartial, objective . . . well, objectivity is impossible. (*Laughter.*) OK, well, let this description go on, and then come in with alternatives, if you have them. The idea of passing the materials around is to try to show what the subjective intellectual and emotional bases of the piece were. . . It was a painterly piece, its graphic nature, its concern with proportion and light, being the clue to the rest. It was the free creative gestures of the individual participants that made it different from the kind of minimalist dance happening in the USA at the same

time. Another important difference was a sense of the non-repeatability of the piece, which was designed for a particular site, a circle 'drawn' on to a specific urban grid, approximately half a mile in diameter, with the intersection of two major roads as its centre, on a particular day, the autumn equinox, 1973.

The integration of a perfect graphic figure defined by the responsible gestures of individual participants who amplified, modified, mediated and investigated the effects of light . . . with the major movements of the piece dictated by the natural phenomena of noon and sunset on a day when these were temporally symmetrical . . . created a sense of satisfaction which has made it impossible to duplicate or attempt to duplicate this particular piece of work. Participants envisaged and thus created a formal pattern that existed in a space beyond the range of their individual perceptions, but for which they assumed individual responsibility. Because of the long time duration, the piece ceased to be a performance with a perceivable beginning and end and with clear boundaries, like an object, but became a condition of its surroundings. Thus the urban environment became a natural environment. The piece was inspired by traditions of the artist as map-maker, a cosmologist as well as a cartographer . . . that is, aspects of the world were explained in the same gestures by which they were drawn.

> Perhaps I'll say that even though I did perform a specific task in that day, as a salad-maker, which took some time, I understood the piece as a light piece, a piece about light, almost in the Impressionistic sense.
>
> Well, I saw it then as a territorial piece . . . There are two things to discuss, first, whether going out with the mirrors to the edge of this circle drawn on the map, flashing the light at someone you might or might not be able to see, about 100 years along, and second, making a ring around a specific geographic area. At the time I saw it as a 'walking the bounds' event . . . but what now seems important is how different the flashing of mirrors across space was to the feeling of working with the candles at sunset — completely different experiences.

This is exactly the point this evening is about. What is trying to be said may be something like this . . . art is a question of individual perceptions. And in a piece like this where each participant had an obviously completely different experience, there's no way of talking about the performance except in subjective terms. Interesting work lends itself to certain kinds of explanations, but it doesn't seem appropriate for the artist to supply these kinds of explanations.

The notebook provides the process of the piece. It's a kind of scrapbook. A lot of people present performed it, and the piece only exists in their memories, and these are all different . . . *Street Ceremonies* happened because for a number of years there had been a sort of obsession with doing it, from about 1970, a

desire to dance the boundaries of the neighbourhood, do something like that. And that's why the phrase 'a sense of organic community' seems important. Nevertheless, it would be pretentious to claim that it had . . . any grand implications along those lines.

Especially since a lot of us didn't live in the area.

Well, I didn't think that mattered. My feeling about it was, I mean, I got very sort of involved with the ritual, apart from just looking at what was happening with the mirrors and so on. What I was getting off on was the whole ritualistic quality of it, the fact that I knew that there were all these other people doing things, and this was very ceremonial . . . magical.

This does seem essential, now, the sense of the responsibility of performers for the literal creation of the piece. It wasn't a question of sending out dancers, people to do this thing, but a question of turning someone on to the fact that it might be interesting to try it . . . that was the attitude. So in that sense, to get back to an earlier question, it was the culmination of a whole period of work. It might be impossible to duplicate this work, given the present . . . well, social, economic and personal . . . factors. The end of an era . . . (*laughter*).

What must have been very nice was to be someone who sort of walked past a flashing mirror and then half a mile further may have seen another one . . . As I was flashing my mirror I was hypothesizing what this would feel like to people who had no knowledge of the piece.

Different people, as they came back to the central area, talked into the tape recorder and told their adventures and experiences . . . ranging from fairly deep experiences of centring themselves in relationship to the situation, to what might be an aesthetic experience, working with light, to social things about getting involved with neighbourhood kids . . . And the police became involved at one point, in a helpful way, and passers-by. These things are incidental. Those kinds of incidents are extremely interesting in art, but one can never calculate them.

It seems to me that this was a supreme example of risk, given the location, the climate, nature of the area, everything . . . but it worked. This is very rare. The thing as a whole transcended itself, on every level you can talk about. I think it transcended the whole concept of 'art'.

It's art because the key issue is recording. Street Ceremonies was a one-off occasion that couldn't be repeated, but it was recorded. Recording, as much as concept, is essential to performance. If the artist doesn't record it, the work remains in limbo for a period, and then recedes in memory . . . Painting a picture and saying this is a record of what I did, and someone doing a one-off performance, never repeating it, but its being recorded, means, this is a record of what I did, I am an artist . . .

There's a difficult choice here . . . if one wishes to function in any way at all in our society, it somehow becomes necessary to have proof of that function. For years no adequate records were kept of any of this work, because of a strong feeling against that. But any worker in any field needs to create a situation in which work can continue. Recording is a part of that for artists. Everything is recorded, with all that implies in terms of modification, subjectivity, etc., in memory, in any case.

*Are you saying that this evening is just nostalgia? (*laughter*).*

THE DREAM WORK

. . . *The Dream Seminar* was a group investigation piece. It was subtitled 'an investigation into the origin of images and ideas', as was *Draw Together*, a group piece dealing with the relation between art and ESP, done in 1972. *The Dream Seminar* was structured in the form of a discussion group among twelve participants: Carla Liss, Esther Beven, Christina Toren, Amikam Toren, Rosemary Dinnage, Domingo Armengol, Suzan Arthur, Tamara Kadishman, Hugh D'Ange, Signe Lie, David Coxhead and Susan Hiller. It extended over twelve weekly meetings in September, October and November 1973. Discussion centred around personal dream material, viewed in the context of a number of papers (which are in that box) submitted as alternatives to the so-called 'normal' post-Freudian and/or mechanistic definitions of dreaming prevalent in contemporary European culture. These papers were considered as heuristic devices suggesting various possibilities of redefining the fundamental facts of dream experience leading eventually to a consideration of the relationship between 'art' and 'dream'.

Naturally enough, new definitions and final conclusions were *not* achieved during the duration of the piece, but the necessary prerequisites, that is, accurate observation and recording, careful description, openness and intimacy among the members of the group, correlations of group dream experience and shared dreaming, analysis of the overlap between dream and waking reality, were investigated. The tone of the project was intensely serious and very funny. Most of the participants committed themselves so deeply to the project that although the meetings were physically located in a miniature classroom in Notting Hill Gate and temporally limited to less than two hours each week, the boundaries of the project extended in time and space to affect many aspects of the group's waking and dream lives.

Could you put this cassette on in a second? Just a word about what's on this *Wallpaper* cassette – a piece called 'Symmetrical notes from *The Dream Seminar*'.[1] Sometimes it seems interesting to work on something beyond the

point at which it would normally be called finished or completed. And this is partly an expression of an interest in finding the identity of a thing in duration and change, and partly the extension of a subjective obsession concerning the paradox of sensed time and the sensed material composition of the so-called physical world that contrasts very poignantly with perceptions of timelessness and non-materiality. Recently the process of working on a painting has been extended so far that the formal integrity of the painting is broken.

I think that what was really fantastic about The Dream Seminar *is that everyone became very committed. It really did for me what I think art should do for you and that is to totally turn you on and allow you to see something that perhaps you never would have seen before . . . most of us were used to, you know, we'd been interested in our dreams, right, and perhaps analysed them according to ordinary textbooks. But to approach them as if they were an unknown land where you were simply kind of an explorer and a watcher . . . was fantastic.*

I want to say, that, I really . . . I felt terribly uncomfortable when everyone was talking about Street Ceremonies. *It didn't seem to match up at all with my experience. In fact that was almost the first time I met you and . . . whatever community was established was in a sense located in that particular geographical area, but it had nothing to do with geography, in a way. And in the same way that fact that on a given night a certain selection of people either chosen by you or selected in another arbitrary way all inhabit the same dream location – you know, sailing on a boat – has the same kind of . . . in a way, it is there, and in a very peculiar sort of way, it also has a curious irrelevance. Because you don't know exactly what field it is that you're tapping into. And that's why all the arguments apropos of* Street Ceremonies – *was it populist or was it not populist, was it a local community or was it not a local community – seem to me to miss the point absolutely and entirely. On the one hand it was very, very private – I felt completely unaffected by the structure of the whole thing, it was a very centrifugal piece for me. I went to a location, I was given a few things and some instructions, and what happened after that was entirely to do with me. I never went back, in fact, to the central . . . rallying point. But some very peculiar things happened. And I had a tremendous resistance. I thought, well fuck this, why should I go walk off somewhere and why should I do anything with my mirror? And in fact, I still have the mirror. . . None the less, despite all this, through it, I gained access to something I know to be a certain kind of order which is quite, quite different from the at least plausible order of my everyday life . . . and order where, for example, strange coincidences happen. And the same thing seems to me to be true of dreams, since you are deliberately exposing yourself to a different kind of order. Surely it's something like . . . being a diviner. Although the diviner is and is not in control of what is*

happening. There have been elaborate sociological analyses of diviners and psychological analyses, each of which seems to show in a very similar way that they are in fact much more canny than they let on. But the fact remains that neither diviners nor mediums would have anything like the importance that has been attached to them if, almost in spite of their expertise, from time to time and in perhaps a rather unreliable way they didn't gain access to some other kind of order.

Well, isn't this true of art? What seems important to suggest is that in the contemporary world the functions of art are not entirely clear. So to attempt to simplify the . . . to say that art should serve X, Y, or whatever is a false track. On the other hand, it seems that for artists to make inflated claims for themselves about – what's Auden's thing, being the antennae of the race, these kinds of things, is extremely distasteful. At the same time, it does seem clear that there are areas, there happen to be areas of involvement for some of us here, that are very difficult to talk about, because they cross certain boundaries. Which is why it seemed preferable to discuss in purely descriptive or formal terms the work under consideration.

During *The Dream Seminar* the interesting thing was not the fact that on a certain night some members of a group might dream that they were on a ship. This isn't interesting. What is interesting is the fact that on a certain night people might appear in each others' dreams and recognize this fact. This is where the boundary is . . . It's always seemed clear that art, and art ideas, are just somehow flying around or existing 'below' a verbal recognition level, or whatever, and artists grab on to them.

What do you mean by recognizing the fact that they were in each other's dreams? You mean, at that time, or when?

Well, if you and I have a dream, tonight, a shared dream, and we can say to each other tomorrow that this happened, and we are aware of it while it happened . . . this would be of some importance. And if it's been a decision . . . again, surely this is what art is 'about'? This is, as stated, the reason for the subtitle of that piece, 'an investigation into the origin of images and ideas'. When an idea manifests in the work of an artist and it manifests in the work of other artists at the same time, it's hardly a question of 'influence'. . . This is where the whole art-historical/critical fallacy comes in.

This is what was actually so fascinating during the seminar – two weeks before the first meeting. . . I knew Susan was doing this dream seminar and I was going to be in it, but I didn't know anything else.

I had an extraordinarily vivid dream in which, with four or five of my friends, some of whom I recognized, from a file of people, we were walking through dream landscapes, and in the end of the dream, we were in a classroom

of little . . . for little children, a primary school classroom, talking to the
headmistress, right? And I woke up. And that was an exact prefiguration of
The Dream Seminar. *I mean, in my dream there were these paintings by little*
kids on the walls, you know, and little chairs, and all of this, which was exactly
the way the classroom was in which we sat. . . And what we were doing in the
seminar in a way was walking through each other's dream landscapes. There
was a point in this dream in which one of the people who was accompanying me
in the file said something about how strange it was that the images that were in
my dreams were of such and such a quality, while the ones in her dreams were
not like that at all. It was extraordinary, but I didn't think too much about it;
although I enjoyed that dream very much until I got to the little room with tiny
little chairs, and sat down with my knees under my chin . . . (laughter) . . . Well,
things like that happened a lot. That was really interesting.

An artist[2] later wrote a letter from New York in which he said that the reason
people in New York did not wish to take part in his dream piece was they found
they were walking in and out of each other's dreams, and they felt . . . he
mentioned the names of several artists who dropped out of his piece because
they were . . . sharing dreams. And they felt that their work would be adversely
affected. The situation at that time in London was very different . . .

A later work called *Dream Mapping* . . . integrates the factors present or
involved in *Street Ceremonies* and *The Dream Seminar*, but the piece still remains
somewhat problematic . . . because it seems to be pointing in an entirely new
direction. In a sense there's absolutely nothing public about this work. All the
art activity is subjective, and only the recording or documentation can be
shared.

The piece began with a site, a location, a field with a series of 'fairy circles'
formed by the *marasmius oreades* mushroom. These rings occur in great
abundance in a field at Purdies Farm in Hampshire – you'll rarely see that many
of these circles in one place. The idea of incubating or creating special
conditions for a group to share a dream experience was suggested by British
dream traditions associated with fairy circles as much as from the ultimate
conclusions of certain of the later stages of *The Dream Seminar*. . . Later there
emerged a method of combining subjective notations as to the sense of
direction/dimension/duration/location of individual dreams, and these
became the composite group dream maps of the last three days of the piece.
Work on the piece began a month ahead of the final three nights, when
identical notebooks with maps of the dream site were sent to seven participants
with instructions to record their dreams, verbally if necessary, but to attempt
to evolve a system of schematic notations or maps. This part of the piece
served as a form of initiation . . . and a form of training . . . particularly for

participants who had not taken part in *The Dream Seminar*, and for the group as a whole this period seems to have intensified their interest in each other and the piece. . . .

At the end of the month, for three nights, participants slept out of doors in the circle of their choice, and recorded and mapped their dreams the following morning. The composite maps were compiled by taking bits of tracing paper and asking everyone to take the main notations from their individual maps and superimpose them one on the other. The last map on each 'spread' is the composite map, and the overlapping or coincidence of personal notations of subjective experiences is shown by heavy lines.

You said 'incubation' . . .

Incubation is a kind of tradition in the history of dreaming, in various cultures. It means going to a specific site in order to have a special dream. Now, the tradition about fairy rings in this country is that if you fall asleep in one you'll

Dream Mapping (detail) 1974; site specific group event, Hampshire, England; participants' dream notebooks and maps

be carried away – to fairyland, right? Um, which is in a sense the same thing, or at least related to the traditions of incubation. Incubation just means going to a certain place to dream, a sacred site. And there's also some information about these fairy circles, that they represent energy patterns. Have you seen that photograph of Stonehenge from the air? You'll see that it is, in fact, encircled by a series of fairy rings which indicate energy patterns . . . On the three nights of the piece that people went out to the field to dream, they sort of staggered along in the dark with their sleeping bags and blankets, or whatever, and decided which particular ring they wanted to sleep in.

Did anybody have a dream of being taken away?
Not in that sense. People had dreams about circles, but . . . we were under tremendous strain on those three nights as you can imagine (*laughter*). Um, in that sense there was nothing – Again, you see, this is a difference between science and art – this wasn't an experiment to prove people would have splendid

Dream Mapping (detail) 1986, dream notebook in vitrine, installed size variable

dreams under those circumstances. It was just a kind of open situation that was set up. What did happen was that people in the piece had dreams of each other with great frequency.

Dream Mapping somehow now appears to be a rather esoteric and closed work. And yet, as you can see, an effort was made in setting out the documentary material, to be as absolutely precise as the actual piece. You can see everyone's dream notebook there, you can read them. This is, again, a sort of very courageous step on the part of the participants, who are willing to let 'their' material, you know, be circulated. And the maps are there, and the composite maps are there, but still it doesn't add up at all to what the piece was about. Documentation really doesn't give enough insight.

Why do you make this very strong distinction between art and science? I don't think there is a distinction that's clear-cut.

What seems to be important is that this is not an attempt, in any sense, to make an equivalent to a scientific experiment. This is an experiential – this is a structure, that invites possibilities of intensified experience. It's not oriented towards 'results'.

I don't know if you want to talk about this, but someone mentioned scientific correlation. There's one piece you did, that ESP experiment in France, Draw Together, *that certainly could be scientifically correlated, formulated and all worked out beforehand. All the results can be tabulated, as in a scientific experiment. There's something, in distinction to this, fairly random and more what I would call performance in* Dream Mapping *– whereas the other was an experiment . . . highly controlled.*

While what you're saying is true, it also has to be said that there was a big postal strike in France at the time of *Draw Together* and most of the returns were delayed and finally lost . . . so because of that it again falls very nicely into the area of art and funky documentation (*laughter*).

That was a piece that was very interesting, though, in certain ways. It was based on something that has a precedent in things like the *Journal of the Society for Psychical Research*, but the original idea was done by Upton Sinclair and Mrs Sinclair.

Over a period of years they'd do a sort of art thing where she would go into one room and draw something, while he pulled something out of a hat. And they got amazing correlations, of course, which isn't at all surprising. In *Draw Together* what was done was to get a collection of images from magazines, newspapers, places like that, and to draw out of a hat a number that referred to an image, and then either David Coxhead or I, at a preannounced time, would look in a concentrated way at the image and try to think about sending it out to various friends who were scattered all over the world at that time. Mostly they

seemed to be in transit. And they sent back drawings of what they had picked up, you see?

And there did seem to be some interesting correlations, particularly on the images that were most vivid, and maybe had some emotional impact. There was one of a Navaho blanket, bright red, with sort of zig-zag motifs. And a number of people sent back either the word 'red', or drew a red square, or something that said 'mountains' or 'triangles' or 'zeds' or something like this . . . Um, this piece had to do very much with the kind of idea that's behind the dream pieces, namely that art is a question of sharing subjectively . . .

> *Before, someone remarked about the optimism of* Street Ceremonies. *How would you compare the degree of optimism, or striving, or failing, between* Street Ceremonies *and* Dream Mapping? *It seems to me that the net is cast rather smaller, but more intensely.*

Just as paintings have become esoteric, in a sense, not through any fault that can be blamed on artists, but because of a kind of problem in the nature of our entire society, so, let's say, dreaming, and that sense of one's own inner life, is . . . something that most people have no contact with at all. And so it is not easy to find people who would normally commit themselves to performing this kind of work. People in *Street Ceremonies* and *The Dream Seminar* selected themselves. I invited participants for *Dream Mapping*.

> *I'm quite disturbed by what I take to be an over-mystification of a quite straightforward idea, a very nice idea. I don't see why one has to see it in such mystical terms. I don't see any reason, for instance, not to publish very clearly what you did, how you did it, and I think it would be very valuable.*

There really isn't any good way to communicate the experiences of these works although certainly there was no intent to make them private and inaccessible. It's a question of finding ways to report what happened . . . without making it seem that the work is result-oriented, because it isn't. You could say that the results or effects of the work include a major book on dreams[3] to be published this spring and also dream projects conducted in other places by other artists.

NOTES

1 Susan Hiller, 'Symmetrical notes from *The Dream Seminar*', in *Wallpaper on Cassette* (London: Audio Arts supplement, 1975).

2 Henry Flynt, *Blueprint for a Higher Civilization* (Milan: Multhipla Edizione, 1975).

3 David Coxhead and Susan Hiller, *Dreams: Visions of the Night* (London, Thames & Hudson, 1976; reprinted 1989; revised 1991).

COLLABORATIVE MEANING: ART AS EXPERIENCE

... I'm still not convinced that what I or any other artist says or writes is all that important, although this is one of the cornerstones of conceptualism, that is, that the artist really knows what the work is about. On a very basic level I would defend that position against any other expert who claims to know what the work means better than the artist does, but – and this is a big but – but I really do not subscribe to the notion that intention and interpretation are, or can ever be, the same. So in talking to you about my own work, I will not be giving the last word on interpretation, although this seems to be what many of you wish to hear from me, and it is what you think you are providing when I listen to you speak to me about your own work. This is the cause of the complication or discomfort I have had nagging away at me all week. I know it's the actual work of an artist that matters, and that despite everything, in the long term it will always be the manifested work, the physical embodiment, no matter how slight, the embodiment and not the talking, not the teaching, not even the writing of explanatory texts, although all of these activities since at least the sixties have quite often been defined as integral parts of some artists' work and are of course in any case very fascinating.

But all this contextualizing on the part of artists now seems a bit muddled to me. Although I realize these are tricky or even dangerous grounds to tread, I want to make an exception here for some, probably imaginary, artists whose work is entirely non-physical in nature, but otherwise, in all cases where there is a material practice existing alongside a set of contextualizing or theorizing activities, I feel uneasy when these linguistic, analytical activities are called part of the work, are used to preface the work.

Because I certainly know that all of you here today are insiders, makers as well as thinkers, I'm hopeful that you won't mistake what I'm saying for a regressive reinstatement of some kind of pure transcendence, while at the same time I would be – I have been – very uncomfortable about any mistaken reception of what I do or what I say as any kind of equally outmoded reductionist, utilitarian approach. I guess I want art that provides both, that offers a non-cognitive or aesthetic experience *by means of* being open to contextualizing, thinking, feeling and meaning. Yes, I want it all, and I imagine it's possible.

Edited transcript of an improvised lecture, 18 January, 1982, in the 'Art Now' series at Nova Scotia College of Art & Design, during Hiller's teaching visit there. Her *Monument* installation was exhibited concurrently at Eye Level Gallery, Halifax, Nova Scotia.

In making *Monument* (p. 182) I was very aware of how conceptualism, or at least conceptual formats, were already somewhat in the shadow of painting, again. And I wondered if I could make something that would provide the deep experience one can have with a painting, but provide this in such a way as to simultaneously reveal the steps toward this deepness and unknowingness, consciously. To take what we have and what we know, maybe separate out and clarify these things, and provoke a new kind of consciousness, maybe based on not knowing as much as knowing, rooting all this in different, contradictory sensory modes, thus maybe providing a revelation of what we don't know that we know.

I try to let my work exist in relation to my feeling and thinking but not be controlled by them. There is another term that assumes great importance for me, and that is – audience, the other as audience. This is something practically everyone here seems to leave out, except when talking about 'art' and 'the community' as though they were positioned oppositionally. I'll come back to this. I would much rather be specific, because good art can't be made out of generalisations, and so in a minute I'll get back to talking about *Monument*.

You can see how improvised this talk is, which means it's more like thinking aloud than a prepared lecture . . . I can't help but notice how many very articulate and theoretical artists have been guests at this college, which is of course very famous for its conceptual history. Right now there is some kind of strong reaction against all this, and there is a return to painting here, as elsewhere. I had a very enjoyable day talking with painters here, and I particularly enjoyed a lengthy and detailed studio crit session. What I enjoyed was the close attention to small details and the leisurely pace of discussion. What I was pleased to find missing was the sometimes acerbic sense of contestation that one finds in England among painters who feel that now is their time – yet again. What I was a little bored to find missing was, as usual, any discussion of content, or of issues, or of how the physicality of painting can be used to address the body of self/others, or of anything in fact that was not almost totally about how to do it, craft. There was a clear agenda that made it obvious what was good or not good about certain paintings we viewed, but this agenda was not articulated or clarified. In other words, the baby has been thrown out with the bath-water – the return to painting here, as elsewhere, seems to mean a return to something like a purely Kantian set of notions about the non-cognitive nature of the aesthetic experience. This seems to let the providers of such an experience – the painters – off the hook. They don't feel they need to be able to think or talk about what they are doing. . .

Mostly, though, I have been asked to look at work which is 'conceptualist' or possibly 'minimalist', ranging from, say, approaches to drawing to photo-

text works. Some of this work is in genres that emerged in the seventies – texts, landscape, even political polemic. I sensed that some of you doing this work are beginning to wonder about where it is placed in relation to painting and to sculpture. To be frank, I felt a lack of conviction except among the women who are doing work they define as 'feminist'. This proves how incredibly important it is to actually have something to say! Otherwise, please don't become an artist – it is, honestly, not a glamorous life, and there are easier ways of earning your living. But by having something to say, I do not mean having something programmatic, packaged, literary or journalistic to say, because for these kinds of approaches there are already more effective arenas, like TV or film.

One thing Canadian art is known for is its innovation – that is, in Britain we are very aware of the importance that video, performance, and installation have been given here – new formats for a new country. This week I've only seen a few videos, and they have been documentaries, quite film-like. I have talked over a couple of proposals for installations with some of you, and this leads me to my main point – because so many of the difficulties and confusions you are having – and this is meant as an exaggerated take on them, based on your own comments to me about each other – the painters with no theory and no content, the conceptualists with no aesthetic sense and no physicality, the video makers with no idea of what to do with video except to use it as a cheap substitute for film – these problems really might be approached more radically and more convincingly if you could think about audience, about what art is in relation to what audience is, and about the function of art. Because, of course, I am always, inevitably, a member of the audience for my own work. Not to realize this can lead to 'talking down' and other kinds of condescension . . .

And if you could think about materials and processes of the self more than you think about other people's ideas and how to conform to them . . . you are struggling, exactly like artists in London, New York, or other Western centres, to find the new way forward, and I am also trying to, or at least this is how I experience my practice. I don't feel it is perfected or achieved, it is in progress. I don't have much time to spend here and I have to do my thing, which is to tell the truth! And the only reason I have for speaking to you, is to inspire you to make art! Because we need more, not less, art, and there isn't much around. Despite its uselessness and pretentiousness, art is productive of new meanings, even despite the artist. While sometimes good intentions lead nowhere. So even while being ironic, even humorous, about all this, there is a seriousness, which I know you all share.

I will tell you a little bit about how I work and how I think about working. I could if I wished frame it in theory, which might predispose a certain kind of audience to pay attention to it seriously. But I prefer to think that art works

create their audience not from those who already are predisposed to share a stated viewpoint, but from those who find themselves participants in creating the meaning of a work. There is, nowadays, a big confusion between subject matter and content in art works. This has come about because people thinking about art have followed literary theory, although, as I mentioned before, sometimes they haven't followed it far enough to be able to tell the difference between intent and interpretation. All sorts of things contribute to content, and this is what interests me. Your subject-matter might be very divided from your content, as when a restricted and repressive format is used to supposedly convey a liberating message. Or when conventional images of bodies are used to talk about 'body', when actually body either speaks or doesn't, in the textures and rhythms and shapes used by the artist. In other words, body can be evoked but not represented. Like death. Which is how my work works, how *Monument* works ... The structure of a work is its content, its subject matter isn't. The structure and the language of a work – in the sense of rhetoric, the how it's said – are how meanings are proposed. And it is on the basis of content that new meanings reveal themselves to be possible. Gaps, flows, contrasts, materials – these things matter even more than subject-matter matters ... or anyway, that's how I see it.

Monument is an installation. In one sense, this means it is part of the sculpture category. But my work has never been considered part of British sculpture, which does not include installations, unless they are by Richard Long. In England we have this idea about something called 'third area' work, perhaps a way of excluding installations from the 'real' art catagories of painting and sculpture ... What I mean by an installation is something that occupies a site in such a way that objects, spaces, light, distances, sounds – everything that inhabits the site – everything is defined by its relationship to all the other things. So nothing in an installation means anything much except in relationship. It's not that the photographs in *Monument* mean x, the park bench means y, the sound tape means z. It's that the park bench in relationship to the photographs in relationship to the sound tape in relationship to the viewer mean something. I will say, again, that my talking here about this work is about intention, about process as I am aware of it, not about interpretation or meaning, which come along later, and in this sense, as well as its starting-point in a specific set of cultural artefacts, *Monument* is collaborative and collective, as are all art works at the points of reception and origination. All my work points to this, which may be what's distinct about it.

One legitimate way for me to talk about this piece would be anecdotally or autobiographically. So let me point out that the photographs are of ceramic memorial plaques I came across in a park in East London, and that when I

returned the next day to take photographs there were people sitting on park benches in front of the plaques eating their lunches, who turned round over their shoulders to look, as if for the first time, at what I was photographing. And when they had seen the plaques they said things like, 'Oh, isn't it sad. Isn't it dreadful.' But what struck me was that they had sat in front of these things every day having lunch for years and years and the things had been, literally, invisible to them. Only my act of noticing, of photographing, had made them visible. These plaques, like war memorials or tombstones, were designed to address the public, but they don't. Maybe because the ideology they represent is archaic or maybe because our culture simply can't handle being reminded of death in any way; but certainly they were not saying much when I came across them.

It's been pointed out to me often that I take as starting points items of British origin that the British themselves perhaps trivialize or overlook. That's because I am a foreigner, but not so foreign that British culture is unreadable or

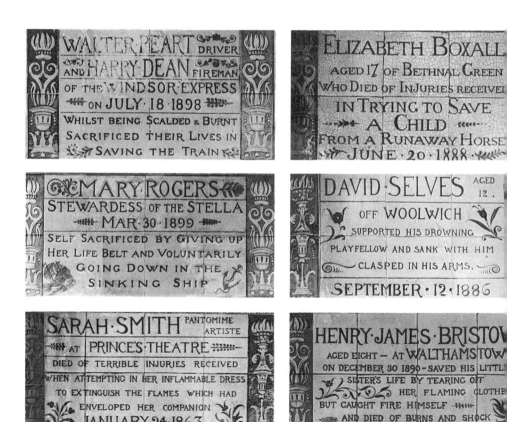

antagonistic. I probably misunderstand British things quite often, and maybe these misunderstandings provide the why and how of much of my work. On the other hand, I deeply feel that I am doing something like 'writing home' when I work, that I am showing something or telling something to the folks at home at the same time as to the folks in my adopted country. After I had lived in Europe for a few years, much of the time in England, I realized that all the statues and monuments were commemorating people of noble and exalted birth, viscounts, lords, noble generals, etc. Coming from a country that wished in its origins to overthrow all that, and that is replete with monuments to ordinary people who became great, rather than to people born great, I suppose I began to feel very alienated from the urban furniture in England, which as you know is memorials to generals and nobles, statues, park benches with inscriptions.

And these pieces of urban furniture began to become things I simply ignored, or deliberately paid no attention to, since what they obviously

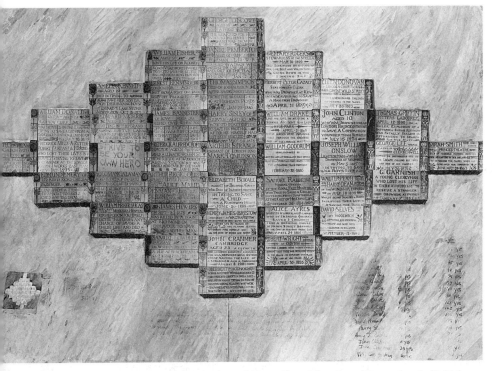

Monument 1980–81; forty-one C-type photographic panels, park bench, audio soundtrack; 'British version' overall size 557 × 670.5

facing⌉ Six individual panels *above*⌉ Study for installation *overleaf*⌉ Installation view

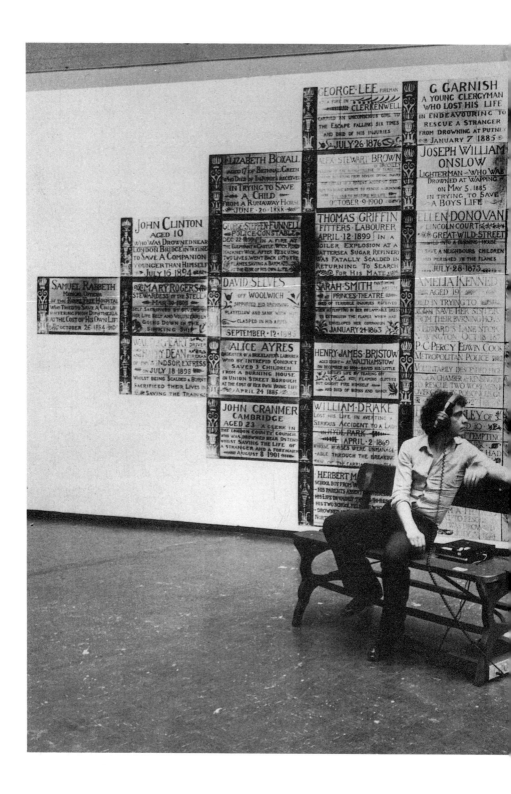

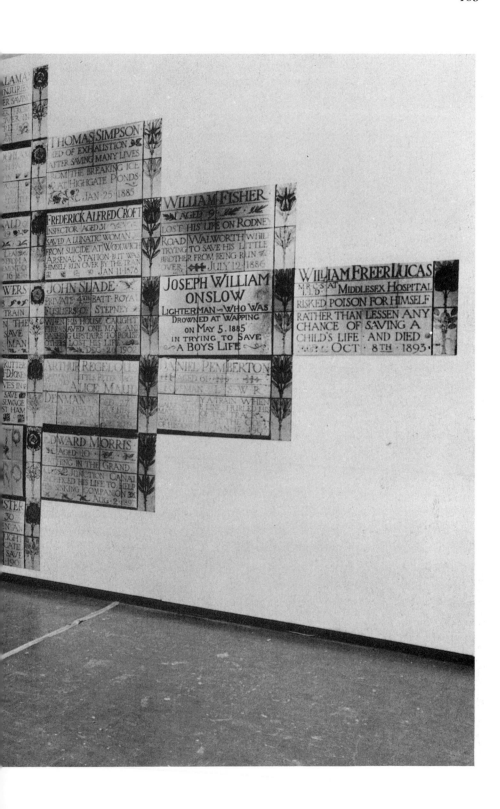

commemorated, as a group, was a system of social inequality which located me very negatively, as a woman and a commoner. Of course there is one category or kind of obvious exception to these memorials, and that is the war memorials commemorating soldiers who died in wars, long, long lists of names usually underneath a statue of Victory or Peace or something similar. This is a kind of memorial that one finds in the United States or Canada, of course, and so it was familiar and yet different in the English setting. For a start, these dead soldiers are only names, they are never depicted as individuals, there are no statues of specific ordinary soldiers, though there are a few statues of generic ordinary soldiers. No, this kind of dead hero is only a name, no sculpture depicts what he looked like as an individual. Commemoration in a list seems curiously modest, and doesn't take up much space, compared to all the statues of generals and nobles.

Of course, I wasn't thinking any of this consciously when I came across the memorial plaques in an East London park that commemorated a different kind of dead hero, heroes who were non-military, civilian, ordinary and local, being all Londoners, ordinary people who had died heroically, men and women. And so I found these plaques riveting, stunning, fascinating. And the next day I returned with a camera to photograph them, not with any specific piece of work in mind, only wanting to have the images as reference points. But the reactions of the people sitting on the park benches became part of my understanding of the memorial plaques, and eventually led to this piece of work called *Monument,* which began for me with discoveries and with contradictions.

The plaques were colourful in themselves, turquoise, blue and green, sometimes stained and beautifully discoloured. They were made of ceramic tiles that had originally been composed on a regular grid, but this had often shifted or become disturbed over the years. They were organized in a long, thin row set into a dark brown stucco wall, a tidy but unfocused arrangement, and it seemed as though more examples could have been added in. As it was, the plaques covered a very specific historical period, and came to an end around World War I.

Later I found out the history of the plaques, who had put them up, and why, but in making *Monument* I quite consciously avoided doing any art-historical or social research, and I limited myself to looking at my photographs of the plaques and thinking about them, just as one might work from sketches of a landscape or of fruit, without knowing the map reference points or the particular type of apple or pear.

Of course, the most obvious appeal was that each plaque sums up an individual act of heroism in a concise and vivid, maybe picturesque way. The

turn of phrase is adroit in conjuring up a picture – words are used to evoke images in the mind very clearly. We all feel we can know these people, that is, we can almost see them. I found the little stories sad, bizarre, odd. There was something I didn't understand, but whether it was the materials or my relationship to them wasn't clear. It was at this point that I began to think about making a piece of work, in order to find out something. As always, I had no idea what form the work would finally take.

The steps in making *Monument* seem to me to have followed on from my initial decision to photograph the plaques and from properties in the plaques, in their context, and in photography as a mode of representing. The first act was to organize the photographs on a large piece of paper as though making a study for something, perhaps a painting. I mused a bit about history painting as a genre. From playing with the photographs in various configurations, I arrived at this open cross formation, which I liked because of its symmetry (there were two stylistically distinct sorts of plaques at the site, and I wanted to find a way to incorporate them both), and its other connotations which seemed suitable for the materials. Also, it was a shape made of segments, organized on a rough grid, like each of the original plaques. It was somewhat irregular, as they had become through time. The stepped edges seemed to suggest that additional units could be added – the shape was not smoothly framed and contained; it was dynamic and open. It was orderly but nonhierarchical. And it was visually very strong. I imagined it big, built up like a wall, each small segment making up units, units making a wall. It would have an almost physical impact, because the photographs would be so illusionistic they would look 'real' . . . I would make them bigger than the originals, to make them more emphatic. At that stage, I counted the number of photographs I would be able to fit into my configuration, and discovered that there was one for each year of my life. *Monument* was already beginning to be about a kind of self-representation through art, as well as all the other obvious themes enunciated by the material itself.

To be true to the materials as I had found them, I felt it would be appropriate to use words, not as explanation, but as part of the texture of the work. My words, a response to the plaques and to the presentation of them as photographs, would emphasize their words by means of contrast. I began to incorporate my own notes and musings into a kind of meditation on death, heroism, gender and representation – themes immediately evoked by the plaques as I saw them. Class, history, religion, consciousness and definitions of 'life' seemed inevitable detours. What I produced was a non-linear, open-ended series of thoughts, as incomplete and non-hierarchical as the arrangements of individual units in my wall of photographs. My text was left as fragmented and

unbounded as the subject-matter, and it was presented as a sound tape to be listened to, privately, on headphones, while sitting on a park bench positioned in front of the wall of photographs. You would, as a viewer, decide whether or not to participate in this closer involvement with the work. You would first look at the photographs, decide whether to accept the invitation to sit down and listen, decide whether or not to engage in a private act of contemplation in public, and even decide whether or not to listen to the entire tape or whether to abandon it at any stage or possibly to rewind and listen to bits over again. When you listened to the tape, you would become temporarily part of the installation, part of the work. You would be very aware of this. You would be seen against a backdrop of representations of dead heroes. You would become aware of the different ways you experienced 'seeing' and 'listening', as well as 'looking at' and 'being looked at'. You would 'see' that you are not a unified subject, and maybe you would see what I saw, which is the unspoken content of the work . . .

I myself like the discursive, dispersed, non-unified nature of the experience *Monument* provides, in its initial impact. This was quite deliberate on my part, and makes it almost impossible to document. On one level the diffuse construction was a statement against archaic notions of aesthetics, but the piece certainly doesn't disdain to set the stage on which a non-cognitive, non-discursive, even aesthetic experience might become available.

Reality is provisional. Art is contingent. The self is in fragments. 'I' am not a container for 'consciousness' . . . By taking these things seriously, I believe it is possible, ironically, and in all sincerity, to approach the viewer with a proposal about the possibility of collaboratively arriving at meanings – by which I mean experiences – that aren't themselves entirely contingent, provisional or fragmented.

SLOW MOTION *an interview with Andrew Renton*

For twenty years you have been an influential, unpredictable presence on the
British art scene, as an artist, a teacher, and in some ways a commentator. Most
recently you returned to what one might consider your original field of work,
that of anthropology, to explore the realm of primitivism, so-called, in
contemporary art. The result is a new book, The Myth of Primitivism. *I say*
recently returned, but it seems to me in some ways you've never really been far
away from anthropology as a discipline, and so I wanted to start by quoting
back to you something you wrote in your introduction to The Myth of
Primitivism: *'While anthropology tries to turn the peoples who are its subject-*
matter into objects, and those objects into theory, art tries to turn the objects
made by those peoples into subject-matter and eventually into style. Both
practices maintain, intact, the basic European picture of the world as a
hierarchy with ourselves at the top.' Can we talk about style first?

What I was referring to specifically were current European practices that
present themselves as primitive in style. I wasn't contesting the notion of style;
style is inevitable. I was saying that to appropriate a look from this idea of
culture which isn't one's own is part of a whole process of maintaining a world-
view with a particular kind of bias built into it. A primitivistic style has certain
obvious references to the art of tribal cultures or valorizes itself in terms of
rough, hand-made, authentic, etc., like making sculpture with an adze with the
intention of evoking some idea of the primeval and authentic.

How do you relate your insights about primitivistic styles to the idea of a
hierarchical world-view?

All modernisms have always been looking for the source of authenticity. There
has been a conflation between the primitive and the less evolved, the child, the
insane, there's a whole category of these references. The main problem from
my point of view comes about with the idea that you could look to other
societies for anything that was less evolved, since all societies have been
evolving for the same period of time and it's only when you look from the
position of Europe that tribal cultures which may not have the same kind of
technology we have but may be much more complicated in terms of verbs or
ritual could be seen as primitive or lacking in development. It becomes truly
ludicrous to assume that groups of people often colonized by the West have got

Edited transcript of an interview held at the Institute of Contemporary Art, London, 31 October,
1991. It was originally published in *Talking Art* (compiled and edited by Adrian Searle, London:
Institute of Contemporary Art, 1993) and is reprinted here with the permission of the Institute of
Contemporary Art. Andrew Renton is a writer and curator of contemporary art exhibitions.

a closer relationship to some original state of humanity; but this is what primitivism assumes, that the further away you get from Europe the closer you come to what existed a long time ago. In other words, time and space get confused.

And that's what the word 'primitive' implies. So when you get artists appropriating art styles from other cultures, and the reason for the appropriation is to be more authentic, it goes round in a circle. It's been immensely successful for Western artists to do this, but it's very one-sided because when South American or African artists use a French style, we say, Oh, it's so inauthentic, they're not being themselves. It seemed to me it was important for artists to see our way through this from as many points of view as possible, since we're in a hall of mirrors bouncing back and forth fantasies which are deeply damaging to other people, and in the end one's own culture becomes less and less able to produce anything that isn't based on delusion, as if our notion of self implies there must be a fantasy of the other as a person elsewhere who is unevolved and primitive.

The notion of otherness seems important to me in relation to your own work. You've lived here for more than twenty years and to all intents and purposes you're a working British artist, yet you're often referred to as an American artist. You were born in the United States; where are you? Is there any sense of the 'other within'?

Of course I'm not British originally, but since I live here and grew up as an artist here, for some purposes I'm considered a British artist, although I'm not certain whether the British art tradition, amorphous as it may be, has ever accepted anyone from elsewhere as being British. The art tradition in this country, which has been fed by immigrants of all sorts, is also constantly deflecting their contributions as being 'not British', and the two things happen at once: one is part of the British tradition when this is useful, but often left out when it's awkward. A lot of the work I make is based on experiences I have with cultural materials that originate in this country, which to me have a freshness or strangeness or even perhaps a resonant other-ness which might be overlooked at first glance. When I began to realize I had an unusual view of certain objects here, then I was able to think about it more clearly and take that otherness up as a position. I think I now see many American materials in the same way as disturbing or odd.

It's quite interesting when you talk about that, since I'd wondered in reference to some of the wallpaper paintings where you use wallpaper mounted on to canvas and then treated in various ways; is that all British wallpaper?

Yes, although someone wrote in a review recently saying 'It's that American wallpaper with those bombers on it again.' But it's not American, it's British,

they are British aeroplanes. There's this tendency to think that all the materials I've excavated and used and treated seriously must come from somewhere else, couldn't possibly be native to 'us'.

Interesting, because that particular paper does actually say 'Royal Air Force' on the planes. Maybe it's the notion of it being mass-produced that leads to an assumption that it is American in some way.

Possibly. But to overlook the fact that it is wonderfully British misses the point, and is also a denial of the serious things that these naive cultural objects are saying all the time. People often ask me where in the world I find the wallpapers. I tell them, any wallpaper shop; it isn't difficult to find but you have to see it's there. One of the things, obviously, about art is that you're looking hard at the world you live in, there it is in front of you. Now if you are into a denial of what your own society has come to be, then it's easy to blame it on someone else, and the Americans are an easy target in that way for all the trash that exists here. As though there weren't plenty of original trash in every country that carries these kinds of meanings. But it is true that the British materials have more to them than what's generally thought of as Britishness, and I think that in this sense my work differs from some British-born artists who use cultural materials, because I see the formal aspects as being available to be read for content.

I'd like to talk about your time-based work, starting maybe in 1980, the Work in Progress *piece (p. 167) which you did in Matt's Gallery, where you situated yourself in the gallery and constructed the show in a process of time.*

That was really after I'd done at least ten years of other pieces which were time-based like *Dream Mapping* and *Street Ceremonies* which involved work with groups of people and didn't end up with an object of any kind. I think then I decided to think about this a little more, because although there is a tremendous sense of potential in collaborative work with groups that has no object resulting from it, the paradox is that in the end that work would have been very esoteric and closed to everyone who wasn't actually one of the participants, so you have a kind of dilemma. And the piece called *Work in Progress* which I did for Matt's Gallery was a transitional piece for me because it started with some paintings I took apart, thread by thread, in the gallery, thinking about Penelope and how she unwove at night what she had to put together in the daytime. At the end of the week I had all these very seductive, crinkly, pale-coloured filaments in the space. At the same time, the gallery was really being put together, was being painted and so forth while my work was going on, and at the end of the week the gallery was ready, and I knew that people were going to be coming in, and if they were coming in they wanted to see something, and I wanted to go on to some kind of conclusion, so I made a

set of what I called doodles. I very quickly made objects by plaiting, braiding and fudging together the threads of the paintings. I turned the paintings into sculptures and placed them round the space.

Each shape on the wall represented a day's worth of this undoing. The implication was that there is really no difference between objects and events. That is, an object is something that is just held together in a slower way, and if you could speed yourself up you could see an event as being bounded in time, in that object-like type of being. It's a question of time-scales really, so what I was talking about was this lack of difference between objects and events. I was also talking about taking projects past what would seem to be a point of completion, so what had been a painting in a previous exhibition of mine, could then be changed back again into the material components which could then be changed again into something else. A lot of what we deny when we're making work is this process of change, since actually everything is changing all the time as we all know. When you fix it in an object you're trying to keep time at bay and make a permanent statement of something or other.

And of course that is emphasized in a piece like Midnight, Baker Street *which has in its title time and in its process photography, that moment when you actually fix time, which of course can't be fixed. It's not just a series of photographs taken in a photobooth, there's more to it. Can you elaborate on one of the important elements of your work, the process of automatic writing, and is it really automatic?*

Midnight, Baker Street presents three views of my face overlaid with script that suggests tattooing. A lot of the work I've done is an investigation of language and the structures of language that create our reality. We have a tendency to separate things into rational, irrational – and a lot of other dichotomies that may in fact hinder us from seeing things very accurately. I keep coming back to the fact that art seems to me to be about trying to look hard and to see as accurately as possible, and so one of the things that began to increasingly intrigue me was the idea of the mark in art and what it means when you make a mark on a surface, that this is the beginning either of a painting or a written text.

The ancient Greeks had only one word for writing and drawing. And there is a kind of linguistic component to a lot of abstract painting, a lot of hieroglyphic-type marks at the base of a lot of painting. And we also have these very curious ways of talking – we say you can read a painting. All these were ideas I'd been aware of, that were brought into focus when I had an experience of automatic writing. This kind of experience of one's self or what one normally experiences as the focus of one's ego not being the vehicle by which a text or a painting is produced, is a very common one and a very

Midnight, Baker Street 1983; set of three C-type photographs each 71.1 × 50.8

enjoyable one. Automatic writing in the usual sense of the word refers to this practice of the production of text which the person producing doesn't acknowledge as coming from his or her central place of identity. It's a practice mediums indulge in; it's also practised by writers and poets.

The experience I had was of being dictated a set of pages which when read afterwards formed a coherent text that began with the question, Who is this one? And the rest of the text answered this question with a series of paradoxes. I made a wall work of this and also a book, called *Sisters of Menon* (p. 52). The book includes the text and some commentary and analysis of my own trying to understand and locate this, both within a tradition of mediumship and within a tradition of modernism in terms of art, because if we look at the history of abstract painting, of gestural abstract painting, we can see the connection. Jackson Pollock, under the influence of his psychoanalyst, began to experiment with freeing up his approach to mark-making, and this evolved into the very influential and beautiful works that he made later. And many other artists followed him. There were also people like Mark Tobey, Dubuffet, others experimenting with forms of automatism, which had been made very popular by the Surrealists.

The crunch came in the fifties, when Ad Reinhardt, the American painter, looking at Pollock's very beautiful works, decided that he too would try this sort of thing. And he produced a series of remarkable works which he later

tried to destroy, because he was very upset by the implications. Reinhardt, being a very analytical person, realized that this work was a valorization of the notion of the unconscious. He was also upset because his text looked like Arabic; they often do have this sense of calligraphy... Reinhardt then began his own research into painting as painting and his own polemic against the unconscious in art. He felt it was a mistake for artists to go down this road. The result of that is that Reinhardt influenced the minimalists and the minimalists influenced the first generation of conceptualists, and all this work is a negation of the idea of the unconscious.

Naturally enough my generation of artists wanted to do something very different in examining what had become a cultural given, that art was about itself. And so the notion of these other dimensions of art, the psychological and the social, are nowadays fascinating to younger artists, although the split exists quite clearly.

But how do you actually reach inside and drag that unconscious out?
It isn't like that, it's not buried deep, deep . . . where would it be? It's very interesting to try the following exercise: turn the television on or the radio or listen to some music. If you're right-handed, pick up a pen in your left hand, or vice versa; have a piece of paper there and see what happens. We are all divided selves and we can do a number of things at one time, and we can also write without having our focus precisely on the content of what we're writing. I suppose it's a little trick, but you made me laugh because it's like asking, how do you begin to make a painting? It's the same kind of question.

You make it sound easy, but isn't it difficult, even painful, as in psychoanalysis?
I don't want to minimize the interest in automatism, because I think as a phenomenon, as the Surrealists rightly pointed out, it is an important thing to experience one's own division. But at the same time, my work doesn't propose itself as being difficult and profound – it's not about psychoanalysis, it's not theory, it's an art practice. There are things that people are unaware of and therefore unconscious of; other people may be conscious of them. My work tends to look at cultural artefacts and to try to tease out some of the unconscious meaning that the culture is representing through its naive production of these artefacts. Automatism is a cultural artefact, too.

In a well-known work like Belshazzar's Feast *(1983–84), it's clear that, as someone wrote, your work creates its own special participation mystique, a situation where perhaps the unconscious of the viewer is brought to the surface, due to the way you've made the piece*[1]. *As a video installation it exists in a number of versions, as a camp-fire, a very British sitting-room, etc., but in all cases its focus is the videotape itself. What do you think happens when one sits and watches it?*

Belshazzar's Feast (p. 84) is a conscious attempt on my part to create a situation of reverie for the viewer. But like all my work it didn't start off like that; what happened was I came across some newspaper articles about people who saw ghost images on their television set after close-down. There was a spate of these articles, and I collected them and decided to make a work which dealt with something that has been said many times (it was said first by Marshall McLuhan) that the television set now exists in everybody's front room as the fire used to, where you had this moving image all the time. It was the focus; people could sit around the fire and look into it and see pictures, tell stories, regenerate imaginative, creative thinking on the basis of this eidetic imagery. Television is exactly the same thing. I'm convinced that one of the sources of pleasure in television viewing is not to do with the programme, it's actually to do with that moving thing. We go back to the cave and the fire, it was important for our species. I think people are using the television set for something quite creative and subversive and original, and these newspaper articles were really about that; that's why I used the reference to Belshazzar's feast, a story from the Bible about how one would interpret a mysterious apparition.

What happened to the people in the newspaper articles was made peculiar by the cultural interpretation and by the denial of the unconscious and the denial of what's actually going on when they looked at their television and saw ghosts. All the interpretations which they got were either 'It's a flying saucer beaming messages' or 'It's a hoax'; it was always empirical, they always wanted to explain these things by saying there's something outside you that's making a picture on your television set. At no point did anyone say, 'Oh, isn't that interesting, the moving imagery has triggered off your imagination in connection with certain anxieties you may have, and you have seen a picture that has spoken to you and prophesied the doom of the planet, as in the Bible.' No one said that. There was this total denial.

I wanted to re-create that situation, to make it possible for everybody, including myself, to have that sort of visionary experience. I made a video which consists of a fire, and the fire is slowed down and people see things in the flames, and the sound-track consists of a reading of the newspaper articles. I read them in a whisper, as though this were a dreadful secret that I'm sharing with everybody. There is also some improvised singing that I consider analogous to the kind of automatic writing that I do, which creates a sort of uncanny atmosphere. When it was shown on Channel 4, Channel 4 told me that aside from the flying saucer contingent who were very enthusiastic, they also had numbers of other letters. I was immensely moved by the response of people who said 'I turned on the television and there was this very strange programme, and I didn't think I'd like it, but I watched it and I thought it was

wonderful; I saw all sorts of things and had all sorts of feelings, my eyes felt different.'

> *It's interesting because it's a reduction, it's bringing the television into a less assertive role, and paradoxically it becomes more active. Another form of reduction is what one might call an anthropological reduction, and that brings us to your version of* Punch and Judy, *which is* An Entertainment *(p. 132). It's an ancient story; it's a game, it's a ritual which starts out with very specific purposes and ends up like most grisly things such as children's stories, it remains grisly to the end, and your version of it, which is rather overwhelming in a way; it's not something on a TV set in the corner of the room, it's something that actually covers the four walls of the room, is something else again. I'm very interested in your take on Punch and Judy and how you incorporated that into a piece of your own.*

Seen from the outside the Punch and Judy is absolutely terrifying, and all the children were terrified, and all the parents were saying 'Oh, isn't it funny?' and 'Look at Mr Punch, isn't he sweet?', and the children were screaming, and the parents were acculturating the children to an acceptance of this particular kind of violence. I made a collection of little eight-millimetre bits at thirty or forty different performances of Punch and Judy by different puppeteers at different times and different places, over a period of several years, and eventually I decided to make a Punch and Judy piece for adults, which immediately meant that the figures had to be enormous so we would be small. The basic idea was taking a little box theatre that the Punch and Judy figures are in, and turning that inside out, so that we were in the middle of it with the figures surrounding us. And then on the sound-track, using the voices of two people who came like I did from elsewhere, one from Switzerland and one from Pakistan, using them as translators of this almost unintelligible text of the Punch and Judy.[2] Punch is a character who's meant to be deformed in every way, including his voice, based on sources in ancient comedy, the phallic hunchback, so his voice goes through a peculiar mechanism whereby it's rendered very hard to understand. When Punch says something on my sound-track it's repeated three times, so the audience can catch it. So he goes 'Smelly baby, smelly baby, smelly baby'; the rhythm is very important, but of course it is hard to understand the words. I have two people from abroad repeating the texts and it begins to dawn on everyone, the absolute horror of the thing. And that was what I wanted to do; I designed the piece to be as macabre and terrifying as possible, I only used the really scary episodes and the figures I found the most evocative, Death, The Hangman. I left out a range of Victorian comedy additions and the super-ego characters like the police constable.

> *On one level it could be your most British piece, on another it seems to be about*

more profound feelings. Paradoxically, the work is extremely beautiful as well as extremely frightening.

Before names are put to things or feelings are packaged or laughed out of existence, that's the sort of situation that I'm trying to create. My piece ends with a section which has not got anything to do with Punch and Judy in a literal sense, but is something which seemed appropriate to do, it's a moment I find particularly horrible, in which the baby is tossed up in the air over and over again on the end of this stick. So I repeat that twenty times in slow motion; the stick and then the dress falls down with the stick, it becomes extremely odd and then it zooms out into the curtain, which is some sort of sparkly material and out into what looks like a night-time of sparkly stars, so you're suddenly in space.

After you've been through this and you've felt yourself as very, very small and perhaps confused and unable to put words to things, then it is possible that there could be a kind of transcendence, but it might be the transcendence of death or whatever lies on the other side of terror, and that this could be provided by art and then taken away again, because then the curtain comes down and you're left alone in this room, the gallery light comes on and you're left again with your life. One is stranded at the end of it, just like when you come out of the theatre, or you look at a beautiful painting and then you go home and it's the dishes and the dole. How does this all coexist together? The piece is asking a question. It's about how there is a wish that art offer consolation.

Does consolation in art take over from consolation in religion?

A lot of writing about art is clearly a religious discourse; there are experiences that are real within religion just as there are experiences of sexual ecstasy; they're all separate things and to lay them all on art, which is what seems to happen a lot, it's too bad.

The origin of Western art is very much rooted in religion and that process of object-making; the substantial nature of faith was manifested in the form of very solid objects, and the sublime creation of Renaissance painting is about the solidity of these things.

I think of religious discourse as being mystical, incoherent, maybe speaking in tongues or lying on the floor in a kind of ecstatic abandon, and it has lots of parts to it that don't have to do with pictures for the Pope. I don't think any art is a valid substitute for religion or for psychoanalysis; and just as I think some artists who use psychoanalysis most specifically in their work have never been psychoanalysed, so psychoanalysis stands as theory which justifies certain approaches to work. The work is then an illustration of a theory that's interesting or not and valuable or not. And I think this might be just like the

relationship between religion and art during the Renaissance.

We've forgotten to talk about your view of yourself as a woman artist.
I feel that to be a woman and an artist is a privileged position, not a negative
one. When I speak of being a woman artist, I'm suggesting that a position of
marginality is privileged. If you're marginal, you know two languages, not just
one, and you can translate and bring into language insights that have been
previously unarticulated. So I consider – like being a foreigner – being a woman
is a great advantage.

NOTES

1 See Barbara Einzig, 'Within and against:
Susan Hiller's non-objective Reality', *Arts
Magazine*, 66:2 (October 1991), p. 60.

2 They are respectively, Desa Philippi, writer
on contemporary art, and Rasheed Araeen,
artist and founder of *Third Text* magazine.

facing ⌉ *Heimlich/homely* 1994; customised box with 45 rpm record,
photocopy showing Breton angel of death; 33.5 × 25.5 × 6.8

6

ART AND KNOWLEDGE

A CRITIQUE OF EMPIRICISM

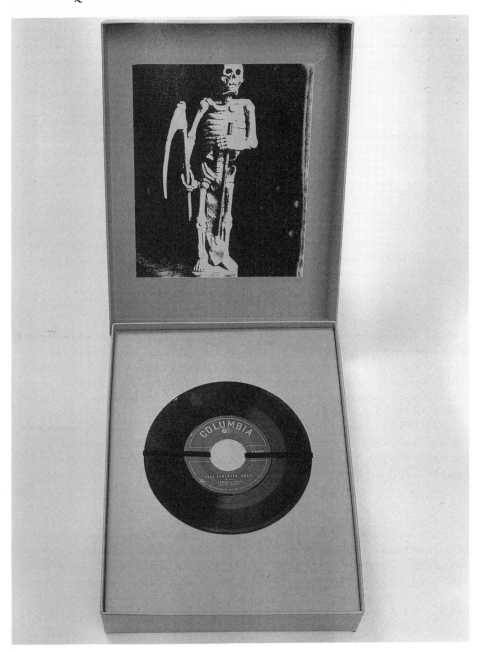

EDITOR'S INTRODUCTION

As Hiller observes, there is constant interplay between culture and the self, between the cultural ground we stand on and its obliteration. Like the Cheshire cat in *Alice in Wonderland*, it disappears to reappear again. She quotes Barthes as stating that society puts an enormous amount of energy into pretending that things don't mean anything, are 'objective', when in fact they mean a great deal as social constructions. When other ways of dealing with 'the real world' are seen as equally valid, one's own society's way of dealing with it becomes not inevitable, not rock solid, but simply one way of doing things, a way that may change. And in such an instance, one can begin to study the art of other cultures, formerly considered 'primitive', not as sources of formal appropriation but as sources of different approaches to 'the real world'. Thus empiricism as an approach to 'truth' is cast into doubt. As I understand it, this is what Foucault means when he is quoted below by Hiller as suggesting that ethnography be looked to not as a source of styles and artefacts, but as a source of ideas. Or, to quote the poet Charles Olson once again, 'O, they were hot for the world they lived in, these Maya, hot to get it down the way it was – the way it is, my fellow citizens.'[1] At the same time, 'It is all not really available for us anymore' indicates that 'we' can no longer get down what 'they' got down, absorbing the knowledge systems and arts of others as if they were classic sculptures to be put into our museums, but must now get it down direct, a project for which empiricism is poorly outfitted. In the same talk, she discusses how concepts of things can get in the way of knowing them; cites Maya Daren and Marcel Griaule as important influences; and provides example after example of how the exclusion of the knowledge that comes from experience, particularly women's experience, has reduced our understanding of reality: 'I think what art does is to reveal hidden, undisclosed, unarticulated codes within a culture.'

In 'Working through objects: Susan Hiller at the Freud Museum, London' Hiller says that 'artists do address the nature of meaning, of reality, and an enormous range of ideas – but always as non-specialists'. As non-specialists, generalists, they are able to relativize specialist discourses, and thus can avoid the trap specialists fall into of believing that their own language is 'more objective and truthful' than others.[2] This text has been condensed from three separate talks and discussions Hiller participated in during her recent installation at the Freud Museum, located at the Hampstead house where Freud practised in exile. She installed a vitrine of twenty-five boxes, in which the themes she discerned in perusing Freud's collection housed at the museum – ethnographica, classical mythology, gender – have become modes by which to organize her own personal collection of artefacts (discards, cast-offs, assorted stuff gathered over the years) and make reference to her previous works – for example, *Magic Lantern*, a sound and slide installation of the late eighties, or *An Entertainment*, a large-scale video installation for four walls. Her use of archaeological collecting boxes is itself referential both to her previous training as an anthropologist and to Freud's use of archaeology as an analogy to psychoanalysis.

At the time of this writing Hiller is away from her London home and studio, travelling in order to 'gather materials' for a new version of one of the Freud Museum boxes, *Eaux de Vie* (spirits) – water from the Lethe and Mnemosyne rivers, the streams of forgetfulness and memory. This box presents us with an apt icon of art as critique of empiricism. Is this water really the water the label says it is? If it is that water, is that water really magical, or just plain old water? Through this box you may recall many stories you once were told. There is the Greek story of the palace of Hades and Persephone, where you go after you die. There most ghosts drink from the pool of forgetfulness, but the initiated avoid it and choose instead the pool of memory. It could be religion, superstition or a fairy-tale. Yet although the bottles are antique, they are corked, sealed, and tagged, like scientific test-tubes, and are accompanied by a text. Questions are-suggested: How does science differ from magic? Isn't its aura of seriousness itself a sleight-of-hand, an atmosphere surrounding the rational secrets that run the machines we use but cannot fathom or fix? And then there may be conjured the ghost of Surrealism and its problematic; thus Joseph Cornell declared himself not a Surrealist when his boxes were identified as 'toys for adults'. He wanted to receive the 'commendation' of Einstein to dignify the work: 'As long as I have been making the objects my feeling has been a more serious one than of mere "amusement", a category into which they have been shoved too often in the 57th Street galleries.'[3] Hiller plays consciously with this collision of 'high' and 'low' categories in relating her own collection to Freud's.

Hiller's boxes are also good examples of how the principle of calibrations that I outlined in the general introduction to this book functions in her work. The artist states that 'each individual box, as well as each box within a series, within this museum, etc., attempts to locate a thing, a word and an image, representation or diagram. It's in the interrelationship between these three aspects of each box that meanings can occur.' In the case of the *Eaux de Vie* (spirits) box, we could also see the relations as being between the languages of remembering/forgetting, life/death, fact/fiction, this world/the other world, science/magic. The meanings cannot be fixed, but are located *between* these languages.

These sites *between* acquire more personal contours in Hiller's recent conversation with Stuart Morgan. She asserts that 'the content of my work is consistent, although the subject matter of different pieces varies a lot'. The dialogue between Hiller and Morgan suggests that the 'set of interlocking metaphors' that from the start drove Hiller's work – what I have called her art of calibrations – is achieving greater visibility with time. As she observes, 'the thing that unifies everything is the use of cultural artefacts from our society as starting points. . . . If you think the idea through, you realize that every type of format is already an artefact.' She views her own practices as materials-based, and regards Conceptualism from the same vantage point, rejecting the popular notion that it is exclusively language-based. This perspective has led her to play with her own formats, cutting old paintings into rectangles and sewing them together, for example, or burning her paintings and exhibiting the ashes in glass tubes: 'They are like burial urns too, and since I regard them as just as

interesting to look at and experience as the paintings, maybe that's a wish for everything to be seen as having the same potential for insight. Like traces or remnants, they point forwards and backwards at the same time.' She becomes increasingly concerned with themes of stillness and death, seeming at times to be speaking from nodal points spontaneously occurring between and

among her formats. These points of silence signify the paradox and promise of Susan Hiller's vantage point which, as she tells us in the first talk included in this volume, gives her 'privileged access to certain chinks or holes through which it is possible to sense an enormous potential reality, of which our culture . . . is a mere curtailment'.

NOTES
1 Charles Olson, 'Human Universe', in *The Poetics of the New American Poetry* (New York: Grove Press, 1973), p. 174.
2 Of course, artists whose work is designed as a demonstration of a pre-existent theory would not avoid this trap.

3 Joseph Cornell, letter to J. B. Neumann dated 25 October, 1946, in the Archives of American Art, cited by Dore Ashton, *A Joseph Cornell Album* (New York: Da Capo Press, [1974] 1989), pp. 5–6.

IT IS NOT ALL REALLY AVAILABLE FOR US ANY MORE

In a way, Jean has given away my secret. I wasn't going to tell you at the very beginning of this seminar that I had been an anthropologist. For a number of years, I didn't tell people in the art world this fact about my past. When it came out that I had been an anthropologist, I think there was a misreading of my work, due entirely, I think, to a long-established dichotomy in the way art was thought of: either as 'transcendent' or as 'social commentary'.

I'm interested in bringing ideas and materials together, extablishing between them some kind of relationship, some kind of dialogue, and I never begin to work on anything with a sense that there are ideas or theories 'out there' that need to be illustrated. So I like to come to it gradually, this thing about my background. But as the cat is already out of the bag, and we are supposed to be talking about theory and about anthropology, which are buzz-words in parts of the art world, and since this seminar is part of a theory series and not supposed to be an artist talking about her work, I'll begin by explaining how I became an anthropologist instead of an artist in the first place, and then how I got back to being an artist . . .

I've come to understand how important it is to find a way of talking about the work that allows it to to retain its necessary ambivalence and paradox; although the desire of this 'talking about' is always to reach a simple resolution of ambiguity, no matter how disguised in academic language. Remind me to come back to this later, the point about who should actually be talking about and in relationship to the work (and how), if not the artist. In some sense I've come to feel that artists' works and theories are entirely separable.

I think I probably always wanted to be an artist. I was always involved with painting and drawing when I was a kid. I remember that I won a city-wide prize when I was 10. I got to be on TV, black-and-white TV, something like Blue Peter, not a big deal, and the host held up this little painting that I had done to the black and white – viewers of this black-and-white picture and said, I just wish you could see the colours in this. The colours are just – and that was it. I knew from then on that I would be an artist . . .

I need to point out that I have certain obsessions. One of them is with gender. So this will be an engendered talk. If you look up that word in the dictionary, it means creative. But you can take it to mean something else. I have

Abridged transcript of an improvised talk followed by a discussion, in the postgraduate art seminar series at Goldsmiths' College, University of London, 12 February, 1992. The series was organized by Jean Fisher, editor of *Third Text* magazine and writer on contemporary art.

to talk about gender here because a lot has been written recently, claiming that problems around sexual preference and gender are irrelevant nowadays in the art world, but I would like to point out that at the time I was first thinking about being an artist, there were very few other women around, apparently. It wasn't, as we now know, that they weren't there, but they somehow were not very visible. To disdain to know about this situation seems to me to be a very dangerous historical view. So in response to the current lack of information about this, and to a pervasive mood that some of you have told me about in previous discussions, I feel I have to talk about gender tonight. This preamble is by way of apology to those of you who may feel bored or annoyed at the prospect . . .

Speaking autobiographically, I could say that self-doubt entered my life when I somehow discovered there were no great women artists. Since I wanted to be great, and I would inevitably become a woman, I hesitated. I procrastinated. Around the age of 14 or 15, I read a pamphlet by Margaret Mead called *Anthropology as a Career for Women*. I think it was the first time in my life that anything exciting had ever been presented to me 'as a woman'. Do you understand what I am saying?

And of course I wanted to travel and experience the exotic. I loved all those feathers. I really wanted that, too. So, it became what I did. It was simple. You could go and study anthropology at a university, and when you did, you eventually became an anthropologist. No problem. Nothing about geniuses being born, or biology getting in the way. And I'm immensely grateful for having had the opportunity to study anthropology, a fascinating field, even though, in the end, I couldn't 'be' an anthropologist. I left that trajectory after doing some fieldwork and completing all the Ph.D. requirements except for my dissertation.

I can sum up for you, very succinctly, why I gave up anthropology. A lot of this implies, I feel, my rather naive notion of what an artist might be, because I thought an artist would be everything an anthropologist was not. What I didn't like about anthropology and what deeply distressed me and why I thought it could not be me who did this job, was initially a sense of hierarchy that was inbuilt, that is, we in the West go out somewhere and study 'them'. And we are funded to do that very, very generously. There is a lot of money around. There still is, so you can go off somewhere else and study other people. Then it is a career. You bring back this material, and you build a career here on the basis of the material from there. And you go up a kind of standard ladder without any sense that you would put yourself at risk in any way or problematize your own behaviour through this experience, right? So it is all schematized.

Now clearly, from a political point of view, the whole practice of

anthropology is an artefact of colonialism. But I didn't know that at that time. I just felt uneasy with this kind of situation, 'us' and 'them'. The second thing about anthropology was that we were constantly being told it was harmless. Well, 'harmless' wasn't the word that was used. The word that was used was 'value-free'. And this is something that runs through science and social science, and has been critiqued most articulately by Chomsky.[1] We were being told that what we did had no relationship whatsoever to the real world. It was pure research, pure knowledge, something that you did that went into a library, and other pieces of work based on this would go forward. Whether the Government used it or not, was not your problem.

The third issue, and coming back to gender again, was what could be called the position of women within anthropology. And here I am using anthropology as a discourse of the other. In a very literal sense, what seems to happen when men and women from dominant Western societies are trained as anthropologists is that they are trained in a discourse which I have subsequently learned to understand as patriarchal. One didn't have the terms in those days for this. What happens is, you go off to study these others very much from an unconscious position of male dominance. And you rarely find anthropologists, even today, finding out much about women others, only when women anthropologists decide to talk to other women. The information that is brought back about women is often brought back on the basis of conversations with men about women. This is interesting, because all it does is reinforce our own notions of women being a problem category, and one that does not consciously theorize or describe itself.

Recently, of course, people have begun, men and women have begun to see that this is a very biased and peculiar view of the world which comes about through a particular form of training, a particular kind of lens which one is given to look at the world. But this shift has yet to filter through to the so-called public at large, of which we are all part. So, for example, one has been told endlessly – and this is a problem for women artists – that there are no women doing real art, anywhere else in the world. Or there are no women mystics. Or there are no interesting rituals or ceremonies performed by women; the rituals in aboriginal Australia for example, supposedly being only male. And the women have little tiny, not very interesting things that happen. There is no art attached. No great costumes. This information was gleaned from Australian men, Aboriginal men who are not allowed to speak of women's rituals. So when asked by an anthropologist who loves the men's rituals, what do women do, they say, hum, nothing. And no one asks the women. Until recently, when women anthropologists began to arrive on the scene.[2]

An interesting tie-in with art is that the Visual Arts Board of Australia

used to promote the work of the acrylic desert painters, from Papuna and elsewhere, as a male art practice. Which is completely not the case if you actually go to Australia and see who is making the paintings; but the big names, the big sellers, the ones who are said to be the best Aboriginal artists are always men. I think this is fascinating. But it comes about through seeing the world through a lens which is constructed here.

Now, why is that? It is because the basic issue in anthropology is the idea of the participant/observer. Anthropologists are required to be simultaneously participants and observers of the culture that they are going into. But as I said initially, they are not allowed to put themselves at risk. So they learn the language, but they are not allowed to have their own world-view changed. They have to come back, write their thesis and go through the whole thing, or else they are not anthropologists. You never hear about what they personally learned, or if they changed. What is the difference between travel writing and anthropological writing? The difference is that travel writing doesn't claim objectivity. It is always a person going somewhere and seeing and learning something. Anthropology recasts the same kind of experience into something else. 'Objectivity' is a fantasy our culture is heavily invested in.

The second set of ideas I want to introduce has to do with the relationships between anthropology and art. These relationships are really quite wonderfully buried when you think about it. One needs to become a kind of archaeologist to excavate them. I have been making little notes about where the word 'anthropological' comes up nowadays in art criticism, and a couple of things struck me about how this term appears in critical practice now. Fetishism, exoticism, travel, guilt, sociologised practices, feathers, and shamanism – all seem to be called anthropological. How does this come about? What relationship do these things have to any notion that anthropologists might have of what their practice is about?

In thinking about this, I realized that one really needed to talk, not theory, but history a little bit. In that sense you can tell, if you know anything about the social sciences, that I trained as an anthropologist in the USA, because in the USA anthropology has a historical and humanistic aspect, if you like, as well as a so-called rigorous scientific aspect. The time-base is important, historical texts, archaeology – the idea of excavating or retrieving something buried or forgotten. Also, there is an emphasis on language structuring reality and on the technical side of applied linguistics, a tool, I suppose, for another sort of excavation. Whereas in Europe there is a conflation between what I would call sociology – which is not a historicized practice – and anthropology. So if I give you a historical perspective, that would be a very anthropological thing to do, from a North American viewpoint.

So let's look at the early days of anthropology, right? After the time when colonial missionaries started writing reports on people to get more money for missionary societies so they could go out and convert the natives. After the time when colonialism could not be said to be unselfconscious any more. So you got British District Commissioners writing reports about how to improve native welfare and so forth. Let's jump to about 1920 then, when we had people who were neither District Commissioners, in other words, government employees, nor missionaries, but they started to do this kind of always text-based work. Anthropology, right? Now if you look at two interesting places, – France and the USA, you will see that oddly enough from the very beginning there were close connections between artists and anthropologists. This interests me, because as well as gender, one of my abiding interests has been the seepage or interchange between discourses that are supposed to have clear boundaries.

In the USA, the very earliest generation of anthropologists, Margaret Mead, Ruth Benedict, Ruth Bunzel, Elsie Clews Parsons (interesting that there were so many women, which is another thing that was very encouraging to my generation), all students of Franz Boas who was a German, right – had all been poets. They had met in a poetry class. Afterwards, they decided that anthropology provided a framework for their interests. If you can think of anthropologists as people who are primarily writers then it all makes sense. It helps to explain things like the Taos connection, the relationship between anthropologists and D. H. Lawrence, and is certainly a very different picture than you get now when you think about anthropology.

In France, at about the same time, there was an intense and close connection between the Surrealist group and the people who later became the most famous French anthropologists. Marcel Griaule was one of them. He later became the director of the Musée de l'Homme, but his friendship with Bataille was formative. What was he looking for? Something about the exotic and transgressive. And whereas the Surrealists had what you could call a bifurcated enterprise, one aspect of which was a politicized critique of their own society, they also had a strong tendency to look elsewhere for curios and artefacts, which fed their fantasies. So there was a split between, eventually, the anthropologists and the Surrealists. Perhaps I can recommend a book to you. It is called *Conversations with Ogotemmêli*, also published in French under the title *Dieu d'Eau*.[3] This book by Marcel Griaule came about after he had been on an expedition that lasted off and on for seven or eight years among the Dogon in West Africa. On the last week or towards the end of the last week when, all the anthropologists were completely packed up and ready to go, a message was sent to them by the elders of the Dogon who said, 'Well, OK, we've had a meeting, yet another meeting about you, and we think we should really tell you what has

been going on. You have been here for eight years and we haven't told you anything.' Of course the French had acccumulated masses of material, which was now shown to be superficial, the sort of explanations given to children.

So after eight years Griaule and Ogotemmêli sat down and a text was dictated to the anthropologist, which he transcribed, and it is the book *God of Water*. It is real interesting. I recommend it. You might want to read it alongside another book called *Black Elk Speaks*, which was dictated to John Niehardt, Poet Laureate of Kansas, by the Oglala Sioux visionary Black Elk.[4] It seems that the notion of anthropology as writing surely did not escape these guys, who used anthropologists as scribes . . .

Now we know what happened to Lévi-Strauss. You study his ideas in art, don't you? But do you know what he said recently? That everything is an artefact of his imagination. Towards the end of his life he is confessing that there is no distinction between objectivity and subjectivity. This is a point I am always trying to make. These discourses are structured in certain ways that are beneficial to people's location in this culture that we live in. But when you push them really hard, they fall apart.

Now I am helping, I hope, to collapse the social scientific paradigm. In a minute I am going to come to the artistic one. I want to discuss another book that I think some of you may already have read. Which is, I consider, a very important book, a text located ambiguously within anthropology, and actually by an artist. Maya Deren wrote a cult book that came out under a number of different titles, just like Marcel Griaule's book. One title is *Divine Horsemen* and another is *The Voodoo Gods*.[5] I consider it a major book within anthropology, but as I suggested, until recently it was outside the academic canon, like *Conversations with Ogotemmêli*. The reason for this was that both authors confess themselves to be present within the material. Nowadays, younger anthropologists are indeed taking up this position. But whether any of the newer books will make an impression outside university departments remains to be seen. In a way, the impurity of *Divine Horsemen* and *Conversations with Ogotemmêli* meant they weren't read by academics but by people outside the discourse of anthropology.

Maya Deren went to Haiti initially to make a documentary film on Haitian dances, a portion of which was screened last year in London. She felt she really couldn't decide what should be filmed until she understood the content of the dances. In order to do that, she had to study the voodoo rites and traditions of Haiti. So she went back to the USA and got a grant from a foundation to do fieldwork in Haiti. Eventually she wrote an impeccable scholarly study on the structure and meaning of Haitian voodoo. She had Joseph Campbell write an introduction to it. But in the last chapter of the book, she writes about

participating in a voodoo ceremony and being involuntarily entranced, 'mounted by a loa', inhabited by a god. She had not wished or planned for this to happen. But it was a remarkable experience, described unforgettably. So her book is suspect academically. As my academic supervisor said to me: 'Well, if she had left the last chapter off, it would have been acceptable Ph.D. material.' But she didn't leave off the last chapter, and it is a great book.

As I said before, nowadays there is a trend of placing the academic author of an anthropological text in some relationship to the other authors who stand behind the text, in other words, the people who are the object of study. I could mention the idea of multivocality. People are now writing their Ph.D. theses so that their voice as the anthropologist is mixed with the voices of various other people who now appear in the text as named speakers. Supposedly the anthropologist is now no longer the most important speaker. And there are other approaches that analyse all the problems and difficulties of the anthropologists in finding a way to even begin to relate to their subject, and approaches that describe the set of experiences that are called fieldwork, and what it all implies.[6] But in all cases these return to us as career moves. Do you understand this point? I have nothing against careers. I just feel that as an anthropologist you might feel, only because I felt it, and so I assume others do too, that you were not the expert who should write up this stuff, and it was the wrong thing to be doing. But of course once you feel that, you are outside anthropology so these objections never get on to the record. Whereas if you remain within anthropology, you are within, entirely within the post-colonialist or colonialist framework of hierarchy, and so on.

Interestingly enough, in addition to the words that I mentioned before – fetishism, exoticism, social issues, feathers, shamanism, there are other ways that the notion of being anthropological is constituted all the time in relationship to art. One thing that we would have to consider here would be the notion of theory and how it feeds in to our practice as artists. So much of the theory that I am familiar with, and that you are familiar with, comes out of two places: first, psychoanalysis and second, linguistics/semiotics, which is anthropology. When I did anthropology, I had to study linguistics as a required subject and so forth. Barthes, Baudrillard, Foucault and all these people have this kind of background. The names fashionable in art schools change occasionally, of course. When I first began to make paintings, Lévi-Strauss and Barthes were stylish, which was lucky for me because I had read them a few years earlier as an anthropology student. So there is the idea that you go outside art for reference points, if not for value.

We tend to look in these two directions. I think previous generations went more towards art history or more towards perception, more towards

phenomenology, various other things, but it seems to me those are the two places – anthropology and psychoanalysis – that theory is coming from now.

I would argue, I think, that art is by definition an anthropological practice and anthropology by definition is an art. I have talked a little bit about the anthropological side. I want to talk about the art side now. I want to put a question. What is it that artists do? What is our job? What is our function? What is our role? What is it we actually do? I have my own answer to this, obviously. It may not be the same answer that you have, but I think what art does is to reveal hidden, undisclosed, unarticulated codes within a culture and I believe this is true in every culture. I don't think this just applies to us in the West, although in the West things will be perhaps more hidden and less consciously articulated by people in general. But the task of disclosure is certainly what artists do everywhere. I think the job of the artist is to make manifest a shared but unarticulated belief or to find a new form for something which is known but not fully understood. It is a self-referential practice, and a cultural practice.

When I first started to make work, I started talking about the basic materials in my own work as cultural artefacts. People thought this was very strange, even weird. I now notice this word is everywhere. I am not taking credit for it. I am saying it is everywhere. All artists are supposedly using cultural artefacts in their work, which is absolutely fascinating. What else would you be doing? I mean, it is redundant.

Now that's one thing. The second thing is, what does the word 'artefact' mean? Did any of you have a background in science? I have a physicist friend who said dismissively of someone's work as a physicist, 'Oh, he is just discovering artefacts, the results are just artefacts of his experiment.' Meaning that obvious redundancies or self-reflexivities are contained within the experiment, so the results are obvious because they were involved in the initial hypothesis or procedure. I hope that's fairly accurate, speaking as someone outside the physical sciences.

Looking at the idea of an artefact, let me start again. We think of artefacts as being things out there. But from the point of view of what the word really means, they are not out there at all. Because the culture that forms us is the consciousness that we share of reality. So the artefacts are, on the one hand, hypotheses, and on the other hand, conclusions. And that is what we are working with as artists. We are being anthropological in a sense that, to me, is much more interesting than the way most anthropologists think of anthropology.

Now where does that leave all this stuff with the feathers and the shamanism and the exoticism and the fetishism, and the social issues and all

this? Well, it means that it is doubly redundant. It cancels itself out because we are all simultaneously participants and observers. There is no need to stress that as a paradigm. That is part of ourselves, our being within this culture. To borrow aspects of what our culture has defined as exotic or other and to recycle that yet again, is simply to present a hall of mirrors where there is an ever-receding sense of what you might actually be able to present or say or understand.

I would emphasize that artists are pursuing anthropological practices in the most profound sense, whether or not they are taking on board as materials things which would normally be construed as artefacts. I would also say that the function of the artist in our society is really no different from the function of artists in other societies, in so far as I am able to know what that would be. Because if your work were totally unintelligible, it wouldn't be accepted as art. People would say it is schizophrenic, or not very good, or there would be a hundred different ways to exclude it from the category of art. Once it is within the category of art it means that it rests very strongly on a cultural consensus about reality. Artists are no more outsiders here than they are in any society. You can't be a real outsider and still be within art. That is another thing we could talk about some time.

Now within this curious and I think very convoluted and fascinating relationship between art and society in our culture, between anthropology and art in our society, there is something filtering through all the time in terms of reference points that are given about what are the material data of anthropology. I'm speaking here of those things that enter into our museums as objects from other societies. You all probably know there is a trajectory over the same period of time that I was referring to before, about 1912 to the present. First, an absolute dismissal of interest in things like African sculpture, which were thought to be barbarous curios of no aesthetic value. Then you get European artists validating these objects as interesting source material. Then you get the objects being collected as art, as well as the development of separate museums of ethnographic artefacts, where they have excluded all the bones and all the other things that used to be housed in those museums, so that the public is eventually only presented with what some curator has decided are the most beautiful or fascinating objects; and then the next stage we are in now is that those objects aren't even in ethnographic museums any more, but they are being shown all the time as major art works, often alongside works from our society.

In the advanced phase of this development, actual contemporary artists from other societies are being brought into a Western art discourse to show their work alongside artists who come from the West. And that is the situation we are

in now. This brings me, finally, to *The Myth of Primitivism*,[7] a recently published book. My only regret about the book is that the first edition does not display the authors' names on the cover, not only because they are very distinguished but because of the mix of artists, writers, critics, historians and anthropologists. The different papers in the book grate against each other somewhat, and they also play with each other. Speaking personally, I can't imagine a more worthwhile project to have been involved with, as an artist, because I can't imagine a bigger issue for an artist than a kind of decision about aesthetic rectitude or goodness or righteousness or even beauty, all the same to me. In other words, how do you judge work? How do you judge your own work? At a moment when international, local, national, historical styles and criteria are all up for grabs? In order to feel our way through what is happening now, we have to figure out a way to non-hierarchically arrange our own mental map, without excluding or denigrating. I am not speaking about the problems or issues that arise for artists from outside Europe and North America who have entered into this context. They speak eloquently themselves about how they see things.

If we seek to know the traditions of others in a way that doesn't put ourselves at risk, we will never learn anything. But if we do put ourselves at risk, we may have to give up many of the values that have formed us, a sense of identity formed with reference to internally and externally colonized others.

DISCUSSION

I don't quite understand why you feel there is something different now, unless you are referring to the opening up of ideas in our own cultural establishment? We have been in a situation of constant change for some time.

Let's backtrack a little, to look at the relationship of Western artists to the cultures that were not Western, in the nineteenth century. First, there was lack of interest, then interest in the exotic, related to Romanticism, then a quest for difference and immersion in the exotic, etc. But all the time, the relationship was appropriative, beginning with the exotic as subject matter for painting but always handled in a non-exotic, Western style – you'll accept my analysis so far? That is, paintings of Morocco or wherever, but always done within the Western tradition. The habit of appropriation is really the issue. In the case of Vlaminck, Picasso and friends who saw the artefacts made by Africans in particular as available for use by them, we can say that there was a clear parallel to the way that Western economic systems saw Africa as a resource, an economic resource to provide raw materials. Artists in the early, classic modernist phase saw the artefacts of those cultures as being available for appropriation. What I would say in reference to this is that whereas

anthropology turns the people outside the West into subject-matter, into text, and eventually into theory, artists take their artefacts and turn them into style. So – first subject-matter, then style within our own art history's use of these things; and in that sense artists are ahead of anthropologists, who are only beginning to appropriate the stylistic possibilities of their subjects ...

All right, back to your question. As you said, we are innundated with more and more foreign input. We know now real artists from what were once thought of as the ethnographic zones, we know them as our contemporaries. These artists seem very knowing about Western traditions and their own traditions. They are invited to show in Europe and we show alongside them. In my view, what is evident is that they are more knowledgeable about us than we are about them ... but in any case the relationship has completely shifted for us, as artists, because we simply cannot assume a hierarchy of value, with us and our values, our kind of art, our kind of culture, at the very top. This is what is different about now.

I wouldn't have thought any artist would look at what an anthropologist may call an artefact as anything other than a work of art, another kind of art. So in that sense, artists were procreating another form of art in the same way they would procreate off something in their own culture. So the African art was not looked at as something secondary.

There is always a hierarchy in terms of who benefits. Picasso benefited from his experience with African sculpture, definitely. But what about the people who made the sculpture? The makers were excluded. So-called African art in quotes became visible in Europe, even valuable eventually, but only on Western terms. it wasn't given the aura of being created by an individual, named person, since the artists were treated as anonymous, which they were not.

You are talking as if there were known artists, individuals, within these cultures. But within a tribe, they are collective.

Well, what you have just said is an example of primitivistic thinking, if you'll forgive my saying so. You are quite wrong. But I'm not blaming the Western artists, I'm not saying it is someone's fault. Within culture, attitudes are inter-locking. With all good intentions, artists here are simply part of the culture and have the same basic prejudices and attitudes. Within a culture, we all see reality in somewhat the same way, because we speak the same language. The gesture of appropriation or exploitation of the materials of others remained an issue that was unexamined within Western art history until my generation and even more so, your generation. It was simply considered normal.

But we don't just live in our culture, we are very influenced by other cultures, and we appreciate the art of other cultures, we really value it. I don't like to use the word 'artefact', I call it art.

Yes, I understand you think my attitude is too prosaic and even perhaps a bit puritanical? But to look more closely into what you feel, you might begin by realizing I say artefact instead of art when I am emphasizing that our idea of art, so-called primitive art, is an artefact of our culture. In ethnographic museums and collections, what remains unclassified is what they have discarded over the years, the bones, scalps, bits of human bodies they collected along with the created objects which may have been useful but are now emptied of use for us, and these objects that we love because they seem beautiful, get called art. Over the years, as we have become squeamish and ashamed, museums have culled out other things. They may still be in a basement somewhere, but not in display cases that you can look at. So there is a constant weeding and censoring and redefining of what was collected elsewhere.

Another point is that when art – and to show my respect for the makers, I can call these objects art – enters our knowledges, the knowledges we have of others, it enters on our terms. You have expressed a feeling of being very, very influenced by these non-Western cultures. But how? By what means? It really is essential to think more deeply. On the one hand we have the new world order, and on the other, the new super-internationalism in art. I believe they go together. These other cultures enter on our terms. I might wish it weren't like this, but it is.

> *To pick up that thread, I felt a kind of optimism when you were graphing our past ways of looking at all this, because precisely this new internationalism is what makes it possible for you to see these issues; isn't that what you are saying also?*

I'm emphasizing the way we are changing and the idea of putting ourselves at risk. When you see a work by someone from London, you look at it and perhaps realize that its meaning exists between you and it, and you get a new, more conscious sense of yourself. You are reconstructed by the experience of looking at something. When you do this with something from elsewhere, maybe an object that once had a particular, specific use, although you don't know what, your experience is bound to be based on a delusion; your response is fantasy. Because you have no idea what the thing was intended to mean, and so you can only substitute your own fantasy. This is on the one hand quite pleasant, and on the other hand deeply misleading. The new internationalism is a construction which is devious and returns to us more of the same because by this means you can never know the other. Since artists, like everyone else, are the victims of their own society as well as the beneficiaries, they are party to this. To have this realization is to put the construction of one's self at risk.

> *Well, Picasso and the others – let's say from that perch of self-examination, how do you go beyond that?*

There is nothing more to say about Picasso's own homage, if you like, to African sculpture. But along with it went his fantasies of what the sculpture meant. Picasso, Henry Moore and others wrote extraordinary things about African artists, unconsciously racist and primitivizing. They knew practically nothing about Africa except a set of ideological fantasies that enabled appropriation to go smoothly. That is because they were typical of their time, as we are all typical of our time. Looking back on their time, we can see through all this. What is strange is that the same thing seems to be ongoing, even in this discussion. To take a well-known example, the big show of the primitive and the modern that took place a few years ago in New York, which juxtaposed magnificent pieces of work from ethnographic collections with works by Western artists, was good and liberal in so far as the names of the artists from Africa and the Pacific were attached wherever possible, but – the reaction of the art press simply reinvented all the fantasies we've been talking about. For instance, one major article expressed the view that the exhibition lacked drama because the African art was meant to be looked at by flickering torchlight. This writer went on about his own fantasy that the masks would really come alive when this flickering light played over the surface. Rubbish. Because some masks would have been seen like that, but others were used in daylight or hung up in someone's home or the village temple. There was no homogeneous context of flickering torchlight, which by the way is part of a larger fantasy about the darkness of this work.

It strikes me there is a parallel whenever people use a style from elsewhere without much knowledge of its original source. On the Continent you see street fashions, British street fashions, mixed up together. Go into a bar and you will find different groupings together, and coming from London you certainly think there is something wrong in this bar.

In other words, there is a content that goes with the style and this is lost when it is adopted elsewhere. Yes, this is universal. Borrowing or appropriation, and the loss or shift of meaning happens everywhere. But the difference is, first of all, I am insistent on talking about this from our point of view, how we do it, and second because of the power position and history of domination of our culture over many others. Although we only know the surface, we pretend we know more. Even when we adopt the signs of the other, we are not establishing an equality.

I think what is more important is when cultures become nomadic. And now it is recognizable. There are not just old imperial centres, or power centres but it's spread out.

I agree, power is spread out and less obviously focused geographically, but of course I don't agree at all about culture being nomadic; this is the kind of

argument I would reject. The people from Guatemala aren't nomadic, they may try to flee but end up on the bottom again in Los Angeles, the Malaysians aren't nomadic, refugees aren't nomads. I guess I'm inserting a kind of memory into this discussion, a memory of an idea of justice which I feel is so important to entertain in all contexts. You have all absorbed a set of notions which leaves your dominance as British artists – I mean your aesthetic dominance – assured. Before we all consent to being used, let's try to be more judicious in our attitudes toward amorality. And I certainly do not mean that we should all be making pedagogical, issues-based art.

I've been very inspired by what you are saying, because I've been thinking it is necessary to problematize the language to stop people from thinking that there is some kind of transnational universal art language which can be used to jump over these problems of people not understanding each other.

One is best off relinquishing a set of fantasies about the universal unless you can figure out – and I haven't myself been able to – how notions of the universal can be separated from notions that remain unspoken, about privilege. If someone can figure out a way to get universality into a non-hierarchical aesthetic, I would be really interested.

Years ago I had a bursary in Morocco, in studios which the French had previously set up to encourage artists to travel there and do little sketches or watercolours or whatever of native life. Nowadays of course these studios are full of other sorts of artists, but I had a real problem there about doing any work at all. What intensified my problem was that my Moroccan friends, who had all gone to very traditional French-type schools, thought being an artist was wonderful. But then they would come to see what I was doing and they felt it was totally irrelevant, not art, horrible. They thought I was deluded, and they felt sorry for me. In their terms, I really was deluded.

If I understood what you said before, though, you said that all artists articulate a belief or code within their culture, and in that way we are very similar to artists in other cultures.

Yes, this is my own fantasy of universality, and thank you for pointing it out now when I can see it clearly against the other things I've been saying.

But I have a different fantasy, which is that artists of another culture have something we don't have, which is something we miss, and that is the agreement of the society about their work.

To be provocative, I would agree that's only a fantasy. One of the ways we could figure out what artists do in different societies would be to do a little reading, even in those dreadfully tainted ethnographies I've been disclaiming. If you read for the tiny bits about art, you'll see how many different notions there are. A few sources concentrate on art; for instance, an article I read about wooden

stools in West Africa, those wonderful objects with the figures underneath. The anthropologist actually went around and asked people in the village which stools were the best, because he couldn't figure it out. And people gave him judicious and articulate ideas about what makes a good piece as opposed to a mediocre piece or an apprentice piece, very distinct from his evaluations. So there was a clear and different sense of aesthetics. Usually no anthropologist has bothered to ask the question in the first place.

And it's important to remember that most of the work we know of from the Pacific and Africa is made of biodegradable materials that disappear rather quickly. So there would not have been many old pieces around to be influenced by. How is style passed on in a case where you may not have earlier works to refer to? In some places, they build gigantic figures or carve masks only every five, seven, thirteen years, whenever the ceremonial cycle comes round again, and the old works are rotted away or sometimes have even been ritually destroyed. So how to reconstruct style? From memory. And discourse. This is essential. Even rituals are evaluated according to whether they are pleasing to people or not. Recently, I watched a documentary on a West African ceremony, the sort of documentary that has subtitles. Some women who had participated in the ritual were asked by the anthropologist how it compared to the same ritual five years earlier, because we tend to think of rituals as fixed once and for all, like Mass, for example. The women laughed and said it was really great this year. They put in some new stuff, I never saw him sprinkle the water like that and wave those branches, it was great. So they were clearly into novelty, not involved with an idea of something changeless, permanent, for ever the same. Do you understand the implications? We really know very little about other people's basic ideas of these things. We have only fragmented knowledge and a number of fantasies.

To get back to style, then, there is a small article by Margaret Mead about New Guinea, suggesting that art styles were passed on by the women although the men made the art. In areas where rituals occur infrequently and the great statues are left to rot in between, she suggests that during the periods of seclusion when women are menstruating and they retire to so-called menstrual huts, they make little sketches on the walls. Yes, she found the walls of these structures covered with scratched images of statues. This would then have been the only ongoing visual record of style. The sketches might go back, say, fifty years, but the statues didn't exist any more to refer to. So we have to concentrate on discourse and memory, as I said.

Among the Pueblo potters of the US South-West who make the wonderful jars and bowls you will be familiar with, the custom is to go out to rubbish dumps where there is a lot of broken old pottery, and to bring back tiny fragments. Out

of these fragments an entire new design will be fabricated, validated the same way we do – using a fragment from the past of art to create a new work.

I want you to have this information, to take all this into consideration to weigh it up against your assumptions that these artists are somehow more at one with other people than we are, or more traditional than we are, or similar notions. We really would need to ask them personally. Because so much of what we know points to a different conclusion, but general assumptions such as you articulated seem not to shift. A number of tribal societies have artists who are shamans, and frequently shamans are social deviants, maybe schizophenics, but certainly ill. They become shamans because they are ill and in search of a cure. One way they can socialize their situation is to take on a shamanistic position which may be valued very highly, or in some groups, considered a very lowly, contaminated role. I wouldn't see them as at one with the group, exactly.

So Joseph Beuys's idea that he was a shaman was wrong because it was a positive definition of the role?

What I'm saying is that shamanism is a positive use of deviation but the shaman may or may not feel and be unified with her/his group. I want to jump quickly from this to what Foucault said, that the heritage of ethnography was an inexhaustible treasure house not of styles and artefacts, but of ideas.[8] That is, if we could actually know all these different ways of conceiving reality, we would have a store of information that might help us to clarify some confusions we face in our own culture. But we don't treat it like that, we treat it as a storehouse of materials to appropriate.

You are suggesting that because of the appropriation and other tendencies within Western culture, we really have passed over the idea of the other; I think there is a struggle between this and recognizing there is something we didn't know. It's striking there is very little idea of the other in our terms of reference, in other words we have to borrow our idea of this too, so it's again an appropriation . . .

We keep talking generalities. It is really a tough way to talk about these things, because as artists we need to be practical and specific and try to relate it always to practice. I think we also need to learn to accept ourselves as being divided, ironic, and so forth, and, at the same time, not to take this too lightly and to be superficial about it. If there is no hierarchy of world-views, why shouldn't we take our own on board with tremendous seriousness? I am simply suggesting that we not be naive, that we not mislocate our desires and fantasies and project them outward.

You can find enough weird stuff within yourself and the world you live in, and in a sense that is enough to go on. It is not really all available for us any more. This is what is different.

NOTES

1 Noam Chomsky, *American Power and the New Mandarins* (Harmondsworth: Penguin, 1969), p. 253: 'The social and behavioural sciences should be seriously studied not only for their intrinsic interest, but so the student can be made quite aware of exactly how little they have to say about the problems of man and society that really matter.'

2 See Nancy D. Munn, *Walbiri Iconography* (Ithaca, NY: Cornell University Press, 1973) [Ed.: See also Diane Bell, *Daughters of the Dreaming* (Sydney: George Allen & Unwin Australia, 1983)].

3 Marcel Griaule, *Dieu d'Eau: Entretiens avec Ogotemmêli* (Paris, 1948); translated, by Germaine Dieterleu, as *Conversations with Ogotemmêli* (London: Oxford University Press, 1965).

4 *Black Elk Speaks*, as told to John H. Niehardt (Lincoln, Nebr.: University of Nebraska Press, 1961, 1979, 1988).

5 Maya Deren, *Divine Horsemen: The Living Gods of Haiti* (London: Thames & Hudson, 1953); *Voodoo Gods* (St Albans: Paladin, 1975).

6 An innovatory book taking most of these issues on board, but also neglected within the academic anthropological canon, is Calixta Guiterras Holmes, *Perils of the Soul* (New York: The Free Press of Glencoe, 1961).

7 *The Myth of Primitivism*, compiled and introduced by Susan Hiller (London and New York: Routledge, 1991, reprinted 1992, 1993); contributors to the book were: Guy Brett, Annie Coombes, Jimmie Durham, Edgar Heap of Birds, Signe Howell, Christina Toren, Rasheed Araeen, Jean Fisher, Jill Lloyd, Lynne Cooke, Desa Philippi, Anna Howells, David Maclagan, Kenneth Coutts-Smith, Daniel Miller, Imants Tillers, Christopher Pearson and Black Audio/Film Collection [ed.].

8 Michel Foucault, *The Order of Things*, (New York: Vintage, 1970).

overleaf] *At the Freud Museum* (detail) 1992-ongoing; vitrine installation, mixed media, size variable

WORKING THROUGH OBJECTS

Working in the Freud Museum has been one of the most interesting things I've been involved in for a long time. Most spaces that one is allowed to temporarily inhabit as an artist are either 'neutral' spaces designated for art and thus marginalized in some way, or – particularly in Europe – derelict spaces: dead factories or abandoned warehouses. The Freud Museum, of course, is quite different. This is a space which was a family home and has become a museum – or a shrine, depending on how you look at it – and which itself houses the collection of the original inhabitant. So it has layers and layers and layers of meaning in the present, as well as a very significant past.

Now my own experience here has been intense, probably because working here has made me think again about issues I thought I had resolved and look at a set of histories I thought I had already rejected. I felt I was constrained to confine my intervention to the room where you now see the installation; this may have been partially an imagined constraint, but nevertheless I felt that my work in the space would be bounded geographically by that room. I also felt that in order to use that room I had only two options: using or not using the existing large vitrine. And if I had not used it, I would have had to block off an entire wall, transform the entire architecture of the room, and in a sense falsify the proposition that the room was offering. Therefore it became a vitrine piece, but my series of boxes was begun quite a while before the vitrine itself became a possibility; when I was first informed of the vitrine I knew immediately that this location would help me to finish the piece of work that had begun long ago in my mind and which I thought might go on for ever.

The limitation of confining my installation to an oversize vitrine in fact became a great opportunity, because I have discovered that when things are condensed or constrained like this, people will involve themselves in a more careful, slow, and intimate way than they do when they come into a space to see an art installation which perhaps has spread itself out in a large room where it is perfectly possible to stand in the doorway and take a mental snapshot of the geography of the space and not get at all involved with the items positioned within it. In fact, and perhaps unconsciously, some artists now make installations that can be summarized quite easily in a snapshot view. The situation here is very different. We are all well trained to go image by image or

Text edited by Barbara Einzig from transcripts of three talks and subsequent discussions at the Freud Museum, London (22–24 April, 1994), on the occasion of Susan Hiller's installation there. The exhibition and talks were organized by Jane Rolo, Director of Book Works, London, and Erica Davies, Director of the Freud Museum.

item by item through a museum case, and people seem to keep this habit of careful viewing when they come to see my collection. So I have had very full responses from people in detail about each of the boxes in the vitrine, which is a very unusual response for an artist to receive.

I take it that any conscious configuration of objects tells a story. In fact, this is something I've believed for a very long time. In the early seventies I made a collection piece called *Enquiries/Inquiries*, which revealed quite explicitly, although drily, in the style of the seventies, that any collection of objects was an ambiguously bounded unit that told a particular story, and it was by setting the boundaries that the story was told.

If you think about the narrative that collections or assemblages of things make, the interesting thing is that there are always at least two possible stories: one is the story that the narrator, in this case the artist, thinks she's telling – the story-teller's story – and the other is the story that the listener is under-standing, or hearing, or imagining on the basis of the same objects. And there would be always at least these two versions of whatever story was being told. This is why I value the comments I hope you'll make later on, so I can get some sense of what it is you think the story is. I have a pretty clear idea myself of my side of the story.

Each box I've made and positioned in the vitrine seems to me to be part of a process which is actually very dreamlike. I'm again using the notion of dream in several senses. If you think of Freud's notion of the dream as a narrative that had both a manifest and a hidden content, this might have something to do with the relationship between the story told by the story-teller and the story that was being heard. I tried to make my boxes exemplify that kind of approach, so that they present the viewer with a word (each is titled), a thing or object, and an image or text or chart, a representation. And the three aspects hang together (or not) in some kind of very close relationship which might be metaphoric or metonymic or whatever. There could be a number of different kinds of relationships among those three aspects. The 'meaning' of the entire bounded unit, of each box, would need to be investigated by seeing the relationship between the word, the picture and the objects, as well as by the placement of an individual box in an extensive series of boxes.

Now in the Freud Museum we already have a complex situation. We have a family house within which is Freud's own museum collection. To situate another collection here is bound to be make it available to be read in the context of the primary collection. This brings me back to what I said initially about coming to terms with certain histories, with, if you like, 'the father', here literally in the house of the father. The hauntedness of this for me has to do first of all with my own gendered position as an artist. Also, as I discovered, it

has to do with issues around ethnic identity, because my own family background has very much a similar trajectory to the Freud family background, and I found this extremely peculiar and resonant and personally difficult as well as interesting. Through this I discovered the continual abrasiveness of that particular ethnicity within European culture. In an art world within which ethnic identity is now one of the modes, if you like, of acceptable self-presentation which is valued, yet there remain certain ethnicities which are always politically incorrect. This was an interesting and explosive issue to deal with.

At first I saw that if I were going to compare my assortment of things with Freud's, there were some easy differences that one could name. For example, Freud had beautiful, classic objects which although not immensely expensive at the time he bought them, were still rare and valuable enough. Everything in my collection is either something that's been thrown away or is rubbish, of no value. The only value these things have is that I have assigned some kind of value to them. So immediately I could say that Freud is an early modernist with antiquarian taste and my collection is obviously very postmodern – fragments and ruins and discards, appropriations, etc. So that seemed a good starting-point.

The more I thought about it, the more I needed to think through the idea of collecting. A deeper, more distanced view reveals that the objects I have collected are constant evocations of mortality and death, which of course could also be said of the objects in Freud's collection and perhaps in all collections.

So there is a kind of circularity that I have discovered in my entire project. Any idea that I might have had about destabilizing the notion of collecting seems to me fairly superficial at this stage, and I certainly wouldn't have discovered these maybe deeper things, if I hadn't had the opportunity to work it all out through collecting these objects in the context of this museum.

Just as we could say that the existence of our dream life is a continual *memento mori* and at the same time an approach to immortality, since dreaming seems to have nothing to do with the necessities of physical existence – so collecting may be the same kind of complex activity. It seems to be on the one hand the kind of sheer accumulating process that all children enjoy, you know, a collection of dolls or little cars or comic books or anything like that, and then after that initial kind of accumulation children go into the sorting process in typologies, putting all the green pencils to one side and the red pencils you know, all the Superman comic books and all the Spiderman comic books, making categories and then some kind of analysis of these categories and all of that. It is a very pleasurable kind of thing, and certainly most people have done that, and then later at a certain point you just chuck out all your collections. Usually, you might keep your stamp collection because your parents tell you it

is worth money, or something like that. But you are fed up with all that. You will tend to continue to define yourself by accumulating objects, but in sets which are not really perceived as collectible units. That is, you furnish a home or you buy clothes, but when you arrange your clothes you don't put all the red things together and all the green things together. In other words, what seems to me to end isn't collecting but it is the whole process of analysing, sorting and creating a typology that is given up, because we certainly go on accumulating objects which give our lives meaning. So I am maintaining that the process of being a serious collector is very similar to that initial making a collection in childhood. If you take a real collector – what I call a real collector like Freud, who annotated very carefully the date, the provenance, the price of each object that he acquired in a very orderly and precise way – you can see that there is a tremendous pleasure there that is taken, an intelligent pleasure in this kind of acquisitive activity. The decision that Freud made to place all of his objects in his working space, to create an ambiance that was very different from the domestic setting, so that everything he looked at in his office and consulting room was basically from a tomb, connected with a dead body or a vanished civilization . . . Well, I think for me it would be a very difficult situation to try to work at a desk cluttered with these immensely resonant and haunted objects, and yet I realize I am doing the same thing in my own way. So I am trying to seek immortality and meaning through objects, and at the same time I am trying to say that my own process of accumulation is really quite analysed and thought through, and in fact is a critical homage to Freud and a form of seeing through and working through. It has a double edge.

First I'd like to talk about the archaeological metaphor in my installation and to attempt very briefly to evoke a trace of something of Freud's use of this metaphor, or more accurately of my view of his use of it. Obviously, when you look at Freud's collection of artefacts you see how important a certain notion of the past was to him. He of course said explicitly that the psychoanalyst, like the archaeologist, was reconstructing a past through excavating fragments. He went on to say that the psychoanalyst was, in fact, privileged over the archaeologist in this sense – that the analyst would discover a truth that was more profound, because none of the fragments would have been lost or destroyed, since the mind never loses any memories. For me, having been trained in archaeology, I know archaeology doesn't necessarily tell any truth. It's a series of fictions, like any narration. We have a choice among these histories and fictions. Of course, Freud had a different notion of science than we would have nowadays, of its offering the possibility of a unitary truth. This must have been helpful to him in giving him a kind of certainty within which to locate his practice.

I suppose I see psychoanalysis as more poetic than scientific, and in fact I don't even see a dichotomy between science and poetry. So I don't see any reason why I would have to establish my credentials as an ex-anthropologist or archaeologist in order to even talk about these things. However, my notion of art practice is an encompassing one. And my remarks around all of this are to situate the collection I've made within a discourse in which we could allow narratives of an archaeological nature to occur. One reason for raising the issues around archaeology is to let you know that the boxes I've used in my collection are archaeological collecting boxes, which may not be immediately apparent. When archaeologists do their fieldwork they carefully place all the

 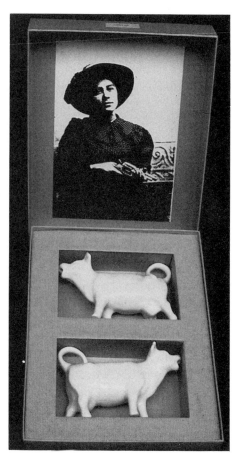

Customised boxes, each 33.5 × 25.5 × 6.8

left⌉ שׂמחה/*joy* 1994; thirty-six 35mm slides, each reproducing a glass slide belonging to in the Freud family (previously uncatalogued) with artist's classification

right⌉ *Cowgirl/kou'gurl* 1992; two china creamers in the form of cows, photograph of American outlaw Jennie Metcalf

interesting things found in a 'neutral' box. Then a series of hands-on acts
transpires: sorting, cleaning, putting into plastic bags, reading, making notes
and maps, even repairing – I always enjoyed these activities. Out of them
come typologies and chronologies. So by putting the remnants that I collect
into these boxes I'm using the box as a frame to draw attention to something
placed within it. Of course, a box isn't a frame, it's a space; and in that sense
everything that I've done in each box is an installation within an installation.
We're in a private home that houses a collection that had been annotated and
dealt with in a scholarly way by Freud, and the house itself today is a
collection of objects; even its ordinary furniture has now become museum
objects. A box within a vitrine within a room within this institutional space
within this house – one is attempting to carve out a space in which something
else can happen, to make some kind of intervention. So I've got a situation
where I've used a pre-existent vitrine which needed to be remade entirely,
shelves, lighting, everything – but in order to look almost exactly as it did
before . . . Embedded in all this I've placed my practice of working through
objects.

I thought I should say one or two things about one or two of the boxes to
give some idea of how they put themselves together.

I'll start with one called *Cowgirl*, because that image of the cowgirl has
become a sort of logo for my exhibition. The box starts with two cow-
creamers, my attraction/repulsion for them. But it's important in connection
with these objects that I never heard a woman called a 'cow' until I came to
England, so this is a box about sexual insult and my reaction to it. The word
'cowgirl' puts the two terms together, and I came across an old photograph of a
famous woman outlaw/cowgirl; in the American West all the famous outlaws
and criminals posed for their photographs, and Jennie Metcalf was no different.
She had herself photographed in her outlaw gear, and she's got a gun, a big
pistol. Of course this image was a totally irresistible Freudian pun, and to
insert it in the Freud Museum seemed to me at first very witty. On that level I
didn't see any more in it. I put it together with the two cow-creamers (we call
them creamers in the USA, here they're called milk jugs, I know that, and it's
interesting that both terms have sexual connotations) and what I want to point
out about them to you is that they vomit milk, which makes them fascinating
cultural artefacts. I always think that the so-called innocence of artefacts is just
a way of letting ourselves as a culture get away with quite a lot while
pretending we don't know what we're saying. So putting these china cows
together with this armed cowgirl in the Freud museum seemed to me a way of
dealing with sexual insult, and there was particular pleasure for me in siting
this in the house of the father.

Perhaps a sense begins to emerge of how they came together for me and how I think they narrate themselves. The objects within each box were the starting-points; the framing of the objects, the finding of the right word or words and the finding of the image, map, text, diagram or whatever, was a way of contextualizing the objects, not to limit their meanings but to open them out to these symbolic links along the themes I've mentioned.

One box that someone asked me about because I apparently misspelled the word that titles it, and I do admit I have a real block about this word – the word is *Führer* – there's a box of that title, misspelled *Fürher*. You would think I would have noticed it, which I didn't until this person pointed it out to me. But in a way I am sort of glad that that happened, because all the objects that I have accumulated are things which are very very disturbing to me, and in a way by making this kind of mistake it indicates that the disturbance is quite real and I am not just putting it on for benefit of actually exhibiting it, if you see what I mean. But I think I have to say something about this box. The box contains a book I found on a rubbish skip and I had it bound. The book was published in Germany and it is a tragic compilation of the history of the Jews from the beginning, from Abraham, up until the year of publication, 1935. It ends there. You can see the relevance of that to the exile of the Freud family, the fact that they needed to leave Germany and come to England.

It's an astonishing book because the format is such that when you open it, you can pull out accordion-like pages that extend to become enormous charts that open and open and open. And that's another thing about the boxes: as objects they exist closed, and you have to make a deliberate act of opening them, just as you do with a book. Displayed like this, they're rather naked. But at the same time this display is limiting, because in many cases the boxes contain books which are meant to be taken out of the boxes, and read. Likewise, the slides are meant to be viewable, etc. So with the *Führer* box, you would be able to open the book which is in the box, and open the large charts – the book, which is about half an inch thick, in fact has a format that expands itself greatly. In the Introduction, which I've had translated and placed in the lid of the box, it says that 'This book is intended to give the Jewish people pride in their history and confidence for the future.' Of course, written in those years, it has a terrible irony. The woman who translated it for me said 'there's something intriguing here, the word *Führer* is used in the final sentence' and I asked what the actual meaning of the word was, and as some of you know, it means guide. So Hitler was actually called 'guide'. Now in 1935 the person writing this Introduction must have been using a coded language, so that when he writes 'May this book be a good guide for you on the paths of life' there is implied a reference to the bad guide, if you like. And the

accession of Hitler to power is in fact documented within the book, because it documents, alongside facts of Jewish history and culture, the main historical developments within Western society, including 'Adolf Hitler comes to power', 'burning of the Reichstag', etc., it's all there towards the end of the book. So all these layers within layers make this particular artefact very haunting to me. I called the box *Führer* because it all pivots on this notion of the idea of a guide.

Well, I'll say something about the 'Look homeward, angel' box, do you remember it, the one called *Heimlich*? Many of the boxes use words from other languages, which is to give a sense of being outside the discourse, unless you speak the language. I've used some native American terms, Hebrew, classical Greek, Latin, German, French, etc. This is another German one, and it's kind of a homage to Freud, one of several boxes that make explicit reference to themes in his work. *Heimlich*, as those of you familiar with Freud's writings on the uncanny will know, is a very important word with reference to the German word *unheimlich*, un-homelike, which is translated into English as 'uncanny'. *Heimlich* means homelike, homely, cosy, from the word *heim*, home. But in Freud's essay on the uncanny he says something that in English seems very paradoxical, that the *heimlich* and the *unheimlich* are very close. If you look up *heimlich* in a German-English dictionary, what you find is that it says 'homelike', 'homely', 'cosy', 'comfortable', then goes on to 'private', 'secretive', 'furtive', 'hidden', 'forbidden', a range of suggestions about what goes on and is protected within the home, within the family, and you suddenly get to the *un-heimlich* without any break. You're led from cosy to incest. All those meanings of home exist in English, but not explicitly, and our word 'uncanny' doesn't relate to any root of 'home'.

In the box is a little 45 rpm record I've kept for years and years, of a song called 'Look homeward, angel' sung by Johnnie Ray. Most of you are too young to recall this, which was one of the very angst-inducing songs of my teenage years. *Look Homeward, Angel* is actually the title of a novel by an American writer called Thomas Wolfe, at that time a very famous regional writer. The angel referred to in the book's title is an angel in a graveyard. And the home referred to obliquely is obviously death. Of course this is not said explicitly in the song. So all the teenage girls were swooning while Johnnie Ray sang 'Look homeward, angel', a song about death under the guise of love or desire. . .

So I don't really want to say much more about that or any of the other boxes except to say that each of them is put together along the same sorts of lines – following through on a set of personal associations which initially for me were embedded in the objects. I started with these objects some of which are objects that I have kept for years, little unimportant things, souvenirs if you

like, with a lot of personal resonance. Of course I didn't know what the resonance was. I just knew that I was somehow stuck with these things and I never wanted to throw them out. So I started to look into what the resonance of each thing might be for me, and then each got its place in a box and eventually I added appropriate contextualizing material, a title, an annotation and a date like a real collector would, and that is my collection.

DISCUSSION

When you were talking about the 'homely' box, I was thinking that in America the word 'homely' has some of those connotations, it means 'ugly', 'worn out' . . . The moment you get into the home, you're in that quagmire.

Yes. The thing is, just as with the *Cowgirl* box, I took a certain amount of pleasure in understanding it for myself. This point which had so eluded me in the past when trying to decipher Freud's text on the uncanny could be understood through objects in a different way, so that suddenly I became entirely clear about the *heimlich* and the *unheimlich*, the problem disappeared, whereas before it seemed more of an intellectual paradox. In fact in talking with a couple of psychoanalysts here recently about that box, I realized that it was simply that people hadn't gone to the dictionary – because it's still considered to be an ambiguous point. I'm sure I'm making it sound much too easy; I'm sure if you're a Freud scholar there are a lot more profound issues around the remark that the *heimlich* and the *unheimlich* are very close, but for me it's clear enough.

When you said we are open to construct our own meanings around the boxes, it seems to me to be exactly the opposite in the case of the Freud objects, in that they're already embedded in myth. There seems to be a critical difference.

Yes. The context Freud's objects are in isn't just the context of psychoanalysis – the fact that he wrote from the objects to texts – but the context of a colonialist European idea of availability. Everything is decontextualized and put in a situation of being possessed by a European of a certain generation. Of course I'm aware that even my collection could come to look like that, eventually.

With his objects, though, there's always the mythic dimension, it's Osiris or the Sphinx, that's part of their definition. Whereas when I go into your room and look at a test-tube that's labelled the water of Lethe, I'm thrown into an entirely different situation of fiction or doubt or belief, which is much more interesting.

Well, it is actually the water of Lethe. I do wish people would ask me this more often because I feel rather offended like Freud did if his collection wasn't appreciated, that people would think I would have just put any old water in

those bottles. But there's more to it than that. For Freud, his travels were pilgrimages in a sense, far different from being a tourist. When he went to Rome it had this inner quality for him. And I try sometimes to have that kind of feeling myself, while actually being of course a tourist. So I've been to many places that have mythical significance, and the rivers we're talking of are in fact magical because they are 'real' rivers at the same time as they map mythic space, or consciousness. But of course to put water in a bottle and give it a name is paradoxical because all water is, as has been said, Ganges water . . . because all water is circulating constantly. And there are other aspects of my collection that are about these paradoxes, the *Seance/seminar* box with the tiny video: that is a collection of shadows.

> *I thought I heard you pronounce Freud's name as* Freund *or friend, and to get back to your point about working in the house of the father, what did you feel about that?*

Well, you know I did a box called in Hebrew *simchas*, which means 'joy', which is what *Freude* means in German, 'joy'. So for me this is also the house of mirth, if you like. One of the wonderful things for me was that the museum gave me access to some very special materials. The Director showed me a cabinet containing a magic lantern and box of slides, which had never been displayed or classified. Of course magic lanterns have interested me for a long time; I did a large piece called *Magic Lantern*, and other works of mine such as *An Entertainment* make explicit reference to them. In the box I made are replicas of these glass slides from the Freud family. Glass slides break over the years, and you end up with incomplete sets. I catalogued these remnants and found there were two kinds of slides, the so-called scientific slides and the fantasy slides: for instance, all the kings and queens of England on a microdot, which projects as a blur unless you have a really good imagination, and *Spirits Ascending: Flight of Spirits Dark and Fair* from the painting by so-and-so – and that's also a microdot in which you can see some vague fluttering shapes. These are next to and completely mixed up with botanical slides, some of which were beautiful ones purchased on the Strand, and others home-made, of garden flowers. There was also a set of Victorian glass magic-lantern slides which seem to predate the arrival of the Freud family in England but which have a number of English themes: the British navy and army, British heroes like the coastguard, firemen, etc. Next to these are the earliest Disney slides, a sequence intended to be drawn slowly across the lens in a frame-by-frame, filmic illusion – *Snow White* and an early *Mickey Mouse*. This was all fascinating. On those long winter evenings they watched *Mickey Mouse*. This added another dimension to my thoughts on the father and families because there's also a very normal side – watching television.

Your collection is really the opposite of archaeology, it seems to me. Archaeology takes the unfamiliar and makes it familiar. You seem to make the familiar strange, and to be distanced from it.

What I feel about my project is that it is to some extent deformed by being displayed, even though every collection is a narrative that wants to be spoken or heard. But by displaying the boxes nakedly with their lids open the meaning is changed. I'm not distanced or dissociated from the familiar, but what it means to keep the lid on is that the content is so Pandora-like that it just might explode in terms of meaning and consequence. That's how the boxes were made to be, though here they seem as though they're making some sort of objective presentation.

It would have been nice to handle them and open them oneself, perhaps.

Yes, that's their original way of being, but not possible realistically in this kind of situation.

The narrative of archaeology is a specialist one, whereas everyday narrative is more accessible.

Well, the point of specialist discourses is that there's some kind of fantasy about them being more objective and truthful than other discourses. As an artist one speaks as a non-specialist – I'm always affronted whenever I'm called 'artist and anthropologist' as though 'an artist' would not be intelligent enough to have serious insights into anything, but an anthropologist or any academic person would – whereas my understanding about, say, anthropology, which used to want desperately to be considered a science, is that now they are all giving that idea up and emphasizing that they are writers of texts, of narratives, with practices that are subjective and provisional . . . I say to them, yes, yes, that's totally obvious and has been for years, but you're still miles behind where artists are in these understandings and practices. You see, I think art is epistemological, I think artists do address the nature of meaning, of reality, and an enormous range of ideas – but always as non-specialists. It doesn't matter whether artists articulate their procedures in words or not; their practices are always culturally meaningful, and that implies a certain kind of ability to negotiate and transform fairly profound issues.

Could you say some more about working through objects?

When I use words I always feel and always have felt that I'm translating from something to something else. At first I thought this had to do with gender, now I'm wondering if that's all, or whether I'm simply the kind of person who understands physically through my sensory experiences, my tactile experiences. Objects can provide me with knowledges of various kinds that I can later translate. I'm not talking about object theory but art, about getting your hands dirty, maybe being stuck at that stage – material practices. Words

come into it too, as in dream memories. I can't say what a dream is, but a dream memory or construction might be a word, a fragment of music, the memory of a colour or a touch, a flavour – but we can't dream without bodies, as you know. And it's that level of embodiment I want to emphasize when I say 'working through objects'. Objects embody meanings.

To go back to what you were saying about the display of boxes – it interests me that you show the frustration of use in some cases.

Yes, the slides that can't be seen or books that can't be opened. Quite. I'm very aware of that. The difference between using and looking is important.

Well, I want to get back to words, your classifications, the terms like 'curated', 'assembled' and so on. How did you arrive at these?

It's just part of the process of making each box. These items were dated, these were assembled, these were sorted, etc. In the *Fatlad* box, which says 'addressed', this term is almost a pun. 'Fatlad' is in fact the Post Office acronym for the six counties of Northern Ireland, and it's how you can remember the postage for a letter to Ireland. If it's a fatlad (Fermanagh, Antrim, Tyrone, Londonderry, Armagh, Down) it's in the UK; if not, it's EEC, for the Republic of Ireland. So when I said 'addressed', I meant the issue was being addressed in that box, and it was also a reference to the Post Office.

What do you feel is your responsibility – your commitment – to the audience in relationship to the levels of meaning and your own reflection on the process?

This is always the point about art, I think. There is a sense that all artists would like to have that non-hierarchical, all-embracing, understanding glance of the mother to encompass our work, so that we wouldn't need to explain anything or even to speak, but just to smile . . . One of my disagreements with conceptualism has always been that I don't believe that intention and interpretation are, or indeed ought to be, the same, so I guess while doing the best I can to be as precise as I can and to encourage others, say my students, to learn to be as clear as they can, as articulate as they can, I do feel it's essential to be honest. This means admitting that I don't understand everything about the work, and particularly not in advance. So my responsibility – to use your term – might be to function as a particularly well-informed viewer or participant, as far as interpretation goes. I want the audience to be part of the meaning construction, in fact I think it's almost immoral to dictate their interpretation. Yet I will try, and try to be as clear as I can. There's bound to be some element of misunderstanding, whether or not the artist tries to censor it out as some do. There's already been some controversy about this current work, and I've got to accept it.

Where would you place that once you have got a take on it?

I really work very slowly, you know. I've been thinking about some of these points for twenty years. I worked from the notion of collections and museums in

the early 1970s, talking about fragmented discourses and so forth. I also made a work that was a collection of cultural facts, very much in the tradition of Freud's collection of jokes. My take changes constantly, and I recognize I am a long way from finally understanding what any collection of objects might 'mean'.

People seem to want you to fill in something, explain something, be accountable for meaning. I think what you are saying very clearly is that there are aspects of the work – you have stories about them, but you are, of course, not completely tying down the complete meaning of each piece and of the whole installation.

Yes, and I would go further to say what I've been saying for years – that meaning is never fixed, it always changes. Not just as I make more work – seeing meaning shift in past work – but as we all live and change collectively. If we didn't believe in the possibilities of change we would disallow a future.

For me the point of how you are talking relates to dreaming and dreams and the poetry of the classic. Dream interpretation never actually fixes the dream, that's doomed, and we all have dreams that we double back on and pick up on and we live that experience, we live it in our waking life. I think a lot of your work has to do with that, in relation to automatism and previous work, like your book on dreaming. So I personally think there is a profound aspect to refusing certain kinds of explanation.

Yes.

You obviously take anthropology as a resource.

No, I have been absolutely conditioned by it.

Well, that's what I mean by resource. Why deny other artists taking resources from other disciplines? This principle is fairly well established.

First of all, I spent about eight years 'doing' anthropology. I didn't just sit down to read one or two selected books about it. I am, you know, biased towards experience and I think the trauma of being indoctrinated into a, as we call it, into a discipline, is different from reading whatever you personally choose.

There seem to be some areas of enquiry that have a different idea of practice and competency. For example, you could say that reading through philosophy constitutes 'doing' philosophy.

Yes, you could. There are differences between fields of reference, obviously. Here in the Freud Museum, in relation to the experience of these seminars, I feel there is a psychoanalytic aura which of course has been used by various contemporary artists. Yet I really don't want to get too involved with that just on the basis of my reading, because I strongly, strongly dislike artists and academics using it when they themselves have never been psychoanalysed.

What I was meaning before was that the need for the discussion to try and ascertain what the specific intention was, that also is part of making work. It is hard to live with this but we do want artists to be certain, clear-cut. I am

talking about myself. I know I want that from work. Of course, I don't get that.
I think you need to find a way through those contradictions you believe in,
because if you don't allow art works their own space you inevitably reduce their
activism. For instance, I don't mean 'vague' when I say 'poetic'. I want to allow
spaces between the either–or you seem to believe in.

There are these contradictions in the practice of art at this historical
moment. You know that I don't hold with definitions of the artist as someone
who is untheorized and doesn't think. I don't mean that at all. Somehow in our
culture we keep on making these false dichotomies – painting equals pleasure,
so Matisse is about pleasure, and it's conveniently forgotten he was intensely
interested in colour theory; he was not a speechless, anti-intellectual person.

*And I also think you are saying there is a distinction between clarity and
justification. If you are involved as an art critic it seems that part of that
activity is to come up with an adequate theory or at least an explanation which
is appropriate to the complexity and contradictions of the work. This is the job
of the art critic, who tries different ways of doing that, but I think
unfortunately art criticism, as some might say, is the last resource of the
scoundrel. It seems to be the place for people who don't know about anything
much, a place where everybody who has dipped into anything somehow ends up.
So there is a bit of psychoanalysis, a bit of semiotics, bits of Foucault and
Derrida all mixed up together. And then some critics want artists to speak in
the same terms of reference. So it becomes all mixed up together, like a cake, and
that's the interpretive model of the moment, which is what you are refusing to
do in this discussion.*

Yes.

*I don't want to give you a hat to wear but in some respects it seems to me you
would actually be more a modernist than a postmodernist in so far as – there is,
kind of – I want to use the word 'hope'. There is a sense in which your practice
suggests possibilities towards something, which is a defining feature of
modernism, as we all know. Modernism has theories about the future from
which it understands and addresses the present. Postmodernism bans that for
all kinds of critical and often good reasons, and in that one respect it seems to
me a lot of your work actually is modernist.*

Well, it has what look like redemptive aspects, but maybe I just like dirty, worn-
out things. Schwitters' practice, of course, comes to mind, if you think that's
modernist, but I never think of myself as a modernist. For a start, I'm the
wrong gender. I would have no place within it and could never go back to those
old assumptions. I think possibly you are a bit critical of mystical, utopian ideas
about the future and hopefulness, whereas of course, having been indoctrinated
within a social science framework I believe that the processes of change are

embedded in the present. So it doesn't feel at all Utopian to say that our practices as artists enable certain kinds of future to happen. It's a simple statement of a kind of social determinism, and I think we live in a socially-determined reality.

> *There is one box in the vitrine that really shocked me, and it was the one with the tiny LCD monitor in it, because I had seen the big version in your other show and liked it. I was very taken with the idea.*

The big and the little.

> *Yes.*

I thought of it as a collection of shadows: collected earth, collected water, collected shadows. And of course I like the idea of the camera obscura, the dark, the dark room, the box. I called it *Seance/seminar*, to draw attention to the kind of issue that has, in fact, been circulating today in a lot of this discussion. A seance, which is supposedly irrational and untheorized, means in French 'a seminar', which we think of as respectable and academic and logical.

> *I was wondering about the relation of all these figures to knowledge, because this has to be at the root of your project. The figure of the angel is an interesting one because the origin of angels is that they appeared when men made contact with the gods, and the angel then appeared as a creature which bridged the destiny of something which was literally a lost contact, a piece of something that could not be said, a piece of meaning that was missed. The idea of the angel as a messenger is quite misleading, because it is not the case of a message at all, it is the case of a communication gone awry, but one starts and you have to finish it. I am wondering about this gap and this kind of idea of knowledge, figures of knowledge in those very objects you are using: the angel, the cow, the home – 'canny' in Scotland is also a kind of knowledge.*

I don't think I could put it as eloquently as you, but what I am suggesting is that knowledge is *between* all these items, aspects, figures, symbols – and I have travelled to the ends of the known world in several cultures to collect specimens to bring back to put in boxes. But it is not that, it's about what is between the objects; context, words, history. In that sense for me it is a fascinating project that isn't exhausted or exhaustible. The difficulty in speaking about this is that it is possible to use up meaning by over simplifying.

> *I was just thinking about one of the boxes that has a little piece of marble . . .*
> *I was imagining it where it was originally and thinking about the meaning it had* in situ *and the meaning it has in here. I was wondering how much of the meaning is already there when it is sitting where it was.*

Well, you see, where it was isn't any place except a map reference basically to the site of Hades, one version of where Hades might have been.

> *That is where you found it?*

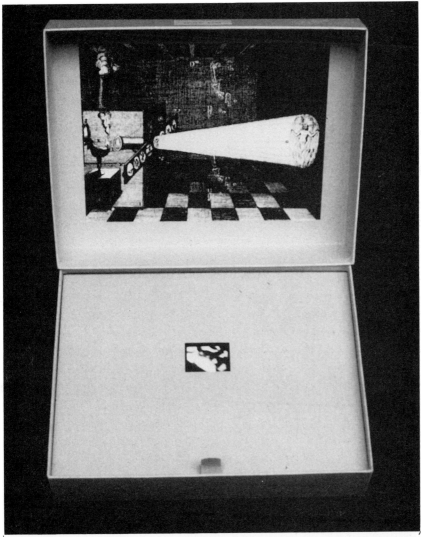

Seance/seminar 1994; miniature television monitor showing a programme by the artist entitled *Bright Shadow* and engraving from Athanasius Kircher's 1671 treatise on magic lanterns

Yes. I don't think I can directly answer the kind of complicated things you are thinking about, but it does make me want to say again that the interesting difference of being a tourist or a pilgrim has to do with the inwardness of the sightseeing, if you like. One thing I always like to do is to have a kind of personal goal in any place I am going to. A lot of the places I have documented or evoked in this collection are mythic and in that sense part of our collective psychic map, the map of our notion of consciousness.

BEYOND CONTROL *a conversation with Stuart Morgan*

You are attracted to things beyond your control.
I'm interested in things that are outside or beneath recognition, whether that means cultural invisibility or has to do with the notion of what a person is. I see this as an archaeological investigation, uncovering something to make a different kind of sense of it. That involves setting up a situation which welcomes this perhaps anarchic, non-volitional stage of awareness.
 An unedited stage?
Yes, in response to a situation structured to create a heightened or more precise awareness.
 Gender has been another concern.

First published in *Frieze*, London, no. 23, Summer 1995, pp. 52–8; reprinted with the permission of the editors. Stuart Morgan is an art critic who teaches at the Ruskin School of Art, University of Oxford.

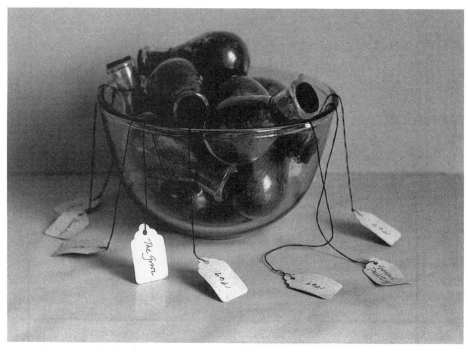

Hand Grenades 1969–72; twelve glass jars, rubber stoppers, ashes of paintings, Pyrex bowl, labels; 11 × 18 × 18

These things go together. Understanding the implications for perception and behaviour of my entry into language as a sexed subject, and understanding how this is definitely not the same thing as being limited to activities that are conventionally defined as feminine, in fact gave me the impetus to explore areas that used to be considered off-limits in art.

Work in Progress (1979) could be seen exactly as a so-called feminine art work: pulling your paintings apart thread by thread, turning them into something different.

The idea of simultaneously making and unmaking could be traced to any mystical tradition. To associate it solely with women seems astonishing.

Is it a means of prevention?

That seems contradictory; in remaking my old paintings I wanted change, but everything changes inevitably. I just brought things more quickly to the point they would reach anyway. In contrast, the culture of art in our society involves fixing: putting things in museums and not letting them deteriorate. But in other societies, the kind of sculpture that influenced the early modernists – African, Polynesian – is left to rot, raising the question of how continuity of

Measure by Measure (detail) 1973-ongoing; works recycled annually in glass burettes with lead date tags; installed in glass and lead accumulator jars on steel shelf; overlal 71.1 × 129.4 × 24.1

style can exist in places where no visual model exists to be emulated. We're different; we think that if we can't keep a painting perfect, we'll have no more painting in future.

You, in contrast, continue your conceptual exercise of burning your work.
Every year I transform some works into other formats. The series of burnt relics began in 1972. I placed the ashes of burned paintings in chemical containers that measure and contain what can't be contained. They are like burial urns too, and since I regard them as just as interesting to look at and experience as a painting, maybe that's a wish for everything to be seen as having the same potential for insight. Like traces or remnants, they point forwards and backwards at the same time.

You also cut old paintings into equal-sized rectangles and sewed those together, one on top of the other.
I called them *Painting Blocks* (series begun 1970/71). Each has the scaled-down dimensions of the original painting. The project turns surface into mass, painting becomes sculpture. It's a materials-based comparison. (At present in this country we have an untrue history of conceptualism which suggests it is totally language-based.)

Other early works of yours, like Dream Mapping (1974) *involved other people.*
That's right. In that piece participants collaborated to develop a system for the graphic notation of dream events. After about a month we decided not to work with words but with diagrams.

Diagrams of what?
Of dreams.

Of what they saw in dreams?
Or of the location of events, or of structures. People evolved their own notational system. For the last three nights we went to a site in the countryside where there was a remarkable occurrence of mushroom circles: fairy rings. In folklore, if you fall asleep in a fairy ring, you'll be carried away to fairyland, like a state of altered consciousness. So on the last three nights everybody picked a fairy ring and went out and slept in it all night. Next day we collectively mapped our dreams, by which I mean that we first diagrammed or drew our individual dreams, then we superimposed them one on the other and came up with a collective dream map. I was writing a book on dreams with David Coxhead, so I was aware of all sorts of traditions about dream incubation, which means going to a special place to have a heightened dream – a pattern the world over for curing ailments – but also the idea of the collective evolution of a notational system for dreams. In many Native American or Australian Aborigine groups such a system as an art form was not seen as

representational; it's not a picture of a dream image but a set of notes in visual diagrammatic form. The two ideas came together in this piece.

But then for me there was a difficulty, which was that work which began as a deeply-felt attempt to be non-hierarchical, non-elitist, non-product-oriented-outside-the-gallery-system, getting back to basics, working with friends, remained more elusive and more esoteric than a painting could ever be, because it was an enactment, a performance where no gap exists between audience and participants. They're the same. So on one level what had seemed a perfect solution was not really such a good format, because the experience of the piece could not extend beyond the original participants. What I retained from this series of pieces was the conviction that the other person has to be in the work, or it isn't interesting to do.

Is there a rift between your two kinds of practice in this early period?
After several years of work that was on the one hand minimalist and materials-based, like the sewn canvases, and on the other hand immaterial and time-based, like the investigation pieces for groups of people, I really wanted to resolve the dichotomy. First I made a mental equation between materials and ideas. (That's why I've always said I have a materials-based practice.) I made *Dedicated to the Unknown Artists* (1972–76), a rough sea postcard work, and a slide piece called *Enquiries/Inquiries* (1973 and 1975), based on a sort of cultural catechism taken from popular encyclopedias in Britain and the United States. (Hence the two spellings of the same word.) These works used an approach which has remained important for me and comes out of minimalism: putting together many similar units with tiny differences. My work was starting to come together from about 1973–75. The early ideas carried through to later works that require the involvement of viewers in a different way. It goes back to Michael Fried's idea of the theatrical. He meant that invidiously. I took it differently. Because I come from a conjunction of minimalism and Fluxus, I combined the interactive with the non-theatrical and turned this into another position which insists on the participation of the viewer as essential to the work. In *Monument* (1980/81), for instance, where the entire piece is activated by a person who sits on a bench listening to a sound tape, a person prepared to be seen in public performing a private act of listening. Since that person is seen by other viewers against a backdrop of photographic images, the piece exists as a tableau with a living centre, while that person is also part of the audience for the work. That was the kind of solution I arrived at for the problem raised by my earlier very private investigative works, which left behind only traces or pieces of evidence and documents. The thing that unifies everything is the use of cultural artefacts from our society as starting-points. At the time, this was a new thing to be

doing. If you think the idea through, you realize that every type of format is already an artefact, including stretchers and canvas, the television screen, so how could artists *not* be working with artefacts? In that sense, everybody is working anthropologically.

And politically, too?

Well, it's work in the world, which contributes as much to knowledge and shifts in attitude as any other form of work. At the same time, art has a mirroring function; it can only disclose an image of what is already available to us. Because we are products of our society and culture, artists don't know anything that anybody else doesn't know, but we can show people, ourselves included, what we don't know that we know.

You also made participatory works for hundreds of people.

Yes, *Street Ceremonies* (1973) in the open air in Notting Hill involved about 200 people. Another much smaller group work was called *The Dream Seminar*, later the same year. Some people from both of those pieces took part in *Dream Mapping*.

Artists' early works prepare for what is to come. In your case, it was a total assault on the integrity of the art object and a full-scale attack on the idea of the individual.

I didn't see it as an attack; more that I was wounded and had to make a response. I'm not saying I consciously felt a sense of damage. Those were confident days. It was wonderful to be in England. People were crossing borders freely. It was part of a mood: a different, more integrated period. We were lucky to be around. My confidence came from having emerged at that period. I had nothing to lose, so why not follow my own predilections? I liked being where I was. There was no pressure to establish an art career. Everyone had abandoned all that; you did whatever you did, and if it turned out to be music or painting or writing, great. Or you didn't have to do anything, you could just grow vegetables. We had shrugged off the need to define ourselves, have a career, get a mortgage, all those things.

One work that emerged from this attitude was Sisters of Menon.

Those scripts emerged on a visit to France, where I was staying in a small village. It was there that the *Sisters of Menon* events occurred. Admittedly, the stage was set for some altered state of consciousness, but it wasn't eerie or peculiar; I accepted this as part of the way images and ideas were transmitted, at least among artists, because you find that in art and also in science, unconnected people in different places seem to come up with the same idea at the same time. So it didn't seem freaky. Suddenly I started to write and write and write . . . That was in 1972, and then I lost the manuscripts or misplaced them or put them away somewhere and forgot about them. When I came across

them again a few years later, I decided that if I formalized the material it could become a work. At that point I added four pages of commentary. The cross-shaped formation is simple to arrange: number 'X' of A4 pages. That made sense, since a cross appears in the text itself; the four pages of commentary became four ends, four panels at the ends of the arms of the cross. The formal configuration and commentary pages were done in 1979, the year I found the lost scripts.

What did you decide it meant?

I don't know. It convinced me of the reality of the divided self, and that one person is many voices, but there is no bounded unit who contains the voices. They could be seen as possibilities of being. We have ways to tune out most of them and tune in some. I suppose that when they become overwhelming, our society says you're mad or schizophrenic. This experience was not overwhelming in that way, nor was it sought for. Except you could say, 'Of course you sought it by going to France and working on an ESP piece (*Draw Together*, a postal event) in the first place.' There was nothing eerie about the experience. The most interesting part of *Sisters of Menon* was that it seemed to address itself to a kind of female sensibility or entity. When my husband tried to tune in on it, he produced a page that said something like, 'Go away, you are not the sister.' There are so many levels, ironies and little jokes, that you have to recognize something with an amazing sense of humour and a very quirky attitude. 'Menon' is 'no men', but I think it was Lucy Lippard who pointed out that it's an anagram of *nomen*, which means 'name': the opposite of not having a name, in other words, siting or situating the voices.

For a while it led me down strange paths; I thought I had to investigate all kinds of historical facts, for instance one of the Menon scripts says 'We are your sisters from Thebes.' Thebes is, of course, the necropolis in Egypt which undoubtedly I had already read about, and one famous precinct there is dedicated to someone called Memnon. I also got involved in reading about the Cathars, because the village I was in was in their area of France, and a circle with an equal-armed cross or X, which was a Cathar symbol, appears at a certain point in the scripts. Cathars followed a Gnostic tradition, which leads to interesting ideas about religion and gender. It all seemed to tie together. Then at a certain point I realized that the scripts were a fragment and an irrational production; you could spend your life interpreting it, but you wouldn't get anywhere. It was a question of accepting this production as a drawing as well as an utterance. The fact that it was a physical production became really important to me. And just to allow it to exist in whatever ambiguous placement it had – just to let it be – was also important. But it did link me with certain traditions pertaining to gender. I became interested in secret languages, ritual languages,

coded languages, artistic languages and in my own problem of finding what was called 'a voice', because the Sisters seemed to have so many voices.

Do you think you lost the manuscript deliberately?

I probably wasn't able to accept it immediately and to say, 'Yes these messages or utterances are as important as any other.' It made me interested in art in a different way; I could see all the trajectories through modernism that had been considered unacceptable. You know, Surrealism was like a dirty word?

Taken seriously, Sisters of Menon *would result in a quite different view of culture.*

I see culture as a series of curtailments. The reason we value art is that despite this, it can provide occasional glimpses of different ways of perceiving and understanding.

How do you see your own work?

I never know whether it is one work or not. I'm aware there's probably the difficulty that one ends up with fragments as evidence of something.

Or as attempts to reach a single place. That wouldn't be so terrible.

Well, to regard *An Entertainment,* for example, as a totality would be completely misleading. It has been seen as a statement about child abuse or domestic violence. In fact, I'm interested in at least three things: one, the kind of mythic underpinnings; two, the left/right dichotomy; three, the eroticized violence, deeply scary but sexy at the same time. I understand the large works as incomplete and as much part of an ongoing procedure as the small works. Even the way *An Entertainment* is constructed, with similar episodes with slight differences repeated and stitched together, different takes on similar scenes, is like the small works. I would say the content of my work is consistent, although the subject-matter of different pieces varies a lot.

The way I see it, using a piece like Magic Lantern *(1987), is that you are suggesting that a mental area exists in which creation happens, whether you are the creator or the audience, that here is a zone in which it is possible, to release your imagination or use it in some way, and you're asking 'Can we talk about this?' In other words, can we consider this area within which anything is possible because it's not real (though to us it's very real within certain boundaries). It's like what happens on a stage or when a story-teller says, 'Once upon a time . . .', then everything after that is modified until the end.*

I like your notion of a zone, but you see, to me that zone is totally real, and *Magic Lantern* is one of the clearest, strictest, most direct statements of this I've ever made. I'm showing you – and showing myself, because it's a machine I can use too – that the perceptions of the body and the effect of light on the eye, the intersection of the body and desire, creates beauty, creates meaning, whatever. That piece can't be documented because the colours you're seeing are

real, but invisible externally. So it's specific to you, but it's also collective, because it happens to all of us in the audience at the same time. It's not unreal, that's what I want to emphasize. Just like the shapes people see in my video *Belshazzar's Feast* (1980/81) are as real as anything else. I think you mean they're not real if they're not objectively there or not outside us? What do you mean?

> *The idea of an invisible stage, the reaction that Coleridge called 'the willing suspension of disbelief' and how this can be maintained or cut off. If you suddenly start quoting Shakespeare I can tell if you're quoting, even if I've never read Shakespeare.*

The only time I've emphasized that is in *An Entertainment*. When the curtain goes down, you're really stranded after you've been up in the stars, and it's like asking a question about how we are intersections of these possibilities, consensus reality and these states where we experience other things. In that work the story just ends; the curtain comes down. Pieces like *Belshazzar's Feast* and *Magic Lantern* don't end so abruptly; you can still see after-images for a while. We're usually not aware that everything we perceive is a combination of something externally given and something we bring to it, so there is never anything without our subjectivity. What I want to make is situations where people are aware what they're seeing is because of who they are; so they are conscious of the fact that they are part of a mechanism for producing pleasure and pain, that we're not just walking through life as though it were someone else's film. It's like dreaming: you're both inside and outside, and it's important to *know* you're in both places.

> *How does that help in your Punch and Judy piece,* An Entertainment? *It's disturbing. It's all around me. The figures are bigger than I am. People are being beaten, the change of size is tremendous. For someone who had never seen a Punch and Judy show, I'm not sure what they would think.*

I don't know, either. My work is particular to this culture. All rituals are scary. Part of what art is about now is to find ways of beginning to say things about the darkness of the culture. The piece is not intended to be an admonition; it was meant to be the experience of a child. I was subjecting myself to what I saw children being subjected to with every Punch and Judy show. Yet at the same time, adults find these little figures hitting each other strangely jolly. The child is just a little person who has the problem of fearful identification at the same time as being told it's enjoyable. The child is being taught something through the terror of ritual, and the hope of the male child is that he will become Mr Punch. Girls see it differently. After seeing my piece, I think everyone does.

> *Are we meant to associate with Punch because he is the protagonist?*

It's a way to avoid being killed.

What kind of ritual is it? What does it mean? There's a man, wife and child.

He murders them all, is sentenced and then kills his judges too.

You can't explain it in those terms; it's not a story about a man who does good or evil. He's not a man, he's Mr Punch, and he's not human. He's monstrous, even his voice is distorted through that funny little thing . . .

A swazzle.

To deform voice as well as body. The curious thing is how this character came to stand for Britain.

Presumably Punch and Judy was not English originally.

Commedia dell'arte characters were brought to England by Italian showmen, who produced first marionette plays, eventually glove puppets. Fights improved; you can pit your right hand against your left so well. That's where English Punch and Judy differs from other versions which are played by marionettes. In the eighteenth century one Italian showman in London reduced it to a series of simple stick fights.

You think a lot about this left/right dichotomy.

It's a universal distinction. (Of course, the left hand refers to the right part of the brain and the right hand to the left part.) The right hand is seen as good, dominant, clean and worthy, the left sinister, gauche, dirty. As society becomes increasing rational we've tended to downgrade the intuitive. Punch and Judy

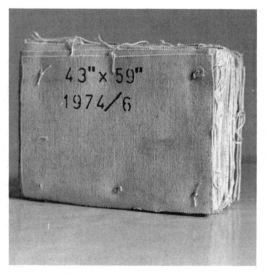
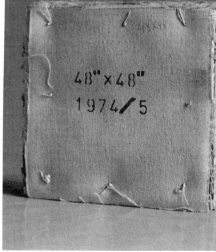

Painting Blocks; recycled paintings, oil on canvas cut and bound with thread; various sizes

puts Punch on the puppeteer's dominant right hand, the dominant side of the brain – and all the other characters, women, children, animals – on the intuitive, denigrated left. As in ancient myth it reduces to a dualism, which may refer as much to these opposed parts of our brain as to anything socio-historical. I find that pretty interesting.

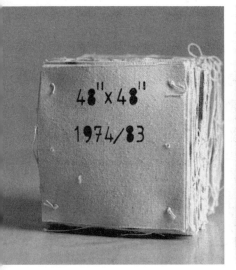
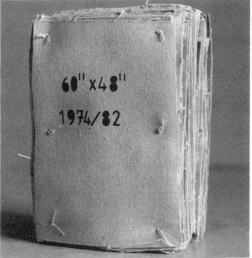

APPENDIX *Sacred Circles*

The 700 objects in this exhibition include many of the finest Native American artefacts, that is, the objects most highly valued by their original owners and makers, and by white anthropologists, curators, and collectors. Materials have been gathered from a wide range of sources; many have never before been displayed publicly, or have been available only in small or geographically isolated collections. The exhibition, organized in celebration of the American Bicentennial, has been given extensive publicity. There is a detailed, well-illustrated and documented catalogue, prepared by Ralph T. Coe, the Curatorial Director. Surely such efforts ought to be, and deserve to be, taken seriously.

For 400 years, from 1513 until the beginning of this century, Europeans and Native Americans fought a series of wars to determine the ownership of what is now the United States. The struggle of the Native Americans was of great importance in the creation of the USA, and was in many ways the anvil upon which European-American character was forged; in 1787, Benjamin Franklin wrote 'During the course of a long life . . . it has appeared to me that almost every war between the Indians and whites has been occasioned by some injustice of the latter towards the former.' By the end of the eighteenth century a number of European-Americans had come to share this viewpoint; however, the forces that drove the newcomers westward were too great to be stemmed or made less harsh by the sentiments of a small intelligentsia. The average European-American had already become a restless, ambitious, aggressive person and nothing could stand between him and his dream of wealth.[1]

From the European-American point of view, then, all the items in this exhibition document the success of the sustained attempt to destroy the Native societies in the USA, and the exhibition itself is a gauge of the degree of that destruction. For the basic fact of the matter is that 'we' now have in 'our' possession a multitude of important Native American objects, whose display by 'us' commemorates our decimation of the makers, our destruction of their history, our appropriation of their lands and our attempted obliteration of the 'sense' of their cultures over a period of more than 200 years.

It would have been educational, as well as providing badly needed 'context', if the exhibition had attempted to make us aware of the interactions between the objects displayed and our own history; but instead, there has been an effort to empathize with the Native American world-view. Passing references to the

Text originally published in the journal *Studio International*, December, 1978 as a review of the exhibition 'Sacred Circles: 2,000 Years of North American Art' (Hayward Gallery, London, 7 October 1977–16 January 1978). It was reprinted in part in *'Art and Society'* History Workshop Papers, 1979.

tragic consequences for the Native Americans of the original White invasion of their territories, and the subsequent efforts of the Whites to subjugate and exterminate them, show how tightly the exhibition is caught in a mass of contradictions stemming from its initial conception as a suitable event to celebrate the Bicentennial. For example: the catalogue reminds us that, while 1976 is the two hundredth anniversary of the American Declaration of Independence, it is also the hundredth anniversary of the defeat of Custer by the Sioux at the Battle of Little Big Horn. All this does, though, is to situate the 'Indian problem' firmly in the historic past. Possibly 'we' need to be reminded that not all the Native Americans are dead, and many are still fighting:

> The Wounded Knee Occupation (1973) and The Trail of Broken Treaties (1972) were carried out by the American Indian Movement in order to draw public attention to the problems of Indians generally . . . One of the . . . demonstrators said: 'The myth has been perpetuated that we don't exist any more; that's the hardest thing we have to fight against.[2]

For information about contemporary Native American struggles, legal, social and political, the exhibition organized by the American Indian Movement (AIM) at Artists for Democracy, 143 Whitfield Street, London W1, to coincide with the Hayward show, also needed to be visited.

Certainly the ostensibly well-meaning references in the 'Sacred Circles' catalogue to the Native tragedy never indicate that oppression, struggle and heartache are contemporary. Neither the brief excerpts from a few well-known nineteenth-century Native American speeches scattered through the exhibition proper, nor the remarks in the free handout reminding us that 'the dominant feature of the history of North American Indian culture has been the crushing effect of the White man's determination to suppress and remove the native population', bring the reality of the situation *now* into focus. For nowhere in the 'Sacred Circles' exhibition – and this is crucial – will you find any sense of how the European-American viewpoint, formed in the early years of Native–White confrontation and crystallized over the centuries, continues to influence present-day White treatment of Native Americans, as well as 'American' attitudes towards indigenous populations in, e.g., Korea and Vietnam. The reason you will not find any sense of this is that the exhibition has been organized within the same terms of reference.

Looking at the blood-stained trophies and souvenirs, immaculately dry-cleaned and antiseptically isolated in the Hayward Gallery, not a trace of their original existence as *things that work* comes across. And, of course, no effort has been made to record the near-accomplishment of genocide in the

presentation of the objects, although Coe's catalogue is highly informative on this point. Only a slight re-emphasis would have been needed for the public to be able to read this material for its historical implications, for instance:

1 *The passage of effective territorial control from Native to White hands is signified by the change of ownership of valuable symbolic objects.* Catalogue entry no. 52, Powhatan's Mantle: Powhatan was the great chief who united the Algonquin tribes of Virginia, and whose daughter Pocahantas saved John Smith. Forty-nine years after the first White settlers had arrived, this mantle was mentioned in an inventory of the Tradescent family, who were 'Virginia landowners'. By that time, the Native Americans, at first welcoming, had risen twice in rebellion and attempted to destroy the White settlements. Defeated, they 'declined' in numbers.[3] So possession of this mantle by a White family at a certain date indicates when the take-over of Indian possessions, lands, etc., was complete in that area of the country.

2(a) *The making of treaties with the Native Americans was considered purely gestural by the Whites.* This is indicated by catalogue entry no. 53, Wampum belt, Iroquois: 'a wampum belt served as a gift, also as a binding symbol of an agreement . . . and they were of the highest importance as documentary evidence of such pacts'. This belt was 'collected' by the Duke of York's secretary in 1700. Seemingly, the document was considered of aesthetic or curiosity value only, not as legal evidence of an agreement. It is now in the British Museum.

2(b) Wampum belt, Delaware, *c.* 1700: associated with the treaty regulating Delaware–White relations in Pennsylvania under William Penn. It shows two figures of equal size holding hands, and was preserved by Native Americans long after the treaty ceased to be honoured, until passing somehow (we're not told how) to the Royal Ontario Museum; the belts kept by the Penn family are in the Museum of the American Indian.

3(a) *War booty, spoils, and trophies were frequently captured by Whites.* The catalogue limits mention of this custom to instances connected with the history of specific 'art' objects: catalogue no. 67 is a nineteenth-century Seminole sash, a relic of the Florida Indian Wars, taken by Lt John H. Hill 'from Gouchataminchas, Nuctilage Hammock, 10 March, 1840'.

3(b) Catalogue no. 430, carved wooden spoon: now in the Smithsonian. It was 'captured by the Second Nebraska Cavalry from the Sioux, 3 September, 1863'.

In fact, frequently the trophies consisted of scalps, fingers and 'men, women and children's privates'.[4]

4 *If not associated in some way with overt violence, Native American objects now in 'our' possession indicate degrees of economic insecurity and stages of cultural collapse which are the direct result of White domination.* Catalogue no. 646, Navajo silver and turquoise bracelet: 'Note the simplicity and restraint of this late 1930s 'pawn' bracelet. Pawn bracelets were put into pawn at the trading post for cash; unredeemed jewelry enters the trade.'

Page 126: 'Chief Mathews (Weah) of the Haida . . . pointed to a depression in the ground where his father's totem pole (today at Oxford University) once stood: "It is customary for the nephews of a Chief to keep him supplied with halibut, but do

you think this is done any more for me? Not one piece! They want to go the
movies . . .'''

Catalogue nos 469 and 471, medicine bundles: Medicine bundles, owned by
societies, villages and doctors were at the very core of Indian religious mystique:
they only found their way outside the Indian world when the last owners disposed
of them. These are all owned by private collectors.

But the catalogue avoids structuring the information in this way. Instead, a
typical entry reads:

> 431 Warbonnet, *c.* 1880 AD, Northern Plains, Oglala Sioux, buckskin, feathers,
> tradecloth, 2.18 m total length, lent by C. F. Taylor Collection, Hastings.
> Warbonnets had a highly symbolic meaning. Traditionally, each feather
> represented a brave exploit, not necessarily of the warrior, but of the tribe itself. A
> warbonnet may also represent the council fire, each feather signifying a member of
> the council with the horsehair tips being the scalplocks of each warrior. The
> central plume represents the owner of the bonnet. The feathers are from the
> Golden Eagle, the sidedrops are ermine, the front band is of seed beads on hide.
> This bonnet belonged to Cinte Mazzo (Iron Trail, 1847–1916). He worked for
> Buffalo Bill's Rodeo for many years.

Symbolical, material and biographical 'facts' are given, and are seen as
comparable descriptive levels which define the object. The historical
significance of 'our' possession of the bonnet is ignored. Such a description
creates the illusion that the meaning of the object has been fully illuminated,
and helps to assimilate it into the White tradition of ownership while
alienating it from the ongoing traditions and struggles of contemporary
Native Americans.

The effulgent prose of the catalogue text and exhibition labels, which try
to give us the 'Indian' point of view, fail utterly to convey anything more than a
liberal–romantic–formalist interest in noble savages and their artefacts. The
sincerity of statements like 'One cannot separate Native American clothing
from either wearing, sewing, ceremony or medicine power', surely has to be
judged in relation to the display of articles of clothing as discrete items praised
for their 'craftsmanship'. Value judgements based on contemporary sensibility
and an ethnocentric aesthetic pervade the text, with words like 'subtlety',
'delicacy', 'refinement', 'ruggedness', 'latent humanism' (the archaeological
Hopewell culture), 'eccentric and macabre' (Temple Mount culture), and
sentences like 'The deer was evidently worshipped as an animal of great
beauty' (Key Largo culture). They must surely raise doubts about whether the
stated aim of the exhibition, 'to provide bases for cross-cultural comparison',
could conceivably have been realized, given such an obvious naiveté about

personal preferences, projections, and culture-bound traditions of presentation.

Or perhaps none of this is naive at all, but rather part of the process of voiding the objects of meaning? A sort of cultural–imperialist pretence of taking the other side's viewpoint? 'Shifting psychic associations led to corresponding interweaving of association and content in design, until in the process, the exact meaning became lost . . .' Is this merely naive ethnocentrism? For surely the 'meaning' was not lost to the people who made and used the items; it is lost to us because it isn't ours. And anyway, if we are really to take 'Sacred Circles' seriously as an art exhibition, if it's really *real art* (using the word the way the show does), then was it an exact meaning, anyhow? Why not investigate the aesthetics of the makers to find out, instead of omitting all reference to their sometimes-recorded judgements?[5]

A further comment on the means taken to void the objects in the exhibition of significance: the private is made public, the sacred is profaned, at the same time that homage is paid to the mystical world-view of the Native Americans. When it comes to display, no respect is shown for the others' viewpoint. Plains shields, for instance, bearing cryptic designs representing the original owner's personal dream or vision, motifs that functioned as mnemonic devices for re-creating that heightened awareness, were never uncovered except just before battle, when an owner would contemplate his shield in order to enter into communion with the sacred once again. Recapturing a sense of himself as a spiritual, and therefore invulnerable, being, he overcame fear. Such shields are nakedly displayed without their covers in this exhibition, showing not only that the organizers don't accept their efficacy as things that work, but that they have no sensitivity towards the Native American mode of display (with painted covers).

It is obvious, then, that although 'Sacred Circles' represents a massive effort of organization, it is at the service of a one-sided and consequently distorted historical perspective. This is what it celebrates.

The point of view throughout the exhibition is that of the collector, and the sensitivity and respect that are said to permeate it are the sensitivity and respect towards *objects* of the curator. For the exhibition also celebrates 'our' success in absorbing the creative energies of the Native Americans into the mainstream of our commerce. As the catalogue (p. 14) states:

> The Indian relic market of yesterday has become a sophisticated art market today. We admire collectors like J. D. Dyer of Fort Reno, Nevada, Morley Reed Gotschall of Philadelphia, William E. Claffin of Boston, who preserved many treasures that might otherwise have disappeared from the record. . . in the last years, all of these objects, once considered homespun and of only marginal local interest, have begun to be collected as avidly as any other art. While this is sad for the old-time Indian buff, it signifies the advancement of American Indian art to the status it deserves.

The degree to which this point of view is not only accepted, but celebrated, is suggested by the availability on the Hayward's lobby table during the private view of a Sotheby's card advertising 'A Sale of American Indian and Pre-Columbian art to coincide with the exhibition of American Indian art opening at the Hayward Gallery, London, on 7 October.' The ethnocentric aesthetic judgements mentioned earlier can be seen as a means of validating the current increase in market value of these objects. The caption of catalogue no. 1, 452, a painted and carved wooden bowl, says: 'Its quality is denoted by the thin painted rim line and the subtle way the heads are stepped upon the rim. Collected in 1768, this bowl was auctioned at Sotheby's, 29 April, 1974, number 128.'

The assignment of these artefacts to our category 'art' signifies the structural necessity in our society to reduce the value of the symbols of 'others' merely to the worth of objects exchanged among its own members; collecting the objects becomes the only way 'we' can express a bewildered sense that there is some value in them. These symbols of others thus are integrated into the mainstream of our culture, and this integration completes the disappearance of the living reality of their makers' cultures, as far as 'we' are concerned. This process, along with the ability to treat indescribably sad facts with a false objectivity that seeks to avoid both condemnation and pathos, must be seen as instances of the brutalization of our psyches resulting from the perpetuation of attitudes more than two hundred years old.

This exhibition, then, is really about using 'art' to cover up some historical truths; about using aesthetic judgements as a way of avoiding moral judgements; about professing admiration for spiritual values which manifesting only materialistic ones; about admiring the 'work' while ignoring its meanings; about voiding symbols of their complexity by eliminating their context; and about valuing art objects more than societies.

To say that the purpose of the exhibition is 'that this art should at least be properly regarded for the sake of a better understanding among peoples' (catalogue, p. 13), is, at the very least, an inadequate way to render justice to the peoples whose works are represented.

NOTES

1 J. D. Forbes, ed., *The Indian in America's Past* (New Jersey): Prentice Hall, 1965), pp. 35–40.

2 James Wilson, *The Original American: US Indians* (Minority Rights Group Report no. 31, 1976), p. 24.

3 John R. Swanton, *The Indian Tribes of North America* (Smithsonian Inst. Bull. Amer. Ethnol. no. 145, Washington, DC, 1953).

4 'The Sand Creek Massacre', Testimony of 1st Lt Cranmer, in Forbes, *The Indian in America's Past*, p. 47.

5 See Ruth Brunzel, *The Pueblo Potter*, (New York: Columbia University Press, 1929, reissued New York: Dover, 1972), or any of Frances Densmore's studies of Native American music.

CHRONOLOGY OF WORKS CITED

Title	Date	Medium	Illustrated (p.)
Hand Grenades, Painting Blocks, Measure by Measure and other recycled works	1969 onwards	canvas, paper, glass; various formats	242, 243, 244
The Photomat Portrait Series	1969 onwards	collaborative serial portraits	not illustrated
Incognito	1972 onwards	found photomat portraits	not illustrated
Dedicated to the Unknown Artists	1972–76	postcards, charts, book texts	138, 139
Sisters of Menon	1972 and 1979	automatic scripts on paper/artist's book	53
The Dream Seminar	1973	group event, twelve weekly meetings	not illustrated
Street Ceremonies	1973	site-specific group event	not illustrated
Enquiries/Inquiries	1973 and 1975	two slide sequences/ installation and artist's book	not illustrated
Dream Mapping	1974	site-specific group event	129, 178, 179
Conceptual paintings and drawings	1972–76	works on canvas and paper	not illustrated
Fragments	1977–78	installation for walls and floor; shards, paintings, charts, texts	22, 23
10 months	1977–79	photographs, texts; installation	48, 49
Work in Progress	1980	solo event and objects	167
Monument	1980–81	photographs, audiotape installation	186, 187, 188, 189
Élan	1981–82	photographs, audiotape installation	39
Sometimes I Think I'm a Verb instead of a Pronoun	1981–82	photographic sequence	64
Bad Dreams	1981–83	photographs; curtains; installation	not illustrated
Lucid Dreams	1982	photographs with ink	not illustrated
Inside a Cave Home	1982	altered photographic series	not illustrated

Title	Date	Medium	Illustrated (p.)
Photomat (Self-) Portraits	1982	cross-shaped photographic works	not illustrated
Midnight, Euston	1982	photograph	68
Midnight, Tottenham Court Road	1982	photograph	156
Midnight, Baker Street	1983	set of three photographs	196
Towards an Autobiography of Night	1983	altered photographic series	not illustrated
Alphabet, Lexicon, Self-Portrait, Autobiography	1983	large altered photographs and set of small studies	5, 55
Ghostbusters from the *Home Truths* series	1986	riplon on wallpaper	ii
Belshazzar's Feast	1983–84	video installation and broadcast programme	84, 90, 91
Magic Lantern	1987	audiotape/slide installation	not illustrated
The Secrets of Sunset Beach	1988	photographic series	108, 109
An Entertainment	1990	four interlocking video programmes; installation	132, 133, 149
Dirty Paintings	1991	small wallpaper works	not illustrated
Nine Songs from Europe	1992	postcards, inspection lamps etc.; installation	161
From the Freud Museum	1992–94	mixed-media installation (sections individually dated and titled, e.g. *Heimlich, Cowgirl*, etc.)	9, 203, 224, 230, 241
Bright Shadow	1994	single-screen video programme	not illustrated

SELECTED BIBLIOGRAPHY

Guy Brett, Rebecca D. Cochran, Stuart Morgan, *Susan Hiller*, 1996, Tate Gallery, Liverpool

Guy Brett, Roszika Parker, John Roberts, *Susan Hiller 1974–84: The Muse My Sister*, 1984, Orchard Gallery, Derry

Corris, Michael, *Susan Hiller's Brain*, 1994, Gimpel Fils Gallery, London

Coxhead, David, Susan Hiller, *Dreams: Visions of the Night*, 1976, London, Thames & Hudson; New York, Avon; Paris, Editions du Seuil; Amsterdam, de Haan; Frankfurt, Umschau Verlag; Tokyo, Heibonsha Ltd; revised and reprinted 1981, 1989, 1991, 1995

Elliott, David, Caryn Faure-Walker and Susan Hiller, *Recent Works*, 1978, Museum of Modern Art/Kettles' Yard Gallery, Oxford and Cambridge

Fisher, Jean, *The Revenants of Time*, 1990, Matt's Gallery/Mappin Gallery/Third Eye Centre, London/Sheffield/Glasgow

Guest, Tim, Susan Hiller, *Monument*, 1981, Ikon Gallery/A Space Gallery, Birmingham and Toronto [English/French]

Hiller, Susan, *Rough Sea*, 1976, Gardner Centre for the Arts, University of Sussex, Brighton

—*Enquiries/Inquiries*, 1979, Gardner Centre for the Arts, University of Sussex, Brighton

—*Sisters of Menon*, 1983, Coracle Press for Gimpel Fils, London

—(compiled and introduced by), *The Myth of Primitivism*, 1991, Routledge, New York and London, reprinted 1992, 1993

—'Hélio Oiticica: Earth, Wind & Fire', *Frieze*, Nov/Dec 1992, pp. 26–31, London

—'O'Keeffe as I see her', *Frieze*, London, summer 1993, pp. 26–9, London

—'An Artist Looks at Art Education', *The Artist & the Academy*, Stephen Foster and Nick de Ville, eds, Southampton, 1994

—*After 'The Freud Museum'*, 1995, Book Works Press, London

—'The Word &the Dream', in *Random Access: Staking the Claims for Art & Culture*, 1995, Nicos Papastergadis and Pavel Buchler, eds, London

Lacy, Catherine, *Susan Hiller: 'Belshazzar's Feast'*, 1985, Tate New Art/The Artist's View, London

Lippard, Lucy, *Susan Hiller*, 1986, Institute of Contemporary Art, London

Lloyd, Jill, *Susan Hiller*, 1989, Pierre Birthschansky Galerie, Paris [French/English/German]